M

ART LE

ART LESSONS

LEARNING FROM THE RISE AND FALL OF PUBLIC ARTS FUNDING

ALICE GOLDFARB MARQUIS

BASIC
CIVITAS
BOOKS

A Member of the Perseus Books Group

Designed by Ellen Levine

Library of Congress Cataloging-in-Publication Data
Marquis, Alice Goldfarb.
 Art lessons : learning from the rise and fall of public arts funding / Alice
Goldfarb Marquis.
 p. cm.
 Includes bibliographical references and index.
 ISBN 0-465-00437-7
 1. Performing arts—United States—Finance. 2. Centers for the per-
forming arts—United States. 3. Performing arts—United States—His-
tory—20th century. I. Title.
PN2293.E35M27 1995
791'.06'91—dc20 94-40365
10 9 8 7 6 5 4 3 2 CIP

A faithful friend is the medicine of life.
—Ecclesiastes 6:16

Such a one is the person to whom this book is dedicated,
ARISS TREAT-SEDGWICK

CONTENTS

ACKNOWLEDGMENTS

IN THE JOURNEY of discovery in writing this book, I was fortunate to find many and varied companions. Some generously shared what they knew; others refreshed my enthusiasm for the project, listened patiently to half-baked theories and tentative speculations, or provided much-needed distraction from my work. Still others housed me, fed me, typed my notes, and pointed me in fruitful directions.

My home base, the University of California at San Diego, continues to offer warm hospitality to this independent scholar. The history department annually renews my status as a visiting scholar, providing me with indispensable faculty privileges at the university library. There, the staff, in particular Susannah Galloway, graciously fulfilled even the most bizarre requests. My mentor and friend, Stuart Hughes, remains, as always, a willing reader and gentle critic.

Many colleagues in San Diego Independent Scholars served as an informal academic department, most notably Jane Ford, Aline Hornaday, and Marian Steinberg. Further support came from that most stimulating crowd in the National Coalition of Independent Scholars. Others who may have been victimized by my years-long obsession include Sue Whitman, Sue Keller, Phil Melling, Charlotte and Martin Stern, the late Henry Stern, and Norma Sullivan.

The typists who turned my scribbled comments and highlighted papers into usable note cards were Karen Pomeroy and Bonnie and Lee Merritt. My son, John Blankfort, remains not only a source of great pride but also a

valuable resource in learning about the best tool a writer could have, the computer. Natasha Josefowitz and Herman Gadon kindly allowed me to scandalize a large party of their friends with as yet uncertain conclusions. In Washington, I enjoyed hospitality—and sound advice—during several research trips from Robert Brown, Lois Fishman, Leah and Anthony McIvor, Kay and Harold Orlans, Jerry Stromer, and Karen Thomas. In New York, I was entertained and enlightened by Sherry French, Elsbeth and the late Hans Heinzheimer, Marilyn Kim, Freda and James Polak, and Rae Margulies; I was privileged to spend many hours in the scintillating, instructive company of W. McNeil Lowry, who died on June 6, 1993. In Chicago, Stanley D. Edwards provided an immense packet of unusual source material.

Some of the most exciting days in researching this book were spent in archives and libraries, especially the first-rate facilities of the Billy Rose Theatre Collection at the performing arts branch of the New York Public Library and the Oral History Archives of Lincoln Center. Above all, I am grateful to some eighty individuals who devoted many hours to my incessant questioning; their names appear in the notes, but I would like to thank especially Livingston Biddle, Francis S. M. Hodsoll, John Frohnmayer, and Anne-Imelda Radice, all of them former chairs of the National Endowment for the Arts, and Leonard Garment, the endowment's godfather.

As for the godparents of this book, I should thank my agent who has also become my friend, Felicia Eth; Martin Kessler, who acquired the proposal for Basic Books; Kermit Hummel, the current publisher at Basic who picked up the project and edited the final result; his assistant, Dana Slesinger; and that indispensable figure guarding the writer from embarrassing error, a sharp-eyed copyeditor named Suzanne Wagner. None of those named above, however, is responsible for lapses of fact or judgment in this book.

La Jolla, California
November 7, 1994

ART LESSONS

1

SEVENTY-SIX TROMBONES

Ya got Trouble,—my friend, right here, I say Trouble,
right here in River City.

—THE MUSIC MAN

WHEN PROFESSOR HAROLD HILL first rapped out these lines on the stage of New York's Majestic Theater, critics cheered *The Music Man*'s nostalgic portrait of an Iowa town besotted by promises of cultural amenities. "A warm and genial cartoon of American life," said Brooks Atkinson's review in the next day's *New York Times*. While "mulcting the customers," the fast-talking professor had also "transform[ed] a dull town into a singing and dancing community." Since that first performance on December 19, 1957, Meredith Willson's charming musical has been staged thousands of times, currently averaging more than two hundred productions each year. A movie version in 1962 reprised the artless tale of how the "professor" bamboozles the naive folk of River City into parting with thousands of dollars for uniforms, instruments, and music lessons for their children. "Trouble . . . with a capital T and that rhymes with P and that stands for Pool," the seductive scamp rants. "Friends, the idle brain is the Devil's playground. . . . Gotta figger out a way t'keep the young ones moral after schoooool."[1]

Though it travels modestly as an evening's light entertainment, *The Music Man* poignantly enfolds Americans' deep and long-standing yearning for cultural improvement. The musical is set in 1912, but its sunny outlook reflects the national mood near the end of the 1950s, when it was first produced. Not only had the United States gloriously triumphed in the Second World War, but its wealth had also helped to rebuild the ruined economies of its European allies, not to mention those of its erstwhile ene-

mies Germany and Japan. Americans who could easily recall the thread-
bare existence of the Depression now were reveling in unprecedented
prosperity. The cars and houses and kitchen appliances that for years were
only a ghostly promise in wartime magazine advertisements had material-
ized in profusion; for the first time in American history, that sweet,
scrubbed, idealized family depicted in those same advertisements had also
come alive, in such numbers that many believed that the entire population
would soon enjoy at least a middle-class standard of life. But as John Ken-
neth Galbraith so cogently argued in a landmark work of 1958, *The Afflu-
ent Society,* "when man has satisfied his physical needs, the psychologically
grounded desires take over."[2]

Like the wide-eyed Iowans of River City who invested so eagerly in Pro-
fessor Hill's extravagant promises, many Americans in the 1960s expected
to collect a special dividend of psychic income from the arts. An editorial in
the 1960 year-end issue of *Life* magazine called for "a second revolution
. . . [a] new role for culture." Democratically dispersed throughout the
population, "the arts by their very nature are equipped to impose form and
meaning on the increasing complexities of human experience," *Life*
argued. In deference to the missionary origins of its publisher Henry Luce,
the magazine conceded that art could not replace religion, but the editorial
asserted that "art is the only other human activity which speaks directly to
the emotions. . . . The refinement must be public and general if our civi-
lization is to be democratic as well as great."[3]

This fervent endorsement of the arts in America's most widely circu-
lated weekly magazine reinforced the immaculate union forged over sev-
eral generations between two widely recommended antidotes to American
materialism: Again and again, the arts were linked with religion. According
to this creed, God marched hand in hand with the Muses, a celestial
parade conjured so seductively by Professor Harold Hill. To partake of the
arts, therefore, was not just a pleasant diversion but also a moral duty; the
benefits went far beyond spending a few enjoyable hours in an ethereal,
spiritual realm. The sermons in behalf of the arts then preached (and
which continue to be preached) laid a heavy moral burden on an experi-
ence that elsewhere was considered simply sophisticated entertainment.
During the 1950s, the era that is the starting point of this book, when
America was still unsteady in its role as world leader, much public agoniz-
ing over the nation's status dwelled on the inferior state of its culture. Adlai
Stevenson, the white hope of intellectuals who was defeated for the presi-
dency in 1952 and again in 1956 by Dwight D. Eisenhower, called for "a

reorientation of our ideals and tastes, the strenuous stretching of mental and artistic talent." The respected political scientist Clinton Rossiter, unconsciously paraphrasing Professor Hill's musical remarks about River City, detected "a crisis in American culture." Rossiter was sure that "no great nation can be said to be worth respecting or imitating if it has not achieved a high level of culture, and it is at least an arguable question whether this nation will ever achieve it."[4]

The rhetoric pressing Americans to attend live performances of classical music, dance, and theater often took on the urgency of a crusade. In a propaganda paper advocating construction of a national cultural center in Washington, D.C., the New York Public Library's music specialist asserted that visiting such a center would galvanize "the onlooker . . . [with] the vitalizing and magnetic current that emanates from the living actor, musician, dancer or poet."[5] The museum visit also was seen as salutary for the soul; it provided a "reverential experience," wrote one Berkeley anthropologist, "that is solitary, contemplative, a rest from the cares of the world, uplifting of spirit."[6] Even the introduction to a book titled *Marketing the Arts* extolled the "incomparable opportunities" offered by the arts "to experience the sublime and divine."[7]

Within the Western world's discourse about culture, Americans seem peculiarly addicted to religious metaphor. In Europe, such associations between art and the Divine were common during the nineteenth century when the cult of "art for art's sake" took on many of the trappings previously devoted to religious worship. The rush to build magnificent opera houses, museums, concert halls, and theaters recalled an earlier time's fervor to construct cathedrals. Those who practiced their art within these temples were not shy about claiming divine inspiration and the audiences thrilled to the mystery at the core of their performances, a mystery that could be studied but ultimately required a leap into passionate spiritual engagement. Marcel Proust, for example, described his profound emotion at a performance by Berma, an actress modeled on Sarah Bernhardt. Berma's fusion of noble words and "perfection in the dramatic art" as she performed a scene from Racine's *Phèdre* charged Proust "like a battery that accumulates and stores up electricity. . . . Even if I had believed that I should die of it, I should still have been compelled to go and hear Berma."[8]

In America, the cult focused on arts and artists of European origin. The few who could afford it traveled to Europe, while those of the middle class—still a minority—enjoyed European performers who toured around the country. Well into the twentieth century, American orchestras sought

European conductors. When the Los Angeles Philharmonic hired Alfred Wallenstein in 1944, he was the first American-born musician to serve as music director of a major American orchestra; New Yorkers had to wait for the advent of Leonard Bernstein in 1969. Despite their New World cousins' devotion to Old World culture, Europeans found little to admire and much to mock in American barbarism. When Aldous Huxley first visited Los Angeles in 1927, he reported that for Americans "existence on the lower animal levels is perfectly satisfactory."[9]

Many Americans were uneasy about the elitist aura surrounding a culture developed by and for foreigners. Walt Whitman complained in 1871 that "America has yet morally and artistically originated nothing."[10] But while the newly rich of the northeastern cities resolutely packed their steamer trunks for grand tours of the Continent, successful entrepreneurs in cities and towns elsewhere in America tried to reconcile European culture's aristocratic origins and *haut bourgeois* patronage with the democratic ideals of American society. Out of their dilemma grew a profusion of organizations, movements, and programs devoted to exposing the masses to the arts religion. With missionary zeal, the Chautauqua movement and others sent out educational speakers and performers to small-town America. Like tent-revivalists, the "better people" herded the public into high school auditoriums for uplifting lectures; they formed book clubs and music societies; they constructed networks of adult education and opened thousands of public libraries.

While the upper reaches of American culture offered but a pale colonial reflection of its European ideal, the broader culture in the nineteenth century promiscuously mingled poetry and doggerel, operatic arias and popular song, minstrel shows and Shakespeare—a panorama as garish as Professor Harold Hill's checkered costume. As the historian Lawrence W. Levine has argued so forcefully, only as the twentieth century dawned did America's cultural leadership manage to impose a hierarchy upon the arts, resulting in what he calls "the sacralization of culture." In the world of music and visual art, the most powerful instrument for constructing this artificial barrier between high and low art was the nonprofit corporation.[11]

This means for organizing high culture was invented in Boston near the end of the nineteenth century and quickly spread across the country. No account of this development can ignore the sociologist Paul DiMaggio's perceptive studies of how financial and social elites defined and captured the high cultural ground by pasting an altruistic, morally chaste veneer over basically self-serving activities. The nonprofit corporations that

Boston Brahmins devised to control the city's cultural life relied on wealthy trustees to finance and manage such amenities as the Boston Museum of Fine Arts and the Boston Symphony. By contributing directly and soliciting donations from others, these trustees seized the taste-making functions previously diffused among impresarios, politicians, performers, women's clubs, and educators. The charters of Boston's nonprofit organizations proclaimed service to the entire community, but in practice, as DiMaggio wrote, the trustees promoted "a view and vision of art" that made it less and less accessible to the wider public. These organizations claimed to benefit all citizens even as they widened the distance between the performer and the public, "to permit the mystification necessary to define a body of artistic work as sacred."[12]

While distancing themselves from commercial culture and refining a jargon and an etiquette that estranged most of the public from their activities, the nonprofit "high" arts organizations that were proliferating around the United States also insisted that they were engaged in civilizing the masses and contributing to general civic well-being. This was the justification for allowing their patrons to make contributions free of federal, state, and local taxes, and for the substantial gifts of land, buildings, and money that municipalities lavished on arts organizations.

The Depression amplified the dissonance between what cultural Brahmins preached and what they practiced. As many old fortunes crumbled, public respect for plutocrats turned to contempt. In the light of that great crusade for democracy, the Second World War, the social distinctions underlying the elite's cultural monopoly also came to be questioned. But the severest threat to the religion of high culture came from popular and commercial art. Magazines, movies, radio, and, eventually, television offered the public a dizzying variety of cheap entertainment. Many years later, critics and scholars discovered a good deal of gold in what originally had been dismissed as contemptible dung. The Saturday radio broadcasts of the Metropolitan Opera eventually ignited a nationwide fever for opera; Orson Welles's *Citizen Kane* continues to attract fresh analysis; Leonard Bernstein's televised "joy of music" performances enthralled young listeners. But when such works were first presented, few intellectual or cultural leaders could find much to admire. Instead, they frequently fulminated against an omnipresent carnival of tawdry entertainment.

"Good art competes with kitsch, serious ideas compete with commercialized formulae," lamented the critic Dwight Macdonald. Mass culture, he warned, "threatens High Culture by its sheer pervasiveness, its brutal,

overwhelming *quantity*." He even deplored any effort to explain or popu-
larize high culture as encouraging "a tepid, flaccid Middlebrow Culture
that threatens to engulf everything in its spreading ooze." Robert M.
Hutchins, who had reinvented higher education at the University of
Chicago, believed that liberal intellectuals' bitterness toward mass media
stemmed from "disappointment at what the man on the assembly line has
done with the free time that they have helped him to obtain. . . . New
methods of wasting [time] and new objects to waste it upon are being
invented every day."[13]

Perhaps there was a moment when a fairly acute observer could have
drawn a sharp line between high art and low art in America, but if so it was in
the distant past. Yet many of those responsible for funding the arts purport to
know where this line exists. At the extremes, such a division appears simple:
A performance of *King Lear* by the Royal Shakespeare Company is defi-
nitely "high"; mud-wrestling in a neighborhood bar is clearly "low." However,
the closer one moves to the center of the spectrum, the trickier the distinc-
tions become. What to make of tap dancing or flamenco? Of a popular com-
mercial film such as *The Remains of the Day*? Of the operetta *The Merry
Widow*? How to classify Luciano Pavarotti lip-synching an aria? Is it high art
when a symphony orchestra accompanies a silent movie or plays Tchaikov-
sky's *1812* Overture accompanied by fireworks? How to regard a snippet of a
Mozart flute concerto in a Pepsi commercial? Clearly, American culture
boisterously, maddeningly, perpetually blends high and low.

In the same pattern, the careers of this country's finest artists have
shifted seamlessly between commerce and art. The beloved soprano Bev-
erly Sills starred in a radio commercial for Rinso White soap powder dur-
ing the 1950s.[14] Leonard Bernstein, much to the distress of the prissy
gatekeepers at St. Culture, achieved fame as a composer of musical the-
ater, not to mention his labors in that purported graveyard of talent, Holly-
wood. In the world of dance, few observers care to classify as high or low
the work of Jerome Robbins and Agnes De Mille, of Gene Kelly and Fred
Astaire. The artist most representative of this peculiarly American min-
gling of the ethereal and the vulgar is, of course, Andy Warhol. "I wish I
could invent something like blue jeans," he once said. "Something to be
remembered for. Something mass." Much to the chagrin of those still seek-
ing to defend high art against the taint of vulgarity, Andy Warhol's works
and memorabilia are now lavishly remembered in a $12-million museum in
Pittsburgh, the largest museum in America devoted to a single artist.[15]

The American propensity for such shameless intercourse between trea-

sure and trash has made life difficult for those striving to convert the wider public to the high art religion. Yet this missionary endeavor forms the primary rationale for spending public money on the arts. But which arts? This seemingly simple three-word question has echoed and re-echoed through recent decades, in academic departments, among artists and the managers of arts institutions, and most acrimoniously in congressional debates over the uses of tax money for subsidizing the arts. "Were art the unqualified good the consensus of the sixties implied, one would think that those who spend the bulk of their time with art should be the best and happiest of people," wrote the philosopher and art critic Arthur C. Danto in 1993. He found the truth to be quite different: "Art people have terrifying egos, and are filled with intolerance and condescension, and spend their time in fierce bickers about what is art and what is not." Danto located one explanation for such unseemly acrimony in the linkage of art and theology, "for religion is the locus of dissent and heresy and imposed orthodoxy and bitter strife and deep and total intolerance."[16]

The arts religion casts its pall over too many programs claiming to attract new audiences for high art. Factual information about the works to be performed and the artists on stage often sinks into a morass of high-minded gush. Docents and other educators hand down the list of masterpieces as though it were engraved upon marble tablets; no further discussion seems possible without betraying one's gross ignorance or base insensitivity. To confess that one dislikes an item on the sanctified list is heresy. In contrast to the intense, lively, and sometimes raucous nexus between audience and performer of times gone by, we are corseted by a stern etiquette of Victorian rigidity. It dictates precisely when audiences may applaud and forbids the slightest murmur of disapproval.

Within this stifling environment, the verb *to celebrate* has spread the mantle of its religious meaning (to celebrate a mass) over any number of arts-related activities. We "celebrate" folk art, which means we no longer have to learn anything about it or its practitioners but simply nibble at a thin, lo-cal wafer of sentiment. To "celebrate" Duke Ellington or Mozart, a sacramental sip without savor or understanding will do. Such empty ritual gestures obscure the real artist in a saccharine mist. We render the arts and artists no honor by prostrating ourselves before them in blind devotion.

As emblems of our civilization, the arts are too important, too interesting, and too enjoyable to be shrouded in idolatry, no matter how well meaning. This book assumes that if we want to help the arts, we must look carefully at the kinds of aid they obtain and how it affects the recipients.

Therefore, it tries to avoid the condescension implicit in vapid gush. Rather, what follows seeks to supply the reader with a historical framework for assessing the condition of the arts and of artists, with some sense of their infinite, gaudy variety.

The following chapters are loosely chronological in telling the story of public arts funding from the end of the Second World War up to the present. Each chapter also focuses on the development of one key element of the cultural world during the entire period. The goal is to arrive at an overview of how public funding has affected the arts not only financially but also stylistically. Despite all disclaimers, the evidence suggests that paying the piper profoundly affects the tune, and to claim otherwise misleads the public. The evidence also appears overwhelming that politics cannot be excluded when public money supports, or fails to support, cultural activities. Above all, this book strives to engage the reader in the lively, fascinating, and intense debate over who, if anyone, should decide what is art.

2

WEST SIDE STORY

COMPARED WITH THE grandiose temples for the arts that would later be built, New York's City Center was absurdly modest. It cost just over $60,000 and took less than a year to open. Unpretentious, too, were its goals. Really, there was only one goal: to offer New Yorkers a variety of cultural events at ticket prices that began at less than one dollar. When this very first performing arts center in the United States opened on December 11, 1943, its organizers hailed a bold populist step toward bringing culture to New York's masses. It marked the city's emergence from Depression stringency: a down payment on a limitless future that would transform New York into the cultural capital of the American Century.

The venue for this simple amenity was conspicuously ornate, a cavernous mock-Moorish hall on West 55th Street, between Broadway and Seventh Avenue. New York's Ancient and Accepted Order of the Mystic Shrine, which had built the hall in a fit of red-fezzed exuberance in 1924, had abandoned it to the city of New York for delinquent taxes some ten years later, during the Depression. Occasionally, a small number of the 2,684 seats in the Mecca Temple, as it was still called, were used for civil service exams or other mundane city activities. In the bleak wartime winter of 1942–43, the U.S. Treasury Department, at the behest of New York's strong musicians' union, sponsored a series of concerts, with admission by purchase of war stamps. After that, the hall had a date with the wrecking ball, whose mindless force would pulverize the mosaics, the elaborate Oriental bas-reliefs, the spacious stage, the balcony dripping with plaster

interlace, all that Levantine frivolity that New York's chapter of the American Institute of Architects now calls "delightfully absurd."[1] On the site, there would be a parking garage.

This prospect offended New York's feisty fireplug of a mayor, Fiorello La Guardia, who, the son of an army bandmaster, fancied himself an amateur opera buff. The final Treasury concert, featuring the pianist José Iturbi (who also conducted the New York Philharmonic), had attracted such a mob that the mayor himself, even with two burly policemen running interference, could hardly get through. La Guardia impulsively determined to turn the hall into City Center for the Performing Arts, to enshrine "the flame of art . . . and to hold until the younger generation lay down their arms and come back, the beautiful, spiritual, and happy things in life."[2]

Following the concert, the mayor joined the City Council president Newbold Morris, the philanthropist Gerald Warburg, and other dignitaries at a supper party given by Jean Dalrymple, a Broadway publicist who had volunteered her services for the Treasury concerts. La Guardia kept talking about the millions of New Yorkers who would attend cultural events if only they could afford them, recalled Dalrymple in her memoirs. Morris, who had previously arranged a series of concerts sponsored by the Work Projects Administration (WPA) at Radio City's Center Theater, suggested using the Mecca Temple.[3]

Such were the quick old days that Morris obtained the $60,750 needed to start the center by calling together leaders of the Amalgamated Clothing Workers, the Jewish Labor Committee, the Workmen's Circle, United Hebrew Trades, the Joint Board of Millinery Workers, and the International Ladies' Garment Workers' Union. Their membership was dominated by Jewish immigrants and their children, many longing for inexpensive cultural offerings. Anticipating work for its members, Local 802 of the American Federation of Musicians pledged $10,000 toward the total. Morris also won support from the Broadway producer John Golden; the conductor Erich Leinsdorf; the philanthropists Edmond A. Guggenheim and John D. Rockefeller, Jr.; representatives from the New York Philharmonic and the Metropolitan Opera; the Dramatists Guild; and such cultural stars as Lillian Gish, Paul Robeson, the *New York Times* music critic Deems Taylor, and the operatic baritone Lawrence Tibbett.[4]

On December 11, 1943, only nine months later, Artur Rodzinski conducted the New York Philharmonic in the freshly scrubbed hall, which *Time* magazine deemed "a masterpiece of Turkish-bath rococo." Tibbett, a

native of Bakersfield, California, who was a soloist that evening and the finale, George Gershwin's *An American in Paris,* signaled City Center's orientation to home-grown talent. The top ticket price, one dollar, indicated the center's populist philosophy. The first season sampled the cultural banquet the center would offer New Yorkers for the next two decades. It included Sidney Kingsley's play *The Patriots,* recitals by the modern dancer Paul Draper and the harmonica virtuoso Larry Adler, and a revival of a recent Broadway production of Thornton Wilder's *Our Town* (with the young Montgomery Clift in the juvenile lead). By February 21, 1944, the newly organized New York City Opera performed *Tosca,* and on the next night, *Martha,* and the night after that, *Carmen,* all to excellent reviews. The center's slogan, "the best in entertainment at the lowest possible prices," became a reality: Admission cost from eighty-five cents to $2.20.[5]

For more than twenty years, Jean Dalrymple would occupy an aisle seat in the last orchestra row as hundreds of productions came to life in that riotously caparisoned hall. As a producer and publicist, she served on the board of directors, and it became a tradition for its members to troop across the street to her apartment after their meetings. Morris, an intimate friend, would sip a dry martini, while the finance committee chair Morton Baum, one of the city's leading tax lawyers, relaxed with a light scotch and soda. As a woman in that all-male milieu, Dalrymple "could do anything [she] wanted by never taking credit." Almost half a century later she recalled, "If I took credit, it would lead to a big fight." Even when she proposed starting what became the New York City Opera under Laszlo Halasz, she "asked Newbold Morris to announce it."[6]

When City Center's incorporators held their first annual meeting in May 1944, Mayor La Guardia cheerfully announced a first-season profit of $844.77. Some 346,750 people had attended performances, including 47,000 admitted with 20 percent–off coupons sold to civic and labor organizations, and 30,000 schoolchildren who paid thirty cents for a play and fifty cents for an opera. The children's program had been organized by a volunteer, Ida Martus, an English teacher who soon obtained a cramped office at City Center and a salary from the New York Board of Education. In the twenty-five years following that first season, she arranged for some 1.5 million schoolchildren to attend City Center performances.[7]

In its second season, City Center attendance reached 750,000 for 357 performances, and it posted a profit of more than $63,000. Such wondrous results came about mainly through performers' enthusiastic contributions to a "people's culture." Iturbi, for example, donated his services as piano

soloist on the first anniversary, and a rush-hour throng pushed to get tickets at one dollar each, open seating. For *Little Women,* opening the following night, the Broadway cast agreed to work for the Equity minimum, $57.50 per week. To stage the holiday program, *A Children's Christmas Story,* the conductor Leopold Stokowski donated $10,000. And on Christmas Day, 1944, Paul Draper and Larry Adler entertained in return for a tiny percentage of the gross.[8]

The euphoria at the intersection of artistic and financial success lasted only a few years. Arts audiences, like those for other entertainment, are extremely picky. They bore easily, even when exhorted by the art religion's rhetoric that the dull event they are witnessing is spiritually uplifting. Once the novelty wore off, City Center found it increasingly difficult to lure bodies into its seats with any regularity. The problem was compounded by an agenda that went beyond the original slogan of high culture at low prices. Dalrymple possessed the contacts and persuasiveness to attract Broadway stars in revivals of Broadway hits. But Morton Baum mocked her "Broadway mentality. He didn't think Broadway was art or culture," Dalrymple recalled. To please him, she scheduled a star-less series showcasing American playwrights. "It was our first losing season," she said. Likewise, at the opera, the ideal of presenting new works by American composers was culturally worthy but worthless at the box office.[9]

The bright spot was the New York City Ballet, which City Center took in during the 1948–49 season. During the 1930s, the ballet company's impresario, Lincoln Kirstein, had drummed up a cult following for George Balanchine's troupe at various posh private venues, including the opulent Warburg family "cottage" in White Plains, New York. Young Edward M. M. Warburg had been a generous sponsor, although his brother, Gerald, sourly told the City Center board he had lost "a potful of money." Gerald also worried about Kirstein's overbearing temperament. If they gave the ballet company a permanent home, he warned the City Center trustees, "it won't be long before Lincoln will be trying to run the whole place." Nevertheless, after a successful two-week season in January 1949 and friendly reviews, as well as funding for new productions guaranteed from wealthy subscribers of the Ballet Society, the New York City Ballet became a brilliant centerpiece in the City Center's diadem of resident companies. Within three years, amid board dissension and financial troubles, Kirstein was appointed City Center manager. Gerald Warburg whispered to Newbold Morris: "I told you so."[10]

Kirstein regarded a profitable cultural institution as some kind of dis-

grace. So did Morton Baum, on whose fundraising skills City Center increasingly relied. "You're trying to make money," he would complain to Dalrymple. "Lincoln Kirstein insists we should lose money or else we can't get any grants."[11]

By 1952, the ballet was in enough financial distress to suit even Kirstein, although the top ticket price had been raised, amid much agonizing, from $3.50 to $3.75. By 1954, costly union contracts and more elaborate productions had also sent the opera into deep deficit mode. Kirstein was furious when the board canceled his plans for five new operas in the fall: Gian-Carlo Menotti's *The Saint of Bleecker Street,* Jules Massenet's *Le Jongleur de Notre Dame,* Vincenzo Bellini's *La Sonnambula,* Nicolai Lopatnikoff's *Danton,* and Igor Stravinsky's *The Nightingale.* Ernest S. Heller, who would become the City Center operating chair many years later, recalled, "We always knew that when he put on a contemporary opera, the sales would fall off dramatically."[12]

In a pattern that would be duplicated at many another performing arts center, the luster of City Center was fading fast. The operatic soprano Beverly Sills, who made her debut there in 1955, found it "an impossible house . . . the acoustics were terrible . . . it was like a big barn, dirty and dusty." By 1957, even Jean Dalrymple was disillusioned. City Center "was no longer regarded as a youthful dream and we could not expect pats on the back for good intentions. Somehow we had become part of the establishment." Thanks to the opera's American tours and the ballet's acclaimed European tours, "we were nationally and internationally famous." Still, the opera was losing money so fast that the drama season was threatened. By 1961, ticket prices broke through the four-dollar ceiling.[13]

But more than its shabby theater, more than the smugness of success, more than persistent deficits toppled the dream of a people's cultural center on West 55th Street. The people for whom this amenity had been created were moving outward into the suburbs, westward into the sunset, and upward into prosperity. At untold human cost, the war had accomplished what an array of enlightened social programs had been unable to do: It had launched the U.S. economy into decades of unprecedented affluence. No sooner were Americans certain that the Depression was safely beyond history's horizon than they proceeded to fulfill the fantasies they had formed through the hunger years and refined during the dislocations and dangers of war.

Whether the new car or the house came first, or whether they could

swing both, was a major subject of conversation between the husbands and wives who married in record numbers during and immediately after the war. Total population had risen only slightly during the Depression, but it zoomed by 30 percent from 1945 to 1960. The number of children grew even faster, by 41 percent, and so did the over-sixty-five contingent, a rise of more than 50 percent. So robust was the economy that more than eight million men and women mustered out of the armed services by 1946 were absorbed without a hiccup into the civilian labor force. The new jobs paid high wages. The lines between white-collar and blue-collar workers blurred perceptibly, and by 1952 real income had grown by 50 percent since 1941.[14]

These prosperous workers settled wherever new jobs opened. Rural areas lost almost nine million people in the fifteen years following the Second World War, and the number of family farms declined by 30 percent. Yet the one farmer who had fed ten people in 1940 was, by 1960, feeding thirty. Unneeded in the fields, these restless Americans settled increasingly within the orbit of some large city. By 1960, 60 percent of the population was living within 212 Standard Metropolitan Statistical Areas (SMSAs). These figments of the U.S. Census Bureau's imagination, however, concealed a demographic upheaval that would bedevil government agencies and the dwellers of aging cities, no less than cultural institutions, for the rest of the century.[15]

The SMSAs lumped together central cities and their suburbs. While the figures showed only a moderate decline in central-city population, they masked a drastic change in its composition. Central cities gradually became poorer, worse educated, ethnically more diverse, and more plagued by crime. Wartime security had dictated that defense plants be located outside urban centers, and inner-city social problems and congestion hastened the flight of industry. Meanwhile, suburbia called. Much of the audience for the likes of City Center's ballet, opera, and theater decamped from New York City to Levittown and its clones on Long Island or in Westchester County; from San Francisco down the peninsula or to the east Bay Area; from Chicago out to Skokie or Evanston. And Los Angeles, whose the center had always resembled a mirage, now marched, subdivision by subdivision, over canyons and hills, toward the distant horizon. In 1940, 44 percent of American homes were owner occupied; by 1954, the figure passed 55 percent. Lenders preferred financing suburban housing, and so did the Federal Housing Administration.[16]

These trends boded ill for central cities, especially in the northeast. By

1960, Manhattan's population had shrunk by more than 25 percent from its size forty years earlier. Even more alarming to New York's business community was the steady erosion of retail employment and sales within the city core. In 1939, retail employment in central New York City accounted for about 68 percent of the regional total. By 1954, such employment had fallen below 62 percent. The retail sales picture was even more dismal, with a drop from 64 percent of the regional total to less than 55 percent. Meanwhile, the area's outer ring was flourishing, its population mounting sharply from 12 to 16 percent of the region's total, in tandem with retail sales.[17]

Many lofty words have been offered as motivation for the determination by John D. Rockefeller III and a phalanx of New York's business moguls, in 1955, that the city must have a grand cultural complex. True, the Metropolitan Opera needed a new home, but that need had existed since the late 1920s. True, the New York Philharmonic's showcase at Carnegie Hall was likely to be demolished for an office tower, but City Center, less than three blocks away, could be refurbished as a new home. True, a nonprofit resident theater on the Upper West Side might draw Broadway northward from its aging, congested epicenter around Times Square, but many other venues could be reclaimed at far less cost. Beneath the flow of fine words, unarticulated, ran a current of fears: that the city was slipping from the summit of the financial world; that Manhattan real estate values would languish; that Cold War exigencies were inevitably concentrating power in Washington, D.C.; that Boeing's 707 jet, rolled out eighteen months earlier, would soon be whisking tourists past New York to London and Paris. But most palpable was the fear that the people who bought insurance and stocks, who saved and borrowed at local banks, who consulted the city's lawyers and doctors, and who formed the backbone of audiences for cultural offerings—the middle class—was souring on big-city life.

Summoned by Rockefeller to lunch at the Century Association on October 25, 1955, were five impeccably tailored paladins of New York's interlocking cultural directorate. Charles M. Spofford was chairman of the Metropolitan Opera's executive committee, a director of several corporations, and a trustee of the Carnegie Corporation, Union Theological Seminary, the New York chapter of the Red Cross, and the Juilliard School. The Metropolitan Opera president Anthony A. Bliss was a partner at Milbank, Tweed, Hadley and McCloy, New York's quintessential WASP law firm, and a member of all the right clubs, including the Century, the River, and the Wall Street. His father, Cornelius, had been a Met trustee for

seventeen years during the 1930s and 1940s. Floyd Blair would shortly be replaced as chairman of the New York Philharmonic by his companion at the luncheon, Arthur A. Houghton, Jr., president of Steuben Glass. An alumnus of St. Paul's School and Harvard, Houghton also belonged to the right clubs: the Century, Union, Harvard, Knickerbocker, and Grolier. He was a director of U.S. Steel, the Lackawanna and Erie railroads, and New York Life; an overseer at Harvard; as well as a trustee of the New York Public Library, the Metropolitan Museum of Art, the Baltimore Museum of Art, and Cooper Union. Wallace K. Harrison was an old friend at that table. He had been the Met's house architect for twenty-five years and had participated in the design of Rockefeller Center as well as the United Nations secretariat.[18]

Around the starched white cloth in that landmark building on West 43rd Street, a Beaux Arts design by McKim, Mead and White, the six men chewed over a piece of startling news. As chairman of New York's Slum Clearance Committee, Robert Moses had recently trained his baronial eye on seventeen gritty blocks around the double triangle at West 65th Street, where Broadway and Columbus Avenue intersect. Blighted by northward seepage from Hell's Kitchen, the area was further degraded by the southward spread of a teeming Puerto Rican influx, a raucous Latin stew that overflowed onto stoops and sidewalks. The neighborhood's street gangs would be romanticized in Leonard Bernstein's *West Side Story*. As landlords attempted to cope with the city's stringent rent controls, they had chopped up many of the spacious, elderly town houses on Upper West Side streets into one-room apartments. Crammed with people seeking a life better than a San Juan slum, they also represented deterioration—even threat—to their more comfortable, longer-established neighbors. Every day, some other Central Park West matron would head for groceries on Columbus Avenue and find, instead of Mr. Blumberg and bagels, a bodega piled high with pink bananas. "Transitional neighborhoods," the planners tactfully called them, but middling couples planning a family, or already pushing strollers, reacted with a rush to the Sunday real estate section. There, page after page painted dazzling promises of a house, a yard, a roach-free kitchen with a dishwasher, a basement game room and a washer and dryer, a tree-lined block filled with people like themselves, a neighborhood school without troubled kids. In short, the good American life.

New York's leadership had to devise a powerful response to this idyll. Encouraged by federal subsidies, urban renewal offered the city its best hope of retaining a vital middle class. No maker of small plans, Robert

Moses envisioned the existing urban slaw around Lincoln Square replaced by high-rise cooperative apartment houses and middle-income rentals, stores and restaurants, a university center, a small park, several new theaters, and that grandest of all structures, an opera house.[19]

As agile as he was bombastic, Moses had telephoned Wally Harrison at home one Sunday evening and soon appeared at his door. "What would you think," he asked the architect, "of a site for an opera house west of Broadway between 63rd and 64th Street?" The question galvanized not only Harrison but the Met's board of directors as well, where the search for a new house had consumed the energies of several generations. In the late 1920s, the opera's desire for a new house had prompted John D. Rockefeller, Jr., to assemble several blighted blocks around 50th Street, west of Fifth Avenue. Around the new opera house, he intended to develop office and commercial space. By October 1929, Junior, as he was commonly called, was committed to paying Columbia University $3.3 million a year in ground rent and had blueprints in hand when the stock market plunged and the Met hastily withdrew from its commitment. Junior courageously advanced anyway, and erection of Rockefeller Center became New York's largest privately funded construction project during the Depression.[20]

The opera house that the father had been unable to realize the son would now attempt to create. "I think at that time they were going to try to get the various parts together at Rockefeller Center, but that never materialized," the Lincoln Center trustee Robert E. Blum speculated many years later. "I think John wanted to make a success out of this second attempt." At the second meeting of the committee to explore an opera house and concert hall near Lincoln Square, John D. Rockefeller III was named chairman. Three men had been added. Devereux C. Josephs was chairman of New York Life Insurance Company and a central figure in the city's Protestant philanthropic web: overseer of Harvard University; trustee of the New York Public Library, the Metropolitan Museum of Art, and the Rockefeller Foundation; former president of the Carnegie Corporation. Robert E. Blum provided the committee with several valuable new connections. As vice president of Abraham & Straus, he would rally the city's Jewish-dominated retailing community for the fundraising task ahead. As president of the Brooklyn Institute of Arts and Sciences, he gave the committee multiborough cachet. His friendship with Robert Moses didn't hurt either. Also added was Lincoln Kirstein. The son of an executive at Filene's Department Store in Boston, Kirstein, like Blum, was a nominal Jew, and the only committee member with any sophisticated opinions about art.[21]

So comfortable was this group in action that on November 8, 1955, just two weeks after coming together, it hired a Philadelphia engineering firm, Day & Zimmerman, to conduct a feasibility study for the contemplated arts center. So certain was the committee that the findings would be favorable that it added three more men to the weekly lunch table at the Century Association. One was the new Philharmonic president David Keiser, a sugar magnate who was also an alumnus and trustee of the Juilliard School. Irving S. Olds, a respected elder of the Metropolitan Opera, was retired chairman of U.S. Steel. C. D. Jackson was another opera veteran and, as publisher of *Fortune,* a link to the powerful Henry Luce publishing empire. To cover expenses for the next five months, the Rockefeller Foundation soon provided $50,000; after that, another $25,000 was forthcoming from the New York Foundation, plus smaller grants from the New York Community Trust.[22]

By the time Day & Zimmerman presented its report, on the last day of 1956, the question the firm had been asked to study was already resolved. A performing arts center would be built near Lincoln Square. But the consulting firm's charts and graphs, backed by arid prose, lent sober, factual underpinning to the conclusions already formed by the exploratory committee. In a cover letter to that formidable address where all the Rockefeller interests lodged—Room 5600, Rockefeller Center—the engineering firm deemed the project "feasible and practicable." Paid to study traffic, population trends, and space utilizations, the Philadelphia engineers also offered aesthetic judgments, certifying the project as "a highly desirable adjunct to the cultural life of the city" that "could have national and international significance."[23]

The report was a model of multitudes of reports that arts organizations would commission in subsequent years. They are unfailingly friendly to whatever project is being proposed. Obviously those who are paying for the report don't want cold water tossed on their dreams. To be fair, the report writers must make sense of the spongiest of data, and read the future in the entrails of fantasy. The quest for hard statistics mires in soft definitions. These often boil down to exquisite philosophical questions. Surveying the 1954–55 season, Day & Zimmerman found more than half a million people had attended 167 events at the Metropolitan Opera. But other "unclassified" venues had attracted some 132,000 people to 110 unspecified operatic performances. Some 38,000 people had attended 47 performances of "modern dance." But almost twice as many had attended 110 dance performances that were "unclassified." The report showed

astoundingly sparse attendance for operettas, musicals, drama, theatrical events, and motion pictures. But only nonprofit events in these largely for-profit fields had been surveyed. Stickiest of all was predicting the extent of the population drain so evident on Manhattan's West Side. For this, the survey relied on the New York Regional Planning Association's forecast of just a 3 percent decrease in population from 1955 to 1975. Based on such boosterish projections, Day & Zimmerman did not believe that "the apparent trend of population away from Manhattan and toward the suburbs had serious import in considering the desirability and feasibility of the [Performing Arts] Center." Indeed, if parking were provided, the center would attract suburbanites, at least for an evening on the town.[24]

In reality, Manhattan would lose more than one-quarter of its population between 1950 and 1980. The Bronx and Brooklyn lost 20 percent of their inhabitants during these years. Despite healthy gains in Queens and Staten Island, the total city population declined by more than 820,000, almost 10 percent.[25]

As the Day & Zimmerman firm was gathering data, the exploratory committee lunched its way through expanding the project's scope. To the opera house and concert hall it added ballet, as being "musically based"—and, of course, adamantly championed by Kirstein. Then came a repertory theater, an American counterpart, so the fantasy went, to London's Old Vic or Paris's Comédie Française. The center would also include a branch of the New York Public Library devoted to the performing arts, possibly attached to a small museum. Such a facility had long been coveted by Carleton Sprague Smith, a musicologist who taught history at Columbia University while also chief of the music division at the New York Public Library. Finally, the explorers envisioned a performing arts school whose students would learn from resident companies while their teachers would contribute their talents.

How to construct such an ambitious complex? In late April 1956, John Rockefeller and a few exploratory committeemen sought answers in Europe. They viewed concert halls and opera houses, talked with arts leaders, and returned with the conclusion that *they*, not the Europeans, were pioneering this type of project. Nothing of its size and scope and complexity had ever been attempted, at least in the performing arts. But there was a model. Increasingly elaborate versions had been springing up like mushrooms (though some would call them toadstools) along turnpikes and around crossroads in the suburban countryside. Invented as early as 1943 and elaborated through the postwar years, these were the commercial

agglomerations that were stealing New York's retail trade: shopping centers. In broad purpose, they paralleled what the performing arts center hoped to accomplish: to cluster amenities for the mutual enhancement of the whole. In structure, the shopping mall provided a model for what would become the cultural mall.

No one acquainted with John Rockefeller recalls that he displayed any interest in the arts. W. McNeil Lowry, who managed the Ford Foundation's munificent arts program when Lincoln Center was developed, said Rockefeller was "a total innocent about any professional question in the arts, totally, with the possible exception of painting."[26] But Rockefeller had intimate knowledge of that urban shopping and office complex called Rockefeller Center. He also knew a great deal about charitable works. Just two years after graduating with Princeton's class of '29, his father had placed him on the boards of the Rockefeller Foundation, the Rockefeller General Education Board, the Rockefeller Institute, the Rockefeller-sponsored China Medical Board, and other boards and committees totaling thirty-one. Shyly, quietly, but doggedly he would search for personnel, find funding, help decide on good works to be pursued, and each year, at his father's bidding, even hire a summertime pro for the Seal Harbor Tennis Club.[27] After the Second World War, international problems had occupied him until late in 1953, when the City Center board was once again flirting with bankruptcy. The Rockefeller Brothers Fund had provided some grants to keep the center afloat, and Lincoln Kirstein, who socialized with the Rockefellers, tried to attract the philanthropist to the City Center board. "It was generally agreed that any new activity . . . [for me in New York] . . . should be in the field of culture," Rockefeller noted in his diary.[28] However, while Newbold Morris and Morton Baum welcomed Rockefeller's skill as a fundraiser, they refused to yield him any policy role. Two years later, Lincoln Center called. "I had begun to think more seriously of my responsibilities as a citizen of New York," Rockefeller soberly declared to Lincoln Center's chronicler, his devoted assistant Edgar B. Young. "For me, new horizons began to open."[29]

His lustrous name aside, John Rockefeller was blessed with total composure in the face of staggering sums of money. Was it admiration or cynicism that motivated his class at Princeton to vote him Most Likely to Succeed? In May 1956, some six months after the exploratory committee began its lunchtime deliberations, a professional fundraiser was sharing his craft with the group. Though no one knew how much would ultimately

be required, H. J. Seymour, who had successfully run several university fundraising campaigns, outlined a strategy. A few massive initial gifts, he advised, would serve as "'bell cows' . . . in a giving parade." Their contributions were targeted for at least $25 million. As numbers were bandied about, the committee was startled to learn that the architects' estimate for constructing the square footage of desired buildings was around $90 million. A hasty call for revised rock-bottom estimates cut the amount in half, but at the cost of eliminating the library and education facilities. By the end of the year, Day & Zimmerman's study estimated $55 million for 20 million cubic feet of structures, with $26 million for the Metropolitan Opera alone.[30]

The confident rhetoric surrounding all these estimates masked the truth: No one had any idea how much this project would ultimately cost. Unlike a shopping center, where developers apply a sharp and ruthless pencil to cost estimates, New York's cultural mall was beset by a pack of separate interests all insisting that they knew best how to spend other people's money. The religion of art dictated costly temples for the furtherance of the cult . . . for the honor of the city . . . for the nation's standing in the world . . . for generations to come . . . to show up the Soviets . . . and for some less idealistic reasons, most having nothing to do with art, that donors quietly harbor: a tax deduction and their name on a building. However, philanthropy has played an extraordinary role in American society. Again and again, generous donations to education, health, and cultural initiatives have pried open upper-crust society's gates for waves of the newly wealthy.

For John Rockefeller, raising money for good works was the sum and substance of a career; his fourteen-year-long crusade in behalf of Lincoln Center was the capstone. Having sacrificed any personal ambitions to his father's agenda, he stoically trod the path marked out for him. At unknown cost to his shy nature, he had come to relish parting the rich from their pelf; "fishing" is what he called it. Over the inevitable lunch, he would prod the quarry with appeals to patriotism, to class loyalty, to corporate pride, to fear of New York's downhill slide. The Juilliard president William Schuman, who attended some of these sessions, recalled Rockefeller's finesse at augmenting the yield. When the donor had agreed to a certain amount, John would earnestly murmur: "I only think you should give your fair share. I don't think you should rush your decision. I think this is too fast; let's just go over it again." Often, at the mention of "fair share," the donor would spontaneously disgorge extra lucre. Calling the affluent to their duty occasionally moved Rockefeller to mild wit. When Schuman was

disappointed at extracting a piddling $0.5 million from the Carnegie Corporation, Rockefeller replied: "Bill, when someone gives you a half-million dollars, you smile."[31]

Clarence Francis, the chairman of General Foods, often accompanied Rockefeller to corporate offices to shake yet another fresh money tree. After listening carefully to Rockefeller's dignified spiel, the company president they were visiting would ask: "John, you really *do* believe in this?" And Rockefeller would soberly answer, "Yes, I *do* believe in it. I believe it is important for our city. I believe it is important for our country. I believe it is important for the world." Francis, who humbly referred to himself as "a prune peddler," would emphasize that "New York now could be made the cultural center of the world." When the costs of the endeavor shot up, the pair had to make repeat calls on the big donors. This time, the case was even more grand: "We're building something for the ages. We're building something that will be here for 500 years. This must be done right."[32]

Such grandiose rhetoric was worthy of a Robert Moses. Builder of parks and parkways, of thousands of housing units, of bridges and stadiums, the scope of Moses' ambition was pharaonic. Posthumous portrayals, particularly Robert Caro's *The Power Broker,* painted him as a devious megalomaniac, obscuring Moses' many achievements. Most impressive is that, in the moral cesspit typical of New York City politics, Robert Moses was honest. Along with his comrade in arms, La Guardia, Moses was impervious to the grease that normally lubricates every twitch and tremor in the city's administration. Tenacious, arbitrary, demanding, implacable, a workaholic, Moses can be seen as the last effective man in a city increasingly beset by packs of howling special interests. "New York is still a dynamic city," he defensively told the West Side Association of Commerce in 1957. "I do not hold with the pessimists who moan that it has declined."[33]

To prove his point, Moses had just handed a stinging defeat to the Housing and Home Finance Agency administrator Albert M. Cole, who had tried to curb Moses' profligate use of federal Title I funds for purchase of Lincoln Center land. From the seventeen-block redevelopment area, some seven thousand low-income families and eight hundred businesses were to be evicted. To obtain title to the twelve-story high-rise at 70 Columbus Avenue, owned in trust for Robert F. Kennedy and three of his sisters, Moses had paid $62.88 per square foot of land, while buying adjacent properties for just $9.58 per square foot. When Cole blustered about holding up all Title I funds unless such anomalies were corrected, Moses

unleashed his own habitual bluster: He threatened to resign. Editorial out-
cry followed. "New York has been committed from the beginning to the
Bob Moses way of getting things done," said the *Herald-Tribune*. The *New
York Times* more than agreed: "You don't bench a Babe Ruth because he
strikes out once in a while. . . . In the memory of living man on the New
York scene, there has never been the equal of Bob Moses for getting things
done." Then, just to be sure that the message reached Washington, phone
calls poured into the White House: from Father Lawrence J. McGinley,
whose Fordham University would build an annex south of Lincoln Center;
from union leaders in the powerful construction trades; from key bankers;
and from John D. Rockefeller III himself.[34]

Still, poor families evicted from their homes had for decades inspired
New York's tabloid scribes. The plight of those remaining in the redevelop-
ment area impelled many a sob sister toward his or her tear-smeared type-
writer, especially since four thousand luxury apartments were part of the
redevelopment plan. After the Lincoln Center corporation had paid the
city almost $4 million for its thirteen acres, on February 29, 1958, it
became the rich landlord for 1,647 poor families remaining in 188 build-
ings. At great cost, Lincoln Center ended up supplying heating oil and
coal, and correcting almost four hundred building-code violations in ram-
shackle tenements that would be demolished within a year. Kerosene
heaters in 130 apartments were replaced with gas heaters. Families were
paid up to $500 to move, while businesses got $2,500. A year later, the site
for the first of Lincoln Center's buildings, the concert hall, was clear and
ready for construction.[35]

The groundbreaking on May 14, 1959, set the tone for legions of per-
forming arts centers to come: platitudinous piffle punctuated by loud
music, smug smiles for the cameras, the scrape of a chrome-plated shovel
into unwilling urban clay. Some 12,000 New Yorkers felt the urge to be
there personally, and a half-million more watched on television as Presi-
dent Dwight D. Eisenhower gave his benediction for "men of vision [who]
are executing a redevelopment of purpose, utility, and taste" and for the
site: "Here will occur a true interchange of the fruits of national cultures."
His arrival heralded by Leonard Bernstein conducting the New York Phil-
harmonic in Aaron Copland's *Fanfare for the Common Man,* the president
entered to the strains of "Ruffles and Flourishes" and "Hail to the Chief."
As Ike applied the gleaming shovel, the orchestra, and massed Juilliard
voices burst into Handel's *Hallelujah* Chorus.[36]

The rites received copious coverage in the *Times* and *Tribune,* not to

mention the less influential but more widely circulated tabloids. But per-
haps an editorial in the modest *West Side News* best summed up the mood
in a neighborhood yearning for good tidings: "The eyes of the world are
upon us . . . the leadership of the world, both friend and foe, takes cog-
nizance of the work now beginning." Masterfully mangling metaphors, the
publisher Harry Rogers told his readers to "be proud to participate in fos-
tering nurture for the mind and spirit of man so sorely needed when mate-
rialistic concepts threaten to engulf us in a slough of despond that sees no
hope for a better world." If Lincoln Center's planners had remained
"rooted in the rut that held no hope for a brighter future," the project
could never have been started; the blighted area would have remained "a
disgrace to the West Side, and a cancer gnawing at the very desire for a
better society." In print, Rogers exulted that "a new era is starting for the
West Side," while his publication also stood to gain advertisers and readers.
The tabloid's record twenty-four pages included full-page congratulatory
ads from the contractor Webb & Knapp, the Central Savings Bank, and the
Corn Exchange Bank.[37]

After the publicity storm had passed, Lincoln Center's organizing com-
mittee was distressed to learn from a July 1959 survey that 75 percent of
New Yorkers had never heard of Lincoln Center. This finding triggered a
vigorous public relations campaign. Models of the buildings to be raised
were paraded around to public places, an essay contest was held at more
than eight hundred public schools, television and radio carried spot
announcements, and brochures went out to 100,000 households. By the
following September, another survey showed that Lincoln Center was now
known to 67 percent of New Yorkers.[38]

In the foreword to Lincoln Center's progress report, published right after
the groundbreaking, Rockefeller repeated all the pious reasons for build-
ing the center. But he added that the "need [is] made more immediate by
the emotional and mental pressures of our day and by the facts of
increased leisure time and higher levels of education."[39] Rockefeller was
not alone in his concerns. Many observers also indulged in the American
tendency to view every blessing with alarm. A New York Public Library
executive perceived the nation's survival more menaced "by mass bore-
dom than by atomic bombs." He anticipated that the growing contingent
of the elderly could "literally die of boredom" and believed that because
working people's unprecedented free time was "wastefully and frivo-
lously used, America will grow constantly weaker in its struggle with

those who would overturn our way of life. . . . Misuse of leisure time can destroy us."[40]

Yet, as the concert hall designed by Wallace Harrison's partner Max Abramovitz began to materialize, the outlines of an "art boom" were also emerging. By 1960, 728 American organizations were producing operas; sales of musical instruments had multiplied fivefold since 1940; and more than half of all the symphony orchestras in the world—1,142—were fiddling and tootling somewhere in the United States. More money was spent for admission to concert halls than to baseball stadiums. Americans also supported 5,000 community theaters and almost 250,000 amateur dramatic groups. In all the realms of culture, optimistic projections beamed far into the future. And why not? The educated audience was exploding far faster even than the burgeoning population. Where colleges had graduated only 140,000 in 1930, they gave degrees to 477,000 in 1960, and to more than one million a decade later. There appeared to be no end to Americans' hunger for higher education. In 1951, academic enrollment was two million; a decade later, it was 3.5 million. The University of California alone expected to have 175,000 students by 1975. Faculty growth more than kept pace, with almost half a million professors pontificating by 1964. The number of doctoral graduates grew even faster; 3,300 attained Ph.D.'s in 1940 and nearly 15,000 by 1964.[41]

One potent contributor to this education surge was the G.I. Bill of Rights. Congress enacted it without a single dissent and President Franklin D. Roosevelt signed it into law in June 1944, two weeks after the Normandy invasion. Along with medical benefits, home and business loans, and help in finding jobs, this program guaranteed free college tuition, plus a stipend for school supplies and subsistence, for every veteran. So popular was this education feature that by the 1949–50 school year, more than one-third of all college students were veterans. Eventually, the government would spend $14.5 billion to send 7.8 million veterans to school.[42]

Not only were colleges and universities turning out record crops of students, they were also training more and more artists. Previous generations of visual and performing artists had attended specialized schools, perhaps apprenticed with masters in the field or studied with private tutors. Following the Second World War, colleges and universities swiftly gathered in the arts. The odd artist or writer in residence was soon joined by a whole department devoted to creative writing, visual arts, music, drama, or dance. As in the sciences, a profusion of advanced degrees bloomed. The M.F.A. became a standard, and doctorates followed. While only 213 individuals

received arts doctorates in 1950, 1,138 (almost as many as in mathematics) were awarded twenty years later. Within less than two decades, colleges and universities would also become notable arts patrons, "the new Medicis," one report called them. By the 1975–76 season, they were spending at least $16 million to bring performing arts groups to campuses.[43]

Many observers worried that the arts and academe were incompatible. In a 1962 speech to graduate deans, the Ford Foundation's W. McNeil Lowry wondered whether the university could accommodate "the drive or fanaticism . . . of the person who has made his choice and will eschew anything else—money, the elite identification of a university degree, even health—to develop the talent he hopes he has." Lowry complained that on campuses, professional standards in the arts had been debased. Non-arts students were taking arts courses for fun, and professors had trouble excluding the untalented or those not planning an arts career.[44] Studio faculties "have forfeited in many cases their privilege of accepting and retaining . . . only students who show initial dedication and continuing ability to perform well," wrote another scholar. "The degree credential . . . has become confused with artistic or teaching competence."[45] The figures behind such observations were astounding. In 1960, 5,500 undergraduates were majoring in theater; in 1967, there were 18,000. In 1948, only 105 colleges and universities gave courses in dance, often as part of physical education. Twenty years later, 110 offered a major in dance, 22 had dance departments, 42 offered an M.A. in dance, and 6 awarded dance Ph.D.'s. Similar spurts occurred in music and visual arts. These programs grew without regard for how the arts sector could support such vastly increased numbers of certified arts graduates.[46]

Even worse, the university setting often hobbled artists of genuine talent, even as it rewarded plodding time-servers holding the right degree. Composers who had spent creative months at the MacDowell Colony, a New England retreat for artists, were particularly bitter, not about teaching or students but about their colleagues: "Enemies of creation," said one. In a survey published in the *Saturday Review*, the MacDowell composers complained of overintellectualized music and of faculties "too cramped, too cozy, too ingrown." No one wanted to criticize anyone else because that would hurt the department. Many university-based composers were writing only for each other, said some, while others resented "cliquishness and faddism." Writers who were MacDowell alumni were similarly disenchanted with academe. The campus atmosphere, said one, "encouraged too many academics to imagine they were artists." Painters were even

more disillusioned. Moving art from professional schools to campuses, said one, "made the art student a dilettante and killed the apprentice system."[47]

As arts instruction relentlessly migrated to the campus, so did performance and exhibition. From Lawrence, Kansas, to Chapel Hill, North Carolina, the local university sponsored its own productions as well as expanding series of touring attractions. Outside large cities, universities became centers of artistic life; in the suburbs, they attracted the audience that previously had looked to the nearby city for cultural entertainment. By 1966, a federal study found, nearly one of every ten colleges and universities had also established a museum, most of them staffed by paid professionals. The authors of this U.S. Office of Education report questioned why millions of dollars should go for this purpose, especially in cities like New York with ample museum resources. The universities' rationale was that "scholars and painters want their own galleries and studios."[48]

As the fast-growing campus community educated its students and provided civilized entertainment for its faculty, it also spawned an audience, seemingly ever expanding, that was more eager to plunk down $10 to hear a string quartet than $1.85 for a seat in the bleachers. As David Riesman wrote in 1956, "We have come in recent years pretty close to accepting the academic life as the nearly universal vehicle for intellectual pursuits and even artistic ones."[49]

There would be a price for this mingling of the artistic with the intellectual. But at the time, universities could do no wrong, certainly not in the eyes of the federal government. In 1953, 62 percent of the $450,000 that universities spent on research came from Washington. By 1962, universities were spending $1.4 million on research and 75 percent of it was federal money; more than half went to just twenty-five institutions. By the end of the 1960s, government money constituted 80 percent of the Massachusetts Institute of Technology's budget. Most of this funding went into science as the Cold War arms race fueled the need for more and more sophisticated weaponry. Professors in the social sciences, humanities, and arts perceived themselves slipping into second-class status as their science colleagues accumulated status and privilege, notably freedom from teaching duties. By the mid-1960s, a typical workweek for a physical science professor at a research university might consist of a day consulting away from campus, at least two full days and a large portion of two others in the lab, and perhaps five hours of teaching, but only of graduate students. The pressure was building to get government funding for nonscience "research" at universities.[50]

Since the fear of Soviet military attack was generating such copious funding for science, arts supporters cultivated fears of aggressive Soviet moves in the cultural arena. In 1952, the government's Advisory Commission on Educational Exchange reported that "the Soviet drive in the fine arts field finds the U.S. at present without a counter offensive." In Congress, the New Jersey Democrat Frank Thompson rhetorically demanded in 1954: "Do you not agree that in the Cold War, that the sooner we can implement a program of selling our culture to the uncommitted people of the world as a weapon, the better off we are?" His colleagues appeared to be unmoved, nor did they act in 1956 when Thompson turned up the heat: "We can't afford to do less than the Russians in this field. We'll lose our shirts if we do."[51]

But others feared American culture was endangered not by Russian ballet dancers but by the trend toward specialization. The cult of narrow expertise was hastened by universities' departmental organization, as well as by the now universal demand that professors hold a Ph.D. As early as 1950, Columbia University's skeptic in residence Jacques Barzun grumbled at experts' insistence on being judged only by their peers: "The universal formula is: 'You cannot understand or appreciate my art (science) (trade) unless you yourself practice it.'" This was a fallacy, he argued, since a person can judge a building or a violin sonata without being able to build or to compose. Most mischievous about the cult of expertise was its intimidation of the wider audience: Fewer critics were willing to speak out if they lacked the proper credential. Barzun saw workers in the isolated disciplines acting "like jealous technicians. . . . It is as if the guild spirit, which is the spirit of trade, has infected the declared enemies of commercialism." Robert M. Hutchins, who modernized the University of Chicago, also deplored overspecialization at colleges. "Boys and girls are mistrained in specialties," he wrote, "and not educated to comprehend the duties of citizenship or the methods by which they might hope to lead happy and useful lives."[52]

These observations lend keen irony to the expectations of Lincoln Center's organizers. Assembling opera, concert music, dance, and theater into one grand development, trumpeted a 1957 fundraising brochure, "is destined to advance performing arts in America to unprecedented heights. . . . The whole will be greater than the sum of its parts." Obviously unfamiliar with the fault lines cleaving the typical campus, the brochure envisioned that Lincoln Center's constituents would relate to each other "like the separate departments in a great university."[53]

Despite the collegial lunches at the Century Association, and the sooth-
ing balm of Rockefeller's prestige, the center's prospective tenants quib-
bled and fought. As the plans expanded to include not only a concert hall
and an opera house but also a dance auditorium, two theaters, a library and
museum of the performing arts, a chamber music hall, and the Juilliard
School, ancient rivalries and feuds reemerged. Each building's resident
organization chose its own architect. An immensely complicated minuet
ensued, with each designer beholden to two clients, the constituent institu-
tion and the owner, Lincoln Center, Inc. The constituents were picky on
matters of sightlines, acoustics, rehearsal and office space, lighting, and
stage and backstage amenities. The owner saw its financial health as
dependent on such considerations as the number of seats in each hall, the
configuration of utilities, and the cubic footage to be heated and cooled.
Furthermore, the architects would have to coordinate their exterior
designs to produce a harmonious ensemble. As Rockefeller's aide Edgar B.
Young blandly put it, "There was a natural tendency on the part of the con-
stituent professionals to seek perfection," while Lincoln Center "had to
face the reality of paying the construction bills."[54]

Meanwhile, the six architects involved in planning the various buildings
were also lunching weekly, their bluff collegiality masking subtle maneu-
vering, as each man angled for more space for his personal monument.
Though all had matriculated in modernism, Philip Johnson recalled, "We
were all looking away from the puritanism of the International Style
toward enriched forms." The discussions, which dragged on into the late
afternoon amounted to "six poets trying to write a poem." Finally, Rocke-
feller stepped in. "We were just six guys talking to the wind," said one
"poet," Gordon Bunshaft, "until John came in as the referee." After one of
these exhausting free-for-alls, Rockefeller staggered to his diary and
groaned about the psychic wear and tear of spending "six hours with six
architects."[55]

In addition to dealing with the architects and constituents, Lincoln Cen-
ter had to reckon with a labyrinth of federal, state, and local agencies
whose money moved the project along. Programs that involve public funds
tend toward exceeding complexity, as clauses pile upon provisos, and sub-
chapters overlie subsections, all reflecting the intense horse-trading re-
quired to obtain political accord. Title I of the federal Housing Act, which
funded the original slum clearance for Lincoln Center, gave New York City
money to buy the land at market value. The city then sold the land at a
lower "fair re-use value" to Lincoln Center. The difference was the "land

write-down," two-thirds paid by the federal government and one-third by the city. New York State, however, had promised to pay half of the city's one-third. Another federal grant covered public projects such as the central plaza at Lincoln Center, the parking garage and subway access beneath it, the performing arts library, and Damrosch Park, at the southwest corner of Lincoln Center. The grant would supply up to two-thirds of the cost if the city contributed one-third. So daunting were these complexities that the exploratory committee at first considered private mortgage funding for the various buildings. By temperament and philosophy, the constituents' trustees were "mostly negative" about government funding, as the Ford Foundation's arts Maecenas, W. McNeil Lowry, recalled. They were afraid that their organizations would be "turned over to the unions." Lowry himself was dubious about building elaborate performing arts centers at all. "This is about the arts, not real estate," he bluntly told Rockefeller. However, once it was determined to build, the amounts needed staggered even Rockefellers. And so, haggling with myriad bureaucrats and politicians over money, and with constituents over heating ducts and carpeting, became the central concern of Lincoln Center's organizers. It was a far cry from producing a concert or opera.[56]

More refined, but haggling nonetheless, was the stupendous drive to collect far larger amounts from nongovernment donors. This drive seemed never to end. As each goal was reached, the ultimate total receded upward beyond reach. Even before the official fundraising kickoff, the Ford Foundation and the Rockefeller Foundation each gave $2.5 million, as did the Philharmonic president David Keiser, through the Avalon Foundation. Vivian Beaumont Allen contributed $3 million for a theater to bear her maiden name. In October 1957, twenty-five civic leaders formed a fundraising campaign committee, with such luminaries as the New York Stock Exchange president G. Keith Funston, the IBM chairman Thomas J. Watson, Jr., the Democratic party boss James A. Farley, and the diplomat John J. McCloy promising to make personal calls upon likely prospects. By October 22, the Lincoln Center board asked the Ford Foundation for $12.5 million more. Alert to Lowry's misgivings, however, the foundation opted to wait and see who else would contribute in the next six months. Asked for an additional $7.5 million, the Rockefeller Foundation offered just $2.5 million and promised the rest after $40 million had been raised elsewhere.[57]

The sums required to materialize Lincoln Center had soared alarmingly in the four years since Robert Moses first coupled slum clearance with cul-

ture. Back then, the Met expected to spend $15 million for a new house and the Philharmonic board believed a new hall would cost about $5 million. By April 1959, however, $46 million was considered just the down payment on a far more ambitious project. Fresh estimates showed that the opera house alone would cost $30 million and the concert hall, $15 million. All the buildings together would cost $79.4 million, 64 percent more than had previously been budgeted. When the building committee learned of these new figures at the end of 1958, the *Fortune* publisher C. D. Jackson wryly told his colleagues, "This has been our first trip together to the cold shower." Was he whistling in the dark or voicing a casual attitude toward other people's money? Whichever, it would not be the group's last chilly encounter with cost overruns.[58]

Meanwhile, the effort to control costs was exacting an artistic price. To save money, the library and theaters were merged into one building, with the library designer Gordon Bunshaft uneasily yoked to the theaters' architect, Eero Saarinen. The Juilliard architect Pietro Belluschi discovered that the building the school really required would never fit into its planned location, at the site's northwest corner; it would be built on a new site across the street. But this meant acquiring more land and connecting it to Lincoln Center via a costly bridge over 65th Street. Furthermore, Juilliard had to reinvent itself in order to educate students in all Lincoln Center's arts. Both the Rockefeller and Ford foundations demanded that Lincoln Center be an educational enterprise, not just an assemblage of isolated cultural activities. Juilliard therefore added a full program of drama and dance to its music curriculum and dropped a prep school that had included some seven hundred pupils, half the student body, at the elementary and high school level.[59]

The school's move from the peaceful academic milieu of Morningside Heights into the downtown spotlight alarmed such informed observers as Joan Peyser, who would later write biographies of Leonard Bernstein and George Gershwin. Students would no longer be able to learn in privacy, she feared. Instead, they would be displayed long before they were ready, "in something like a large fishbowl, placed conspicuously on a table made of travertine marble." Lincoln Center's planners, by contrast, wanted a stream of young artists who were only a step or two away from professional careers. Peyser also doubted the wisdom of moving the public library's music collection to Lincoln Center, since scholars would not have at hand the 42nd Street library's immense resources in other, possibly related, disciplines. The new center's enormous cost, she feared, would tune music

presented there to financial stability, to nationwide television taste, to tourism, and to launching music stars, with a net loss to the nation's culture. "Technique and polish can be guaranteed where there is plenty of money," she concluded. "Vitality needs more care."[60]

As president of the Juilliard School, the composer William Schuman had helped to shape its new persona. He had also played a forceful role on the Lincoln Center Council, where representatives of all the constituents jostled for the spotlight. Because of his strong background in education, an area the center's management wanted to stress, he was named president of Lincoln Center in the fall of 1961. Schuman envisioned Lincoln Center not as a landlord but as a leader, coordinator, and presenter of new programs. He was on the job the following January, when he was dragged willy-nilly into the primary management task—fundraising. For allies, he hunted among executives who were retiring, hoping they could tap their old contacts for perhaps the next ten years. He spoke before groups, he begged elegantly in rich offices, and, of course, he lunched. Not battles but civilizations were remembered by history, he would remind his quarry. Supporting Lincoln Center demonstrated pride in one's country. If Schuman failed to net $50,000 over a noontime meal, he would tell his wife it was "a wasted lunch."[61]

Schuman came from the same solid bourgeoisie that has spawned most artists since the early nineteenth century. His parents were cautiously supportive once their son determined to make a music career, but they were realistic about the slim chances for success. In business, his father reminded him, "you don't have to be very, very bright to make a living." But in music, "you're up against genius." Asked whom he had in mind, Schuman, Sr., replied, "Irving Berlin." And the son believed "he was absolutely right."[62]

As a youthful composer, Schuman wrote short pieces for vaudeville and popular songs with Frank Loesser, author of such later hits as *Guys and Dolls*. Though Schuman had expected to divide his time equally between popular and serious music, he eventually chose serious work because "it provided me with every opportunity that my imagination could conjure up." Popular music, by contrast, "had to be immediately appealing." Yet Loesser demonstrated the spectacular rewards of popular success. Loesser was starving when Schuman first worked with him. Then Hollywood called and when a study funded with a small grant took Schuman to the West Coast, he contacted his old collaborator. Loesser inquired: "Would you

consider it pretentious if I sent the chauffeur for you?" The last time they had seen one another, Schuman "used to buy [Loesser] lunch at the Automat."[63]

Later, Schuman deftly fed his creative urge as a serious composer while feeding his family by teaching at Sarah Lawrence College, directing publications at G. Schirmer, and eventually rising to president of the Juilliard School. He stitched together bits and pieces of free time, adding up to the one thousand hours or so he needed each year in a quiet room, writing music. When Rockefeller invited him to lunch in the summer of 1961, Schuman expected to discuss possible presidents for Lincoln Center but was stunned when asked to take the job himself. After Schuman was installed, Rockefeller told him, "Now don't feel that you have to write music," implying, Schuman recalled, "You've got a big job now." Rockefeller meant it, said Schuman, in "the kindest and most sympathetic way, but, of course, it had nothing to do with what my life was about."[64]

"My mind seethes with ideas and projects," Schuman told a New Yorker reporter shortly after taking on the Lincoln Center presidency. Even then, his inventive inner life began daily at 6:30 A.M. during lap swims in his indoor pool in New Rochelle, and continued in the hot shower, crowned with an icy spray. During his fifty-minute drive to work, Schuman was "composing a little along the way." At odd moments during the day, he retired to a small apartment near Lincoln Center for further creative interludes. During such stolen moments, he brought forth seven symphonies and many other works. "I don't compose all the time," he said, "but then no one can compose all the time. So, instead of wasting my time, I administer."[65]

The choice of William Schuman to run Lincoln Center set up a classic conflict of a sort that continues to torment cultural organizations all over the world. On one side are the well-intentioned patrons, mostly businessmen, more or less committed to the arts but primarily, understandably, oriented to the bottom line. When a financial crisis strikes, their first resort is to cut spending. On the other side are the artists, people driven by their talent to create. To them, patrons are a necessary evil who should cheerfully furnish whatever sums it takes to prepare the wonderful feast that only talent can spread before them. Though he straddled the managerial and artistic worlds, Schuman's heart was committed to artists. Thus, as he concisely put it, Lincoln Center's future role was "to lose money wisely." At a 1966 Princeton conference on economic problems in the performing arts, he would elaborate "Schuman's Law and Postulates." Deep as the red sea of deficit was, he argued, "I think it should be deeper. Basic to our

problem is not that our deficits are too large, but that they are too small." Budget constraint, said Schuman, "denies artists the right to displease, to provoke, to puzzle: basic ingredients all for artistic health."[66]

This view, which artists consider perfectly natural, led to the first great postwar financial crisis in the arts. For while audiences were blooming, and the number and quality of performances flourished, arts organizations all over the country were singing the blues. Sparked by its chairman, Congressman Frank Thompson, the U.S. House Select Subcommittee on Education listened to a litany of dire money problems at hearings in Washington, New York, and San Francisco during the winter of 1961–62. Leopold Stokowski shook his great white mane as he predicted that without additional money "the future of the fine arts in the United States is in great danger." The American Federation of Musicians president warned that "serious music cannot survive much longer in the United States without assistance from the government." The Metropolitan Opera president Anthony Bliss reported that the Met lost more than $3,500 every time the curtain went up. And a young San Francisco Ballet dancer testified that as he had worked only twenty-four weeks during the previous year, his expenses exceeded his income.[67]

The riddle of insolvent arts organizations in the midst of a public clamoring for more arts so fascinated a key executive at the Ford Foundation that he would spend twenty-three years and well over $300 million attempting to solve it. W. McNeil Lowry arrived at Ford in 1953, just when the foundation had embarked on the most ambitious and generous philanthropic spending spree ever devised. As the owner of 90 percent of Ford Motor Company stock, the foundation had supported civilized television for adults—"Omnibus," hosted by Alistair Cooke—and for children—"Sesame Street." It financed James Laughlin's avant-garde publishing house, New Directions, and *Perspectives USA*, an intellectual *Reader's Digest* published in four languages and sold in sixty countries. During the early 1950s, it spent $25 million through the Fund for Adult Education to develop "mature, wise, and responsible citizens who can participate intelligently in a free society."[68]

Despite such good deeds, mockery dogged the "philanthropoids," as one of their tribe called them. Jacques Barzun likened foundations to the rich man of the Bible. They depended on beggars for salvation. He considered the writing of grant proposals to be an art form: "Just as there is the love sonnet and the meditative sonnet, so there is the problem project and the survey project." Dwight Macdonald, in a barbed *New Yorker* series

reprinted as a book, identified key words favored by Ford funders: *grass roots, perspective, pinpoint, showcase, think through, tailor, brief* (as a verb), *button up, kick off, germinal* (to describe a small grant), and *frame of reference.* The foundation's annual report, he wrote, "is somewhat more readable than the phone book and somewhat less so than the collected sermons of Henry Ward Beecher." Its language seemed dead, like Latin, "designed for ceremony rather than utility." Rather than to convey ideas or express views, the report's purpose was "to reassure the reader that the situation was well in hand."[69]

In 1949, the foundation had dispatched a study committee on a 250,000-mile odyssey to learn what problems faced the nation and the world. After consulting one thousand experts, the committee concluded that knowledge was the key to their solution. Ford largesse was to be concentrated on learning in five areas: peace, strengthening democracy, strengthening the world economy, education, and "behavior between individuals." Two years later, the foundation began spending the first of $57 million to improve education with such ventures as giving high school and college teachers a year off with pay, funding a fifth year of schooling for elementary and high school teachers, sending Ford fellows to study abroad, supporting African studies at universities, and preparing dictionaries in Pushtu, Amoy, Wu, Lao, Sindhi, Marathi, Uzbek, Karen, Uighur, and Telugu. In Ankara, Turkey, Ford started a library school after learning that the entire nation had only two trained librarians and that books were shelved by date of acquisition. In southern India, Ford gave $0.5 million to print cheap books in local languages. Such varied activities led to periodic soul-searching within the foundation. W. McNeil Lowry joined Ford's multifarious educational enterprise in 1953 during one of the resulting reorganizations.[70]

Lowry (or Mac as he was known to literally thousands of beneficiaries) was born in 1913, in one of those Main Street midwestern towns where a single bright boy was considered a municipal treasure. His mother was a schoolteacher and his father had to drop out of the University of Missouri to care for his parents. Lowry's forebears had done "a typical westward pioneer thing," he recalled many years later, migrating from Virginia through Tennessee, Kentucky, Illinois, Missouri, coming to rest in Columbus, Kansas. A tiny crossroads not far from Joplin, Missouri, Columbus had "no original works of art, only a high school orchestra, no theater. . . . But there were books," Lowry recollected. "I read every book in that small town library." When the Depression came, the librarian begged the town

supervisors for more money, "because McNeil Lowry has read all the books. . . . He's read what's in the high school library, he's read what's here." The supervisors bought more books. Though he later learned that he could have tried for a Harvard or Yale scholarship, money was so tight that Lowry chose "the best state school I could get to." He started at the University of Illinois in 1930, "working every hour I was not in class," and stayed on until 1941, teaching and earning a Ph.D. in English literature, with a minor in philosophy and Greek. In 1935, he took some time out in New York, trying to break in as a playwright while working as an editorial assistant on a small magazine at Columbia University. "Don't wear your Phi Beta Kappa key," he was gruffly warned. "It will get caught in the typewriter." Lowry came to Ford after a stint in journalism, first as associate editor of the Dayton, Ohio, *Daily News* and then as Washington bureau chief for Cox Newspapers.[71]

In March 1957, as Lincoln Center was gearing up its prodigious fundraising effort, Lowry persuaded the Ford Foundation board to approve a five-year program, "very small and exploratory," in humanities and arts. (Perhaps the board willingly approved because the arts then appeared to be uncontroversial: A Ford grant to defend the Bill of Rights in 1952, at the height of the McCarthy investigative madness, had drawn virulent opposition.) In the first eighteen months, Lowry and a half-time assistant visited 178 cities, "talking to everybody in the arts." Based on this research, he developed two types of grants: one to individual artists for specific projects, the other for "experiments, demonstrations, and studies." The budget was $2 million per year "for the whole God-damned country," and none of it went for direct operations or general support. Later, when Lowry was about to ask Ford directors for much more to develop ballet, theater, and orchestras, his boss warned him not to discuss ballet first, because "all they'll do is talk about pink tights and toe dancers." Still, for many years, "the board loved the humanities and arts program, because they could get on the front page with a $60,000 grant. . . . Nobody else was doing it!"[72]

By 1974, Lowry would lavish some $320 million on the arts, a patronage program far more generous than the federal government's during the same years. In 1966 alone, Lowry funneled $80 million to orchestras. Through it all, he believed that the arts could become self-sufficient if only they were well managed. Typical was his first grant to the Guthrie Theater in Minneapolis: $337,000 for preopening expenses and to subsidize the first three years, until it became self-supporting at the box office. Mac Lowry organized workshops for arts professionals; subsidized ensemble companies;

advised on management; gave development grants to individuals; funded new playwrights, composers, and choreographers; gave scholarships to promising students and young professionals; studied audience development; sought out minorities for recruitment; and encouraged higher wages for professionals.[73]

Word of Lowry's largesse spread with electric speed through the arts community. At City Center, Jean Dalrymple instantly contacted him and was "rather shocked," she wrote, "to find that he had never been to City Center and knew almost nothing about our work." To fill him in, the wife of Mayor Robert Wagner invited Lowry to a lunch at Gracie Mansion to meet City Center stars: Helen Hayes, José Ferrer, Maurice Evans, George Balanchine. A gala performance by members of all the City Center companies followed, not so much to raise money (although $25,000 came in) but, wrote Dalrymple, to display "a sampling of all our treasures to Mr. Lowry." At a backstage reception in his honor, Lowry "exclaimed that City Center's achievements were far more impressive than he ever would have imagined." Ford then funded several seasons featuring American opera. It was artistically triumphant programming, which, however, drew so poorly that City Center ended up losing money.[74]

When Lincoln Center came to call, the Ford Foundation board reflected Lowry's skepticism about lavish performing arts complexes. As the Ford board voted to give the center $2.5 million to acquire land, Henry Ford II wondered, "This is a Rockefeller town. What the hell are we doing?" When another trustee suggested that Ford put up the entire $75-million projected cost of Lincoln Center, Lowry recalled, "Ford almost threw up," and Lowry brusquely told the board, "Don't be stupid: it's going to cost at least two or three times those $75 million." John Rockefeller soon told the Ford Foundation president Henry Heald that the Lincoln Center board did not want Lowry to carry on the liaison between the center and the foundation. Rockefeller conceded that Ford's man knew about theater, music, opera, and ballet, but, as Lowry recollected, "this was for the big boys. This was about real estate, this was about the cost of buildings." Rockefeller proposed that relations between Ford and Lincoln Center be handled by Eugene Black, president of the World Bank, who already sat on the boards of both institutions. To his credit, Heald told Rockefeller that "Ford Foundation trustees didn't talk about anything connected with the arts until Mr. Lowry was ready to."[75]

Interviewed for Lincoln Center's oral history archives thirty-three years later, Lowry was still raging about his encounters with Rockefeller.

Opposed to the very idea of "a rash of cultural centers on the face of the nation," he also derided Lincoln Center's organizers as "all those charac- ters—bankers and real estate men. . . . I mean how many people can waste money better than bankers or real estate people? Nobody. No artist. They talk about the improvident artist, who is not realistic about getting things done or can't administer anything. Hell! They're hard-nosed, firm man- agers . . . compared to these characters." As for John Rockefeller, he never called on Lowry in his office, but was obsessed with having lunch: "He had it exclusively," Lowry chortled. "That's why every one of the real estate pro- jects that the Rockefellers were ever associated with is full of lunch rooms and restaurants."[76]

In an interview in 1993, Lowry grinned wolfishly, even as he regretted some of his "intemperate remarks." He planned to modify his statements, he said, but he died a few months later without changing a word. Nor was he the only person involved with Lincoln Center's organizers who resented their high-handed maneuvering, their genteel slugging, their incessant, clubby lunching.[77]

Within New York's cultural cosmos, the partisans of City Center were most apprehensive that Lincoln Center would manipulate a takeover of the low- priced offerings so painstakingly developed at the Moorish temple on 55th Street. When the City Center board first heard about the plans for Lincoln Square, its financial situation was "again . . . absolutely awful," the trustee Ernest S. Heller recalled. "Lincoln [Kirstein] walked in . . . with a box and he sat down at a table and he opened this box and he set up a model, a cardboard model of a building and he said, 'This is what we're planning for the ballet company.'" The board was aghast. "We haven't got enough money to pay our employees next week," Heller heard, "and he's talking about a building that's going to cost $10 to $15 million. . . . He was crazy. . . . He was absolutely nuts!" The model Kirstein unveiled was Philip Johnson's design for the New York State Theater, to be constructed at Lin- coln Center's southeast corner.[78]

To build Kirstein's dream setting for ballet, a complex funding formula had been cobbled together, but with no firm tenant except Balanchine's troupe, the project lingered on the back burner. Then Robert Moses announced plans for his last hurrah, a costly replay of New York's 1939 World's Fair, to be held at Flushing Meadows in 1964–65. New York State's contribution was to be $15 million for a theater at the fairgrounds. Nelson Rockefeller, who had pushed Lincoln Center forward ever since his elec-

tion as governor in 1958, redirected these funds to building the theater at Lincoln Center. He hoped to pacify City Center while also savoring a sibling's smugness in pulling his older brother, John, out of his perpetual fundraising jam. The fair would open in April 1964, so the New York State Theater, as it was officially named, would have to be hastened to completion. With characteristic élan, Nelson told Kirstein, "We should build a monument that will last forever."[79]

These developments sent tremors of alarm through the managers of City Center. Its most vital component, the New York City Ballet, was about to be snatched away. The New York City Opera's profitable menu of musicals would be endangered by the music theater Richard Rodgers was planning at the new building, to augment the ballet. Then the Metropolitan Opera suggested its national company as another State Theater tenant. Deeply involved in constructing its own luxurious new home at Lincoln Center, the Met was not about to invite competition from the New York City Opera with its eclectic programs, its subway audience, and its top ticket price under five dollars.

On the surface, the struggle over control of the New York State Theater at Lincoln Center appeared to be over a building, over money and power, perhaps even over art. But underneath it ran deeper class and religious animosities. Since the days of the patroons, New York politics had been filtered through the prism of ethnicity. As immigrant groups claimed particular neighborhoods, politicians sought to minimize squabbling by awarding various amenities to each ethnic group. By the 1930s, for example, the administrations of four colleges run by the city had become fiefdoms of New York's dominant religions: City College and Brooklyn College went to the Jews, Queens College to the Protestants, and Hunter College to the Catholics. While WASPs had long shared the city's financial realm with Jews, they virtually monopolized the cultural institutions. Indeed, one impetus for founding City Center was to provide a stage for the cultural strivings of Jewish philanthropy; almost the entire board there was Jewish. By contrast, WASPs dominated the early explorers at Lincoln Center. The few Jews invited in were wary. Lincoln Kirstein had quit after four years with a blast: "The criterion is manipulation of real estate sweetened by the education business," he wrote John Rockefeller in his resignation letter. "Is there any master, patronage, or grand design?" And Morton Baum, chairman of the City Center finance committee, still nursed wounds from his tenure as a Metropolitan Opera trustee. "They had a slogan," recalled Mac Lowry, "everybody around the elite part of New York

had, 'Not one of us.' They denied that this was anti-Semitic, but it was. Baum knew it."[80]

Robert E. Blum, an executive at Abraham & Straus and an heir to the great Federated Department Stores fortune, believed he might have been named to the Lincoln Center exploratory committee as "a professional Jew." In the loftiest WASP pattern, he had gone from Hotchkiss to Yale. There he learned to shrug off slights. He was not tapped for the exclusive Skull and Bones secret society, even though as business manager of the *Yale Daily News* he should have been "a shoo-in." (When his son attended Yale, Blum recalled, "he turned down Bones for Keys and that tickled me.") Undaunted, Blum associated more with gentiles than with Jews. "I guess you'd call us climbers," he said. "We liked being with people who were running things."[81]

Ernest S. Heller, who served for years on the City Center board, recalled encountering "very serious anti-Semitism" during his college years at Princeton. Son of a wealthy importer of precious and semiprecious stones, Heller had attended New York's elite public high school Townsend Harris. With his parents, he had traveled widely and lived in Paris, where he became fluent in French. Yet at Princeton he found only four Jews in a class of some seven hundred. "I wasn't really accepted," he said. "I couldn't get into a club. . . . Even the faculty were kind of anti-Semitic." Heller rushed toward a degree in three years because he "felt very bad." A measure of how anti-Semitism has abated since then is that he still attends class reunions and, he said, "I'm friendly with people I didn't even know in college."[82]

After the Second World War, institutionalized anti-Semitism dwindled all over the United States. At Harvard, the president James Bryant Conant had begun, in 1933, to dismantle the quota system that had limited Jews to 10 percent of the student body. At Columbia and other elite schools, the Ivy League attempt to maintain a homogeneous national leadership class by excluding Jews ended soon after the veterans appeared on campus. At all these select schools, wrote Leonard Silk and Mark Silk, "genteel anti-Semitism slowly faded until, like the Cheshire Cat, there was nothing but its smile—and the memory of its claws." As for the faculty anti-Semitism that wounded Ernest Heller at Princeton, the war and the years that followed were also the turning point. By 1964, the sociologist E. Digby Baltzell, an acute observer of the establishment, found that "no faculty at any leading university can afford to be anti-Semitic in its hiring policies." The views of the wider public had also radically changed. As late as 1944, a public opinion survey found that almost one-quarter of Americans believed

that Jews were "a menace to America"; by 1950, only 5 percent thought so. The sort of casual anti-Semitism Mac Lowry identified in the code phrase "not one of us" also diminished rapidly. In 1946, 64 percent of survey respondents reported hearing something derogatory about Jews in the previous six months. By 1950, it was 25 percent, and by 1956 only 6 percent.[83]

Clearly, the horrendous outcome of the Nazis' anti-Semitism revolted all thinking Americans. Within the establishment, discrimination against Jews became morally questionable, but more pressing and practical reasons also motivated the inclusion of Jews. One was the erosion of old fortunes by the Depression and hefty taxes. Along with the money, the service and philanthropic ethic was dwindling within the younger WASP generation. At the same time, ambitious new charitable endeavors called for unheard-of sums. The trustees who for years had been quietly making up the year-end deficit at the Met (both opera and museum) or at the Philharmonic (both Los Angeles and New York) were stunned by the amounts now required by these institutions. And when the New York establishment teetered on the financial high wire of building Lincoln Center, it was clear that fresh resources were needed.

There is no indication that John Rockefeller or his lunch partners knew of the sociological study Baltzell was writing at the University of Pennsylvania. But as the fundraising for Lincoln Center stretched ever forward and upward, they were immersed in the fragile condition of the Protestant establishment that Baltzell described. As the obvious megadonors were exhausted, as another professional fundraising firm was hired, as the retired executives wore out their welcome among former business contacts, the grind per donated dollar grew. In 1960, a campaign to "endow" seats in the concert hall brought in $3 million in gifts of $1,000 or more. A direct-mail appeal in suburbia netted almost nine thousand contributions, but they added up to a scant $0.5 million. A fundraising firm combed newspapers, magazines, and even genealogies for people with an interest in the arts. Committees of women, suburbanites, and businessmen were among the dozens of groups seeking contributions. But the work was slow. George Moore, vice president of the First National City Bank, boasted that his patron committee would never ask for less than $100,000. However, in the end only 163 donors gave more than this sum, and only 306 gave more than $10,000.[84]

Though Rockefeller and his cohorts were ignorant of Baltzell's book—it was not published until 1964—they arrived at the same conclusions as the sociologist. "The caste line," as Baltzell asserted, was "dysfunctional." The

most successful and talented Jews were still being socially excluded and the result was "a great postwar boom in gilded ghettos, centered around opulent synagogues and country clubs." Baltzell contended that the only way for the WASP establishment to maintain its leadership role was to welcome these affluent Jews. Of all the ethnic groups in America, he wrote, these "behaviorally assimilated" people most closely embraced the WASP ethic: work and thrift, leadership, service, family, and, above all, charitable giving. No doubt the sociologist was impressed by the prodigious amounts the American Jewish community had raised to rescue the Holocaust survivors and for the State of Israel. In 1946, the United Jewish Appeal had amassed more than $100 million. In 1948, it collected $200 million, in a year when the United Way raised $186 million and the Red Cross, $72.5 million.[85]

The fight over the New York State Theater was a part of this Jewish drive for a place at the cultural table. Jean Dalrymple called it "a very understated, gentlemanly fight." Heller recalled "a terrible fight. Morty [Baum] and I both went on television and radio to argue our point of view." The question of who would control the new theater was still unsettled when this jewel box opened on April 23, 1964. John Rockefeller spoke, and so did William Schuman, Robert Moses, and Lieutenant Governor Malcolm Wilson, chairman of the New York State World's Fair Commission. Governor Nelson Rockefeller said, "It takes courage to vote for culture when you're in public life." But no City Center official said a word.[86]

It may have taken courage "to vote for culture," but that was Albany. In New York City, gangs wearing three-piece suits and carrying attaché cases scuffled stylishly, perhaps lethally, over cultural turf. No one was better trained—or more motivated—than Nelson Rockefeller to step into their cross-fire. In his family of five boys, cheerful, energetic Nelson had early on seized leadership from his retiring, obedient elder brother, John. During the 1930s, Nelson had guided the family's vacancy-ridden Rockefeller Center toward profitability. When Diego Rivera insisted on adding Lenin's portrait to a mural commissioned for the RCA building's lobby, Nelson ordered the artist paid off and the mural hacked off the wall. Nelson had also been president of the Museum of Modern Art, where, he claimed, he learned politics. Like many raised within the cotton-wool cocoons of the very rich, Nelson could be supremely oblivious to the everyday. He never carried cash, blithely borrowing cab fare from his companions, and had no qualms about getting the director of the Museum of Modern Art to help

him hang a new painting in his apartment. At the opening of Lincoln Center's concert hall in 1962, Nelson lost a stud from his dress shirt in the elevator. Picking it up, he asked William Schuman to put it back in his shirt. "But Governor," Schuman asked, "why don't you buy a new shirt? They've been buttoning them in the back for . . . the last twenty years." Said Nelson: "They have?"[87]

When it came to building a broad base for his political ambitions, Rockefeller was considerably more up to date. He thrived on bending people to his will, though often, to be sure, in a good cause. Soon after being elected governor of New York in 1958, he established the nation's first state arts council and rallied around its bounty the growing constituency for the arts. Educated, affluent, and vociferous, this group spanned the political spectrum from liberal Democrats to ultraconservative Republicans. It also included such powerful labor unions as the American Federation of Musicians, Actors' Equity, and organized stagehands, electricians, and carpenters. Nelson Rockefeller was the first prominent politician to recognize that this new interest group also engaged powerful people in the media who normally avoided the electoral trenches. For the drive to build a performing arts center at Saratoga, for example, Gene Robb, a publisher of newspapers around Albany, not only supported the effort editorially but also became the center's president; when Robb died, his successor as publisher joined the arts center's board.[88]

The feud between City Center and Lincoln Center was particularly dangerous for both Rockefellers. It undermined John's fundraising efforts and could even leave the family responsible (at least morally) for making up the continuing shortfalls. The brawling also threatened to shatter the arts coalition Nelson had so painstakingly forged. As the dispute boiled over into the media, the governor summoned Morton Baum and Mayor Robert Wagner to his New York City apartment. In the presence of choice Matisses and Picassos, the governor and the mayor bemoaned the condition of state and city finances. Baum, whom Kirstein had described as "the prince of impresarios," then donned his tax lawyer's hat and held forth at length on taxes and public finance. His City Center board colleague Ernest Heller said Baum knew more about such matters than both public officials. When he finished, Rockefeller conceded, "All right, Morty, you can have the State Theater." At the opening, Nelson reminded Baum: "Mort, we built this for City Center. Now move everything in—lock, stock, and barrel." But Baum and his colleagues were still bitter about past slights and worried that Lincoln Center's nabobs would snatch away the theater via backdoor maneuver-

ings. More than three decades later, the friction still generated heat among City Center's partisans. Heller, for one, was convinced that William Schuman wanted control of "all the real estate" at Lincoln Center. Baum believed that "the Metropolitan would stop at nothing" to keep the New York City Opera off its front doorstep. Jean Dalrymple's frail ninety-year-old body shook with rage as she asserted that John Rockefeller "tried to grab City Center . . . he wanted power." Harold Schonberg's article in the *New York Times* on November 8, 1964, cracked the ice at last. The music critic described opposing delegations "marching into the Mayor's office, armed with statistics, legalities and polemics." Lincoln Center insisted on control of the State Theater, while City Center claimed "legal and moral right" to the building. "Who will be the Solomon?" asked Schonberg. Two months later, the *Times'* faithful read, "City Center Joins Lincoln Center."[89]

By then, fresh conflicts were exercising culturally minded New Yorkers. Across from the State Theater, the Lincoln Center concert hall had opened with exquisite pomp on September 23, 1962. In a blaze of lights illuminating the nationwide CBS telecast, flanked by crowds of the curious, the formally clad audience swept over a red carpet toward the glass and travertine edifice. Mayor Wagner arrived with the Philharmonic president Arthur Houghton; John Rockefeller escorted First Lady Jacqueline Kennedy. The garage beneath the hall and some surrounding streets remained unfinished, creating the tiresome congestion that keeps New Yorkers' tempers ablaze. Leonard Bernstein led the Philharmonic in a featherweight program typical of such events: the "Gloria" from Beethoven's *Missa Solemnis,* a premiere of Aaron Copland's *Connotations,* Vaughan Williams's *Serenade to Music,* and the first movement of Gustav Mahler's Eighth Symphony. At intermission, the television audience, estimated at 26 million—a record for a concert—saw interviews with Mayor Wagner and Governor Rockefeller, views of the audience described by Alistair Cooke, Mrs. Kennedy in the Green Room with Bernstein, and an instant architectural review by Aline Saarinen, wife of the architect Eero Saarinen. The next day's newspapers heaped praise upon the hall. "A concert-goer's dream," said the *Daily News.* "Handsome by day . . . remarkable beauty by night," wrote Ada Louise Huxtable in the *New York Times.* A "dazzling cultural pearl," cried the *World Telegram.* But there was a sour note. To Harold Schonberg, the *Times'* chief music critic, "the music was far less important than the sound." And the sound was "inconsistent"; in the orchestra it lacked bass, while in the top terrace bass notes sounded "almost amplified and too live."[90]

The extended rumpus that followed these relatively mild observations illustrates the complexities and the extraordinary expense of building modern performing arts facilities. After a few concerts in the new hall, complaints about acoustics reached a crescendo. Players could not hear themselves or each other. Some listeners heard echoes; others deemed high-frequency sounds too shrill. Acousticians lent their sensitive ears and recommended budget-breaking remedies. And then the wits got to work. One told of the hall's acousticians being asked about the sound problems and replying, "Eh?" William Schuman told the press, "The way I look at this thing is that Philharmonic Hall has opened, and within three days it's famous for its acoustical properties." To the Lincoln Center board he said, "Acoustics is hearsay." After $405,000 worth of remedial work during the following summer, the conductor George Szell suggested "a little simile. Imagine a woman, lame, a hunchback, crosseyed and with two warts. They've removed the warts."[91]

Further tuning recommended by a new expert was slowed by a sheet-metal workers' strike and gobbled another $375,000. Schonberg detected improvement but told *New York Times* readers that "the echo still persists." More drastic, costly changes followed, including removal of all carpet and replacement of the softly upholstered seats with thinly padded wooden ones. That cost $0.5 million more, but the sound inside the first large concert hall built in New York since Carnegie Hall's construction in 1891 still received only the faintest of praise. In fact, Carnegie Hall, which Lincoln Center's organizers had expected to be torn down, had been saved by a concerted citizens' campaign led by the violinist Isaac Stern. Now it stood ready to compete for bookings with the new hall, and its sound was sweet. When both the Boston Symphony and the Philadelphia Orchestra moved their New York seasons back to Carnegie Hall in 1974, the Philharmonic board decided to spend half of Avery Fisher's $10-million gift to solve the acoustics problem once and for all. Less than twelve years after its gala opening, the interior was wrecked and a totally new hall constructed inside the shell. Its new name—Avery Fisher Hall—was appropriate indeed: Fisher had made his fortune manufacturing high-fidelity audio equipment.[92]

All the static over concert hall acoustics was temporarily drowned out in the crescendo of superlatives that greeted the opening of the Metropolitan Opera House on September 16, 1966. *Life* magazine gushed that it was "the single biggest theatrical event in all of human history . . . the cultural super-event of the culture center of the culture capital of the civilized

world." Its 3,800 seats dwarfed Paris's 2,347, La Scala's 2,135, and Vienna's 1,620. As some three thousand plebeians gaped, dignitaries paraded across the inevitable red carpet: Mayor John Lindsey and Governor Rockefeller, the United Nations secretary general U Thant, First Lady Lady Bird Johnson, and Imelda Marcos, the wife of the Philippine President Ferdinand Marcos. Dr. Hans Rath, who had designed the hall's spectacular levitating chandeliers, and his wife arrived in a horse-drawn carriage. The rest of the formally clad audience, who had paid at least $250 for a ticket, jostled on the grand staircase and along upper-tier balconies to watch the arrival of others. (Normally blasé New Yorkers indulge this habit at season openings to this day.) The house's technical facilities were superlative, and the first performance's director, Franco Zeffirelli, appeared to have used them all. "What a house!" the director had exclaimed on his first visit. "I love gadgets. I love toys, and this house is a Cadillac!"[93]

Nevertheless, the premiere of Samuel Barber's *Antony and Cleopatra,* commissioned by the Met, sank almost without a trace. Harold Schonberg cryptically located its cosmic impact "somewhere above the primeval atom . . . and somewhere below the creation of the Milky Way." In *Harper's,* the critic Robert Kotlowitz judged it "a soporific," unredeemed by the spectacle of hundreds jamming the stage in costumes ranging from Elizabethan to Aztec. "Gorgeous girls belly dance," he wrote. "Animals come and go, making the audience nervous at every misstep. It all has the conviction of a mannequin-filled department store." Conveying a new caution about extravagance for the sake of art, Kotlowitz also pointed out that the ultimate cost of the building would pay for six new high schools in New York, or twenty-seven elementary schools.[94]

Such observations convey New Yorkers' exhaustion with more than ten years of rat-tat-tat of the tin cup in behalf of Lincoln Center. Almost everyone agreed that the new building was magnificent, but at what cost? The original estimate of $32 million had been shocking enough, an expenditure of $8,421 per seat. But then expenses took off, so much beyond the amounts in hand that the chairman of the Met's New House Committee, John Drye, told John Rockefeller, "I couldn't go to jail with a finer bunch of fellows." Eventually, costs would reach almost $50 million, nearly $12,000 per seat. The new Met was four times the cubic size of the old, and it swallowed 42,000 square feet of marble from the same quarries as St. Peter's Basilica in Rome, plus more than 3.5 million square inches of gold leaf. With its murals by Marc Chagall glowing through the glass facade of an evening, it symbolized the flowering of the American Century when the

building's plans were drawn. But that mood was withering by the time the building opened. By then, young Americans were slogging through the jungles of Vietnam and the evening news dwelled depressingly on carpet-bombing and body counts.[95]

Through it all, the Met's management remained exceedingly arrogant. In 1967, its first financial report in ten years revealed that while the previous season had been the most successful in its history and income had doubled, expenses had more than trebled. A night at the opera could take in $42,000 at the box office, but raising the golden curtain cost $59,000. Within four years, the annual deficit of more than $3 million was expected to double. By then, the Met was disbursing more than 10 percent of all the money spent on musical productions in the United States. In a study for the Twentieth Century Fund, Martin Mayer noted that while the opera was taking in more revenue than all the other Lincoln Center constituents combined, "the Met has taken no interest whatever in the success of the other institutions at Lincoln Center." Indeed, the Met's management complained about the cost and quality of all services provided by the center and refused to sign a contract for occupancy of its building for two years after opening night.[96]

Amyas Ames, who became chairman of Lincoln Center's executive committee in 1968, believed that the Met behaved like a spoiled diva because of "a split personality." The old building on Broadway at 39th Street had reverberated with one hundred years of glorious sound. Ames concluded, "It was a tearing of everything they were fond of and happy with when they tore the old bricks down and they were forced up to this new-fangled place." Of all Lincoln Center's constituents, "they were the biggest, the highest budgeted, the biggest audience, the most popular, the most written about . . . and they gloried in it." But many opera fans bemoaned the Met's conservative programming. Productions of American or new European works rarely appeared on that opulent stage, and its imperious manager Rudolf Bing was actually proud that the Met was a museum of music. "It's not fair to the Met's public to test new composers on them," he told one interviewer. "I don't believe in undiscovered genius or undiscovered great works."[97]

This lapse had left the New York City Opera bravely mounting budget productions of such modern works as Igor Stravinsky's *Oedipus Rex*, Carl Orff's *Carmina Burana,* and Benjamin Britten's *The Rape of Lucretia.* However, the move to the New York State Theater was proving ruinous for the former City Center companies. The New York City Ballet's *Don*

Quixote, staged to celebrate the company's new home, was said to have cost more than any production in the history of ballet. Operas produced for less than $21,000 at City Center now cost more than $100,000. In its last four years in the old home, the City Center's deficit had averaged $325,000 on attendance ranging from 40 to 80 percent of capacity. In the new home, attendance rose to 93 to 97 percent of capacity and even though ticket prices steeply escalated, the average annual deficit leaped to $1.8 million.[98]

The glaring conclusion that new arts centers would likely be unprofitable hardly deterred the assortment of civic boosters, downtown real estate developers, and genuine arts lovers who indulged the edifice complex that swept across the United States during the late 1950s. By 1962, some seventy cultural centers were being built or contemplated. Behind many of them were women described by Edith Wharton as "those ladies who pursue Culture in bands, as though it were dangerous to meet it alone." Sweeping along their moneyed menfolk, they were "mustering," said *Newsweek,* "to meet Culture head-on." The most energetic, practical, admirable, ruthless, and successful among these Amazons for the arts was Dorothy Chandler, founding mother of the Los Angeles Music Center. Buff, as she was affectionately called, bullied and cajoled politicians, wheedled or shamed donors, and rallied legions of ladies who lunch to prodigious fundraising feats. Their reward often consisted of spreads in the pages of the Chandlers' newspapers, the *Los Angeles Times* and the *Mirror.*[99]

In no way can one fairly compare the Los Angeles Music Center with its infinitely grander contemporary, Lincoln Center. Nevertheless, the two complexes represent an end and a beginning. With a final price of more than $185 million, there would never be another Lincoln Center. The $141.4 million raised from the private sector was by far the largest amount ever given by individuals, foundations, and businesses to a single arts complex. John Rockefeller had done his duty: Over almost ten years, this one individual had collected (or contributed) about 70 percent of the total, all the while peppering his diary with anguished notes about cost overruns, emergency meetings, fiscal crises, and fundraising burdens.[100]

By contrast, the Los Angeles complex, built at a cost of $34.5 million, marked the start of a wave of cultural centers constructed across the United States. While many of these would eventually face the same problems as Lincoln Center—squabbling constituents, nagging deficits, and aging audiences—their difficulties remained on a lesser scale. Lincoln Center was enormously successful in revitalizing Manhattan's Upper West

Side; some 700 million dollars' worth of new construction in the vicinity yielded the city some $30 million in additional sales and property taxes. Yet it accomplished little to stem the middle-class exodus from New York. In Los Angeles, on the other hand, the Music Center anchored a spate of high-rise development that gave the sprawling city, for the first time in its history, some sort of downtown. From coast to coast, the effort to build performing arts centers brought the Jewish community fully into elite society. In New York, it was a noisy struggle; in Los Angeles, a quiet fact. In both cases, the WASP establishment pragmatically yielded its monopoly on management of cultural institutions; they had become just too expensive.

While the Music Center's campaign lacked substantial East Coast foundation funding, it exploited every odd nook and cranny for extra dollars: the Mormon Choir of Southern California gave $25,000 in proceeds from two performances of Handel's *Messiah*; the Los Angeles Turf Club gave $50,000; the Santa Anita Foundation, $25,000; the Japanese community and Japanese government, $10,000; the Chinese community, $15,000; the Philippine Women's Club, $5,000. Of gifts over $1,000, the New York group attracted 2,657, while the Los Angeles group, from a much smaller population, took in almost as many, 2,351. Moreover, although twenty-four $1-million-plus donors made up three-quarters of Lincoln Center's total contributions, the cost of fundraising had consumed close to $2.5 million. While the Los Angeles campaign goal was far more modest, its total fundraising cost was minuscule, less than $185,000.[101]

Perhaps some of the differences were gender based. The New Yorkers reflected the expansive grandiosity of Lincoln Center's all-male board, a hierarchy that required expensive offices and staffs of flunkies. The Southern California effort reflected more than a century of American women's experience in charitable drives. The hub of the Music Center's fundraising was in "The Pub," a small structure near the garage and pool of the Chandler home, Los Tiempos, where volunteers shared five telephones spread among spartan desks, chairs, and tables. For these determined ladies, for the publicity sure to follow in the local papers, Hollywood came through. Cary Grant gave $25,000 and so did Nat King Cole. A benefit performance of *Cleopatra*, the most expensive movie made up to then, sold out all 1,500 seats at the Pantages Theater at a minimum of $250 each. During the intermission, Rosalind Russell announced that those in attendance had given more than $1 million. The public partook of the spectacle, packing bleachers in front of the theater by 4:00 P.M. When celebrity-laden limousines began unloading several hours later, each arrival was announced over

loudspeakers. Culture lovers or not, it was a roster worth waiting for: Rex Harrison, Doris Day, Jack Benny, Walt Disney, Lucille Ball, Joanne Woodward, Paul Newman, Gene Kelly, John Wayne, Andre Kostelanetz, Art Linkletter. When the Music Center Pavilion was dedicated on September 27, 1964, Buff Chandler announced that the campaign for the entire complex would be complete if 10 million Southern Californians each gave one dollar. Volunteers combed the Los Angeles basin with shopping bags designed by Walt Disney and carted home $1.7 million. The *Los Angeles Times* published the name of every donor, if known, and even ran a picture of a retired postman who gave a dollar.[102]

Whether they gave thousands or a single crumpled dollar bill, many of the donors would rarely, if ever, set foot inside the Music Center. To some, their gift was a token of affection for a place where they had only recently settled. Others saw a music center as a centralizing symbol for a spreading quilt of small towns stitched together—as they were also separated—by freeways. But to many of those who gave large amounts of money or time, the Music Center was a way to put their thriving region on the cultural map. Along the way, these newcomers, champions of the arts, found a place for themselves in Los Angeles society.

John Rockefeller and Buff Chandler: two very different people in two very different places, neither of them passionate or at all knowledgeable about culture, yet both moved to devote a decade or more to developing homes for the performing arts. Why? In the case of John Rockefeller, a lifetime devoted to good works required a capstone to give it meaning. When the *London Times* called Lincoln Center "one of the most humane public gestures ever made by private enterprise," perhaps John Rockefeller III believed he had repaid the world for the robber baron's fortune amassed by the first John D. Rockefeller at the turn of the century. The grandson earned admiration, not because he was rich but because he was good.

Mrs. Chandler also craved admiration, after suffering through a long, painful struggle for acceptance within the stuffy Pasadena crowd inhabited by her husband's family. The Chandlers had for years snubbed this daughter of a dry goods merchant from Long Beach, who had snagged Norman while they were both students at Stanford University. His family expected her to join quietly in the Chandler womenfolk's languid life of luncheons and teas, bridge and shopping. In 1932, Buff Chandler had suffered a nervous breakdown. Josephine Jackson, a pioneering psychiatrist who treated her, diagnosed idleness as the cause of her profound depression. "She had

not been wrong to be unhappy," wrote David Halberstam in *The Powers That Be,* "indeed she *should* have been unhappy, it would have been terrible if she had been happy. Life, Dr. Jackson insisted, demanded involvement." Liberated by her therapy, Dorothy Chandler refurbished not only her husband's constricted social life but also the newspapers he had inherited. She tempered their ultraconservative political stance and insisted that their women's pages recognize the newcomers on the social scene. Though herself a moderate Republican, she cultivated prominent Democrats, even Jewish ones, and saw to it that they were appointed to boards previously monopolized by WASPs. She groomed her son, Otis, to become publisher of a newspaper that would dominate Southern California like the sunshine of endless summer and become the centerpiece of a vast media empire. But while she vigorously courted the big money for the Music Center, she also understood the parochial, time-tested ways of organizing women for good works. Ladies clamored to join the Performing Tree, the Reachout Committee, the Symphonians, and the country-clubby Women Fore of the Music Center. The most energetic might then be asked to join the Amazing Blue Ribbon 400 and obtain the privilege of giving the Music Center at least $1,000 each year. All were energized by Buff Chandler, "a woman before her time," wrote Halberstam. "A feminist in pioneer country. . . . A mover, always driving and pushing. A relentless woman."[103]

Though perhaps unique in the way she bestrode the cultural as well as the media scene in Southern California, Buff Chandler was by no means the only activist rallying support for cultural activities in one or another American city. Whether music, arts, or cultural centers, whether symphony halls or resident theaters, the nodes of support for the arts were spreading from coast to coast. They included the best and the brightest, the richest and the most powerful. Above all, they included those many thousands of Americans, first thwarted by the stringency of the Depression and then delayed by the hardships of war, who were finally claiming their rightful place at the cultural feast. To those aspiring to make a difference in Washington, they were becoming a formidable constituency.

3

A MAN FOR ALL SEASONS

WHILE CAMPAIGNING IN 1960, John Kennedy astutely courted the gathering constituency for the arts. In the drab prose typical of exhortations in behalf of the lively arts, the Democratic party platform urged the establishment of a federal advisory agency to "assist in evaluation, development and expansion of cultural resources."[1] In September, the candidate wrote to the classical music trade publication *Musical America* of a "creative burst" heralding "the New Frontier in the Arts. For we stand, . . . on the verge of a period of sustained cultural brilliance." In the *Saturday Review,* Kennedy asserted that "the encouragement of art in the broadest sense is indeed a function of government."[2]

Such statements delighted congressmen who for years had been trying to get direct federal funding for the arts. As early as 1948, Jacob K. Javits, then a House freshman, introduced a resolution asking the president to summon "representatives of theater, opera, and ballet; critics, editors, and publicists; educational leaders, the public as audience, and government officials to devise a plan" for aiding national arts companies. The resolution failed, Javits's colleagues dismissing his efforts as parochial plays for his own constituency of New York arts organizations and unions. Most congressmen looked back with considerable distaste on the WPA (Work Projects Administration) arts programs of the 1930s. Those federal programs, which subsidized painters and sculptors, writers, musicians, and theater, had ended in 1943, amid complaints about radical productions and support for overt Communists. By 1958, however, even Dwight D. Eisenhower saw

that the arts could be drafted as a Cold War weapon. He signed a bill to donate public land for a privately funded cultural center proposed for Washington, D.C.; its promoters promised that showcasing the arts of a free society would challenge the Soviets in the cultural arena. Emboldened by this small gesture, each congressional session thereafter featured Senate hearings where a parade of arts people sang deficit blues. The various legislative remedies that followed sometimes passed the Senate, if only for federal "seed money," but died in the House.[3]

As a senator, John Kennedy took no part in these efforts. But from the very first day of his presidency, he placed culture at center stage, at least ceremonially. Summoned to the inauguration by telegrams from Jacqueline and John were 155 cultural luminaries, including Ernest Hemingway, William Faulkner, John Steinbeck, Arthur Miller, Thornton Wilder, Tennessee Williams, Alexander Calder, Stuart Davis, Edward Hopper, Igor Stravinsky, Paul Hindemith, and Leonard Bernstein. Soon, White House dinners featured Nobel laureates, poetry readings, music recitals, and theatrical performances. The Kennedys entertained the French minister of culture André Malraux and sponsored a concert by the cellist Pablo Casals. Faulkner was among the few who declined to dine at the White House, saying it was "too far to go for supper." Nevertheless, the arts were suddenly fashionable. In the *New York Times Magazine,* Arthur and Barbara Gelb rejoiced in the article "Culture Makes a Hit at the White House."[4]

Kennedy himself was not well informed or particularly interested in the arts. August Heckscher, a New Yorker who had studied the fragile economics of the arts, said Kennedy was "a little bit like the average husband, sort of being dragged by his wife to do a lot of cultural things he really didn't enjoy doing very much." But while an after-dinner cello sonata may not have stirred Kennedy's soul, its political benefits seemed obvious. Unlike such blunders as the Bay of Pigs, supporting the arts was uncontroversial. More important, the arts constituency was growing and it included many powerful local figures: bankers, lawyers and doctors, university presidents, newspaper publishers—and their wives. In many cities, cultural events formed a new, elegant social platform, a neutral ground where Republicans mingled with Democrats, and old money with new.[5]

During the 1960 campaign against Richard Nixon, Kennedy had steered clear of endorsing federal arts funding, promising only a token arts advisory board. But in 1960, Governor Nelson Rockefeller established in New York the first state arts council, billing it as "one of the most exciting and significant pioneering experiences ever undertaken by a state govern-

ment." The following year, after a survey of the state's cultural resources, the legislature gave the new council $450,000 to spread culture to places like Oneonta, Kingston, Amenia, and Delhi. While such a modest budget was lost on most New York City residents, Rockefeller saw it as a signal that his state would lead the nation "toward the fulfillment of its high cultural aspirations." Nor was the new agency ignored in Washington. The council's sixty-three-page report, with its photos of dancers in flight and abstract paintings and of a smiling governor with his attractive new wife, Happy, was entered into the *Congressional Record.*[6]

Since Rockefeller loomed as Kennedy's likeliest opponent in the 1964 election, the president moved to enhance his own cultural profile. In August 1961, the Metropolitan Opera's musicians were about to strike and trustees threatened to cancel the entire opera season. After RCA refused to renew its recording contract, the Met management cited this loss in income, plus a deficit of $840,000, as a reason for reducing the musicians' pay. Their wages had risen precipitously in just a few years, even as the trustees faced extraordinary extra expenses in connection with the new Lincoln Center house. The *New York Times* urged a federal, state, and city bailout, calling the Met "a cultural institution that the nation cannot afford to lose." At Jackie's behest, the president sent Secretary of Labor Arthur Goldberg to mediate. "Both sides were right," recalled Jack Golodner, a Washington lawyer for arts unions who was then a congressional aide. "But a third party wasn't there—the public." This was also the conclusion Goldberg reached the following December. In a report drafted by a young assistant, Daniel Patrick Moynihan, Goldberg noted that the arts economic crisis was not caused by decline but by unparalleled growth, "a growth so rapid, so tumultuous, so eventful as to be almost universally described as an explosion." He recommended "a six-point partnership" to support the Met: the public, traditional patrons, corporations, labor, and government, both local and federal. More than a simple one-time grant to the Met, the report also recommended that the government act as "a direct consumer of the arts" by commissioning sculpture and paintings, awarding music scholarships, and contributing to capital construction for arts facilities. This proposal elicited a record avalanche of mail to Goldberg's office; the writers favored federal arts funding three to one. Along with support from elite arts patrons, the Goldberg scheme attracted strong backing among such unions as the American Federation of Musicians, which had undergone a bitter strike at Broadway theaters the previous year.[7]

The Cold War lent an icy glaze of fear to the clamor for federal aid to

the arts. They were "a necessity," said Senator Javits, "in the defense of our free society." In September 1961, the president endorsed a stirring document on cultural policy drawn up by the State Department. Improving the arts "would be a boost to national morale," it said. Such a step "would do no less than transform the national character and open, for the whole world to see, an exhilarating new chapter in the American Revolution for the 1960s." In November 1961, Kennedy told the advisory commission of the National Cultural Center that "every stone" placed in a Washington cultural center would strike a blow against the Soviet Union's "major effort in this field. . . . [The Soviets] recognize, even though they manipulate this desire, the tremendous interest people have in the arts."[8]

An instinctively political animal, John Kennedy had no more qualms than the Soviets in manipulating the public's growing interest in the arts. "He knows the propaganda value of artists," observed Gore Vidal. High and low art conspicuously mingled as Kennedy crisscrossed every artistic endeavor for stars to illumine the advisory commission of the National Cultural Center: George Balanchine, Lincoln Kirstein, Leonard Bernstein, Agnes De Mille, Norman Cousins, Henry Fonda, Erich Leinsdorf, Samuel Barber, Gian-Carlo Menotti, Walter Lippmann, Alan Jay Lerner, Eugene Ormandy, Leontyne Price, Isaac Stern, George Szell, Robert Penn Warren, Gore Vidal, Jack L. Warner, Thornton Wilder. The appointments were strictly honorary, since the center was hardly more than a ghostly hook on which to hang woolly pronouncements about the importance of art in the nation and, pressing the Cold War button, in the world. To head the drive for materializing the ghost, Kennedy appointed a New York legend—buyer of the Empire State Building, prolific Broadway producer, a rainmaker for Democratic party coffers—Roger Stevens.[9]

Beyond blessing the arts with gestures and declarations, however, Kennedy was extremely cautious about committing federal funds for the arts. The decision kept falling into rifts among his advisers. At the president's behest, August Heckscher studied what the government could do for the arts and concluded that while the Office of Education already had arts money, a cohesive policy was needed. As to a specific policy, however, the presidential aides Richard Goodwin and Arthur Schlesinger, Jr., could not agree. Heckscher was "a sweet and bumbling man," according to Thomas Hoving, who was then director of the Metropolitan Museum of Art, but he was "indecisive." He did urge the president to establish a federal council on the arts by executive order and to name an arts adviser, on the order of his science adviser. Six months before he was assassinated,

Kennedy did appoint an arts advisory council, but it was largely honorary. Hoving believed it was "a classic Kennedy operation . . . politically inspired" to ride the cultural wave building in the country. Though the president's esteem for the arts may have been crassly political, his final words on the subject were eloquent in describing the place of arts and the artist in civilized life. At the dedication of a library honoring the poet Robert Frost, on October 26, 1963, at Amherst College, Kennedy asserted that "art establishes the basic human truth which must serve as the touchstone of our judgment." The president spoke movingly about the solitary task of the artist, who, while "pursuing his perceptions of reality . . . must often sail against the currents of his time. . . . In serving his vision of the truth, the artist best serves his nation."[10]

A month later Kennedy was dead. Livingston Biddle, then an aide to Senator Claiborne Pell, recalled that at the funeral someone asked, with understandable apprehension, "What does Lyndon Johnson know about the arts?" In the months that followed, this question hardly mattered, as it became clear that however little Lyndon Johnson knew or cared about the arts, he was determined to woo the arts constituency as ardently as his predecessor. To push forward arts funding legislation, he appointed Roger Stevens as his special adviser on the arts and urged him to propel a languishing arts bill through Congress. The hearings again focused on the plight of individual artists: their need to train abroad, sporadic work at low wages, intense competition, low status. "If government can aid in the recognition of the artist, thereby increasing his morale and desire to contribute to society," Stevens told the Democratic convention in 1964, "we can easily be on the road to . . . 'The Great Society.'"[11]

Yet the pressure for government action in behalf of the arts was not coming from long-suffering individual artists; rather, a coalition of unions and major arts institutions was putting on the heat. Supporters of Arthur Goldberg's recommendation for federal arts funding included not only New York City's congressional delegation but also the American Federation of Musicians, Actors' Equity, the Motion Picture Association, and John D. Rockefeller III. As new cultural centers were rising all over the country, decay threatened at the traditional core. While regional nonprofit theaters were coming into bloom, Broadway was wilting. New York had sixty-six playhouses in 1931 and half as many by 1960. In 1928, there had been 268 productions; in 1960 there were 57. Between 1928 and 1960, total attendance at Broadway plays had declined by one-third, to 8.1 million, despite

population growth and a rise in personal income of 365 percent. In 1961, the Dramatists Guild called the decline "the worst economic crisis the theater has ever had" and voted overwhelmingly to accept cuts in royalties.[12]

No one was more alert to the distress darkening the Great White Way than Roger Stevens. For more than a decade, he had been financing plays on Broadway, beginning with Jean Giraudoux's *The Madwoman of Chaillot,* the 1949 winner of the Drama Critics Award. Associated with Robert Sherwood, Maxwell Anderson, and Elmer Rice in the Playwrights Company, he played a financial role in some forty Broadway plays, including such hits as *The Fourposter, Cat on a Hot Tin Roof,* and *The Bad Seed.* In 1956 alone, Stevens had a partial or full financial interest in some fifteen plays in New York theaters or touring, one-quarter of all Broadway output for the year. Whether Eugene O'Neill or T. S. Eliot, Shaw or Shakespeare, Stevens invested money in producing their plays, as he also did to stage Leonard Bernstein's *West Side Story* and Robert Bolt's *A Man for All Seasons.* Simultaneously, Stevens trod the political boards. Excited by Adlai Stevenson's 1952 campaign, he worked as a volunteer fundraiser. Four years later, he was chairman of the Democratic party finance committee.[13]

Appointed by Kennedy to energize the lagging drive for the National Cultural Center, Stevens brimmed with fundraising ideas. One was to stage simultaneous fundraising dinners in 150 cities, where patrons would watch a star-studded closed-circuit telecast while mingling with live stars attending each dinner. Mindful of every wrinkle, Stevens told the Cultural Center board that a large attendance would demonstrate broad national support for the center and perhaps convince foundations and philanthropists to contribute. He also suggested that the telecast would broaden the audience for cultural events. To stir up interest, organizing committees in each of the 150 cities were asked to choose from a list the celebrities who might agree to attend the dinner in person. Their selections convey the grip of popular culture on supposedly sophisticated American audiences. Baltimore wanted to dine with Dorothy Lamour and Arlene Francis; Toledo requested Red Skelton or Jack Lemmon; Kansas City preferred Jack Benny, Spencer Tracy, and Fred Astaire; Pittsburgh, home of a great orchestra, asked for Dick Powell, Ralph Kiner, or Arnold Palmer; Chicago, where high culture was long established, sought Ethel Merman and Judy Garland.[14]

The telecast, which took place on November 29, 1962, demonstrated not only the uneven development of American cultural sensibilities but also the intense grip that television had fastened upon the public's leisure

hours in just over a decade. That an affluent, elite public in 150 cities was willing to pay dearly for a meal and some celebrities on a screen gave some indication of television's universal appeal. In 1948, Americans owned just over 100,000 television receivers, two-thirds of them in New York City. In a dozen subsequent years, Americans had bought 41 million television sets. By the mid-1950s, more than 90 percent of upper- and middle-income families owned a TV; in 1956 alone, Americans had spent more than $15 billion on sets, service, and accessories. As television commandeered more of the public's leisure hours, intellectuals bemoaned its baleful effects: the passiveness of watching it promoted generalized lassitude; its pervasive bad taste lowered all the public's taste; its trivial values so widely disseminated would undermine the viewers' (presumably superior) values.[15]

Despite the most sophisticated of studies, no conclusive evidence ever emerged to support these charges. However, there was conclusive proof that Americans' appetites in all kinds of entertainment had drastically changed. Movie attendance had plunged from 82 million customers in 1946 to half that number eight years later. The decline of Broadway was another symptom of changing cultural cravings. As more channels became accessible on the little flickering screen, would there be any audience left for theater, concert music, opera, or dance? The alarm over such a drastic sea change in public taste contributed to the pressures in Washington for support of traditional high culture.[16]

When Lyndon Johnson proposed a national foundation on the arts in his state of the union address in January 1965, the battered arts advocates in Congress took heart. But soon an unseemly squabble erupted over a competing effort to involve the federal government in supporting the humanities. Nonscience academics who had watched the National Science Foundation expand from a 1951 budget of $225,000 to almost $0.5 billion in the mid-1960s were now demanding a parallel program for scholars in history, literature, and social sciences. A commission on the humanities packed with such notables as the presidents of Yale and Notre Dame, the chairman of IBM, the president of the Atomic Energy Commission, and the president of Phi Beta Kappa, found it "in the national interest" to establish a national humanities foundation. Fervently supported by twenty-four learned societies in disciplines from numismatics to metaphysics, the report urged that the proposed foundation also include "the creative and performing arts . . . the very substance of the humanities."[17]

The prize was about to be snatched away from those who had struggled

for so many years to get federal support for the arts. The patrician senator Claiborne Pell of Rhode Island had repeatedly persuaded his colleagues to vote for the arts only to meet defeat in the House. His schoolmate and aide, the blue-blooded Philadelphian Livingston Biddle, was aghast: "The performing arts under the aegis of academicians?" Biddle rushed to the U.S. Bureau of the Budget (now the Office of Management and Budget) to explore prospects for two separate agencies, one for the humanities, the other for the arts. "The President, I was told, *certainly* would not approve two new agencies," he wrote many years later, "and it was considered doubtful that he would approve one—other than what already existed, a purely advisory National Council on the Arts."[18]

This council had come to life in September 1964 as a purely ornamental sop to the vociferous arts constituency. Lodged within the Executive Office, it included twenty-five highly visible, unpaid art stars with staggered six-year terms and a chairman who would serve for eight years. Its mission was perhaps deliberately vague: to suggest ways to "maintain and increase" the nation's cultural resources; to propose encouragements for "private initiative in the arts"; to coordinate existing resources at federal, state, and local levels; and "to conduct studies on ways to promote and encourage creative activity, high standards, and increased opportunities in the arts." Even this nebulous charge and the absence of funds to fulfill it evoked anxieties that the council was the "camel's nose" of federal arts funding. Opponents feared that the government would soon support all sorts of activities, as one wag alliteratively wailed, from "bellydancing to the ballet, from Handel to the Hootenanny, from Brahms to the Beatles, from Symphonies to the striptease."[19]

Compared with the momentous decisions Lyndon Johnson was taking in March of 1965, the appointment of Roger Stevens to chair the new council was insignificant. American planes were pounding North Vietnam and the first waves of U.S. Marines were landing at Da Nang. A bomb shattered the U.S. embassy in Saigon. Students were preparing for a mass demonstration in Washington against American involvement in Southeast Asia. By July, some 125,000 American troops would be in Vietnam. The president announced a doubling of draft calls. Meanwhile, in Alabama, thousands of people led by the Reverend Martin Luther King, Jr., were marching in behalf of black voting rights from Selma to Montgomery, their peaceful trek harassed by state police wielding nightsticks, whips, and tear gas. To protect the demonstrators, the president sent 3,000 National Guardsmen. In August, the Los Angeles neighborhood of Watts exploded with black

rage: 500 blocks burned and looted, $40 million in damage, 34 killed, 15,000 policemen and National Guardsmen rushed in to restore order.

Against this phantasmagoric backdrop, the congressional wrangling over funding the humanities and arts was a tea party. Those who had insisted that the arts be part of the humanities realized that they might end up with nothing, as fresh turmoil, whether against the Asian war or for civil rights, was daily absorbing the attention of the public and the energies of politicians. On September 16, 1965, the House and Senate agreed on arts-humanities legislation. The final structure had been hammered out during a contentious Saturday morning session in Stevens's two-room suite in the Executive Office Building. Present were Pell and Biddle, Representative Frank Thompson, the presidential aide Larry O'Brien, Stevens, and his assistant Charles Christopher Mark. Mark described what followed after O'Brien finally pulled a sheet listing all the congressmen from his pocket: "'An arts foundation alone?' he asked himself. He made an 'iffy' sign with his hand. . . . 'A humanities foundation without the arts?' He gestured with his thumb down. 'An arts and humanities bill under one umbrella?' He turned his thumb up."[20]

Accordingly, the legislation set up Siamese twin endowments linked at the head by the National Foundation on the Arts and the Humanities. *Endowment? Foundation?* The lofty words veiled spongy meanings. "To enrich with property; to provide a permanent income for": This is the *Oxford English Dictionary* definition of *endowment.* However, the funds provided for the two agencies were the very opposite of "permanent," being subject to the annual appropriations whims of Congress. Nor was "foundation" anything but a misleading euphemism. The *Oxford English Dictionary* defines it as "an institution established with an endowment and regulations for its maintenance." As creatures of Congress, subject to annual appropriations and frequent reauthorizations, the two agencies huddled helplessly under the mythical "foundation" umbrella.

As he smilingly signed the legislation in the White House Rose Garden on September 29, 1965, Lyndon Johnson could appreciate that at least when these people fought, they did it sedately, with words, not bombs or billyclubs, and for all he knew, perhaps they could do some good. The product of a hardscrabble childhood exacerbated by the Depression, Lyndon Johnson had fitfully completed West Texas State Teachers College with the bare requirements for a high school teaching certificate. His talent lay in political manipulation; he saw the arts and humanities purely as constituencies to be humored. In the context of $1.4 billion in economic

aid to Appalachia, almost $7 billion in foreign aid, more than $47 billion in
defense spending, the amounts contemplated for the two tiny agencies
were mere specks. Some $5 million was budgeted for the coming year, to
be divided equally between them.

However piddling the amounts, the final debate over establishing the
National Endowment for the Arts (NEA) was fierce. Aside from frivolous
philistines who mockingly suggested that the government would fund belly
dancing, many thoughtful inhabitants of the art world were skeptical. Rus-
sell Lynes, the editor of *Harper's* magazine was worried about "creeping
mediocrity. The less the arts have to do with our political processes," he
wrote, "the healthier they will be." The playwright Thornton Wilder told
the *Washington Post* that "there are no Miltons dying mute here today." In
any small town, he said, "anyone who can play the scales is rushed off to
Vienna to study music," sponsored by the town music appreciation club.
The *New York Times* chief drama critic Brooks Atkinson worried that gov-
ernment funding for theaters would lead to "influence or control." The
painter Larry Rivers suggested that a government role in art "is like a
gorilla threading a needle . . . at first cute, then clumsy, and most of all
impossible." The San Francisco Beat poet and bookstore guru Lawrence
Ferlinghetti ridiculed a "federal tether" hobbling poets and publishers.
The film and theater critic Stanley Kauffmann experienced "a small shud-
der" at the possibility of subsidizing folk artists: "Does the bill envision a
grant to a brothel barrelhouse pianist? Or does it mistake singers such as
Joan Baez for folk artists?"[21]

The endowment also attracted opposition from arts organizations. The
president of the American Artists Professional League told a congressional
hearing that artistic sterility could result from government interference
with art; many works that had achieved immortality over the years, he
argued, would not have passed muster with "experts" when first written or
produced. Fearing that government would seize control, most members of
the American Symphony Orchestra League had long opposed federal sub-
sidy; in a 1951 poll, 91 percent had voted against it. By 1961, the member-
ship was divided, and when the NEA was about to become a reality in
1965, the league's executive vice president testified that "the vast majority"
was unopposed, though lukewarm, to government funding. That a vote to
spend federal money for the arts did not impress many folks back home
was clear during Claiborne Pell's 1966 reelection campaign: He begged
Roger Stevens not to mention Pell's role in starting the NEA.[22]

A good deal of romantic rhetoric embellished the arguments in favor of

the NEA. The New York representative Adam Clayton Powell thundered that "failure vigorously to encourage the development of our artistic and cultural resources would be just as harmful to the quality of life in this nation as neglect of our manpower or our natural resources." Pell saw the arts as a beneficial leisure activity and the artist as an animator to "invigorate this newly gained time for us all." John D. Rockefeller III asserted that "to free men, the arts are not incidental to life but central to it." An officer of the American Federation of Musicians, whose members seek their livelihood in the arts, welcomed the federal contribution in New Deal terms as "a pump-primer."[23]

In speeches, testimony, and print, NEA proponents called attention to the American government's paltry contribution to the arts, particularly in comparison with other countries. Livingston Biddle noted that governments in the Soviet Union and Canada were spending twenty-five times as much as the $5 million proposed for the NEA and NEH (National Endowment for the Humanities). A scholar who had studied European arts funding claimed in 1964 that the United States was "the only large, progressive nation in Western civilization without a systematic subsidy of the performing arts." Even a *Newsweek* article purporting to consider how much government money should go to whom concluded with a ringing sermon: "It isn't an easy job shepherding a giant nation through the baby steps of its development as a culturally responsible entity but . . . it should and must be done." The anonymous author saw as a "hopeful sign . . . that as a nation America has declared its concern for something more than a new refrigerator and another car."[24]

All of these arguments, both for and against, would be brandished with only slight variation throughout the coming decades. Neither opponents nor champions had their facts altogether straight. Most persistent was the assertion that Americans were spending far less than any other country on the arts, an amount that some put as low as half a cent per person per year. This argument ignored another Great Society initiative, the Elementary and Secondary Education Act and the Higher Education Act, which in 1965 were providing more than $50 million to bring the arts into the nation's schools; these programs alone amounted to thirty-five cents per capita. In addition, the General Services Administration had since 1962 required that up to 1 percent of the cost of every government building be spent for art. Finally, the scenario of the arts as Uncle Sam's stepchildren overlooked several unique features of the American tax system. One was that the government provided a postal subsidy, enabling nonprofit organi-

zations to mail letters and promotional brochures at a fraction of normal rates. Another was the tax deduction for charitable contributions, by which the government forwent many millions of dollars in income-tax revenues from individual arts patrons and corporations. In 1965, this indirect subsidy brought the arts some $45 million in corporate donations alone. Finally, the United States had developed a thriving system of tax-exempt foundations. In 1965, they were pumping about $500 million into arts, culture, and humanities.[25]

The most striking foundation contribution to the arts was Ford's multi-million-dollar effort. Operating without the constraints attached to tax-payer funds, Ford was able to pick and choose its beneficiaries, often targeting large sums for specific goals to be attained over many years. The dance program was typical of the foundation's approach and illustrates McNeil Lowry's practical explorations of how to fund the arts. Ford began studying dance problems in 1957, as Lowry directed his humanities program toward performing arts. Two years later, Ford began giving scholarships to gifted dance students in New York City and San Francisco. In December 1963, the American dance world received a Christmas gift of unrivaled magnitude: more than $7.7 million, the largest amount ever given to a single art form by a foundation. The purpose was to "transcend the community ballets" and to propel excellent local companies into national prominence. Some grants extended over many years. The New York City Ballet, for example, was assured of $200,000 for ten years; the San Francisco Ballet received $644,000 over ten years. Other grants addressed specific goals: $155,000 to the Joffrey to liberate itself from dependence on a few large donors; $175,000 to the Utah Ballet for local performances and scholarships; $400,000 to the National Ballet in Washington, D.C., to improve its school and lengthen its season; $144,000 to the Boston Ballet to professionalize the company; $174,000 to the Houston Ballet for training and budget support.[26]

Ultimately more important than the abundance showered on struggling dance companies, many of them as yet marginally professional, were the discriminating methods Mac Lowry and his staff devised for decision making. As an industry, the arts world was pathetically naive. While critics dealt in a more or less sophisticated manner with aesthetics, the business side theoretically fell to trustees, usually wealthy individuals willing to meet the inevitable annual deficit with personal contributions. Though facing budgets of millions of dollars, the artists found it distracting, if not demeaning, to worry about the nuts and bolts of managing the enterprise—box office,

accounting, subscription sales, promotion, advertising, publicity, fundrais-
ing. Many of them viewed trustees' natural concern for the bottom line as
intolerable meddling with their Muse. To avoid any semblance of seeking
to control the content of what was presented, the Ford Foundation relied
on independent, anonymous experts to evaluate grant applications. As it
attempted to raise the quality of dance performance, the foundation also
awarded substantial amounts to strengthen companies' notoriously slovenly
management. In 1962, Ford started a program for training administrative
interns, eventually spawning an entirely new profession of arts manager.
Ford also developed the idea of asking grantees to seek matching grants,
to develop long-term plans, to audit their books regularly, and to submit
final reports on how the grant was used. Such pioneering efforts demon-
strated how the government programs to come could fund the arts with-
out interfering in their content; they were the model on which the NEA
was structured.[27]

As the NEA was getting under way in 1965, the Ford Foundation
remained by far the nation's most generous arts patron. As the National
Council on the Arts gathered in the White House Rose Garden to applaud
Lyndon Johnson's signing the NEA-NEH legislation into law, the Ford
Foundation was preparing a lavish program to support financially strapped
symphony orchestras. In 1966, as the council was agonizing at one of its
quarterly meetings over how to stretch its limited succor across a large,
needy constituency, Roger Stevens was summoned from the meeting by a
phone call from a Ford Foundation executive. Its trustees were about to
give sixty-one orchestras some $80 million to match new endowment gifts
and the foundation wanted Stevens's assurance that the government would
not also fund orchestras. The NEA chair had no trouble making such a
promise; the council had $2.5 million for NEA's first nine months and
could expect barely $4 million in uncommitted grant funds for the follow-
ing year.[28]

As a highly visible conclave of America's arts aristocracy, this council had
no peer. It included the violinist Isaac Stern, the Museum of Modern Art
director René d'Harnoncourt, the film director George Stevens, the archi-
tects William Pereira and Minoru Yamasaki, the choreographer Agnes De
Mille, the conductor Leonard Bernstein, the newscaster David Brinkley,
the composer Richard Rodgers, the actor Gregory Peck, the author Ralph
Ellison, and the sculptor David Smith. Though many gifted individuals
would serve on the council in the future, never again would such a distin-
guished body of talent gather around the NEA's grant-giving table. Still, at

least one observer noted unseemly haste in the selection: Determined to act quickly, Lyndon Johnson had sent Roger Stevens into an adjoining room with orders to return in a half-hour with a complete list. Before announcing the appointments, however, Johnson collected a dossier on each prospective member, including biographies, notes on political affiliations, and names, especially of congressmen, of their endorsers. The geographic distribution of its members conveyed at least the president's and Roger Stevens's notions of where America's culture resided: Of the twenty-five members, eleven were from New York, four were from Washington, and four from Los Angeles. A number of cities developing vibrant new cultural institutions were not represented, among them Chicago, San Francisco, Dallas, Miami, New Orleans, St. Louis, Minneapolis, and Boston.[29]

Each individual on the council overflowed with ideas for how the government could aid his or her own art form. The arrogance that often accompanies outstanding achievement was not lacking. Eleanor Lambert, whom the fashion industry dubbed the "Empress of Seventh Avenue," was appointed to the council at the insistence of Senator Javits, who wanted the fashion industry represented there. Among many other achievements, Lambert had developed the International Best Dressed List in 1940, had formed the Council of Fashion Designers of America in 1962, and was an instigator of the Metropolitan Museum's Costume Institute. Yet when Lambert appeared at the first council meeting, she recalled many years later, Agnes De Mille snorted: "I don't think you belong here. Fashion is not an art."[30]

Even before the NEA-NEH legislation was passed, the council developed ambitious plans. At its second meeting in June 1965, the group raced around a multitude of cultural bases. It recommended establishment of national theater, opera, and dance companies, along with a national youth orchestra, a heritage theater of folk forms, financial support for existing professional companies in all the arts, pilot projects for regional repertory theaters, a film archive, training for filmmakers, and funding for museums. Also discussed were how to increase opportunities for artists, how to improve communications within and between various fields, and—a question that still vexes the arts today—how to build larger, better-educated, and more discriminating audiences. The meeting exuded excitement, wrote one observer: "The dreamed-about projects became a moveable feast for the arts, so long seated at the bottom of the federal table."[31]

Once its tiny portion was before it, the council in November 1965 dispensed the funds with the frenzy of a famished creature. Meeting at a

former Biddle family home become a conference center in Tarrytown, New York, the gathering was as much social as professional, with consultations and discussions continuing in the bar to the early morning hours. In two hectic days, the council gave $350,000 to the American Ballet Theater for touring, $100,000 for an artists' revolving housing fund, $250,000 for producing up to ten (as yet unspecified) plays, $500,000 for creating lab theaters, $80,000 for broadening experiences of promising art school graduates, $375,000 to give sabbaticals to artists who were also teaching, and $100,000 to be divided among fifty composers.[32]

In the context of federal spending even then, these amounts were insignificant, although they meant a great deal to their recipients. But as a portent of NEA's tendency to lay funds large and small on thousands of diverse arts endeavors, this first allocation meant much. Michael Straight, then a reporter for the *New Republic,* watched with "disbelief": "I could see no pattern in the grants. Some seemed to me arbitrary; most I felt were peripheral. I doubted if the Endowment should be a provider of housing or a backer of plays. I was certain that it lacked the wisdom to identify and reward individual talent in the arts." Nevertheless, Straight, who would later spend eight years as the NEA's deputy chair, decided not to write about his misgivings. Along with many optimistic friends of the arts, he felt that criticism at this stage would hurt the fledgling effort.[33]

At subsequent meetings during its first two years, the council in short order approved a broadly scattered series of further initiatives. Their imaginations goaded by each other's brilliance, their reach vying in friendly competition with each other's achievements, the council's luminaries hurriedly approved relief packages for a world whose dimensions were unclear. Few scholars had yet examined the arts universe in any detail beyond the biographical, the anecdotal, or the polemical. The dispassionate discourse in two studies published as NEA was getting started disguised insistent advocacy of government support for the arts. Most influential in the short run was a Rockefeller-funded report, *The Performing Arts: Problems and Prospects,* written by the futurist Alvin Toffler and the *Life* film critic Richard Schickel. It swept along many liberal Republicans as it frightened Democrats with the specter of a 1968 run for the presidency by an arts-minded Nelson Rockefeller. But the longer life span went to a fiscal analysis by two Princeton economists, William Baumol and William Bowen's *Performing Arts: The Economic Dilemma,* commissioned by the Twentieth Century Fund. A profusion of studies in recent years that advocate more government aid to the arts still cite this work's conclusion

that the arts could never be self-supporting because they are labor inten-
sive and cannot effect economies of scale; a string quartet, so the argument
goes, must always have four players. This argument ignores the obvious
increase in productivity when the string quartet plays in a larger hall,
makes recordings, or sells videotapes.[34]

Such advocacy clothed as serious scholarship, along with the stimulating
company of stellar colleagues on the council, captivated even sobersided
R. Philip Hanes, Jr., a member originally opposed to the NEA. While
building a business empire on cotton-knit underwear, Hanes also had
founded a strong community arts council in Winston-Salem, North Car-
olina. In its first year, the National Council rapturously plunged into a mul-
titude of projects joined only by a tenuous thread: They had something to
do with the arts and they needed money. It funded *The American Musical
Digest,* a publication with no capital beyond its grant; despite a second
grant, this short-lived sheet never did fulfill its mission of countering the
influence of the *New York Times* critics. The council gave a Washington
consultant $85,085 to ponder the feasibility of starting a national institute
of design and then rejected his affirmative report. It ordered a study for
improving highway signs. It paid for sending a Buckminster Fuller geo-
desic dome to the Spoleto Festival in Italy. It provided design interns for
Lady Bird Johnson's America the Beautiful Fund. It awarded $10,000 to
each of ten poets and critics who, "in the Endowment's opinion, had not
been given the recognition to which they were entitled."[35]

Whipped forward by Isaac Stern, the council authorized $31,400 for
Alexander Schneider, a violinist with the Budapest String Quartet, to
search out musicians for a national chamber orchestra, and was ready to
commit $400,000 to establishing it. Existing orchestras were irate as word
got out that the new group expected to engage their musicians for two
years of touring at higher salaries than they were currently getting. The
plan was dropped after Schneider spent a year auditioning five hundred
players and reported finding only fifteen worthy of inclusion. So furious
was the orchestra world's reaction that Roger Stevens, at the next council
meeting, apologized to Isaac Stern and explained that he had to cancel the
project in order to save the NEA. Another fiasco was the council's plan to
spend $310,000 to start a booking agency for aspiring musicians through
the Carnegie Hall–*Jeunesses Musicales* agency. The director of NEA's
music program at the time, Fannie Taylor, later wrote that the music world
"became hysterical" over this proposal, as existing booking agencies feared
unfair "poaching" by a subsidized competitor.[36]

Every council member's wish list received kindly consideration during those first two years, with sums large or small awarded sometimes for need, sometimes for past achievement, and sometimes just to demonstrate the council sponsor's power. The total effect was, as Michael Straight charitably put it, "idiosyncratic." Agnes De Mille's potent advocacy sent $142,250 to Martha Graham to fund an eight-week, thirty-two-city tour, her first in fifteen years. The poet Kenneth Patchen obtained $10,000 to move to a milder climate. The Radcliffe Institute for Independent Study received $25,000 to help women with domestic responsibilities pursue writing careers. American participation in the 1966 Venice Biennale secured $38,000. A project to assemble artists, scientists, and engineers to explore art and technology was given $50,000. The choreographer Jerome Robbins acquired $292,797 for the American Theater Laboratory. More than $50,000 went for studies by the Oahu Development Conference on preserving Hawaii's natural beauty.[37]

Beyond direct aid to artists and institutions, the council also supported that perennial missionary effort of the art religion, audience development. The Idea Theater at the University of Wisconsin obtained $203,767 for a three-year experiment in "increasing public receptivity to cultural programs" in five small rural communities. "Outreach" programs at museums in Boston, Fort Worth, and Detroit garnered $341,000 in three years. The newly established Coordinating Council for Literary Magazines doled out $50,000 from the NEA (plus what such an endorsement brought in matching foundation funds) to a raft of rarefied, small publications, including the *Kenyon Review, Poetry,* the *Hudson Review,* the *Virginia Quarterly,* the *Chelsea Review, Coyote, Burning Deck, Audit, Wormwood,* and *December.* (*October* would come later; founded in 1976, this visual arts periodical still receives NEA funding.)[38]

With more than half its membership based in the northeast, the council overwhelmingly favored projects in its own backyard. Perhaps that canny Texan Lyndon Johnson anticipated the council's East Coast snobbery when he dropped a bombshell (fortunately figurative, in that war-oriented time) as he signed NEA-NEH into law: "We will create an American Film Institute," he announced. Roger Stevens's eyes widened: "An American Film Institute?" Biddle was stunned: "Where did that come from?" He suspected that Stevens's speechwriter Frank Crowther, a movie buff, had surreptitiously dropped the recommendation into the presidential text, perhaps to counter Stevens's bias toward theater. Another explanation is that Johnson

was paying off some West Coast political debts; the film industry, then suffering from television's inroads on its audience, was the only corner of the creative world offering staunch support for his policies in Vietnam.[39]

Just before Congress approved establishment of NEA-NEH, Johnson had been abjectly humiliated by the very people he was trying to woo. Hoping to lock Kennedy's arts constituency into his administration, he had invited three hundred artists and their disciples to a White House Festival of the Arts; the day was to include exhibitions, music, theater, films, dance, and readings. So inflamed was the political climate, however, that a number of artists, including the writers E. B. White and Edmund Wilson, declined to attend. The poet Robert Lowell publicly canceled his appearance via a letter released to the *New York Times.* "Every serious artist knows," he wrote, "that he cannot enjoy public celebration without making subtle public commitments." The poet Mark Van Doren and the writer Dwight Macdonald attended, yet signed a petition deploring Johnson's Vietnam policy, and John Hersey infuriated the president by reading a grisly antiwar passage from his best-seller *Hiroshima.*[40]

The president's zest for the arts waned considerably after this debacle. While Congress had authorized as much as $20 million for the two endowments, Johnson's budgets for 1967 and 1968 called for appropriations of just half this amount, and the Johnson team made no congressional effort in behalf of even these lesser sums. The NEA's managers were even more distressed that the American Film Institute (AFI) was commandeering far more than any of the other programs. To AFI's initial 1967 budget of $5 million, the NEA had to commit $2.4 million over the next three years. Why the government should aid an industry that in 1967 was taking in almost $3.5 billion remained a mystery and the cause of much strife within the endowment in subsequent years. The AFI's mission also remained unclear. Was it scholarly study of film art? Showing the public film classics? Preservation of deteriorating nitrate-based film? Training young filmmakers? Furthermore, the appointment of George Stevens, Jr., to head the AFI while his father sat on the National Council on the Arts exuded a perturbing aroma of conflict of interest. When the Ford Foundation declined to renew its $1.3-million commitment to AFI after three years, and the industry itself refused to provide a matching sum, Stevens's successor as chair, Nancy Hanks, attempted to cut the NEA's contribution from 60 to 50 percent of the AFI's total budget. The institute's managers then showed her a letter from Roger Stevens in which he had promised AFI 10 percent of all NEA funds.[41]

The NEA-NEH legislation had attempted to insulate the agency from political pressures: Grant applications would be reviewed by a panel of experts in each field; their recommendations would then have to be approved by the council and the chair. The congressional committee reviewing the bill affirmed that the endowments' principal objective was "the encouragement of free inquiry and expression . . . conformity for its own sake is not to be encouraged . . . no preference should be given to any particular style or school of thought or expression. Nor is innovation for its own sake to be favored. The standard should be artistic and humanistic excellence."[42]

Probably the most idealistic readers of this statement were those who would staff the new agency. Many had considerable experience in academe, at foundations, or at arts institutions; few were practicing artists. Stevens summoned many of his people. Ruth Mayleas, for example, headed the service department at the American National Theater and Academy, where Stevens was on the board. She became one of the three earliest program directors at NEA. Heading both the dance and theater programs, she offered, she said, "two for the price of one." (Mayleas went on to direct the Ford Foundation's theater program and is currently senior adviser at Arts International.) Charles Mark, who would become NEA's circuit rider to the states, had spent three years at the Winston-Salem Arts Council and was director of the St. Louis Arts Council when Stevens phoned with the NEA job offer. David Stewart was a pioneer in educational television and had just finished a study at Dartmouth on the use of films in university courses when Stevens invited him to Washington for a chat. Stewart was treated to lunch at the posh Sans Souci restaurant, where Stevens was a regular, and hired to direct NEA's education program. The attorney Charles Ruttenberg had been part of that legion of Washington lawyers practicing privately while pursuing political pull. He had "no desire to be in government," he recalled, but "Roger got after me." With an additional nudge from Johnson, Ruttenberg became general counsel to NEA-NEH.[43]

Ana Steele, who became acting NEA director in 1992, joined the agency in its earliest days and is now considered its institutional memory. She had graduated as a drama major and spent five years in New York City trying to break into theater. While visiting her family in Wilmington, Delaware, she read in a newspaper about "this thing" on arts starting in Washington. "I had an image of a huge government agency," she recalled much later. "I was very idealistic. I was thrilled, but I was also deeply suspicious." Steele submitted letters and résumés: "Then I did the nerviest thing of my life. I

called them and said, 'I'm taking the train down to see about a job.'" Luckily, her cab driver knew the location of the Old Executive Office Building, a massive Beaux Arts pile near the White House. "I saw this extraordinary building. I saw the seal of the Vice President of the United States. I thought the whole building was the Endowment." Steele was ushered into an office "packed with boxes, and files and phones," and occupied by "this big, bald, grumpy guy." Briefly interviewed by Stevens's secretary, she was hired for her theater background and told to report for work on Monday, December 22, 1965. However, no theater program yet existed, so Steele prepared fact sheets, did public relations, and processed surveys of state arts programs in the catchall Office of Studies and Analysis.[44]

A frail, pale figure who resembles Julie Harris at her most waiflike, Steele was rapidly swept into the ad hoc, hectic, exhilarating atmosphere of a new agency inventing itself afresh on a daily basis. While she found the new agency "incredibly exciting and invigorating," more experienced administrators deemed it frenetic if not demented. Richard Hedrich was a former political science professor who came in as the grants director for both the arts and humanities endowments. He had spent six years in the Office of Education at the U.S. Department of Health, Education and Welfare and was "dying to get into the arts," he recalled. "It was classy." One of the few early staffers with an understanding of governmental procedures, the sober civil servant Hedrich was still shaking his head almost thirty years later over the hyperactive bedlam into which he was inducted, following a five-minute interview with Stevens's deputy, Livingston Biddle. On his second morning at the new job, he found stacks of grant applications pushed aside and his secretary stretched prone on his desk. "I'm doing back exercises," she informed him, and calmly continued until asked to depart. Hedrich, who later directed such public programs as the PBS "Civilization" series at NEH, deplored the NEA staff's resistance to being organized: "They bristled at such awful things as budgets." Staff meetings lacked any agenda, he recalled, and people would wander in and out, while Stevens, ensconced in a presidential rocker, busied himself on the telephone. Once Hedrich heard a disembodied voice, which turned out to belong to someone sitting on the floor behind Stevens' desk. Through it all, Stevens looked "bothered . . . pestered . . . he acted like he was brushing off flies."[45]

If there were flies on Roger Stevens, their bothersomeness and pestering were largely self-inflicted. By all accounts, he relished juggling an implausible array of grand projects. While acting as the president's adviser

on the arts and as chair of the National Council on the Arts, he had continued as president of the National Cultural Center, to which the Kennedy assassination ironically had lent not only a name memorializing the dead president but also urgency. On December 2, 1964, just ten days after the Dallas tragedy, Lyndon Johnson plunged a gold-plated spade into the frosty soil near the Potomac to break ground for what, thanks to Stevens's swift yet discreet discussions with the stricken family, would be the Kennedy Center for the Arts. As construction got under way, Stevens moved from New York to a Georgetown house rented from a former ambassador to the Court of St. James, but he appeared to light only briefly at home. In the ten months leading up to Congress's approval of NEA-NEH, he crisscrossed the country, giving thirty speeches, mostly in behalf of the legislation. In the summer, he opened the Tanglewood Music Festival. He spoke about arts in America in London. He made six radio and television appearances. He participated in nine panel discussions, some as far away as Los Angeles. He participated in advisory groups on every art from drama to stamp design.[46]

Tall and bald, a man, as a *Fortune* writer put it, who "would not look incongruous in a Roman toga," Stevens loped the two and a half miles to downtown Washington every day he was in town. Then he shuttled on foot among his three offices—the presidential assistant's in the Executive Office Building, the NEA's at 18th and G streets, and the Kennedy Center's on Pennsylvania Avenue. The newly hatched jet age was made for Roger Stevens. As he logged 250,000 air miles during the NEA's first year, the chair paid 90 percent of the fares himself. The agency's $28,500 salary hardly covered his cost of living in Washington. Out of his own pocket, he also paid several aides to deal as randomly as he did with his multifarious projects, whether real estate, theater, NEA, Kennedy Center, or politics. "I worked on real estate in the morning when the theater people were asleep," Stevens explained, "and on theater in the evening, when real estate people were relaxing."[47]

As his colleagues frequently noted, Stevens would lose interest in the details once a big deal was completed. One of his pet projects was Westbeth, a costly plan to turn an abandoned Manhattan telephone building into housing for artists. Questioned by the council on its legalities, Stevens airily replied that "it was OK" with the counsel Charles Ruttenberg. "Of course he hadn't talked it over with me," the attorney later said. "I had to scramble." That Stevens's interests in commercial theater and real estate could possibly influence his decisions at NEA appeared never to enter the

chairman's mind. The New York attorney Charles McWhorter, a Republican who later served on the council, called Stevens "a walking conflict of interest . . . but principled; fair." Nor did Stevens have the slightest interest in how government money was actually disbursed. Richard Hedrich recalled a staff meeting into which an aide rushed to announce council approval of a large grant for a New York group. Stevens expected to be in New York that afternoon and blithely told the staff he would present the check personally. "Somehow," said Hedrich, "he thought that I had a government checkbook in my pocket."[48]

Stevens's whirlwind of activity exhausted, confounded, irked, and awed many associates. Charles Mark recalled Stevens working "at all possible hours on all possible days . . . Saturday and Sunday meant peaceful days of work with . . . a chance to catch up on planning and details." Stevens regularly complimented Mark about the speeches he asked the assistant to write almost every day but was always vague about how they were received. One day Stevens abruptly told Mark that he had never delivered one of those speeches: "[I] couldn't read all that purple prose in public . . . I'll have to find someone else to write my speeches." Mark assumed that he was fired, but Stevens calmly moved on to another subject and Mark stayed on for five more years. David Stewart recalled chasing around New York on Stevens's heels. "He could walk around mid-Manhattan without ever crossing an intersection," Stewart recalled in wonderment, plunging through dim arcades and obscure underground passages a step behind. On the way to an appointment, Stevens dodged into an art gallery where a favorite New England artist was having a show. "He was always moving," said Stewart, "very kinetic."[49]

Charles Ruttenberg wryly remembered a red-eye flight with Stevens from Los Angeles to Washington. To sleep, Stevens popped a little green pill into his mouth and gave one to Ruttenberg. A short time later, when they were both still wakeful, Stevens said, "Maybe we should take another," which both men did. Ruttenberg snoozed across the country and awoke only when the plane was circling Dulles Airport at 7:00 A.M. On landing, Stevens waited alertly in front of the terminal while the attorney picked up his car in the parking lot. Ruttenberg thought he felt fine—and promptly plowed the car into a lamppost.[50]

Roger Stevens's early life had been a roller coaster impelled by the Depression. The son of a wealthy Detroit real estate broker, he had graduated from Choate in 1928 and was headed for Harvard when the family fortune was swallowed by the 1929 crash. After a year commuting from

home to the University of Michigan at Ann Arbor, he quit school and spent several years at odd jobs, pumping gas at twelve dollars per week and polishing gears on the Ford assembly line. "I was quite a good-for-nothing," he said much later. In the unpromising year 1933, an unpaid apprenticeship with a Detroit real estate firm brought him to the threshold of wealth. Using small savings and his wits, Stevens gained control of bankrupt office buildings and, as the economy improved, he sold them at a profit. By 1936, the twenty-six-year-old entrepreneur was earning a princely $25,000 a year and had $50,000 in assets. The following year, he married Christine Gesell, the niece of the famous child psychologist Arnold Gesell, and embarked on a six-month honeymoon around the world. Stevens sometimes consumed five books in a week, raiding the public library for Shaw, Joyce, Shakespeare, Fielding, Proust, and Pirandello. In the 1940s, he discovered the Detroit Theater Guild and became active in its administration.[51]

When Stevens arrived in New York, he was ready to swallow the city whole. Most publicized was his formation, in 1951, of a syndicate to purchase the Empire State Building. By dint of an intricate patchwork of deals and loans, his group paid $51.1 million, more than had ever been spent to buy a single building. Three years later, with far less notoriety, the landmark was sold for a $10-million profit. Illustrative of the man's style, though it may be apocryphal, is a tale associated with this transaction. Stevens, it is said, asked his attorneys during the negotiations to tell him all the ramifications of the complex purchase contract. He stretched out on a sofa, closed his eyes, and appeared to be dozing while the lawyers droned on. They were astonished when the dickering began in earnest the next day, as Stevens recalled every nuance of what he had been told.[52]

Stevens exhibited the same amalgam of woolly distraction and steel trap in his work at NEA. He would call on each newly elected senator and representative, ostensibly on a purely social mission. Polite niceties out of the way, he would then whip out a list of the trustees of the larger arts institutions in the politician's district and demand that he or she note how the names overlapped with a list of major campaign contributors. "Invariably," wrote his aide Charles Mark, "the lesson was clear. Roger would point out these people needed federal help." With his own staff, Stevens enjoyed juggling competing claims. "He'd sit at his desk, usually smoking a big cigar, and we'd sit around him," said the education program director David Stewart. "He preferred to play the part of a blackjack dealer; the phone was one of the players. . . . You looked for an opportunity to get your case

to him. . . . Five or six people would be pressing at once. I never saw him slip. . . . He kept all these different 'deals' separate."[53]

Not surprisingly, the endowment reflected this brilliant man's idiosyncratic personal style. Paul Spreiregen, an architect recruited to run the design program, found "no rules." He received a fistful of blank airline tickets to fill in any time he needed to travel somewhere. He expected to learn about the other arts from his coworkers, but instead of a collegial atmosphere he encountered intense competition: "My colleagues were among the most avaricious I've ever seen," he said. "It was a Machiavelli grad school." Increasingly frustrated as others shot down his programs, he believed that "Stevens would not have missed the architecture program; the performing arts were his great passion." Spreiregen soon wondered, "What am I doing here, getting projects for others when I want to do projects myself?" He left after four years and pursued a successful private practice in Washington, D.C.[54]

Considering Stevens's intimate knowledge of real estate, it seems difficult to believe that he had no regard for architecture. But then, he also had intimate knowledge of theater and was by no means a bystander during the most profound change to overtake the American stage in its entire history. As the owner of Broadway theaters and as one of the most active of New York's commercial producers, he sat front and center at the transformation of American theater from a basically commercial activity that was dependent on the public buying tickets to a basically nonprofit activity that relied on private contributions and grants to augment ticket sales. While the huge bulk of Stevens's papers at Lincoln Center's performing arts library includes hardly a memo or letter bearing his signature—they may have been "sanitized"—it does convey the immense complications of producing theater for profit in New York during the late 1950s and into the 1960s. Overshadowing the artistic tasks of finding a play, hiring a director, casting, and rehearsing were immense administrative and financial obstacles. Usually investors were limited partners and the producer was the general partner, with profits split fifty-fifty. The voluminous paperwork associated with each production testified that only lawyers were guaranteed profits from every show wending its way toward Broadway. For the rest, investing was extremely risky, with frequent calls for additional investments after the original amount was committed. For each of these limited partnerships, a statement had to be filed with the U.S. Securities and Exchange Commission, and also a statement with the New York State commissioner of corporations. Each play required a fresh business

license, a separate bank account and checkbook, and its own stationery.

Once funded, the producer faced nettling labor negotiations with Actors' Equity, United Scenic Artists, the Dramatists Guild, and separate unions for press agents, costume designers, and musicians. Agents for all the actors and the director made special demands; the foreigners among them (mostly British) required clearance from American unions and a green card from the U.S. Immigration and Naturalization Service. Meanwhile, the producer also needed to locate theaters to rent for out-of-town tryouts and the anticipated Broadway run. Usually there were wearisome, sometimes acrimonious sessions to persuade the play's author to rewrite his or her creative masterpiece into a commercially viable vehicle. Then came time-consuming efforts to sell the play to Hollywood. As all these negotiations became more complex, the paper connected with each production reached voluminous mass. As productions became more expensive, each one became more risky, in a spiral that drove away all but a few affluent "angels."

Broadway production costs began to inflate during the late 1950s. In 1957, for example, a play Stevens was involved with, *Cloud 7,* was budgeted for $80,000. This included $50,000 for physical production and $12,500 cash reserve. Sets cost $8,500; advertising and publicity, $5,000; and the out-of-town tryout, $7,500. The director received $5,000 while rehearsal salaries amounted to $3,750. In 1962, Stevens was involved in producing Gore Vidal's *Romulus,* a play of comparable complexity. The script traveled all over New York before attracting forty-six investors of as little as $500 and seldom more than $2,500. Each of them required a contract and a full accounting of income and expenses. Many needed several reminders to send in the "overcall," the extra 20 percent they could be (and increasingly were) assessed when expenses rose. The production cost at least $150,000.[55]

As Broadway costs and complications mounted and production consequently declined, New York theater folk devised a new format, off-Broadway. Tennessee Williams's *Summer and Smoke* was the first such production, in 1952. Starring Geraldine Page and subsidized by theater unions willing to accept lower pay and less stringent working conditions, this successful run at Greenwich Village's Circle in the Square Theater triggered a miniboom in serious theater at out-of-the-way locations. In 1956, Circle in the Square's *The Iceman Cometh* helped to reestablish Eugene O'Neill's reputation. Within relatively few years, off-Broadway, and the even cheaper, even farther away from the beaten track off-off-

Broadway, became the principal sources of innovative theater in the New York area. Instead of organizing afresh for each production, as in the Broadway system, many of the newcomers sold subscriptions for a "season," thereby getting audiences, in effect, to become "angels" for a series of plays. Organized as nonprofit corporations, these companies also sought contributions and grants. But here, too, the competition was keen. By 1977, a Circle in the Square production of Molière's *The Misanthrope* at a new uptown location closed quickly after losing $400,000, and the only consolation was that this loss was about half what it would have been on Broadway. By January 1993, Circle in the Square was effectively bankrupt. Subscribers had dwindled from a peak of 22,000 to some 8,500; those who had paid $75 many months earlier for a three-play season were still waiting for the season to begin. Their money had been spent and yet the deficit stood at $1.5 million. Amid a drastic shakeup among administrators, and fears that New York's attorney general would step in, only a single candle glowed: The magnetism of being "in theater" had attracted 350 acting students. Their $900,000 in tuition fees comprised the institution's principal income source.[56]

The drama of institutional theater, a nonprofit enterprise where box office is augmented by grants and contributions, has played on many stages all across the country since the Second World War. Act one features a brilliant, charismatic individual with exciting new ideas and the drive to realize them. In act two, community leaders join local drama buffs to provide what they believe is generous support for the talent in their midst. Audiences flock in, awards and honor accrue, everyone rejoices that the institution will endure and prosper forever. On the crest of success, production costs rise. Deficits loom. In act three, tragedy closes in. The brilliant director sickens, ages, dies, moves on, loses his or her creative grip. Recession cuts contributions, and anxious trustees call for more popular plays and more frugal productions. But the audience accrued over many years of mailings, special privileges, parties with the cast, and appeals to their superior taste, their good citizenship, and their loyalty also ages, or moves away, or decides it prefers a fresher, younger theater, a shoestring operation in a bare-bones warehouse or loft. Curtain.

Act one began to play in Minneapolis–St. Paul in singularly grandiose fashion in 1959, when Sir Tyrone Guthrie breezed in and announced his intention to bring "great drama to an area which has had no theater." He almost made residents forget that their region already harbored a long-

established professional stock company, at least one hundred popular community theaters, and a throng of committed university and high school theater folk who had labored for many years to whet the public's appetite for drama. The titled British director and his two American colleagues, Peter Zeisler and Oliver Rea, cast themselves as "Three Wise Men from the East," according to the Guthrie Theater's chroniclers, "bearing gifts and traditions of British and European theater. . . . Their assumption was that once the unwashed were baptized in the rivers of Guthrie's classical drama, the audience would be saved forever." In fact, the Twin Cities boasted an inordinately educated population. The Hormel Meat Packing Company in nearby Austin had for years hired no hog buyer lacking a college degree. The first little theater in America had been founded not too far away, in Duluth, and had staged the first American production of Shaw's *The Dark Lady of the Sonnets.*[57]

Building on Guthrie's prestige with strenuous promotion, his supporters raised $2 million for an imaginative structure where not one of the 1,437 seats is more than fifty-four feet from the thrust stage. The fundraisers discovered that, as one of them put it, "it was easier to raise large sums of money on the basis of white ties, the religious nature of theater, and classic plays than of old tennis shoes, salty words, and flamboyance." Thus, newspaper photos showed Sir Tyrone at an elegant party in white tie and tails and did not focus on his feet, shod in tennis shoes. As the theater was opening in 1962, a survey of people living within one hundred miles showed that only 3 percent would be definitely interested in attending, whether from genuine interest, from curiosity, or for the intellectual or social status to be derived from being seen there. Though tickets cost only $1.50 to $5.00 the potential audience exhibited an affluent profile remarkably similar to that revealed, again and again, in countless other surveys: 55 percent women, 23 percent over age fifty, 38 percent single, 20 percent married but attending *sans* spouse, 29 percent college graduates, 33 percent holding postgraduate degrees. Most also attended other high-art performances: sixty-six percent went to the symphony and 38 percent to the opera. Most also frequented professional sports: fifty-six percent attended baseball; 28 percent, football.[58]

The notion of theater as just another spectator sport appalled the very few—but very persistent and ultimately very influential—Americans who perceived a sacred mission in rescuing drama from commercial muggers. The old highwayman had been Hollywood, which for decades had been

Broadway's principal patron. The new bandit was television, the intrusive diversion that was transforming Americans from intellectually curious, sociable, responsible, energetic, high-minded citizens into passive, isolated, indolent, sluglike robots. Or so its highbrow enemies claimed. To expose this endangered species to finer things, the Ford Foundation poured many millions into "improving" television, pioneering nonprofit programming as well as trying to bring the mass of commercial network viewers more elevated fare. One such attempt was a new version of *The Iliad.* Alistair Cooke set the tone as he explained that the drama was "about a buccaneer named Paris who went cruising in the Aegean Sea." After a year's effort and five rewritings, the script offered such immortal lines as: "I'm sorry for that man Hector" and "You don't know how it is to be a woman. I had a husband. And when he was gone, just like your wife, I waited. . . . No, you don't care. It's a long time now, I'm old."[59]

Meanwhile, Ford also was nourishing original theaters, which were blossoming as never before. Some were in places that previously made do with road companies of Broadway shows; others nested off- or off-off-Broadway. Nina Vance's Alley Theater in Houston garnered $5 million to move presentations of her visionary drama from a tiny dance studio on an alley into a 242-seat jewel box created inside an abandoned fan factory. Discovering Vance, said McNeil Lowry, was "like going out with your lantern and finding . . . one of the great directors." Ford also provided crucial support for Ellen Stewart, founder of New York's La Mama complex. In 1967, following La Mama's impressive European tour, Ford granted the company $35,000 to purchase a former sausage factory on East Fourth Street, which became two 99-seat theaters. The following year, Ford gave $165,000 for purchase of a seven-story loft building on Great Jones Street. The strategy was to provide enough money for talented founders to expand and to raise artistic standards, while encouraging local communities to maintain the enterprise at its new, higher level.[60]

To enable artists to learn from each other, Ford also fostered the Theater Communications Group (TCG), a trade organization whose membership now includes some 340 nonprofit theaters in the United States. It sponsors conferences and workshops, provides technical assistance, publishes scripts, and offers practical help with promotion, financial management, and subscription sales. Founded in 1959, TCG has been headed for more than two decades by Peter Zeisler, who had been Sir Tyrone Guthrie's associate in Minneapolis. A sardonic iconoclast who resembles a disillusioned Santa Claus, Zeisler sees little to admire in contemporary

American politics, culture, or art. During his Guthrie years, he says, "we were there to provide a service, not just leisure entertainment." In 1963, he points out, admission to a Guthrie performance was subsidized by the Ford Foundation and cost as much as admission to a first-run movie. By the mid-1960s, actors had more continuous employment in resident (non-profit) theaters than on Broadway and more series subscribers occupied theater seats than holders of single tickets. But as contributions and grants fell below rising costs, Zeisler said, theaters had to raise ticket prices "and start thinking like commercial houses." [61]

As happened in many other philanthropic arenas, when the government stepped in, Ford declared its mission successful and moved into other fields. But unlike Ford, which concentrated nourishment on the sturdiest, handsomest plants in the theatrical jungle, the government's program had to broadcast less food to a much wider spectrum. In its first five years, the NEA theater program distributed more than $1.4 million to 333 theaters, mostly in $25,000 dollops. Such an indiscriminate spreading of money, while required in all government programs, encouraged the best as it also buoyed the mediocre and extended survival of the marginal. Based on NEA's assertions about supporting only "excellence," grants of even small amounts conveyed a "seal of approval," easing recipients' funding appeals to other sources: corporations, foundations, state and local arts agencies, and individuals. Reflecting the firehose approach to grantmaking so evident in the early decisions of the National Council on the Arts, and reinforced by the chairman's idiosyncratic agenda, the NEA's theater program never developed policies or priorities. One stated goal, for example, was to help "decentralization of the American Theater." Yet, of thirty-five grants totaling almost $0.5 million earmarked for this purpose during the endowment's first five years, eighteen went to the traditional hub of theater, New York City. The program director Ruth Mayleas herself stubbornly refused to leave New York, maintaining both her home and office there, commuting to Washington when necessary.[62]

The NEA's early drama program wanted to support "theaters with continuity, with an ongoing vision," said Mayleas. Initially, she decided who would get grants on her own and only later did a "buffer" of expert panels winnow applications and recommend recipients. Mayleas insisted that no institution receive money without a site visit and that the prime criterion be "artistic quality." This worthy goal inevitably came to grief in the flood of new theaters born just before and after NEA's founding. Some sprang up on college campuses and in suburbia, while a growing number of drama

graduates founded alternative companies in picturesque, isolated places like Sonora and Nevada City, California. Of 157 institutions surveyed by the Theater Communications Group in 1979, only eight had existed before 1950, some thirty-three were founded in the fifteen years before 1964, and ninety-nine in the next fifteen years. By 1975, the U.S. Census Bureau felt obliged for the first time to include nonprofit professional theater in its periodic surveys of the American economy. The figures showed 398 non-profit productions, compared with 59 on Broadway. Five years later, institutional theaters surpassed Broadway theaters in attendance. By 1982, nonprofit theaters also had surpassed the New York stage in gross income, giving three times as many performances. Act two of the tragedy of institutional theater was in full swing.[63]

Only a brief intermission preceded act three. While Broadway productions dwindled below thirty at the end of the 1980s, long-running lavish musicals and their multiple road companies kept ticket sales stable and pushed box office receipts beyond $0.5 billion. The number of road performances almost equaled those on Broadway, as did box office receipts. The financial health of nonprofit theaters peaked around 1984, when TCG reported to the U.S. Census Bureau a record 234 companies. In that year, almost 3,500 productions attracted more than 15 million people to some 57,000 performances. By 1989, productions had dwindled by one-third; while attendance grew slightly and the number of performances fell slightly, total costs had soared by 50 percent.[64]

An assortment of plagues converged in act three. One of them, paradoxically, was abundance. As college and university theater departments continued to churn out drama B.F.A.'s, M.F.A.'s, and Ph.D.'s, this surplus talent fed into a restless, marginally employed theatrical proletariat. In 1951, the number of degrees in drama was so small that it went uncounted. In the 1957–58 school year, American colleges and universities awarded 3,900 B.F.A.'s in speech and drama, 800 M.F.A.'s, and 100 Ph.D.'s. By 1964–65, there were 5,000 new B.F.A.'s, 1,360 M.F.A.'s, and 230 Ph.D.'s. In the next five years, by 1969–70, the numbers had leaped: fifteen thousand received a B.F.A.; 2,500, an M.F.A.; and 301, a Ph.D. For those with advanced degrees, there were chances for academic jobs, principally training even more theatrical talent.[65]

For those at the low end, waitressing, taxi driving, or messengering provided income while waiting for the big break. When such jobs palled or dried up, actors could rely on the government subsidy of last resort, six months or more of unemployment compensation. Seldom mentioned in

discussions of actors' and theaters' plight is that most actors earn most of their professional income from working in areas never listed in their theater credits: industrial films, trade show presentations, commercials, and television soap operas.[66]

Meanwhile, actors had also discovered entrepreneurship. The enterprising individual found a market for "performance art," a blend of storytelling, dance, and ritual, often with a strong propaganda edge. Encouraged by concessions from Actors' Equity for theaters of less than one hundred seats, small groups carved spartan spaces out of abandoned downtown industrial buildings and survived on audiences deemed unprofitable by theater unions. Greater Los Angeles, for example, had only six theater groups in 1972; two years later there were sixty-five, and by 1990, 250. As Ray Tatar, manager of the California Arts Council's Touring and Presenting Program, observed, "It seems that the national theater is not a building in Washington, D.C."[67]

As the 1980s ended, the success of resident theaters and the glut of new groups and individuals created critical strains. At the NEA, existing companies had become habituated to a particular grant amount each year, but the rush of applications from competent new companies forced serious reevaluation. Should some declining companies be de-funded? Should some grants be drastically reduced? Should newcomers not be funded, or should grants not increase as a company's quality and following rose? The day came when twenty companies were getting half the money and fifty others were squabbling over the rest. "Those at the high end felt there was no reason their money should be decreased," said Jessica Andrews, who then headed the NEA's drama program. The panels sought new ways to distribute existing funds. Their solution was an initial 10 percent reduction for everyone. Then companies were grouped by various levels of skill. The very best got their 10 percent back; the lesser ones did not. Some, whose quality was deemed to be falling, had to be cut more. The job for the panels was "painful and difficult," said Andrews, who now runs the Shakespeare Theater in Washington, D.C.[68]

By 1992, as other programs and the states' portion increased, the NEA drama budget fell by another 15 percent, forcing, as one observer put it, "a certain kind of cannibalism." Theater people looked back to a golden age when they could count on the NEA grant paying some 7 percent of total expenses; by 1992, they were glad to get half that percentage. Nor did state and local theater subsidies fill the gaps. In 1991, the New York State Council on the Arts, by far the nation's most generous, precipitously dropped its

theater budget to less than $2 million, from $4.6 million available only two years earlier. Meanwhile, in New York City, where theater is crucial to the tourist industry, the Department of Cultural Affairs was trying to fill the gap by allocating $11 million in 1992 to underwrite drama.[69]

Also worrisome to theater people in the 1990s was an epidemic of exits—from death, old age, or fading vision—by the brilliant talents who had pioneered institutional theater some thirty years earlier. Most discussed was the demise of Joseph Papp, who had built an itinerant troupe playing in New York parks and playgrounds into a multitheater empire. While scorning Broadway, he had also launched *A Chorus Line,* a bittersweet musical that, through many touring incarnations, funneled handsome profits into Papp's more daring ventures in the refurbished library on Astor Place. Financially, Papp's Public Theater was already in decline in 1990, before the founder's death. Repeated raids on the *Chorus Line* endowment for operating expenses had reduced it, within four years, from $24 million to $17 million; Papp expected a further decline to $10 million by 1994. His chosen successor, Joanne Akalaitis, appeared to hasten the downward spiral. What some (few) admired as her resolute resistance to "the Cuisinart culture"—pandering to a subscription audience she called "essentially dull people"—others (many) saw as her stubborn allegiance to obscure, boring, money-losing productions. When trustees summarily dismissed Akalaitis in the spring of 1993, her replacement was George C. Wolfe. Fresh from directing *Jelly's Last Jam,* a huge Broadway hit, he was already preparing its commercial successor, *Angels in America.* On an inevitably part-time basis, this busy man deigned to run the institution into which Papp had poured his whole life.[70]

The ructions at the Public were overt manifestations of the malaise that had been simmering inside the world of institutional theater for some years. In 1985, the Theater Communications Group had attracted two hundred theater representatives to a soul-searching symposium entitled "Taking the Next Step." Over several days, directors, managers, and trustees hashed over the "artistic deficit," a bureaucratic locution describing the decline of art when financial concerns become paramount. Some believed that subscriptions, which had once been billed as salvation from hand-to-mouth operations, had become a tyranny. Productions promised many months earlier in glossy brochures now marched relentlessly across the boards, with no chance to close failed ones or to extend the runs of hits. Others resented previews. Originally welcomed as a substitute for out-of-town tryouts, they now stole the public's and critics' attention from

openings. Still others bemoaned competition from the commercial media of film and television. There an actor's weekly salary could exceed a playhouse actor's earnings for a whole year. With disconcerting frequency, participants in the symposium longed for the legendary, perhaps mythical, shoestring days. As one artistic director said: "There are too many 'no's' now. I said more 'yeses' when I didn't have a nickel."[71]

A good many of these dour observations can be put down to the grousing endemic among creative artists. It would be difficult to find an age in all of recorded history when artists were content with their status, wages, or working conditions; when artists basked in sufficient esteem from patrons or the public; or when artists believed that they had scaled the summit of their métier, with no further, loftier peaks beckoning to their talents. In the 1960s, many arts insiders believed that such perennial grumblings could be alleviated by organized public esteem, reinforced by public grants. If only excellence could be found and properly rewarded, so went the argument, the arts would be stimulated into perpetual bloom. But even then, many artists and their friends were dubious. In 1968, the director of the Charles Playhouse Michael Murray wrote to Jules Irving, then director of Lincoln Center's Vivian Beaumont Theater, that regional theater was "becoming more and more boring." Murray was dismayed that the musty "living library" of classical plays, "tossed out years ago" by progressive directors, was "now being solidified, institutionalized, and enshrined by business managers and boards . . . the creative possibilities are diminishing . . . something drastic must be done to locate new plays and new audiences—whether that be street theater, black theater, guerrilla theater, cinematic theater or what have you." As the NEA was getting under way in 1965, the critic Stanley Kauffmann asked in *Commentary:* "Can Culture Explode?" He foresaw that "in a matter of years, very little performance will be financed entirely by venture capital, that the majority of performing groups . . . will have to find subsidized modes to exist."[72]

Not least of those modes was Broadway itself. Using government grants, nonprofit theaters became the chief venue for tryouts of Broadway-bound productions. The public funding had stimulated a creative interchange between institutional and commercial drama, as NEA's founders had hoped, but with several unexpected plot complications. One was that nonprofit theaters were taking much of the risk of new productions, while their Broadway partners were reaping the profits. Beginning in the 1975–76 season, nonprofit theaters spawned more new Broadway plays almost every year than commercial producers.[73]

In 1992, for example, the La Jolla Playhouse mounted a revival of Pete Townshend's 1969 rock opera, *Tommy*, directed by the Playhouse artistic director Des McAnuff. In 1993, a partnership that included McAnuff moved the production to Broadway, adding only $600,000 in "enhancement funds" for the transition. Not only did the Playhouse gain only minimal income from the Broadway production, touring companies, record spinoffs, and possible Hollywood royalties, but it also lost McAnuff, now Broadway bound. Despite such cavalier treatment, each year more nonprofit theaters funnel productions that their contributors and grants have subsidized into commercial channels. Robert Brustein, who pioneered nonprofit theater at Yale and now directs the American Repertory Theater in Cambridge, Massachusetts, deplored the "homogenization of the non-profit stage" in 1990, when August Wilson's *The Piano Lesson* became a Broadway hit after two years on the nonprofit circuit. He observed that institutional theaters were taking fewer risks with experimental plays, as their directors sought artistic fees and even producers' shares in commercial productions. Some nonprofit theaters were creating profit-making subsidiaries to enable them to reap earnings without endangering their tax-exempt status. In 1992, eight nonprofit productions made the transition to Broadway, worrying commercial producers about subsidized competition.[74]

Such future possibilities had been swept aside in the euphoria over getting the government directly involved with funding the arts. By June 1966, the new agency had eleven programs to aid various disciplines. The council meetings had attracted such distinguished visitors as Lukas Foss, George Kennan, Yehudi Menuhin, W. McNeil Lowry, and Robert Motherwell. Also present at one or more meetings were the deans of the schools of fine arts at Penn State, Boston University, Yale, the universities of Arizona, New Mexico, and Texas, and Carnegie Tech. These schools were prominent among the institutions of higher learning that poured tens of thousands of graduates into the performing and visual arts, a glut that no funding system could possibly absorb.[75]

Nevertheless, the NEA leadership and its supporters were convinced that many Americans were still deprived of first-rate art. In a 1966 article, Roger Stevens noted that while the United States had 1,400 symphony orchestras, 5,000 community theaters, and several hundred opera and ballet companies, most of them "lacked a sustained quality of performance and were insulated from . . . exposure to high standards of excellence." Only one in five residents of cities with more than 25,000 people could

hear a professional orchestra or see a professional theater performance; one in seven could watch a professional dance performance; and only one in nine could attend a professional opera. To fill such gaps, Stevens recommended more money for touring, and many agreed. The futurist Alvin Toffler expected that more access to the arts would spawn a mass audience, similar to that created for literature by the advent of universal literacy and inexpensive reading matter.[76]

To promote such access, Congress had instructed the NEA to give each state $50,000 to study the feasibility of setting up an arts council. Once established, the council would be funded equally by the state and federal governments. Stevens's acute political antennae sensed a fresh opportunity to build the arts constituency nearer the grass roots. To that end, his assistant Charles Mark, armed with wads of air travel vouchers, set forth "on an odyssey," he wrote, "that made Ulysses' wanderings seem like a day trip to Disneyland." Mark admits that he exaggerated at will. He would tell leaders in one state that the adjoining state had already decided to form a council. "If they agreed to try legislation," he wrote, "I would go back to that adjacent state to tell the same story, but with more credence." By the end of his first year on the road, Mark had persuaded forty-five states (out of fifty-five eligible states and territories) to form a council. Some liked the idea of 50,000 extra federal dollars, while others responded to pressure from local cultural leaders, a group that frequently included owners of local media and invariably involved important political contributors. Mark "was out there pushing, cajoling, stretching the truth, and persuading the political leaders, and strategizing with the cultural forces in every state." He found a receptive audience, since "the sons and daughters of the ruling classes on the local level wanted more for their children than three opera productions a year and five symphony concerts." By 1966–67, states were giving more than $2.6 million for the arts: Thirteen states had arts councils and applied for up to $50,000 in federal matching funds; another thirteen states asked for $25,000 study grants to prepare for full programs the following year; and twenty-eight states expected a functioning council before the year was out and wanted combined study and program funds.[77]

While most federal programs distribute funds to states on the basis of population, the endowment's money was (and continues to be) spread equally among every state and territory. This meant that in 1967, for example, Puerto Rico and the District of Columbia each received just under $50,000, the same amount as New York and California; West Virginia got $46,400, while Illinois made do with $37,000. While the rhetoric over bring-

ing truth and beauty into every hamlet rang through statehouses from coast to coast, more covert non-art motivations carried the day. Consonant with Americans' pragmatic bent, the arts were sold as satisfying not only the soul but also many practical considerations. In New York, the emphasis was on providing a livelihood for hordes of artists and on attracting even larger hordes of tourists. Elsewhere in the northeast, the arts were to help lure suburbanites back to the central city. In the midwest, the arts were expected to keep educated young people from migrating away from declining farm towns and to attract professionals and industries. In the Sun Belt, the arts were part of the rambunctious local boosterism that also lusted after major-league sports teams. In Indiana, the chairman of the state arts council, an elderly newspaper publisher, saw arts promotion as gainful employment for his equally elderly mistress. Named as the council's executive secretary, this lady submitted funding applications to Washington adorned with Valentine paper lace, cute little hand-drawn angels, and busy bees.[78]

Once established, state arts councils generated a kaleidoscope of artistic initiatives. Connecticut blew a whole year's budget on bringing Martha Graham's modern dance company to Bushnell Memorial Auditorium in Hartford and then had to scramble for private contributions to make up the deficit. The Maryland Arts Council persuaded a local bank to sponsor a statewide tour for the Baltimore Center Stage Theater. The thrifty Missouri Arts Council signed up seven corporations to help publish its forty-page annual report. In Iowa, the council found a utility company to be patron of a fifteen-county tour of two art exhibitions. The New Hampshire council used $12,000 to publish 150,000 copies of a booklet promoting the state to industry. So influential had the arts constituency there become that a determined group of artists and arts managers beat back the legislature's attempt to abolish the arts council. In New York, a threat to cut 5 percent from the state council's budget in 1969 prompted formation of the New York State Performing Arts Association, "the opening shot," wrote one observer, "in a demonstration of arts power which was to reach bombardment proportions." Amyas Ames, then chairman of Lincoln Center, recalled those marches on Albany: "We would get out there on the [Lincoln Center] Plaza for a bus at 7:30 in the morning." Among the chilled advocates was the former Museum of Modern Art president Blanchette Rockefeller, whose husband, John, headed Lincoln Center. "We'd all pile in," said Ames, "Blanchette and thirty or forty others, and be driven to Albany. That's a long, hard day's work."[79]

By then, many arts advocates realized that each discipline's needs far out-

stripped even the rosiest fantasy of future NEA funding levels. In 1970, when the budget was still less than $10 million, Roger Stevens suggested that $5 billion would be a plausible amount. "This would finance building of museums, performing arts centers, and other necessary facilities throughout the country," he wrote in the *Saturday Review*, "and provide sufficient subsidy to enable everyone who wishes to participate in some artistic endeavor to do so." He envisioned a sweeping laying on of benign hands in behalf of every imaginable arts-related endeavor: education, urban design, audience development, management, international exchange. These generalized policy goals mirrored the council's erratic grant awards, a scatteration of balms applied without any sense of priority or strategy.[80]

From the agency's beginnings, brave words about the sacred nature of the arts had obscured the black hole where policy might have resided. By 1968, the U.S. Bureau of the Budget was insisting that the NEA, like every other government program, define its objectives. Trying to comply, Stevens's aide Charles Mark kept formulating goals and Stevens kept brushing them aside. As the budget people pressed him, Stevens finally agreed to justify each grant under such vague objectives as "aid to artistic institutions . . . wider distribution of the arts . . . and aid to individual artists," goals so broad, Mark wrote, that "we never had any trouble deciding where to place each [grant]." When Mark was asked by UNESCO (the United Nations Educational, Scientific, and Cultural Organization) in 1969 to write a paper on American cultural policy, he declined, because in four years at Stevens's side, he wrote, "I had seen no evidence of a cultural policy of any kind." But the UNESCO official insisted that a policy existed; he called it "pluralistic laissez-faire."[81]

Nebulous as this policy was, it was sufficient to establish the government as a new patron for the arts. With official honors for outstanding artists, with emergency aid for strapped cultural treasures, with combat on the Cold War's cultural front, with many pious statements about the spiritual values of art, public funding at the federal, state, and local levels had consolidated the traditional arts constituency. As arts councils proliferated in each state and in many localities, legislators began to understand the uses of the arts outside the concert hall and far beyond the proscenium arch. With federal expenditures for 1969 of less than $8 million, politicians recognized that supporting the arts reaped an astonishing harvest of good will among people who mattered. As opposition waned, the investment of more government money promised even greater returns.

4

THE NUTCRACKER

LESS THAN A YEAR after the NEA got under way, in 1966, Roger Stevens envisioned the agency's work ending fairly soon. Once it had helped local presenters assemble subscription series and sparked an interest in the arts within the soul of perhaps one American in ten, he wrote in the *Saturday Review*, "the need for federal support would largely disappear." The endowment then would provide only nominal "seed money" to promote artists' training, commission new works, allow arts teachers more creative time, educate critics, and help state and local arts agencies find their own resources.[1]

Only a year later, NEA leaders described to a congressional reauthorization hearing how the agency could prudently spend more than $148 million. With Lyndon Johnson's budget calling for just $10 million, Livingston Biddle and Charles Mark painted a dream scenario: giving the arts "a television dimension," creating handsomely equipped communal foundries for monumental sculptors, starting a national magazine of arts criticism, organizing a national design institute.[2]

Little did Biddle and Mark imagine that within a decade their pipe dream would become a reality—and more. The windfall would come from the unlikeliest source of all, a Republican president whose last known involvement with the arts had been in the glee club and a few student theater productions while he was an undergraduate at Whittier College in California. The Republican platform in 1968 gave no hint of what was to come. Its only reference to the arts and humanities was ominous: Both

"will continue to thrive so long as the deadening hand of the Federal bureaucracy is kept from the palette, the chisel, and the pen." After the election of Richard M. Nixon, Roger Stevens tried to obtain reappointment as the NEA chair, even though he had contributed to Hubert Humphrey's campaign, and was curtly rebuffed. "He chose to be political, and he picked the wrong side," Nixon's arts adviser Leonard Garment told Stevens's emissary, Michael Straight.[3]

Months went by as the new president struggled to extricate more than half a million American troops from bloody engagements in Vietnam. Campuses were boiling over with violent demonstrations against the war; appointing a leader for a tiny agency with a budget under $10 million could wait. From the very beginning, however, the endowment had attracted attention far beyond its picayune budget. As the Lincoln Center chairman Amyas Ames bluntly put it, "People who love the arts are also successful in their communities—they make money. It is they and their friends who are the contributors to politicians. Politicians are . . . responsive to people who are successful." Based on such a frank equation, Washington's favorite parlor game finely minced a host of delicious candidates to chair the endowment. John D. Rockefeller III, still burning from his encounters with the composer William Schuman at Lincoln Center, did not care for further exposure to artistic temperaments. Nor did the job interest John Hay Whitney, an art collector, a generous contributor to New York's Museum of Modern Art, and an enthusiastic investor in Hollywood films and studios. The speculations swirled briefly around John Walker, the recently retired director of the National Gallery, but he was considered too old. Thomas Hoving, the aggressive director of the Metropolitan Museum of Art, was urged more than once to take the job by the Nixon aide Peter Flanagan. Warned that he would have to curb his tactless tongue, Hoving declined, bristling that Flanagan "sounded like a [Nazi] *gauleiter.*" The Metropolitan Museum president Douglas Dillon was also mentioned; he had been Kennedy's secretary of the treasury and was chairman of the Business Committee for the Arts.[4]

Summer came, and a prospective chair at last made a round of courtesy calls preliminary to an official announcement. He was Morton May, a St. Louis department store magnate and the nation's leading collector of German Expressionist painting. May, nicknamed Buster, expected to divide his time among his business, the NEA, and his favorite charity, the Boy Scouts of America. At this prospect, Senator Claiborne Pell exploded. "I pick up this telephone two or three times a week to call the chairman of the Arts

Endowment," he snapped at Michael Straight. "And when I call him, I want him to be in my office in twenty minutes." Pell apparently forgot that Roger Stevens had worn enough hats during his NEA tenure to stock a small millinery museum. Garment then leaked the possibility of Michael Straight to the *New York Times*. This raised the hackles of the New York senator Jacob Javits, whose wife was an actress and favored John Walker. To help with the search, Garment enlisted Straight, Stevens, the New York attorney Charles McWhorter, and a vivacious dynamo of a woman, Nancy Hanks. Laboring over lists of prospects, the searchers one day "looked around," recalled Garment, "and there in our midst, like Poe's purloined letter, was Nancy Hanks. 'Not me,' she protested. 'Yes, you,' we insisted." Michael Straight, whose family trust was handled by Garment's law firm, became deputy chair.[5]

Though Pell doubted that she was qualified, the Senate handily approved Hanks's appointment. Eight months into the Nixon presidency she took office, with the coming fiscal year's budget due in just twenty-six days. Meeting with Hanks in California soon after her confirmation, the president assured her of support but was vague about details. The president had given no hint that the arts were on his mind. While he often appeared at the ballpark posing as a fervent baseball fan, Nixon's only gesture toward culture had been a hastily organized White House party to celebrate Duke Ellington's seventieth birthday; it was intended more as a sop to the black community than as a tribute to the arts. Then, suddenly, toward the end of 1969, the Nixons discovered culture. Beverly Sills sang at the White House. The presidential couple attended a Philadelphia Orchestra concert honoring the conductor Eugene Ormandy, and they appeared at an opening of the Pennsylvania Academy of Fine Arts. In December, Nixon not only recommended a three-year extension of the National Foundation on the Arts and the Humanities but also that its budget be doubled.[6]

The architect of this turnabout was one of the few men Richard Nixon ever trusted. The son of Jewish immigrants, raised in Brooklyn amidst what he later called "a commotion of cultures, an outpouring of novelists, poets and songwriters, jokesters, jugglers, and artists of every description," Leonard Garment seemed a most unlikely candidate for Richard Nixon's confidence. As a youth, he had been active in the Young Socialist League; he worked his way through law school by playing the clarinet in Woody Herman's band. When the two men met in 1963, Garment was a Democrat, head of litigation at the Wall Street law firm of Mudge, Stern, Bald-

win and Todd. Nixon was the new senior partner, fresh from his defeat
(and his subsequent embarrassing public tantrum) in a race for governor of
California. Though seemingly opposites, the two men had much in com-
mon: Both came from extremely modest homes, growing up on the fringes
of a powerful metropolis; both worked extremely hard to realize their
ambitions; both relished the exercise of power; and both were occasionally
taken aback by how far they had come. A stranger to New York, ensconced
in the hushed luxury of a firm exactly like the one that had turned him
down after his law school graduation, Nixon felt uneasy. He was intimi-
dated by Garment's easy familiarity with New York's cultural milieu. Gar-
ment assured the new man that his colleagues were more in awe of a
former vice president and presidential candidate than Nixon was of them.
Guided by Garment, Nixon found his way in the law firm. The presidency
was still a possibility, Garment told him.[7]

As the Nixon administration gathered its troops after the election, Gar-
ment moved to his firm's Washington office. The lure of power proved irre-
sistible when the president asked him to become "the Republican Clark
Clifford." In that role, Garment smoothed the president's relationships
wherever they might be frayed, whether recruiting minorities for the
administration, initiating cordial communications with Israel's new prime
minister Golda Meir, or brokering a bloodless resolution to the armed con-
frontation between government agents and Native Americans at Wounded
Knee.[8]

A quarter-century later, Garment still plays a central role in that
almighty bipartisan village on the Potomac of perhaps two thousand souls:
movers and shakers, political potentates and pundits, seekers, leakers, the
canny grand masters of the political chessboard. This community's life-
blood is gossip, a commodity in which Garment trades astutely and without
guilt. Charming, outspoken, quick witted, Garment describes himself as "a
manic-digressive," and the proof lies heavy upon the several desks and
tables in his office, each groaning under piles of papers and books. His
business is not done there, a visitor suspects, but rather in a padded coun-
try rocker next to the telephone. For Nixon, he says, "I ran errands; I car-
ried messages," and long after Nixon's departure he continues to play that
part, a snowy-haired, bespectacled Mercury, messenger of the gods.[9]

To the man he had propelled toward the presidency, Garment proposed
a startling departure. "It struck me as politically wise," he said, "to build up
the Endowment." In a long memo outlining a response to Nancy Hanks's
plea for more funding, Garment urged Nixon to approve her request for

$40 million. Such an eightfold increase over Stevens's budget, he wrote, "would have high impact among opinion formers. . . . Support for the arts is, increasingly, good politics . . . you will gain support from groups which have hitherto not been favorable to this administration." Beyond the "hardcore radical critics" who urged more arts funding, Garment pointed out, stood "the vast majority of the theatre board members, symphony trustees, museum benefactors and the like." He reminded the president that arts boards "are made up, very largely, of business, corporate, and community interests." Garment says Nixon went along because he "liked to surprise people. . . . Like 'Mr. No Taste' becoming a godfather to the arts. It was one-third politics, one-third substance, and one-third irony." Garment explained to Nixon that a huge increase in arts funding was essential because "the key is in the headline. Doubling won't do when the money is peanuts—a bag of peanuts becomes two bags of peanuts." But an eightfold increase would make headlines.[10]

On December 10, 1969, Richard Nixon asked Congress to approve $40 million for arts and humanities for fiscal year 1971. Touching on the Cold War theme, he called culture a tool of democracy; while government must avoid forcing the arts into "some common denominator of official sanction," the NEA had "the rare capacity to help heal divisions among our people and to vault some of the barriers that divide the world." In contrast to Garment's internal memo, which stressed the elite leadership in the arts, Nixon emphasized the broad audience reached by the agency's clients: "from ghettos in Watts to the White House."[11]

At her swearing in, on October 6, 1969, Nancy Hanks emphasized a similarly populist vision. "It is part of the essential idea of our country that the lives of the people should be advanced in freedom and in comprehension of the tough and soaring qualities of the spirit," she said. "This is not possible without the arts. They are not a luxury; they are a necessity." On the other hand, she also mentioned the crasser burdens loaded again and again upon the arts' spiritual mission: fostering urban tranquility and promoting economic development. How even a far more generous budget could cover the agency's primary function—encouraging excellence in the arts—while also dealing with deep social and economic problems remained unclear.[12]

Nevertheless, the NEA had already injected itself into such peripheral endeavors. Following riots in Watts and unrest bubbling in other inner cities, the NEA had hastily developed plans to spread $400,000 among sixteen cities for ghetto arts programs during the summer of 1968. The funds

would have to be matched locally two to one. Unlike previous programs
that had sponsored single appearances by Aretha Franklin, Sammy Davis,
Jr., and Count Basie, these new endeavors were to encourage indigenous
talent. As even admirers conceded, such programs were often amateurish
and short lived. While the money helped support the black professional
artists who managed them, the participants were largely nonprofessionals,
and their goals were more social or recreational than artistic. Still, the
urban establishment was terrified of further racial unrest and tried to gain
additional support for these programs. Douglas Dillon, the chairman of the
Business Committee for the Arts, urged corporations to get involved in this
effort, which was "essential in handling the crisis of our cities." The arts, he
believed, could help "rid our society of its most basic ills—voicelessness,
isolation, depersonalization—the complete absence of any purpose or rea-
son for living."[13]

At the other end of the social scale, the well-off trustees and patrons of
elite arts institutions openly expressed what Lincoln Center's organizers
had conveyed only as a shadowy subtext: that the arts were a crucial part of
urban economies. Indeed, the presence of Lincoln Center had by 1980
triggered $1 billion in new construction, giving the Upper West Side fresh
prestige as a place to live, to shop, and to eat. Some $3 billion were flowing
into New York City's economy from the 25 percent of all tourists who vis-
ited the city for cultural reasons. In San Francisco, where in 1967 the city
was subsidizing cultural attractions, principally museums, to the tune of
$3.6 million, Mayor Joseph Alioto delicately told an interviewer: "The arts
give a flavor or a luster which is important to the personality of a city." In a
book devoted to encouraging corporate support for the arts, the ARCO
chairman Robert O. Anderson suggested that a business that neglected
"the cultural environment of the communities in which it has plants or
offices" would have difficulty attracting superior employees. When the
NEA came up for congressional reauthorization in 1973, traditional arts
advocates were reinforced by lobbyists for major cities, all asserting that
government-supported art was vital to their economies.[14]

Because a vibrant local economy is also critical to the health of local
media, their owners and executives often stepped outside journalistic
aloofness to participate directly in managing arts institutions. The *New
York Times* publisher Arthur O. Sulzberger, for example, for many years
served as a trustee and president of the Metropolitan Museum of Art. The
president of Capital Newspapers, which owns dailies around Albany, New
York, not only saw to it that the papers gave ample coverage to the arts but

also was a major fundraiser and president of the nearby Saratoga Performing Arts Center. In Louisville, Kentucky, the Bingham family, publishers of both local dailies, not only provided generous funding for local arts but also executives to serve as board chairmen, presidents, and trustees. In Alaska, Northern Television's outlets in Fairbanks and Anchorage "virtually function as the promotion arm of community cultural organizations," wrote one ardent advocate of corporate involvement in the arts in 1971. The company's president was on the Alaska Council on the Arts and had "been especially effective in keeping the Governor's office and state legislators informed about the contributions of the arts, their financial needs, and the direction of help that must be given by both government and business." In Denver, the publisher of the *Post* was instrumental in the development of a large new performing arts center. The endowment's advocates frequently played the media card. The architect of NEA's founding legislation, Livingston Biddle, reminded the White House that, although the arts constituency included few voters, it had considerable prestige. "It shaped opinions and was responsible for editorials."[15]

Along with Leonard Garment, no one was more sensitive than Nancy Hanks to the uses of economic and social agendas in promoting the arts. An arresting blend of Southern belle, meticulous manager, and tough power broker, Hanks is still revered as the NEA's most successful chair. The daughter of a striving father and an angry, strident mother, Nancy constantly had to reach out for new friendships as her parents restlessly moved on, from Florida to New Jersey to Texas. Her father, Bryan, earned a comfortable salary as a utility company lawyer, enough to provide the family with its only real home, a summer place at Cashiers, in the mountains of North Carolina. Outward appearances rather than substance motivated her parents, and their daughter in many ways followed this pattern. Thus, she would telephone or write to her parents every day of her life, but seldom spent much time with them. She loved Cashiers but would usually visit there in October, after her parents had left.[16]

At Duke University, Hanks threw herself into social life. Pressed by her parents, she prized sorority membership when its importance was already declining and made it a rule to say hello to every student on campus. The freshmen elected her their representative to student government, where she also served as treasurer as a sophomore. As a junior she became house president for her sorority, and in her senior year was elected president of the student government. Yet "she never identified herself with the major issues that faced her contemporaries, as southerners, as whites, as women,

as Americans," wrote her biographer, Michael Straight. "It was a pattern that persisted throughout her life." An indifferent student, Hanks was uninvolved in the battles against McCarthyism and racial segregation that dominated political life during her college years. Neither did she have any interest in the arts or much direction for a future career when she graduated in 1949. "When I left Duke," she said, "I never gave a thought to what I might be twenty years later."[17]

Like her father, who depended on personal contacts to advance his career, Hanks was adept at grasping the coattails of the powerful. In 1951, she was hired, with her father's help, as a receptionist in Washington's Office of Defense Mobilization. Though her typing was incompetent, her well-groomed good looks and ebullient personality captivated her colleagues. Two years later, she wrote in her nightly letter to her parents: "Mr. [Nelson] Rockefeller in today and he surely seems to be a very nice man." It was an encounter that would shape the rest of Nancy Hanks's life.[18]

Glued to the dapper millionaire, Hanks became his confidential secretary as she followed him through a maze of Washington posts bearing weighty titles but questionable power: chairman of the president's Advisory Committee on Government Organization; assistant secretary at the newly organized Department of Health, Education and Welfare; special assistant to the president for Cold War strategy. Nancy and Nelson worked together long and late; they traveled to the 1955 Khrushchev-Eisenhower summit in Geneva, and Nancy, at least, fell hopelessly in love. Nelson was forty-five years old, an unhappily married man with five children. Hanks was twenty-five, so enchanted with her lover that she mended his socks, baked his birthday cake, and paid for lunch when, as usual, he had no cash in his wallet. Nelson showered her with gifts, including airline tickets, drawings and etchings by Degas and Picasso, and a $200,000 securities portfolio. Her parents briefly questioned Nancy's romance with a married man, but they came around after Nelson paid $5,000 to dam a creek in Cashiers, then sent along a canoe and motorboat to ride around the resulting lake.[19]

Though the romance ended abruptly and, for Nancy, tragically in 1955, Hanks continued as a creature of the Rockefeller family. In 1956, Nelson summoned her to New York to be a key staffer (along with Henry Kissinger) for the Special Studies Project, financed by Nelson with $1 million from the Rockefeller Brothers Fund. The resulting grand plan for the American future, as drawn by one hundred notables working for four years, was to be the catapult hurling Nelson into the presidency, if not in 1960 then surely in 1964 or 1968. After Nelson was elected governor of

New York in 1958, Hanks moved to Albany, running glorified errands for him while on loan from the Rockefeller Brothers Fund. When a press adviser abruptly told Nelson, "Get her out of here . . . if you have political aspirations," Nancy was shipped back to New York. For the next ten years, as Nelson divorced and remarried and as she underwent a mastectomy and hysterectomy, Hanks's workaholic style and lack of entrenched ideas bene-fited various Rockefeller family projects, most notably in her role as the architect of the 1965 Rockefeller report formally titled *The Performing Arts: Problems and Prospects.*[20]

The Rockefeller report envisioned a negligible role for government in funding the arts, secondary to foundations, corporations, and individuals. Washington might set "a national tone of interest in and concern for the arts," foster cooperation among various government agencies, and "study our cultural growth in broad, long-term perspective," the report suggested, while the states should sponsor arts touring, and localities promote arts in education. While these ambiguous recommendations hardly provided a blueprint for Hanks's tenure at the NEA, they neatly matched the policy void she inherited from Roger Stevens.[21]

Like Stevens, Hanks possessed endless energy and unlimited appetite for hard work. But unlike Stevens she had no other responsibilities; the endow-ment was her sole domain, her political sphere, her family, and, some said, her obsession. Cheerful in adversity as in triumph, Hanks would seize any occasion, perhaps a successful congressional hearing, to throw a staff cele-bration. At Christmas, the office party sometimes featured the Grants Office Players in a skit written by a staffer who later became a playwright. On the other hand, Hanks demanded a tight ship. She made frequent sur-prise tours of the building to check on staff efficiency, knew the name of each employee, and insisted that phones be answered within the first three rings. To a young assistant in the visual arts program, Renato Danese, "she was magnetic . . . a presence. . . . Everybody had a crush on her."[22]

All over official Washington, Hanks exercised her talents for captivating important people. Meeting with a crusty critic, Senator Jesse Helms, Nancy "didn't bother with the facts," one associate recalled. Instead, "she would gush, 'Oh, Jesse, what a nice belt buckle,' and then she'd romance him about the belt buckle." If Helms had a complaint about an NEA grant, she would bring out her Southern accent and burble: "Gosh, the kids have gotten a little out of line with this. But we'll fix it." With congressmen, Hanks seldom dwelled on what she called "the great philosophical impor-tance of the arts"; rather, she recalled, "we did our homework. If we were

talking about Canton, Ohio, we knew what we were talking about . . . the Congressmen got the feeling we knew our business—that arts were business. When members got home, they heard about it." Every congressman whose vote was needed heard from important, supportive constituents.[23]

One of Hanks's cleverest allies was Jack Golodner, a labor lawyer whose Washington experience extended back into the 1950s, when he worked for a Democratic congressman from Connecticut, Robert Giaimo. Like many congressional aides, Golodner became a lobbyist, Washington's first in behalf of the arts, after leaving Giaimo's office in 1962. An early client was Actors' Equity, and Golodner, who is not easily awed, says he was impressed to meet the union's president Ralph Bellamy. After the NEA was established, Golodner was retained by the American Council for the Arts, a group, he says, that was initially "appalled at having a lobbyist." But the organization soon appreciated the services of a professional, an insider who provided a detailed loose-leaf manual on the fine art of Washington advocacy.[24]

"We had people in every state," Golodner recalled. "We had a telephone tree to mobilize letters and calls," and a newsletter, "Word from Washington." With Hanks, Golodner formed a new organization, the National Committee for Information on the Arts and Humanities. "She understood coalitions," said Golodner, "the need to get out of the deadly circle of the arts people, a circle that gets smaller and smaller." To that end, he suggested working with lobbyists for the 4-H clubs, the Boy Scouts and Girl Scouts, the Catholic Conference, and the AFL-CIO, organizations whose membership totaled some 60 million. Golodner and Hanks persuaded the boards of these organizations to support the endowment, once demonstrating the benefits by sending a troupe of actors to entertain at a Boy Scout jamboree. In lobbying Congress, said Golodner, "our effectiveness was in showing how arts money affected not just the arts but the whole community."[25]

This grand design of involving whole communities in the arts had fascinated advocates well before the NEA's beginnings. But the actual audience in the concert hall or theater remained stubbornly homogeneous. No matter how many schoolchildren were "exposed" to the arts, no matter how many low-priced tickets were given away, only those near the upper levels of income and education were drawn to more than an occasional visit to, perhaps, yet another Yuletide performance of *The Nutcracker*. In one such outreach experiment, the Meadow Brook Theater at Oakland University in Rochester, Minnesota, gave more than 800 couples free tickets to a seven-

play season. All agreed to attend at least one play, but only 765 did so; an average of only 133 attended any one play. In the following year, all 800 were to pay one-third of the ticket price; in the two following years, the price would rise to two-thirds, then the full amount. By the third year, only 93 couples were willing to pay two-thirds of the normal series price. Analysis of this study showed a direct correlation between interest in attending theater and a high level of education. Nevertheless, participants did not view a theater visit as an aesthetic or educational event but rather as a social experience.[26]

Even among affluent, well-educated Americans, the craving for frequent encounters with the arts remained sporadic. Development workers at Minneapolis's Guthrie Theater found, for example, that engineers typically were not interested in its offerings. A Ford Foundation survey during the early 1970s discovered that while 96 percent of respondents had seen a movie in a theater or on television during the previous year, only 31 percent had seen a play, only 16 percent had seen a live professional performance, and only 10 percent had seen more than one play. While 60 percent had been "exposed" to a Broadway musical, only 18 percent had seen a live professional production, far fewer than the 25 percent who had attended at least one live professional performance of jazz, rock, or folk music. Even more select were the audiences for live symphonic music, 10 percent; opera, 4 percent; and dance, 4 percent.[27]

To brighten this dismal picture, the NEA and its grantee the Associated Councils of the Arts sent forth Louis Harris, in the guise of the National Research Center of the Arts. By cunningly mingling arts and entertainment, the Harris pollsters unearthed startling new figures about the average American's aesthetic orientation. Almost half said they "go to see things like art shows, museums, historical houses, or antique, craft, or furniture exhibitions." This proportion showed, the survey trumpeted on page one, that visual arts activities attract more Americans than do spectator sports. Almost as many respondents reported that they attend theater, movies, ballet or modern dance, opera, the circus, or other pageants. Some 43 percent reported engaging in creative activities such as photography, painting or sketching, woodworking, and weaving. Given the deliberate mingling of serious arts with frivolous pastimes, it was no surprise that 37 percent of Americans "attend musical performances such as rock, jazz, folk, symphony, or chamber music concerts."[28]

When asked about attendance at specific arts events, Harris's respondents revealed less than passionate interest in anything approaching

serious art. Only 9 percent had attended a live dance performance during the previous year, 28 percent had seen a concert or opera, and 33 percent had been to the theater. Of those who had gone, many went just once. Museum attendance had also been sparse, even when the categories were generously broad: twenty-six percent had partaken of two or more visits to an art museum, 22 percent had been drawn to a science or natural history museum two or more times, and 30 percent had gone more than once to a history museum or a historic building or site. Even given the survey's broad definition of the arts, large segments of the American population expressed disinterest in attending arts events. Among rural dwellers, 37 percent never went, and 30 percent of city folks were also absent. In the South, 51 percent never attended. These figures compare with only 10 percent who reported attending frequently. Even with the distorting inclusion of rock and folk concerts, movies, furniture shows, and Broadway musicals, absentees outnumbered frequent attenders in every subcategory except sixteen- to twenty-year-olds (the typical rock concert audience), college graduates, and the highest income group.[29]

The survey reinforced a paradox uncovered by many other public opinion studies: Americans venerate the arts much as they do religion, even though they seldom attend or participate. Almost 90 percent of Harris's respondents agreed that cultural facilities were "important" or "somewhat important" to the quality of life in their community; some 80 percent agreed that the arts played a role of some importance in the local economy. More than half the public expressed "a great deal of respect" for professional musicians, and almost half for painters and sculptors. But no amount of linguistic legerdemain could conceal the fact that relatively few respondents favored government funding for the arts. While more than 60 percent approved of public funding for libraries and parks, and 40 percent agreed that tax money should help zoos and art museums, backing for subsidies to performing arts dropped precipitously: to 16 percent for symphony orchestras, 12 percent for noncommercial theater, and 11 percent for dance and opera.[30]

How to keep the money flowing to such revered but relatively unpopular arts has challenged the ingenuity of many friends of public arts funding. The survey confirmed that Hanks was on the right track when she emphasized the non-art aspects of the arts: their contributions to "quality of life," the boost they provided to urban economies, the reverence they evoked even in those who never attended, and the political clout of the few who often did. She buttressed her early requests for massive funding increases

by channeling most of the new money to museums and symphony orchestras, the groups best organized to apply pressure in Washington. They would "enthusiastically support" giving the endowment $40 million, Hanks wrote the president in 1970. "I believe we have . . . a strong constituent waiting in the wings." Meanwhile, Hanks stirred up excitement in the field by visiting orchestra and museum boards to chat about what they might do *if* she got the money. The message was clear: Call your congressman. The message was also wildly successful; NEA funding leaped by 1,400 percent during Hanks's eight-year tenure. The perpetual pressure from arts-minded constituents converted even such fiscal misers as Senators Barry Goldwater and John Tower.[31]

NEA's expanded budgets amply rewarded the agency's staunchest supporters. Museums received nothing in 1970 but more than $9 million in 1974. Music was budgeted for $2.5 million in 1970 and more than $16 million four years later. The agency's other programs also received more generous amounts, but not of windfall proportions. To counter complaints that the endowment was favoring the nation's wealthiest and most elite arts institutions, Hanks encouraged such "populist" initiatives as launching a new program in folk arts, adding jazz to the music program, spending a good deal of the visual arts budget on sculptures to enhance downtown areas, and scattering funds among pottery workshops, street theater groups, totem pole preservation societies, graffiti artists, and professional clowns. To calm critics who saw elite organizations collecting the bulk of NEA's funds, spending on inner-city arts programs was formalized into a new program, code-named Expansion Arts. This was the first departure from organizing the endowment's programs by discipline. Within three years, the Expansion Arts budget expanded sevenfold, from $1.1 million for 68 organizations in 1972 to $7.4 million for 293 organizations in 1974. By the end of the 1980s, Expansion Arts was receiving only 5 percent of the endowment's program funds but was spreading it among 435 recipients.[32]

So tangled is the web of government programs that Congress and the president might well have been convinced that only more money for NEA could keep the arts in America from expiring from acute starvation. In fact, many other agencies had programs that benefited arts organizations and artists. In 1967, a report from the U.S. Office of Education described 120 federal programs that gave money and services to artists. A 1971 survey by the Associated Councils of the Arts located 182 arts-related programs spread through twenty-six federal agencies and departments, among them the Social and Rehabilitation Service of the National Institute of Mental

Health, the Department of Labor, the Department of the Interior, the Small Business Administration, and the Atomic Energy Commission. "A demonic cultural grantsman," wrote one observer, "might uncover scores of pragmatic ways" to get government funding. The possibilities ranged from arts facilities built on urban renewal land to the State Department's foreign cultural touring program. One of the biggest programs, Title I of the Elementary and Secondary Education Act, provided $41 million for art, music, and other cultural programs for educationally disadvantaged children in low-income areas. The money was there, but finding it required expertise. When New Haven's Long Wharf Theater hired a development director in the late 1960s, she found so many ways to get public money for bringing in the elderly, adult literacy students, and poor children that she earned her year's salary in two weeks.[33]

As the government intruded into the finances of arts institutions, other regular contributors faded. Chief among them was the Ford Foundation, which had invested hundreds of millions of dollars to promote professionalism in the performing arts. By 1972, the foundation was instead moving into other fields and committed relatively small sums to reverse the persistent atmosphere of crisis in arts organizations. Nor did arts organizations themselves maintain the comparatively high levels of box office income they had achieved in 1965–66, when the endowment began. By 1973–74, as NEA grants had grown from mere tokens to substantial sums, theater ticket receipts dropped from 68 percent of total budget to 52 percent; opera ticket revenue fell from more than 50 to less than 40 percent; symphony ticket income sank from 38 to 30 percent; and dance company ticket income fell from 42 to 27 percent. Part of this reduction no doubt came as total budgets rose, but the development of new public funding sources at all levels of government relieved some of the pressure, especially on prominent arts organizations, to become self-supporting.[34]

An amusing side effect of the bonanza reaped by NEA was that its sister agency, the National Endowment for the Humanities, was showered with a comparable windfall. The original legislation had envisioned two wise, benevolent patrons cooperating in laying public money upon all manner of worthwhile ornaments to American culture. The reality locked two cliques of competing, bickering cultural mandarins within a single appropriations cage. There was so much infighting, said Richard Hedrich, who briefly supervised grants at NEA before moving to NEH, that only three joint grants were ever given. Unlike the National Council on the Arts, which was dominated by arts stars, members of the National Council on the Humani-

ties were mostly academics. "There was constant worry about popularization," said Hedrich, "anything that would compromise the sanctity of the humanities."[35]

Under its founding chair, Barnaby Keeney, the NEH had directed its modest grants mostly to universities, where the prestige of humanities professors suffered from the inability to bring home grants comparable to those attracted by their science colleagues. Keeney was a medievalist who had been president of Brown University. In 1965, he had led the unsuccessful effort to subsume government arts funding under a single humanities endowment. As the NEA gathered media attention, the NEH languished in the murky shadows of arcane academic disputations. Many of its original supporters wanted to help universities, while more experienced Washington hands studied the membership of the congressional subcommittee dealing with its appropriations and found most members came from small western states with few large universities. "One group wanted to subsidize a profession," wrote Ronald Berman, the NEH chair during the Nixon years, "while the other wanted to equalize the flow of benefits among and between the states." What exactly constituted the humanities remained in contention: Was it scholarly work or, as Berman wrote, "whatever might be humane, humanitarian, or of general human interest"? The endowments' godfather, Claiborne Pell, came down on the extreme populist margin, Berman scoffed, urging small grants to "grocers and lumberjacks who might wish to acquaint themselves with serious reading."[36]

Worried about being slighted by a Congress that valued newspaper clippings, Keeney's acting successor, Wally Edgerton, had started funding state humanities councils to create an activist constituency parallel to the noisy arts councils the NEA had so deftly developed. He began holding meetings of the National Council outside Washington, in places like Seattle or New Orleans, and, said Hedrich, "the public relations officer sweated to get media coverage." Academic humanists even swallowed their disdain when Edgerton invited the uncredentialed popular historian Barbara Tuchman to give the NEH's well-publicized annual Thomas Jefferson Lecture.[37]

Despite such strenuous efforts to place humanities in the public eye, the Nixon administration delayed almost two years before naming Berman as permanent chair. He was a professor of English literature at the University of California at San Diego who had headed the Office of Naval Intelligence in the First Naval District during the Korean War. Berman doubted that Nixon could ever have benefited politically from courting the arts constituency, yet he describes using a similar argument while under considera-

tion as NEH chair: that Republicans could make friends among predominantly Democratic academics by supporting the humanities endowment.[38]

As Nancy Hanks succeeded in shaking the money tree for the NEA, its twin benefited equally, and Berman faced the pleasant dilemma of disposing of vastly increased funds in a prudent—yet congressionally visible—manner. The NEH therefore began to contribute substantial sums to museum exhibitions. Explaining that it was funding the scholarship underlying such blockbusters as shows of King Tut's golden hoard, Chinese archaeological treasures, and Impressionist paintings in Soviet collections, the NEH contributed far more to such displays than the NEA. Thomas Hoving, who conjured up a parade of megashows while director of the Metropolitan Museum of Art, found the NEH infinitely more receptive to his plans than its sister agency. The NEA provided mere "dribs and drabs," he said, less than the cost of time and materials needed to fill out grant applications. By contrast, Berman cheerfully supplied $300,000 to help bring over the Unicorn Tapestries from Paris's Cluny Museum for a reunion with their stylistic cousins at New York's Cloisters. The resulting show of ninety-seven glories of medieval weaving at the Met was named, in seemly, scholarly modesty, "Masterpieces of Tapestry from the Fourteenth to the Sixteenth Century." Nevertheless, it attracted 377,000 visitors, "one of the biggest hits," as Hoving irrepressibly put it, "of the Met's history." Berman was stunned: "Nobody realized that there was a mob out there . . . a new group"—people not in the habit of visiting museums who would crowd in to see even relatively obscure artworks.[39]

Much to Nancy Hanks's annoyance, the extra money she had garnered continued to pay for the humanities endowment's encroachments on her "turf." Museum planners quickly learned that, as Richard Hedrich put it, "bad art is good humanities." Wilder Greene, who directed the American Federation of Arts, usually applied to both endowments for money to organize traveling exhibitions. While the NEA was "terrific" in judging the quality of proposed shows, and its grant "was a seal of approval" that often attracted other funding, the NEH was fussy about how applications were written. "It was not just an art show we were planning," he explained, "it was of scholarly and social import. It inevitably needed not just a curator, but a series of experts to explicate it." For a proposed show of Yale University's silver collection, for example, the NEH required a squadron of writers to explain the pieces' social significance and the technical skill required to create them. Such demands contributed to the gross distension of museum catalogs, from handy booklets identifying the works on display

into cumbersome, costly, often unreadable coffee-table tomes. However, while the arts endowment never funded more than one-third of the cost of a proposed show, the NEH gave a good deal more, much of it spent to satisfy its own complicated requirements.[40]

As Nancy Hanks well knew from her work with the Rockefellers, museums housed not only valuable works of art but also highly visible, vocal trustees and donors. In the late 1960s, while she was still with the Rockefeller Brothers Fund, she sat on a panel ordered by Lyndon Johnson to study the unmet needs of American museums. As happens with many government studies of "unmet needs" in a particular area, those who would benefit the most wrote the final report. In this case, the American Association of Museums had called in a dozen directors of important museums. Together with Hanks, whose Rockefeller patrons were the primary benefactors of New York's Museum of Modern Art, the group met at the resplendent Belmont estate in Maryland. The result of its deliberations, *America's Museums: The Belmont Report*, was published in 1969 and contained few surprises. Museums were falling behind as educational institutions. Valuable artworks were moldering for lack of conservation. Buildings were in disrepair. Only a multimillion-dollar federal effort could restore museums to health.[41]

When Hanks became NEA chair the following year, she set out to include museums in the endowment's programs. In 1971, they received some $927,000 in grants; in three years, the amount multiplied almost tenfold, the largest percentage growth of any endowment program. By 1977, the NEA's museum program spent $11 million to help buy 333 works by living Americans, to support 733 exhibitions, to aid publication of almost 200 catalogs of permanent collections, and to assist with installation or improvement of more than 200 security and climate control systems. Even as the money available for grants was growing, applications for spending it grew faster. From 243 grant applications received in 1971 by the museum program, the number swelled to more than 1,100 six years later.[42]

Because of the perceived museum crisis stirred up by *The Belmont Report*, and goaded by the steady lobbying by powerful trustees, Congress began to consider yet another agency to help art, history, and science museums, as well as zoos and botanical gardens. Hanks struggled mightily to enfold the new program within the NEA's mantle. She commissioned a costly survey of all museums in the country, then called in museum leaders to review it and make recommendations. The group could not agree, and neither

could a second contingent Hanks summoned. By publishing three versions
of the survey, she hoped that the museum constituency would coalesce
behind NEA. Instead, more dissension ensued, as the surveys had shown
that, based on numbers and attendance, only 20 percent of museums were
devoted to art. Hanks nevertheless persisted in trying to satisfy the demands
of all the museums. She appointed museum people to NEA panels and
placed several on the National Council on the Arts. She persuaded the
council to approve nine categories of museum funding, eight of which could
also apply to non-art museums. From the ensuing flood of new applications,
116 grants went to art museums, but also 22 to history museums and 10 to
science museums. They included contorted stretches toward an art context.
For example, a museum with a large collection of mouse skins received a
grant to make the cases in which the skins were displayed more attractive.
Another grant funded a University of Texas study of how the political orga-
nization of the ancient Persian empire influenced Persian art.[43]

But the museums and their trade group, the American Association of
Museums, insisted on an empire of their own. Though already receiving
funding from the Smithsonian, the National Science Foundation, the U.S.
Office of Education, and NEH, museums tirelessly lobbied for more. The
director of NEA's museum program recalled with distaste, "They were all
so damned greedy. They figured, 'Any way we can get more money without
having to work for it is a good way.'" In the waning days of the Nixon
administration, Congress tacked the new Institute of Museum Services
onto the NEA's reauthorization and, with logic only a legislator could
fathom, placed it inside the U.S. Department of Health, Education and
Welfare. "It was an orphan," wrote Hanks's biographer, Michael Straight,
"unwanted by its parents, and shunned by its relatives, the two endow-
ments." Like "endowment," the name "institute" blurred its mission; the
word implied that the agency was pursuing an educational, scientific, or
scholarly goal, when, in fact, it was merely a conduit for distributing money
to institutions professing such goals.[44]

The institute's governing body, the National Museum Services Board,
featured an ethnically and regionally balanced array of museum folk,
chaired by George Seyboldt. He was a trustee of the Boston Museum of
Fine Arts, a member of the National Council on the Arts, and a leader of
the drive to establish the institute. His lobbying partner, Lee Kimche, an
organizer of science museums, became the director. Filling out the board
was an assortment of ex-officio members, each representing an agency
with funding claims competing with the institute: both endowments, the

Smithsonian, the National Science Foundation, and the commissioner of education.

Though the institute set up a complex machinery to evaluate grant applications, its criteria for what constituted a museum were generous. Unlike other institutions claiming to educate the public, museums were not accredited or subject to any particular professional standards. The American Association of Museums in 1970 had failed to endorse even the loosest definition of a museum: "an organized and permanent non-profit institution, essentially educational or aesthetic in purpose, with professional staff, which owns and utilizes tangible objects, cares for them, and exhibits them to the public on some regular schedule." The institute watered down even this minimal definition. It would accept grant applications from any museum employing at least one person, whether paid or unpaid. Money would be distributed according to twelve criteria, including "severity of need," geographical location, audience served, content of collection, and capacity to attain self-sufficiency.[45]

This recipe for a population explosion in the museum world had the desired effect: a rapid proliferation of all sorts of institutions under the rubric of "museum." In the fight over who would dole out museum money, the word *excellence* was seldom heard. Rather, another criterion, *access*, came to the fore, and, indeed, the very meaning of the word *museum* began to change, as public money became available for "science centers," children's museums, and aquariums. Many new spaces sought to reinforce ethnic or gender self-esteem, such as the Mexican Museum in San Francisco, the Museum of American Jewish History in Philadelphia, the Seneca-Iroquois National Museum in Salamanca, New York; the National Center of Afro-American Artists in Boston; and the National Museum of Women in the Arts in Washington, D.C. Many others were commercial and industrial exhibitions, such as the Museum of Broadcasting in New York City and the Computer Museum in Boston. Still others served subareas that split from art museums, such as the Center for Creative Photography in Tucson and the Craft and Folk Art Museum in Los Angeles.[46]

With spiraling demands from the constituency it had helped to create, funding for the Institute of Museum Services continued to increase. For 1979, it requested $7.7 million, more than double the previous year's appropriation. By 1985, museums were receiving money from twenty-seven programs within five major federal agencies. In 1987, Congress demanded details on funding overlaps. The resulting study by the Institute of Museum Services revealed that in addition to the three institute

programs, museums could also apply to eleven programs within NEA, twelve programs at NEH, four at the National Science Foundation, plus nine cabinet departments and such independent agencies as the Advisory Council on Historic Preservation, the General Services Administration, the Library of Congress, NASA, U.S. Information Agency, and the Postal Service. In fiscal years 1985 and 1986, federal grants to museums totaled more than $115 million. This total does not include substantial federal subsidies to the Smithsonian, nor the far greater support museums received from states and local funders.[47]

Though the endowment lost the battle to control public patronage for museums, its own museum program continued, but the amounts allocated for it remained static, even as the agency's overall budget leaped beyond $100 million. While Hanks was omnipresent wherever the arts were discussed, the endowment's policy, as under Stevens, remained murky, all but indiscernible. Hanks "put money all over," said the former council member Douglas Dillon; she dutifully provided each congressman with a list of grants to announce for his or her district. Hanks was "a great politician," said Stephen Benedict, a sociologist specializing in the arts. When Senator Ted Stevens wavered on supporting the endowment, she financed a tour of the Joffrey Ballet to his home state, Alaska. While NEH chairman Ron Berman wanted to concentrate his funding on areas with widespread public impact, such as importing the "Masterpiece Theater" series for public television, he felt hampered, he wrote, because "the Arts Endowment had made it a practice to give out innummerable little grants in order to wet every beak." Such a procedure "prevented organized disaffection. But it kept every grantee in a state of uneasy gratitude, pleased to have money yet annoyed to have so little of it."[48]

Michael Straight was dismayed by the incoherence at the endowment's core. He deplored the multitude of pilot programs that never emerged from their cocoons into wider application, the overlaps with arts programs in other government agencies, and the lack of coordination among federal, state, and local funders. He found it difficult to assess what Hanks had accomplished, as the NEA kept no records of what recipients actually did with their grant money, compared to what they said they would do in their applications. Nor did anyone track how many of the 40,000 or so proposals that were rejected went forward anyway, with support from local patrons, corporations, or, perhaps, from the artists themselves. "Is the purpose of government to provide working capital for expansion of the arts," Straight

asked in 1988, "or is it handing out continuing subsidies to arts organiza-
tions as it does to the growers of sugar beets? Does it really wish to decen-
tralize the arts, or is its unconscious . . . intent to centralize the patronage
power in itself?"[49]

To be sure, Hanks did not appreciate such tart observations from her
deputy. Straight's father was J. P. Morgan's partner Willard Straight,
founder of the *New Republic,* who was killed in the First World War. His
mother was the heiress and philanthropist Dorothy Payne Whitney, who
founded Dartington Hall, a British school devoted to the arts. Michael
received his early schooling there, won first-class triple honors at the Lon-
don School of Economics, and went on to Cambridge during the mid-
1930s. The Spanish Civil War was raging and the Nazis were threatening
all of Europe. Feeling helpless to hold back the forces of darkness that
appeared to be closing in, Michael joined a Communist cell whose mem-
bers included Guy Burgess and Anthony Blunt. It was an act of youthful
idealism that would shadow the rest of his life.

Straight eventually abandoned the Communist party and, following the
Second World War, became the national editor and publisher of the *New
Republic.* In 1963, after President Kennedy had appointed him to the
largely ceremonial Advisory Council on the Arts, Straight was asked to be
chair of the projected NEA. At that point, Straight confessed his youthful
political indiscretion to the presidential aide Arthur Schlesinger, Jr. During
some fifty hours of interviews with FBI investigators, Straight identified a
number of his party cellmates, some of whom had moved into important
British government posts. Anthony Blunt, for example, had become keeper
of the queen's pictures and was not publicly identified as a Communist spy
until 1981. Although the information took seven months to reach British
intelligence authorities, Straight had relieved his conscience. However, so
potent was the residue of 1950s redbaiting that he could never be ap-
pointed to head any government agency.[50]

Nevertheless, Straight's interest in the arts, his impeccable Washington
contacts, and his close personal friendship with Leonard Garment con-
vinced Garment that he would be a strong deputy chair for Hanks. While
the press referred to Straight as the endowment's "resident Brahmin," or
its "patrician presence," he proved a prickly colleague for Hanks. The
endowment benefited from the lavish parties Straight hosted for the quar-
terly meetings of the National Council on the Arts, his assiduous entertain-
ing of skeptical congressmen, and the veil of bipartisanship his presence
lent the agency. Yet Hanks did not appreciate Straight's criticism of the

agency's policy vacuum and its occasional tendency to award grants to dubious artistic projects. The love-hate relationship between the two was "profound," said Ana Steele, the endowment's institutional memory. Sometimes it seemed to her that "Nancy was in the wings wringing her hands, while Michael was on stage making a mess."[51]

The hand-wringing and the "mess," however, remained purely internal. When reporters came around, both Straight and Hanks offered impossibly rosy pronouncements on the endowment's intense impact upon the American public. About one-third of all Americans had been exposed to a federally funded arts program in the previous five years, one *U.S. News and World Report* article glowed in 1973. Poets were swarming into schools, instilling a love of verse and respect for grammar. Standees jostled to hear classical concerts in low-income neighborhoods. Televised arts, Straight told the reporter, would shortly convert more than half of the entire population into passionate arts lovers. The following year, Hanks told another *U.S. News and World Report* reporter that "it's a myth that the United States is culturally backward." Rather, the nation was "at least even" with Europe, as it was already the home of two of the world's six greatest ballet companies and five of the ten best orchestras.[52]

From her first moment in office, Nancy Hanks was keenly interested in publicity. She generated a list of all the newspapers carrying news of her appointment as chair, with asterisks marking those that had featured it on the front page. Articles under her byline appeared in such varied publications as *Foundation News, Museum News, International Musician, Parks and Recreation, American Education, House and Garden,* and *National Businesswoman.* Leading newspapers also ran feature stories about this attractive female dynamo in high government office. But the blinding visibility of which her NEH counterpart Ron Berman bitterly complained was not evident. A study of the *Reader's Guide to Periodical Literature* from 1965 to 1980 indicates that few editors of major magazines devoted much space to either endowment. Aside from jubilation over grants in trade publications for various arts disciplines, the NEA was hardly hot copy for the press.[53]

This was not for want of trying. Hanks's closest aide was Florence Lowe, whose sole mission was to perfect the chair's image as first lady of the arts. Not a press release left Lowe's desk without Hanks's name in the lead paragraph. She assembled massive briefing books and used them to make Hanks appear omniscient about any arts event or trend anywhere in the country. With two assistants, Lowe scrutinized every invitation, accepting

only those that would yield favorable print, and possibly a press conference in a mayor's or governor's office. She accompanied Hanks on every trip, as confidante and "impresario of the public view." While herself ignorant about the arts and hardly interested in the NEA, Florence Lowe was fiercely loyal to her boss. She selected Hanks's dresses, made her hairdressing appointments, and cut off the phone when Nancy needed to rest. Lowe kept track of every person Hanks met, and saw that a letter went to each one. By 1977, Lowe had five assistants and proudly described herself as founder of "a Nancy Hanks cult."[54]

Beneath the image, Hanks was hardly a sophisticated connoisseur of music, drama, or dance, and her sense of the visual arts barely extended beyond the crewel work to which she was addicted. Yet her enthusiasm, her vocal concern, and her single-minded crusade for the arts and the endowment built a chorus of affectionate fans, both inside and outside the agency. Bert Kubli, who then headed the art in public places program, flatly called her "the most intelligent person I've ever met. She was magnetic . . . she had a passion for detail combined with great conceptual ability." The Broadway producer Harold Prince, who was on the council during her tenure, wrote, "I cannot conceive of someone doing that job as you have." To Nick Webster, then manager of the New York Philharmonic and a frequent NEA panelist, Hanks was a "god." Allan Jabbour, first director of the folk arts program and now head of the Folk Archive at the Library of Congress, admired her inclusiveness, whether of staff, Congress, or the public; "she had an intuitive sense of what would work . . . she would avoid areas of problems."[55]

Unavoidable, however, and increasingly menacing was the challenge of pacifying the Frankenstein that NEA had itself created, the state arts agencies. As anticipated under Stevens, these bodies served as lobbying outposts for the arts in all fifty states and six territories. But the missionary circuit of Stevens's emissary, Charles Mark, also yielded a fractious array of special interests constantly demanding more money and power, even as they chafed under the NEA's regulations. The confrontations had begun under Stevens, when state agencies insisted on receiving copies of all grant applications from their state. Stevens's refusal fueled anger and pleas for relief from Washington's burdensome administrative demands. In 1968, the state arts councils formed the National Assembly of State Arts Agencies to press their own interests in the capital. As NEA's appropriation swelled, so did the states' share; by 1972, each state was getting $125,000. In a small state like Idaho, this sum represented a munificent subsidy,

while it was piddling in states with a complex arts infrastructure, such as New York or California. By 1975, state arts agencies had assured themselves of 20 percent of the NEA's total appropriation, with each one guaranteed at least $200,000. Each state could apply for additional grants through the endowment's panel-based process. Much to the states' chagrin, the endowment tended to appoint reviewers who "toed the line," Michael Straight noted, while freezing out opponents. When states complained that the endowment often bypassed them to deal directly with local arts organizations, a state representative was appointed to sit on each of nine discipline-based panels.[56]

When state arts agencies gathered for their first national conference in the late 1960s, Charles Mark reassured delegates worried about federal control of the arts. "The government couldn't control the government," he told them. "It was a huge monolith that oozed its way along like a giant snail, leaving a residue of paper and red tape behind." By contrast with this sluggish behemoth, the state arts councils could be described as agile terriers persistently nipping at their congressional delegations for additional benefits. With so many newspaper publishers and other influential folk among their advocates, the states loomed as "dangerous rivals for federal funds," observed the NEH chair Ronald Berman. "Eventually they would absorb amazing amounts of money into bureaucracies of art, money that would be used . . . only to lobby for more money."[57]

From the northeastern vantage point that typically governs Washington's received opinions, a vast cultural desert stretched dismally westward from the Hudson and Potomac rivers, a heathen hinterland unrelieved by any mark of civilization until one reached the opera house in San Francisco. In fact, the arts had accompanied westering pioneers so closely that opera houses sprang up in frontier communities almost as fast as saloons. In the nineteenth century, such stars as Jenny Lind, Sarah Bernhardt, and the Barrymores regularly toured the American west. The leading families in Wyoming, for example, aspired as much as their eastern counterparts to ship their children to New England for schooling at elite prep schools, conservatories, and universities. During the 1930s, the regionalist movement in art produced an array of acclaimed painters, notably Grant Wood and Thomas Hart Benton. Frank Lloyd Wright in the midwest, the Greene brothers in Pasadena, and Irving Gill in Southern California developed original architectural styles that were only later, and grudgingly, esteemed in the east. Modern dance was another wind from the west that slowly stirred eastern sensibilities. Isadora Duncan was born in San Francisco and

captivated Europeans after a brief stopover in New York, while Martha
Graham received her earliest recognition while performing with the Ruth
St. Denis/Ted Shawn company on the West Coast. The Second World War
had generated a great wave of artistic refugees who found work and appre-
ciative patrons all across the country. Southern California became a special
haven for the European music community in exile. It included Igor
Stravinsky, Arnold Schoenberg, Erich Korngold, Kurt Weill, Ernst Křenek,
and the youthful André Previn.[58]

To advance cultural life in these seemingly barren backwaters, local arts
councils had been steadily organizing since the Second World War.
Spurred at first by the Junior League of America and later by the American
Symphony Orchestra League, more than 250 were functioning by 1966. In
many communities, the arts council represented the summit of local soci-
ety, uniting the educated and the socially prominent, mostly women, in a
crusade to bring home the finer things in life. They maintained community
calendars to prevent scheduling conflicts and disseminated news of local or
touring cultural attractions. Some of these busy ladies managed auditori-
ums, some ran cooperative fundraising drives, some organized local arts
festivals, and all lobbied strenuously for public funding.[59]

No sooner had federal money reached the state level than these local arts
councils devised a myriad of worthwhile projects on which to spend it. In St.
Louis, the council expected to publish a magazine to proselytize to that
perennially elusive mass audience for the arts. Another project there was to
establish "Saturday Centers," the arts equivalent to Sunday schools, where
children would explore fine art, drama, and creative writing. While many
councils simply promoted traditional culture, others encouraged innova-
tion. "How are you going to fascinate those dreadful children we have
brought into the world," the manager of the Dallas Civic Opera asked a
midwestern arts conclave in 1968, "if we're going to have people coming out
and jumping around on their toes in the same old ballet, or people playing
the masterpieces of the retrospective orchestra repertoire." New York pro-
ductions were so expensive, he argued, that they were doomed to be "main-
stream . . . defined with one word—mediocre." He urged productions of
new works, "and right here is where we're going to have to do so."[60]

In scenes reminiscent of *The Music Man*, the arts in Kansas attracted
zealous supporters. At the first statewide gathering of local arts councils,
one art collector from Shawnee Mission contended that "cultural depriva-
tion is just as debilitating as disease and we must provide for its allevia-
tion." The meeting was dominated, however, by the many non-art reasons

perpetually put forward to support spending public money for arts. The president of the brand-new state arts commission revealed this boosterish goal: "to create a new appreciation of Kansas." Educated young people were leaving the state and new industries were loath to locate where culture was sparse. If the arts were more developed, he said, "we will be that much more successful in selling the merits of living in Kansas to ourselves and others." He then urged those present to contact legislators, "convincing them to support the arts." Governor William H. Avery had already felt the heat from arts-minded Kansans. He confessed that he came to support establishing a state arts council "at the very adamant urging of some of my friends," and the measure passed the legislature by a single vote.[61]

Within a few years, the arts became a major force in state politics, the ladies from the local councils descending wrathfully on the capitol in Topeka whenever budget cuts threatened. While the state forestry and fish and game agencies lost money, the arts were sacrosanct, according to Jonathan Katz, then working for the Kansas Arts Council, now director of the National Assembly of State Arts Agencies in Washington, D.C. "The legislature got more mail on the arts than on abortion," he said. "The governor begged us to call off the dogs." Katz, who left Kansas in 1976, fondly recalls his baptism as an outrider for the arts in Kansas. A native New Yorker with a Ph.D. in English literature, he was called to Wichita State College as a poet in residence and professor of literature and writing after a stint organizing graduate students following the bloody massacre at Kent State University in Ohio. When he moved to Topeka as the state arts council's third employee, Katz quickly adapted to political realities. The governor's wife mentioned she was looking forward to seeing him without his beard, and Katz immediately shaved his whiskers. From 1972 to 1976, Katz saw local arts councils grow from ten to fifty-five, all managed by volunteers, mostly women. "They were the salt of the earth; they knew what had to be done," he remembered affectionately. "Their communities were dying." Most were not so much interested in the arts but in using the arts to keep their town from vanishing off the map. Having cultural facilities might lure their children back after college and attract doctors and dentists, better teachers, and more businesses.[62]

As Katz helped to transform the Kansas cultural scene, the experience also transformed him. In 1976, he moved to Sangerman State University in Illinois to teach arts administration in one of twelve such graduate programs lodged at various universities. The model was at the University of Wisconsin's business school, where the syllabus included courses in micro-

economics, financial and administrative accounting, budgeting, marketing, organizational behavior, business law, statistics, and a six-month internship at an arts organization. As a profession, arts management had not existed before the mid-1960s. By 1981, there were twenty-three programs in performing arts administration, plus thirteen in museum management. Many of those who ended up in arts management had started out with undergraduate majors in dance, music, art, or theater. To those daunted by intense competition within these fields, or perhaps confronted by their own deficits of will or talent, the field of arts management presented an attractive compromise. It substituted a skill that could be learned for God-given genius and offered a chance to work within a creative climate.[63]

The introduction of professional managers into the creative arts world was a mixed blessing. While trustees appreciated having at least one person who spoke their businesslike language, the artistic personnel often resented the manager's obsession with the bottom line. Introducing modern administration had been one of the Ford Foundation's principal goals for its massive funding of the performing arts during the late 1950s and 1960s. Through the Business Committee for the Arts, founded in 1967, some corporations were already lending the arts seasoned managers. The NEA soon preferred dealing with consistent, dependable administrators, cool heads who understood how to fill out complex grant applications and meet deadlines, rather than with volatile artists, their outlandish visions, unorthodox work habits, and temperamental spirits. But while professional management pleased trustees and private patrons, it dampened the creative impulse. It preferred the predictable to the fanciful, the serious to the light-hearted, the well-known classic to the imaginative leap, the pedestrian to the unexpected.

What would the endowment's sober managers have made of George Balanchine's wild inspiration of 1941? He asked Igor Stravinsky to write the music for an elephant dance featuring the Barnum and Bailey Circus and the New York City Ballet. The composer agreed to write a polka for fifty pachyderms bearing fifty ballerinas, a composition presented more than four hundred times by the circus. Stravinsky never saw the ballet, but in Los Angeles he did once shake the foot of Bessie, the elephant who had carried the dancer and actress Vera Zorina. After the Boston Symphony performed an orchestral arrangement of "Circus Polka" in 1944, the composer received "a congratulatory telegram from Bessie . . . who had heard [the] broadcast." Later, Paul Taylor would choreograph the score for human dancers.[64]

Such a sprightly creative caper—and involving a profit-making institution like the circus, to boot—would have been ineligible for government grants. Fearful of being accused of squandering funds on money-making frivolities, the endowment sternly limited grants to institutions certified as nonprofit by the Internal Revenue Service. It thereby sanctified the absence of profits, condemning arts organizations to perpetual struggle. Any surplus income had to be paid out as wages or expenses, or placed into an endowment with small return. This precarious financial status promoted the incessant rattling of tin cups in behalf of artistic endeavors, while putting the reins of each organization firmly in the hands of the trustees and their agent, the professional arts manager. During the 1960s, Twyla Tharp could successfully apply for a New York State Arts Commission grant with one unforgettable line: "I write dances, not applications. Send money. Love, Twyla." By the late 1970s, one astute observer lamented, "we [had] created an administrative technocracy in the arts, designed to solve problems, but now a problem in itself." Robert Brustein, a brilliant director, then head of the Yale Drama School, deplored "subordination of . . . artistic growth to managerial know-how."[65]

Rhoda Grauer, who was Tharp's manager and later director of the NEA's dance program, has watched the inexorable complexification of the management side in the arts. She proudly recalls that during her years with Tharp, the company never had a deficit, "but I didn't have to juggle a multi-million-dollar budget." The slippery slope begins, she says, when an artist gathers a board of trustees possessing managerial skills. "The next curve," Grauer says, "is that [the board] wants the organization to grow (even though some should not), so it attracts moneyed people. To raise money, they have to have parties. But to attract their friends, you can't have it in a loft, you need to have it at the Waldorf. So half the company's energy goes to entertaining its benefactors."[66]

While working for the Spoleto Festival in Italy in 1966, Grauer wrote her first grant application, "the least complicated of any I wrote later." Returning to New York, Grauer at age twenty-eight had never balanced a checkbook, yet managed fundraising and bookings at the festival's New York office together with a single aide who could not type. Lacking even a calculator, Grauer ruled off yellow scratch paper and wrote the dates for each booking across the top, the names down the left-hand side, and the amounts needed each week alongside. Bleary eyed, she called in the accountant to check her figures. He studied the yellow papers. "My God, Rhoda," he exclaimed, "you've invented ledger paper!" From such simplis-

tic beginnings, the profession of arts manager matured into a calling of challenging complexity.[67]

When Grauer took over the NEA dance program, only twenty companies were receiving grants. When she left in the late 1970s, grants were going to ninety companies and six-hundred choreographers. "There was an explosion among those who dared to identify themselves as artists," she said. Many others were still unaware of NEA grants, she said, including some of the best. After leaving the endowment, Grauer experienced the other end of the grant process as a producer for New York City's public television station, channel 13. A cool, businesslike woman who relishes her expertise at swimming bureaucratic channels, Grauer also savors the artistic milieu, giving her hair a quick lick with a brush and dressing for work in jeans and a T-shirt. She has filled file cabinets with increasingly complex applications for government grants. For a public television series on world dance produced by channel 13 in 1993, the application to NEA was a pamphlet of thirty pages. However, the request to NEH for a more substantial grant was a three-inch tome weighing nearly four pounds. The actual application covered only thirty-five pages; the rest was stuffed with backup information: photos, budgets, letters from scholars endorsing the series, and proposed television treatments.[68]

Until the end of the Second World War, dance was the most exotic of American cultural blooms. Dance was nearly invisible to the general public outside of the cotillion circuit, where well-born boys and girls were bundled into long trousers and frilly dresses for weekly, excruciatingly formal sessions with stern mistresses of etiquette. The resolute few who pioneered modern dance, geniuses like Martha Graham and Merce Cunningham, struggled as bizarre visionaries within a bohemian fringe, while the New York City Ballet established itself largely on the basis of Lincoln Kirstein's single-minded, passionate patronage, and the awe-inspiring European background of its director George Balanchine. Even so, the Russian-born choreographer eked out his existence by devising dances for Broadway shows and Hollywood films. But the art boom of the 1950s set off an explosion in the dance world. Not without controversy, the Ford Foundation in 1963 showered $5 million upon the New York City Ballet and divided another $3 million among ballet companies in Utah, Pennsylvania, Houston, Washington, D.C., San Francisco, and Boston. The *New York Herald-Tribune*'s dance critic, for one, complained that the grants went largely to Balanchine disciples, adding luster to an established talent,

perhaps even "an endorsement of an artistic dictatorship." Ford should have supported a fresh ballet choreographer such as Robert Joffrey, she suggested, and also the struggling modern dance troupes of Martha Graham, José Limón, and Paul Taylor.[69]

The NEA soon leaped into the breach. Its very first grant had been $100,000 to rescue the financially gasping American Ballet Theater (ABT). So eager was the NEA Council to comply with its colleague Agnes De Mille's pleas in the company's behalf that it ignored its own policy requiring outside matching funds and allowed ABT to use box office receipts as a match. This ballet troupe had opened in 1940 with a multifaceted company, staging new works by such choreographers as Jerome Robbins, Agnes De Mille, and Antony Tudor. The dancer-director Lucia Chase had bankrolled the company from the beginning, but its move to the far larger, far costlier Metropolitan Opera House at Lincoln Center proved beyond her resources, especially with the New York City Ballet competing scarcely a hundred yards across the plaza. As New Yorkers' appetite for dance surged, the dancers and other company professionals understandably demanded better pay, longer seasons, and benefits such as health insurance. The answer appeard to lie in touring. In 1967–68, the endowment spent $25,000 to underwrite five weeks of visits by four companies to two states. Under pressure to spread the benefit to every imaginable place where a congressman could claim credit for importing a cultural amenity, the endowment swiftly expanded dance touring.[70]

In the persistent tension between excellence and inclusion, the program opted for inclusion, dropping all quality standards. This greatly expanded the companies that could be sent on tour and also the costs of doing so. By 1976–77, touring consumed more than half the endowment's dance budget of $3.6 million, even as states and localities were spending more than $32 million. In that halcyon season, ninety-two companies performed in fifty-six states and territories for a total of 432 weeks. Unlike theater or opera tours, which are encumbered by bulky sets and costumes, dancers appeared to be ideally peripatetic. Any work struck them as preferable to unemployment. They "were used to roughing it," wrote Michael Straight. "They stuffed their belongings into knapsacks and . . . clambered into aged vans and limousines cast off by funeral homes. . . . They danced in all kinds of halls; they spent countless hours in schools. In the course of fifteen years, they helped to establish dance as a distinguished art form throughout the nation."[71]

By the end of the 1970s, however, the mad tarantella was winding down.

The potential audience was saturated even as university-based schools and other programs churned record numbers of graduate dancers into an over-. crowded market. In New York, four resident companies offered simultaneous seasons, while a flock of smaller groups, about one hundred in modern dance alone, cavorted in small halls and lofts. The growth elsewhere had also been phenomenal: Ten modern dance troupes resided in Boston alone; some two hundred in the entire country. Repertory companies revived dances of the past, but, without the impetus of the original choreographer, the performance style often seemed "flattened," wrote one critic, and these programs offered "the same bland sameness of meals eaten in fast-food restaurants." Other companies tried various hybrids of ballet and modern dance. The fact was that, during the 1950s and 1960s, the dance world experienced the upswing in a cycle evident in all the arts throughout modern times: A wave of dazzlingly revolutionary creators had overlapped a groundswell of new, devoted consumers.[72]

As in all cycles, a downturn followed, with soul-searching in its wake. "Are We Funding Junk?" a *Saturday Review* article asked in 1980. The NEA's touring program was underwriting one-third of local presenters' expenses, bringing forth 167 eligible companies within a decade. Many critics wondered whether the endowment was doing professional dance any favor by such hasty pump-priming. By the 1980s, the deficit disease (not to mention a hideous corporeal scourge, AIDS) was ravaging the dance universe. A generation of brilliant choreographers was taking its last bows and the creative management of many companies was replaced by businesspeople as trustees. "When the board uses capitalist economics," said Rhoda Grauer, "and starts to plan programs, it's the beginning of the end."[73]

One striking symptom of the creative funk was dance companies' reliance on old chestnuts. A 1980s survey of thirty-five regional dance troupes showed that more than 40 percent of all home season programs consisted of holiday performances of *The Nutcracker*. In 1992, about 230 productions of this lightweight sugarplum were pitter-pattering across American stages, earning $46 million at the box office, some 40 percent of the typical dance company's total annual income. Within an eighty-mile radius of San Diego alone, ten *Nutcrackers* were available. In Washington, D.C., the president's thirteen-year-old daughter, Chelsea Clinton, appeared in a 1993 *Nutcracker*. And a film version of the forty-year-old Balanchine *Nutcracker*, featuring the New York City Ballet, was released in time to slake any lingering holiday craving for *Nutcracker* sweetmeats. Even New York's esteemed American Ballet Theatre expected the earnings

from a $1.5-million California *Nutcracker* in 1993 to extricate it from the jaws of near-bankruptcy.[74]

Burdened with a $5.7-million deficit accumulated under the management of Mikhail Baryshnikov and his successor, the ABT was facing extinction as its twelve-week New York season opened in May 1993. Dancers agreed to reduce guaranteed work weeks from thirty-six to twenty-six and to work at the same wage levels for another year, and other unions also negotiated concessions. For the rest of the year, the company was booked only into Washington's Kennedy Center and Orange County's Performing Arts Center, an abrupt drop from 1989, when ABT toured for twelve weeks, including runs in Washington, Chicago, and San Francisco. Even then, the days of dancers with backpacks rumbling around the country in converted hearses were long gone; the ABT's one hundred dancers plus staff lumbered to tour dates with sixty tons of sets, costumes, and equipment. In 1993, ABT's budget was down from $23 million during Baryshnikov's final year to $14 million, and not a single new work was planned. While the company celebrated its reorganization near the end of that year with a fundraiser at New York's posh Four Seasons restaurant, unveiling a $16.2-million budget, its debt still exceeded $2 million.[75]

Nor was the Joffrey better off. Its founder dead of AIDS, the troupe accumulated a $2-million deficit under his partner, Gerald Arpino. Then a feud in 1992 with its Los Angeles trustees, compounded by the rioting sparked by the Rodney King verdict, scrubbed the West Coast residency at the Wiltern Theater and resulted in a seven-month layoff.[76]

Yet, like mushrooms sprouting beneath a forest's decaying trees, smaller, more modest, more personal companies have taken root all over the country. "There's dance in every burg in the U.S.," said Bonnie Brooks, the director of dance companies' trade organization, Dance/USA. She points to the field's 1,000 percent growth since the NEA began. In Ohio, the state university lodges the nation's largest and best-regarded dance program, and five professional ballet companies find support; in Dayton, local funding has actually increased as part of a comprehensive city cultural plan. San Francisco, Minneapolis-St. Paul, Seattle, and Boston continue to support vital troupes, and there is plenty of room for growth elsewhere, in places where dance is still considered risqué, among people, said Brooks, "afraid of the body, of seeing people in tights."[77]

However, the scale on which smaller local dance companies operate bears little comparison with the stricken giants. Jean Isaacs, who has directed a dance company in San Diego since 1974, manages a budget of

$200,000. Though the troupe is consistently ranked as the best in this second-largest city in California and attracts an overflow crowd to every performance, it received its first NEA grant, $10,000, in 1993, after seven failed attempts. The California Arts Council has for years provided some $4,000, while the city gives about $40,000. Artistically, the company is better than ever, says Isaacs, even though she and her partner work without salary in order to pay their dancers each $7,000 to $8,000 per year. The NEA's small grant is important largely because it validates the company's work, making it easier to get grants from the many foundations that use NEA panel comments to evaluate applications. So does the U.S. Information Agency's International Fund, which underwrote the company's 1993 appearance in San Luis Potosi, Mexico. Clearly, losing the city's grant would be "most devastating," says Isaacs, "but we would still survive. The loyalty of students is most rewarding. One of them gave us $1,000."[78]

Isaacs, who has sat on many panels herself, presents an insider view of the grant-review process. At the state level, she found a bias toward San Francisco, where the arts council staff from nearby Sacramento is more familiar with the dance scene. "They funded organizations that barely exist, that don't even have a season," Isaacs cynically observed. "Anybody doing tap dancing is automatically funded. Nobody knows about it, but it's culturally specific." Grants went to 40 of 110 applicants in 1993, although eight of those rejected appealed the review panel's unanimous decision and received grants. The NEA's review system, she says, is in similar disarray. The review panel attempts to force each company into a niche—ballet, modern dance, established, "cutting edge." Isaacs's applications were repeatedly rejected because the company didn't fit into any category. In 1993, however, "the panel found the label, 'post–Humphrey-Limón,' and the grant came through." The panel refuses to view videos and insists on making decisions based on its members' opinions or on a single, costly, unannounced, anonymous "site visit" by an "expert" consultant. These visitors' expertise often lies elsewhere; for several years, a folk dance specialist reviewed Isaacs's company and, predictably, her grant was rejected.[79]

Such tales of ineptitude, caprice, and favoritism are inevitable when hundreds of panelists review thousands of grant applications. Under Roger Stevens, the personal knowledge of the prestigious council members, not to mention the small budget, limited frivolity and bias. But as the money poured in, so did applications, and a proliferating mass of panelists labored to shovel it out. Competition was ferocious. A 1971 program to select 20

visual artists for $7,500 fellowships attracted 278 applications. By 1973, more than 200 panelists were reviewing grants, including such authorities as Harold Prince and Zelda Fichandler in theater; Roy Lichtenstein and George Segal in visual arts; Julian "Cannonball" Adderley, Risë Stevens, Robert Shaw, and Gian-Carlo Menotti in music; and Toni Morrison and Kurt Vonnegut in literature.[80]

With continued expansion of the NEA's programs and of funds for each of them, and with rules limiting each panelist to a three-year term, the overall quality of the people reviewing grants declined. The input of artists was diluted by more academics and professional arts managers, while pressures for ethnic, gender, and geographic representation further tipped the balance from excellence toward access. Nevertheless, most panelists relished the periodic gatherings in Washington to winnow the best from piles of grant applications. Nick Webster, the manager of the New York Philharmonic, treasured "the wisdom and broadly national view" he encountered during his term on the orchestra panel. "Decisions were never whimsical," he recalled, even though a congressman's interest would sometimes trigger reconsideration of a rejected application.[81]

When the council members Billy Taylor and Gunther Schuller successfully separated jazz, folk, and ethnic music from the main music panel in 1976, Larry Ridley became the jazz panel's chair. A bassist who was chairman of the music department at Livingston College of Rutgers University, Ridley had to devise a way that jazz artists could be funded even though most of them enjoyed no nonprofit umbrella. The solution was to form the National Jazz Service Organization to administer the endowment's grants, and, incidentally, to lobby for more funding. A tall, handsome, thoughtful African-American, Ridley had played, it seemed, with all the jazz greats, from Duke Ellington and Benny Goodman to Dizzy Gillespie, Thelonious Monk, Dinah Washington, Art Farmer, Sonny Rollins, and Billy Taylor. Although such colleges and universities as Utah, Drake, Penn State, Bennington, Grambling, and Bowdoin had invited him for visits as a jazz artist in residence, many of Ridley's Rutgers colleagues questioned whether a jazz musician was fit to be chair of the university's music department. Quietly persistent, he led the department for eight years, until 1980.[82]

As one of America's unique contributions to world culture, jazz surely deserves recognition, but whether the endowment's grants to individual musicians or its sponsorship of a jazz service group have enhanced the art form appears questionable. Long before NEA support, generations of jazz musicians had already developed a dense professional network. Long

before racial segregation ended, black and white performers had worked out respectful relationships. Scorned by polite society, they were free to experiment, perpetually renewing instrumentation and styles, testing the results among their peers and before paying audiences. The jazz world was wild, it was fiercely competitive, it was restlessly alive. Some called it a jungle; others, a sin-soaked netherworld. But many question whether the jazz of the concert hall, of academe, or of NEA peer review can do anything but dim the brilliance of this improvisatory music.

Even during Roger Stevens's chairmanship, the visual arts program had presented a challenge to the prudent reviews conducted in most other disciplines. The rebellious tone had been set by the program's first director, Henry Geldzahler. Pudgy and nervous, the thirtyish *wunderkind* commuted between his desk at the NEA in Washington and another full-time job as curator of twentieth century art at New York's Metropolitan Museum. "Henry thought he was only in charge of decisions," one colleague recalled, "and that someone else would implement them." When the staff met, he would demand why letters were unwritten and checks to grantees unmailed. Informed that his duties included such mundane tasks, Geldzahler dashed through the desk work "with a furious attitude." Livingston Biddle recalled showing a congressman through the NEA offices, when they came upon Geldzahler, making himself at home at Roger Stevens's desk. The would-be art czar was smoking an expensive cigar of stretch-limo proportions and was garbed in a white linen suit and a white broad-brimmed hat. "Just *what* is that?" whispered the congressman, and Biddle soothed him with a mini-discourse on the close links between eccentricity and genius.[83]

Brian O'Doherty, who succeeded Geldzahler in 1969, continued the tradition of pursuing several careers simultaneously. As an artist, he exhibited under another name, Patrick Ireland. As a critic, he wrote under his own name, serving as the editor of *Art in America* from 1971 to 1974. During the early years, the visual arts program director simply handed out grants. When pressured to form an ad hoc panel, one of the first grants was to Ed McGowin, who proposed to paint twelve pictures, signing each one with a different name. This project was acclaimed as a work of conceptual art by the avant-garde curator Walter Hopps, who called it a statement of "liberation from strictures." Besieged by more than one thousand applications, another ad hoc panel in 1972 held each of 750 slides up to a bare light bulb to winnow those to be considered further. Slides of the survivors' work

were projected onto a screen for about one minute each. Sometimes a panelist commented: "This one is by a student of mine," or "This one is black and you've only picked one black so far." After observing this procedure, Michael Straight prophetically recorded in a memo: "The program is misconceived in principle and inoperable in practice. I believe that it harms rather than helps artists. I believe that it will harm the NEA."[84]

Hanks was concerned enough about the directions that panels were taking that she often slipped into their sessions, sitting unobtrusively in the back of the room, compulsively stitching crewel embroidery. Nick Webster recalled Hanks appearing unannounced when the music panel was discussing a controversial issue; "she'd ask questions, sometimes little zingers, [using] a Socratic method." Hanks was convinced that the panel process shielded the endowment from charges that the government was attempting to control the artistic process. She believed that varied voices from the field represented a guarantee that a broad range of artistic visions would find support. But from the beginning the panels also represented a threat. Though summoned only as expert advisers to the National Council on the Arts and ultimately to the chair, the panels increasingly viewed themselves as taste-makers. With thousands of grant applications to review, both the council and the chair had to rely largely on the panels' recommendations. With sound reasons, Roger Stevens had warned Hanks to keep a wary eye on them, "or they will run away with the Endowment."[85]

Hanks also kept a sharp eye on the staff, which had grown phenomenally. By 1974, 14,000 grant applications were arriving in a year, and every month there were 1,800 phone calls and 320 letters of inquiry. In 1966, only 28 people had staffed the offices full time; ten years later, there were 130 full time, assisted by some 70 "floaters" and a smaller number of freelance consultants. By 1977, Hanks' office alone had a staff of 17, not counting speechwriters and clerk-drivers; the deputy chair had an assistant and a typist; and 24 others served in administration. There was a table of organization, but, according to Hanks's management consultant, the endowment really consisted of "a chairman and 220 assistants." Many of those attracted to working at NEA had been artists, but arts managers were increasingly evident. It was not unusual for a secretary to invite coworkers to a lunchtime poetry reading or for a staffer to duck out for an hour or two to audition. Brian O'Doherty still wore his hippie fringed jacket to work, and the music program director Walter Anderson retained the piano in his office, but the staff's sense of being a creative island in Washington's bureaucratic swamp was waning. One official perhaps protested too much

when boasting to a visiting scholar: *"Bureaucrats* do not make decisions here!"[86]

However, *politicians* did, and the best of them was Hanks herself. The Ford Foundation's Mac Lowry marveled at her ability to find "advocates for the arts or programs for every Congressman whose votes she needed." When the NEA's appropriations began their steep ascent in 1970, Hanks and Straight besieged Capitol Hill every single day. Each Tuesday, Straight entertained congresspeople at dinner, followed by attendance at a Kennedy Center concert. In Washington, where fulfillment of the public's genuine needs draws scant admiration as compared with finesse in manipulating the power structure, Hanks was adored. One of the arts' most ardent House supporters, John Brademas, noted with some envy that "a well-placed call from Nancy triggers calls from all over the country and these people can exercise considerable pressure." Even President Nixon, who fancied himself a sophisticated player of the game, was impressed with her political skills. "Whenever I fail to make a sale," he said in 1971, "Nancy Hanks always makes the sale." Reappointing her in 1973, Nixon noted that during her tenure, NEA funding had increased by 900 percent: "That is why we are reappointing you here. I don't want anything else increased by that amount."[87]

Hanks used the new money to start an array of politically popular initiatives. To counter charges of elitism, Expansion Arts was to bring cultural amenities to storefronts and churches serving poor inner-city children. To please the president, NEA coordinated a crusade for improved graphic design within sixty-three federal agencies. To calm the fractious multitudes in the music field, Hanks created separate funding mechanisms for various genres. Jazz-folk-ethnic acquired its own review panel and budget. When the council member Harold Prince lamented that talented Broadway composers were "forced to move to California to write underscoring for movies," Hanks added musical theater to the opera program. To enlist the 350,000-person army claiming to be creatively potting, weaving, woodworking, quilting, rug-making, basket-weaving, or doing other handwork, Hanks contacted the American Craft Council to ask how NEA could help. Though the Craft Council was skeptical, the endowment established crafts fellowships, apprenticeships, and workshops through the visual arts program, and by 1977 was spending more than $1 million to include craftspeople among the artists it sent into schools for presentations and courses.[88]

Folk arts were sucked into the endowment's orbit in 1974, after Congress had threatened to establish a separate folklife center. This prospect

moved Representative Henry Gonzalez to mock the NEA with populist verse:

Higgledy, piggledy, my little white hen.
She lays eggs only for gentlemen.
I cannot persuade her with pistol or lariat
To come across for the proletariat.

The NEA's program, funded with an initial $500,000, did not divert Congress from establishing the American Folklife Center at the Library of Congress the very next year. Allan Jabbour, who headed the NEA's program and then moved to the Folklife Center, came away with dazed respect for Hanks's political agility. "Her intuition told her that the folk arts would become important," he said. "She had no idea what the hell she was getting into. She just sensed that it would play well on Capitol Hill." [89]

No one can charge that all these elaborations of the endowment's mission were destructive or evil. Indeed, by the end of Hanks's eight-year stint at the endowment, an extraordinarily rich menu of cultural activities had spread across the United States. The banquet far surpassed what Hanks's Rockefeller panel had recommended back in 1965. Instead of the fifty regional nonprofit theaters it had envisioned, close to one hundred were operating. Instead of a dozen opera companies, there were nearly one hundred. Instead of fifty metropolitan symphony orchestras, about one hundred existed. As for dance, which the Rockefeller panel had not even considered, the number of resident companies had grown from ten to seventy, and touring multiplied the feast.[90]

State expenditures on the arts had grown from $4 million to nearly $70 million. New York State alone spent almost half of this amount, and the city of New York spent $50 million more. Nevertheless, New York's dominance in the cultural world was inexorably waning as a cultural revolution swept across the United States. Experiences that once had drawn visitors to New York were now available in Cincinnati, Houston, and Minneapolis, and even in Toledo, Austin, Duluth, San Jose, and Madison, Wisconsin. To be sure, expenditures on the arts in New York had also grown, but at a lesser rate than elsewhere: half as much, for example, as in California. In the early 1960s, New York had taken in 40 percent of all arts spending in the United States; by the late 1970s, New York's share had dropped to 30 percent.[91]

While the NEA undoubtedly contributed to the arts boom, rising edu-

cational levels and prosperity were powerful factors in building the audience that typically seeks out a cultural experience. The endowment moved into an array of pilot projects, initiatives, and new programs, but no thread of policy seemed to link all these activities into a coherent plan for enhancing the nation's cultural life. Politics, which many can play, especially in Washington, appeared regularly to win out over art, the province of the favored, often reticent, few. "We now have art policy or cultural policy as a political question," a political scientist dryly observed in 1977. He noted that the "haves" within the arts constituency had managed to see their needs converted into quasi-entitlements and that they would work hard "to maintain their share of the budgetary pie. . . . The decisions to spend and where to spend the cultural dollar are coming from the political marketplace." As the Nancy Hanks era was ending, these words resonated with increasing clarity, not only among the endowment's new administration but also in all the states and localities where the arts were in play among boosters, planners, downtown developers, social engineers, and activists of every stripe. While the creative wave had crested, the rush to harness the arts to tourism, to downtown redevelopment, to the alleviation of social problems, and to the delivery of political messages had just begun.[92]

5

THE SORCERER'S
APPRENTICE

THE NATIONAL ENDOWMENT for the Arts marked its first decade
of existence with two days of festivities in 1974. On September 3, current
and former council members, panel chairs, and guests partook of an infor-
mal meal and entertainment by grantees, staff, and past and present coun-
cil members. The next day, the celebrants lunched with congresspeople at
the Capitol and dined with more congresspeople and other dignitaries in
the atrium of the Kennedy Center before attending a performance of
David Merrick's show *Mack and Mabel* in the opera house. The commem-
oration actually came only nine years after the NEA's founding, so, the fol-
lowing year, the real anniversary was celebrated on September 29 and 30 at
the Lyndon B. Johnson Library in Austin, Texas. In addition to the council,
guests included Lady Bird Johnson, Senators Hubert Humphrey and Jacob
Javits, Kirk Douglas, the artist Jamie Wyeth, and the operatic baritone
Robert Merrill. The soprano Beverly Sills told the group, "Art is the signa-
ture of civilization."[1]

Within just a decade, the endowment was swaddling its governing body
in a patchwork of pious rhetoric, ritual, and light entertainment. Mean-
while, the council members' attendance at regular meetings had dropped
drastically. All but one of the twenty-six members had attended the first
meeting in April 1965. The council's thirty-ninth meeting, May 1–4, 1975,
in Seattle, had attracted a bare majority of fourteen. But while twelve were
absent from the council's table, the room was packed with nineteen pan-
elists, thirty-two staff people and consultants, and eighteen guests. The

council spent about seven hours in closed sessions, reviewing grant recommendations, plus about ten hours in open sessions to discuss policy. A good many additional hours went into the numbing ceremonial of self-congratulation obligatory for all official bodies: presentations of the Governor's Arts Awards and the Seattle Mayor's Public Service Awards in the Arts.[2]

According to many participants, the early council meetings were panoplies of wit and passion, spirited with debate, crackling with new ideas. The fashion ambassador Eleanor Lambert recalled the freshness and excitement of those gatherings: "I felt part of the center of creative thought." In the presence of brilliant colleagues, Lambert "felt embarrassed," she recalled. "They might not think costume to be much of an art." Nevertheless, she obtained $25,000 for a Metropolitan Museum seminar for costume curators to share knowledge about clothing conservation, the use of sterile cupboards, and safe cleaning methods. Agnes De Mille once pleaded for twenty minutes in behalf of a $50,000 grant for new choreography by Jerome Robbins. "She was so eloquent," said Lambert, "she got tears in everyone's eyes." Robbins used the money to create his *Schoenberg Variations* and two other classic ballets.[3]

Attending the council some years later as a visitor, Lambert found the discussion "abysmally dull," she said. "It was so inane that . . . [one member] . . . took a *New York Times* out of his briefcase and read it while the talk continued." As money and grants proliferated, administrative problems plagued the council; each program vied for more of the budget pie. Charles McWhorter, a New York attorney and Republican activist appointed to the council by Richard Nixon, watched the transformation from "a collegial group of amateurs" to a more business-oriented and political gathering. A staff attorney at AT&T, McWhorter had been interested in cultural matters since his attendance, at age sixteen, at the Interlaken Music Camp. In 1956, while he was chairman of the Young Republicans, he had organized the Newport Jazz Festival, before joining Vice President Nixon as chief aide.[4]

At council meetings, McWhorter sometimes startled the staff by wearing a serape and beads, but his was a generally conservative voice, questioning many of the endowment's new programs. In particular, he opposed the Expansion Arts program's efforts in slum neighborhoods as "a catch-all for do-good instinct." The program's multiplicity of small projects and pilot programs, he argued, opened the way for "abuse, not excellence," turning the arts into a social program. Often it "funded a person in a storefront," with a sparse following. Instead, he contended, "someone on the spot

should be looking for little blades of grass to nurture." With his strong political connections, however, McWhorter served as a sterling witness for the endowment at congressional hearings. He understood that the Department of the Interior subcommittee charged with NEA oversight consisted mostly of congressmen from western states who were amenable to "offset politics": They received support from easterners for agricultural or reclamation projects in exchange for their backing of arts funding.[5]

Although the council was to be an independent guarantor of excellence in the arts, political arrangements had been part of its composition from the beginning. While the president named all members, New York's Senator Jacob Javits had insisted that the fashion industry be represented and had also joined Senator Claiborne Pell in claiming two seats for labor unions. In 1975, political deal making intruded further, as Congress directed that council appointees be confirmed by the Senate. This placed the president's nominees into political play, encouraging senators to trade confirmation for unrelated political favors, further diluting the council's prestige. The producer Hal Prince was one council member outraged by Jimmy Carter's blatantly political appointments. He and several colleagues called on the White House and "suggested [they] would go public if that policy continued."[6]

Carter's subsequent appointments were more appropriate, but the overall caliber of the council was in decline. Instead of an acknowledged elite, a brilliant gathering representing the nation's most accomplished cultural figures, the council became a collection of figureheads, representing various powerful interests within the culture industry. Unions, state and local arts councils, advocates for various disciplines, trustees of arts organizations, corporate patrons, and arts managers were named to the council, while each of the genuine artists fought tenaciously to obtain extra support for his or her field.

Nevertheless, the regal progress of the council's meetings still conveyed an impression that it was functioning as intended, carefully reviewing panel recommendations, studying budget allocations, and setting overall policy. To prepare for the quarterly deliberations, each member received papers supporting grant applications and summarizing the panel discussions that had led to recommendations for approval or rejection. By 1977, these papers, bound into "books," had become obese, even overflowing into two hefty volumes. "Many actions were taken *in vacuo*," complained one council member. "We stamp approval upon actions without adequate knowledge. . . . The majority of the Council voice approval or disapproval

on a majority of grant proposals in areas of self-admitted incompetence."[7]

As often happens when a part-time board supervises a professional staff, function leaked out of the meetings and was replaced by empty gestures. The ritual began with the presidential appointment and, since the political horses had already been traded with the Senate, was followed by the exchange of extravagant flatteries (hopefully with media in attendance) that passed for confirmation. The appointee immediately received a magnificent certificate, more suitable as a reward for faithful service than as a token at the outset of a six-year term. It was a sixteen-by-twenty-inch rectangle of archival quality, cream-colored tag board, with the name and personal details in copperplate calligraphy to match the majestic boilerplate. The president signed at the bottom, next to his ornate seal, scalloped and embossed, resembling a miniature paper doily. Thus initiated into their august status, the council members would converge on Washington four or five times a year for carefully orchestrated deliberations, punctuated by luncheons, receptions, and dinners. Treated like visiting royalty, council members graciously accepted the obeisance of staff and grantees, with only cursory glances at the weighty volumes of materials they were to review.[8]

"There seems to be little time or opportunity for dialogue with program directors and panel chairmen," wrote the council member J. C. Dickinson, director of the Florida State Museum, to his colleague Hal Prince. The council's only encounter with top NEA staff, he added, was at a working dinner, at which "attendance [was] not good." Dickinson also worried that the endowment's priorities and spending plans came mostly from the "professional segment of the cultural community" and wondered whether "these pressures represent[ed] . . . the demands of the American people." Having expressed his concerns at a council meeting, Dickinson, predictably, was named to a committee to study reform. He sent a survey on problems and solutions to seventy present and former council members, but received only three replies.[9]

Hal Prince was unimpressed with Dickinson's complaints. The heavy books did not overwhelm him and, if uninformed, he was glad to rely on the staff: "This is as it should be." The Broadway producer was not about to antagonize the staff or council colleagues, since he was pushing a private agenda. With support from two council colleagues, the conductor and composer Gunther Schuller and the opera composer Carlisle Floyd, Prince labored to persuade the endowment to add musical theater to its opera program. Such a move would benefit leading producers of Broadway musicals, like Prince. Government support would shift the expense of developing

new musicals from the commercial to the nonprofit sector, as was already happening in serious drama. Grants would support librettists and composers while they were perfecting their product and might also go to nonprofit companies for tryout versions of new musicals. These productions, in turn, would train actors, dancers, musicians, directors, and other theater professionals, giving Broadway producers a wider choice of personnel. So eager was Prince to place musical theater under the endowment's umbrella that in June 1978 he flew overnight from London to attend the council's deliberations. Some three and a half hours later, with the program approved, he was on his way back across the Atlantic.[10]

Technically, Prince's participation in the discussions and voting did not constitute a conflict of interest, since the benefits he would gain were not a grant but were only potential and indirect. Yet the possibility of conflicts of interest had been bothersome since the NEA's inception. At the council's second meeting, staff counsel had warned members to "remain as free as possible from affiliation with organizations, associations, institutions, which could conceivably have an influential relationship with the Council or the Endowment for the Arts." In an effort to curb perceptions of self-dealing, the endowment's attorney instructed panelists and council members in 1975 to "excuse themselves . . . when an application with which they are affiliated comes up for discussion." Hal Prince himself had inquired in 1976 whether it was proper to lend his name to Advocates for the Arts, which lobbied for increased arts funding; Michael Straight had assured Prince that no conflict existed.[11]

As the council faltered, Nancy Hanks's term came to an end, and the new president, Jimmy Carter, confronted the delicate task of finding a successor. The Washington rumor mill ground on, as one after another candidate, including Nancy Hanks herself, was considered and found wanting. Among them was McNeil Lowry, the Ford Foundation's Santa Claus to the arts, whose insistence on speaking his mind was considered a detriment. By now, dozens of arts "service" organizations had settled in Washington, the better to pursue the political interests of their particular field. In addition, state and local arts councils had organized into Washington-based "advocacy" groups, and the interests of major arts organizations, especially in New York, were assiduously promoted by still other lobbyists. Finding an NEA chair who would please them all challenged the new White House staff and even the president himself. The battle royal over a new chair for the humanities endowment had been so intense that a White House aide

observed that the president was spending more time on this appointment than he was on the crucial SALT disarmament talks with the Soviet Union.[12]

At last, Carter chose a man who had hammered out the original NEA legislation and seen it through Congress, who had worked at the endowment during its earliest years, and who had spent decades as an aide to Senator Claiborne Pell, the agency's leading advocate at the Capitol. Livingston Biddle sprang from a long family tradition of public service. His cousin Francis had been attorney general under Franklin Delano Roosevelt and Francis's brother, George, an artist, had helped to extend WPA benefits to needy artists during the Depression. Senator Pell and Livingston Biddle had attended the same classes at the exclusive St. George's School in Newport, Rhode Island, before going on together to Princeton. The two also shared "a fundamental feeling," as Biddle delicately put it, "that privileges in one's lifetime dictate a deep responsibility to others."[13]

Beneath Biddle's pixieish appearance and faultless manners lurked a natural flair for political intrigue. For years, Liv, as he liked to be called, had struggled with writing in the attic of his pre-Revolutionary Philadelphia farmhouse, a gifted amateur with a private income. After producing four novels, two of them best-sellers, and an assortment of shorter nonfiction, he had exhausted "the interwoven, immensely intricate tapestries of Philadelphia society," he wrote, and was seeking fresh material and, perhaps, fresh challenges. John and Jacqueline Kennedy were making the arts fashionable when Biddle joined Senator Pell's staff in 1962 as a writer of speeches and articles. The Philadelphia patrician soon found his special calling: to carry the arts beyond high-class White House entertainment by persuading the federal government to take up its duty, as he saw it, to provide them with financial support.[14]

In his memoirs of those years, Biddle zestfully describes the late-night strategy sessions, the Byzantine negotiations, the cloakroom intrigues, and the final suspenseful votes that resulted in the birth of those fraternal yet estranged cultural twins, the endowments for the humanities and the arts. Naive at first, Liv soon mastered Washington's subtle power game: the calculated leak, the artful media spin, the gentlemanly headlock, the thrust and parry of debate. In the Second World War, Biddle's poor eyesight had kept him out of the draft, so he volunteered to drive an American Field Service ambulance. "The officer who took me in," he recalled, "said there were only two criteria, and I'd already fulfilled the first, I was breathing. I also had the second, a driver's license." Such wry understatement fooled

many a political opponent into underestimating Biddle's will and tenacity.[15]

When Biddle took over the chairman's office on November 7, 1977, he brought an intimate knowledge of the endowment's inner workings, as well as of its friends and enemies. He had spent several years as Roger Stevens's deputy before returning to Pell's office to help congressional passage of huge funding increases for the endowment during Nancy Hanks's chairmanship. While the NEA's appropriation would continue to grow during his tenure as chair, from $100 million to $165 million, Biddle believed that there was no limit to the amount the arts could absorb. He likened their plight to the desert flowers he had watched during his wartime service, blooming briefly after a rain before withering in the sun's heat. "This is the situation of the arts," he said. "They are not deeply rooted enough to survive drought."[16]

Intelligent, energetic, and idealistic, Biddle also was shrewd enough to spot the NEA's weaknesses, particularly its feeble policy and increasingly entrenched bureaucracy. Almost immediately, he gathered all program directors and bluntly told them that they should consider five years on the job as "a benchmark," after which "they should think it a good idea to move elsewhere." Biddle suspected that those who had served longer had become too involved with their fields and that they were playing favorites among their clients, while losing touch with the public's needs. When the constituencies of various programs angrily protested, "it convinced me that I was right," said Biddle. "I saw grants to the same organizations year after year. I believed that the more you open the door, the more people come in." Ruth Mayleas, who had run the drama program since the beginning, while commuting from New York, was so angry at being asked to step down that she filed suit, before moving on to run the Ford Foundation's drama program. The only survivor of Biddle's program director massacre was Brian O'Doherty, who nimbly shifted from visual arts to a new program in media arts. To shake up the grant review panels, Biddle decreed that one-third of their members be rotated every two years.[17]

The new chairman then reorganized the administration, naming new deputies for programs, for policy and planning, and for intergovernmental activities. To counter criticism that the council had become a rubber stamp, he formed its members into parallel committees, for budget, for policy and planning, and for federal-state partnerships. But while appointing new people and forming new committees was easy, achieving real change in the endowment's operations was difficult indeed. Flush with money that the endowment had provided to aid their organization and

maintenance, and fortified by a change in the law to allow greater use of their funds for advocacy purposes, the arts service organizations vigorously lobbied not only Congress but also the NEA itself. Allied with the program directors Biddle was painfully dislodging, they resisted his changes and doggedly pursued their own agendas.[18]

Phil Kadis, a cultural reporter for the *Washington Post,* was brought in as deputy chair for policy and planning. In response to demands from Sidney Yates, one of the endowment's chief congressional supporters, Kadis was charged with drawing up a five-year plan for the agency. After a year, Kadis realized that his plan was "much vaguer than I had hoped. . . . Each of the various disciplines was a barony." He was taken aback by their resistance, he said. "Trying to pin down programs and their directors was like nailing jelly to a wall." To his dismay, Kadis learned that the NEA "was no different than most government agencies . . . instead of seeing itself as serving the public, it had become the representative of the arts in government." The minuscule endowment had acquired some of the same defects as the mighty Pentagon, with its notorious revolving door between the defense industry and the military. Kadis found each program director disinterested in improving the agency's service to the public, while fiercely defending his or her own field and hustling to increase its budget. After two and a half years of attempting to create the five-year plan, Kadis gave up, "recognizing I was not getting anywhere." He became Biddle's special assistant and stayed at NEA to the end of Biddle's term.[19]

As the reorganization fizzled, Biddle turned to other, politically motivated, endeavors. He raised funding for arts in urban ghettos and other ethnic enclaves by 40 percent during his first year, to $11 million. He also established the Office of Minority Concerns and the Hispanic Task Force within the endowment, and instructed panels to pay special attention to grant applications from minority artists. These initiatives suited Biddle's philanthropic bent and also fitted the Carter administration's desire to use the arts for social programs. While a detailed five-year plan never materialized, Biddle supported a council committee's recommendations to fund more individual artists and to direct organizations' grant money to new work instead of ongoing activities. This committee also urged that artistic quality, not budget size, be the criterion for grant size. It urged the endowment to nourish new institutions and also encourage small presses and artists' spaces. These and many other thoughtful suggestions were enough to satisfy Congressman Yates's demand for a plan. Yet so amorphous was the endowment's mission, and so raucous the constituency it had built, that

the chair had his hands full in simply pouring pacifying words on the various contenders.[20]

To this end, like Nancy Hanks, Biddle spent a good deal of time on the road, meeting with the NEA's clients and talking up the arts, a referee-cum-cheerleader. On a typical day in Cleveland in 1977, he was taping a television interview at 8:00 A.M.; spoke to the Cleveland Youth Orchestra at 10:00 A.M.; visited with the art museum director at 11:00 A.M.; gave a televised speech before a civic club at noon; walked through an arts center; held a press conference; and met with local arts patrons at the Cleveland Foundation Library. At 4:00 P.M., he appeared before the editorial board of the *Cleveland Plain Dealer,* followed by an early dinner and speech at the posh Union Club. After attending a performance of the Cleveland Ballet, he was guest of honor at a reception and, after obligatory conviviality and toasts, fell into bed. It was well after midnight.[21]

In his mission as ambassador for the arts, Biddle had an extraordinarily potent partner. The vice president's wife, Joan Mondale, emerged from the shadows of her husband's career to devote herself to promoting the arts. When Jimmy Carter's appointment of her as chairman of the revived Federal Council on the Arts and the Humanities was deemed unconstitutional, he named her honorary chair. The irreverent named her "Joan of the Arts." Her husband obtained four staff positions to aid her arts crusade, including Bess Abell, Lady Bird Johnson's former social secretary, a formidable administrator nicknamed "the Iron Butterfly."[22]

Joan Mondale traveled some 17,000 miles during the first eighteen months of her husband's vice-presidential term. She met with artists, visited museums, spoke at luncheons and dinners, attended performances, and raced all over town in what politicians call "quick hits," appearances that would attract media coverage for a particular issue, person, or event. In Houston, she rallied preservationists attempting to save old clapboard houses in the sixth ward. In the Kentucky hills, she boosted a crafts center. In Kansas City, she opened an exhibition of Native American art. In Chicago, she dedicated Claes Oldenburg's sculpture *Batcolumn.* In New Mexico, she toured to honor the painter Georgia O'Keeffe and the potter Maria Martinez. In Los Angeles, she donned an apron, straddled a potter's wheel, and threw a ceramic dish, as news cameras whirred. In SoHo, she ate stuffed artichokes and fettucini with Robert Rauschenberg, Roy Lichtenstein, and Louise Nevelson. In Buffalo, where city leaders contended that a new sculpture at the federal building would look best at the bottom of Lake Erie, Joan

treated the mayor to a slide lecture on urban art. In Atlanta, she pulled the mayor away from an important Falcons game in order to attend her dedication of a playground featuring Isamu Noguchi sculptures.[23]

In Washington, too, Joan Mondale tirelessly promoted the arts. Three weeks before the inauguration, as President-elect Carter and her husband conferred on the new administration's plans at Georgia's Sea Island, she persuaded the future interior secretary Cecil Andrus to stock locally made crafts in national park souvenir shops. She tried to convince the new general services administrator to spend 1 percent of the total cost of all new construction on art, instead of just ⅜ percent, and obtained a compromise at ½ percent. She pried $20 million out of the Department of Housing and Urban Development for the NEA's Livable Cities project. She prodded the staff of the re-activated Federal Council on the Arts and the Humanities to inventory federal cultural projects; it unearthed some 100 million dollars' worth. Her husband telephoned the budget director to reverse a $5-million cut in the NEA's funding; asked why he was so adamant, Fritz Mondale replied that if the cut went through, "my wife would divorce me."[24]

To Biddle, extra money for the endowment signaled "a special commitment . . . a message of good cheer to the arts." But to Joan Mondale, her sudden prominence was a release from decades of lonely drudgery as a political wife. From the day Fritz Mondale determined to seek his first political post, as Minnesota's attorney general, politics, wrote Mondale's biographer, had been "an almost all-consuming challenge that required sacrifice of everybody in the family." The day he was appointed, "the phone rang incessantly," Joan recalled. She was changing their four-month-old daughter on the bassinet when "the phone rang, rang, rang, and she rolled off and fractured her skull on the bathroom floor." Then the bank called to report a forty-dollar overdraft.[25]

Like her husband, Joan was the daughter of a peripatetic Protestant minister. Born in Eugene, Oregon, she had lived in Ohio and Pennsylvania before her father took a job as chaplain of Macalester College in St. Paul, Minnesota. After attending the city's most exclusive prep school, Joan Adams majored in history and minored in art and French at Macalester. Graduating in 1952, she hoped for a career in art and, after a year working in the slide library at the Boston Museum of Fine Arts, she returned home to work in the education department of the Minneapolis Institute of Fine Arts. Two years later, Joan married Fritz Mondale at the Macalester student union, after a fifty-three-day courtship during which they had only

eight dates. Joan continued at the museum, her $100-a-week salary supporting the couple while Fritz went to law school.[26]

From the moment he picked up his diploma, politics dominated the couple's life. They moved into a small apartment at her parents' home in order to save for a house. Having bought a spacious Victorian in one of Minneapolis's most desirable neighborhoods, they used it for political entertaining. Once Joan had seventy-one guests at a sit-down dinner in honor of the popular musician Henry Mancini. When Mondale was appointed to fill Hubert Humphrey's unexpired Senate term in 1964, they moved into a decrepit split-level in Chevy Chase, Maryland. While Fritz took his place in the elegant Senate chambers, Joan dealt with a broken dishwasher, clogged drains in the kitchen sink and shower, and the dust shrouding the shabby furniture. Six months later, the family was back in Minneapolis, as Fritz campaigned for a full Senate term. Father was seldom home, living in a small room in Washington's Congressional Hotel and commuting whenever possible to politick in Minnesota.[27]

After the election, the Mondales moved to Washington for good in 1964. They lived in a spacious three-story house, attractively decorated but sparsely furnished for lack of money. Fritz spent so many weekends on political business in Minnesota that his children were surprised when he was at home. Joan did not care for the capital's social whirl and missed the camaraderie among political wives in Minnesota. Reporters from home-state newspapers were so put off by her self-effacing wifeliness that they called her "Phony Joanie." With her three children in school, Joan began to join civic organizations, was a volunteer tour guide at the National Gallery, and attended a weekly ceramics class. She also wrote a children's book, *Politics and Art,* published in 1972, in which she stated: "Artists can reveal the truth about ourselves in powerful and compelling ways . . . and when they do this, they can spur us into action."[28]

While such warm baths of generalized good will continue to be a staple of official discourse about the arts, they do little to excite the public's interest, and even less for artists themselves, who are typically practical about ways and means and skeptical, if not cynical, about the high-flown benefits of what they do. Nevertheless, Joan's uncritical ardor for matters artistic certainly spurred *her* into action when she became the Art Veep—but it was not always welcomed. Within the art world, many complained that her attempts to set minority quotas for trustees and museum exhibitions were politicizing the NEA, a pork barrel masquerading as a creative well. A New York museum official called it "phony populism, it was grass-rootsie." A

conservative critic grumbled that Joan Mondale "appreciates the arts almost every minute of the day . . . and one could wish her an honest Philistine to grapple with." [29]

As the NEA entered its second decade of life, conservative critics who had failed to throttle the infant endowment in its cradle were joined by serious scholars and artists. The accounting for all arts spending at all governmental levels had "softened to the point of nonexistence," complained Dick Netzer, a New York University economist, in 1974. The attempts to insulate the arts funders from politics, he charged, also shielded them from any evaluation of results. The system, he wrote, was "an apparently aimless dispensation of funds on the basis of nothing more concrete than Noble Intentions." When the historian Arthur Schlesinger, Jr., protested naked politics in council appointments, Biddle reportedly "smiled serenely and murmured, 'Politics is one of the great humanities.'" Testifying before a senatorial committee, the Yale Drama School director Robert Brustein deplored Claiborne Pell's populist aims for the endowment. "What you are talking about, finally," he told the committee, "is not the humanities, but a government-sponsored form of adult education."[30]

Ronald Berman, who had chaired the NEH during the Nixon years, noted in 1979 that after the expenditure of almost $1 billion, he was "hard put to name a single work of art worth recollecting that [the NEA had] made possible." Nor could he link NEA grants with any serious effort in training or apprenticeship. The endowment, he concluded, represents "the arts" rather than art, "a way to distribute funds, rather than promoting achievement." The influence of the arts establishment among politicians and within the NEA's corridors had driven out critical standards. "Art is whatever is done, whether crafts, hobbies, or simply the display of intentions," he wrote. "It is an ennobled form of middle-class entertainment." The very word *creative*, he grumbled, no longer described an achievement but only "an attitude about the self. . . . It belongs not to aesthetics but to pop psychology."[31]

Another critic noted that since the endowments had been founded, "the growth of the cultural bureaucracy is as imposing as it has gone unremarked." After a decade, at least 250 federal or quasi-federal programs were assisting the arts. By 1978, at least eight hundred executive-level officials were involved with cultural patronage, many of them dispensing an estimated $400 million with the aid of "a retinue of deputies, associate directors, assistant directors, program associates, administrative assistants,

public information officers, fiscal management directors, and so forth." To Karl E. Meyer, who now sits on the editorial board of the *New York Times,* "it was all too clear that a program of public assistance to the arts, prodigious in its amplitude, existed in a vacuum and that government, abhorring a vacuum, had filled it with a bureaucracy." Among congressmen, however, "the arts are politically salable." John Brademas, an Indiana Democrat who later became president of New York University, was convinced that his colleagues "could get into more difficulty voting against the arts than for."[32]

Likewise in state after state, the arts lobby was so well organized that governors found it lethal to cut entitlements. In Georgia, Jimmy Carter was forced to retreat from including cuts in the state arts council funding in an economy drive. In Michigan, the major arts organizations circumvented the governor to obtain line items in the budget through the state legislature. In Pennsylvania, the six largest arts organizations threatened a similar approach directly to the legislature until the state arts council guaranteed them 40 percent of all its funding. To Charles McWhorter, the arts were "as bad as any bunch of dollar-grabbers."[33]

Biddle placidly declared that the militancy of local arts advocates "demonstrated the rising tide of civic participation in the values of the arts." He provided grants to organize the National Assembly of Community (now, Local) Arts Agencies, which became yet another powerful voice to remind congressmen that helping the arts back home paid off. In every discipline, one or more service organizations sent spokespeople to the Hill and used their own publications to rally the membership for letter writing, telephoning, or personal appeals to politicians. Thanks to NEA grants, American PEN swelled from a tiny writers' circle with a budget of less than $10,000 into a sizable association that could spend $200,000 to send famous American writers to an international conference. The Coordinating Council for Literary Magazines was formed to funnel NEA grants to its unprofitable, largely obscure, perpetually proliferating membership. An NEA emissary spent all night mollifying squabbling dance troupes and pressing on them a $25,000 grant to start the Association of American Dance Companies, now defunct and replaced by Dance/USA.[34]

So long as the endowment's budget was rapidly increasing, the ever-expanding web of arts service organizations could be funded without depriving existing grantees. But as the budget stabilized and was even eroded by inflation, cannibalism menaced this crowded field. Long-established organizations felt threatened by younger, more agile upstarts. Those in cities like New York, where the arts are a vital economic resource, feared that

they would be plundered by regional consortia, which the NEA had also encouraged. "Every constituency wanted to be heard," recalled one NEA program director. To surmount this unruly jungle, a new umbrella group was formed in 1977. The American Arts Alliance at first included such cultural treasures as the Metropolitan Opera, the New York Philharmonic, and the Guggenheim Museum, but eventually its membership grew to more than four hundred. Its generalized goal was to highlight the importance of the arts, to develop and exchange information, and, above all, to lobby Congress on the need for more public money. Headed by Ann Murphy, whose Capitol Hill experience went back to the early 1960s, the alliance soon became a dominant voice for the arts in Washington. Its representatives sat on NEA panels and testified before congressional committees. "With such muscular bulls on the loose, butting and stomping one another," one critic wondered, "how can the work of the NEA . . . be . . . anything more than a gigantic political brawl?"[35]

Buttressing the mass of arts service organizations was a growing army of scholars scrutinizing various aspects of the arts and producing, for various interested parties, excruciatingly dense and diffuse reports. In 1974, an informal gathering of sociologists had presented a two-day series of papers on "Social Theory and the Arts" at the State University of New York at Oswego. Refreshingly informal, the group had no money, no rules, and only volunteer hosts. Within less than ten years, this annual conference acquired formal procedures, a tidy treasury, and four times as many papers. It also attracted political scientists, historians, and other scholars, many of whom were finding extra work as consultants to arts organizations, to their service groups, and to the NEA.[36]

Despite an enormous volume of articles, books, studies, and reports, the interface between social science and the arts remains ragged, if not useless. Statistics are unreliable, artists ignore questionnaires, categories overlap, accounting methods vary, and new kinds of art emerge without warning. To the despair of the scholars attempting to dissect the arts scene, the American cultural landscape is far too diverse and rambunctious for neat analysis. Not even the U.S. Census Bureau has been able to sort fine artists from commercial artists, classical musicians from barroom fiddlers, actors in serious drama from those starring in commercials, full-time ballet dancers from Broadway hoofers. (Indeed, in the real world, the high artist and the low money-grubber are often one and the same person.) Every arts organization appears to have its own bookkeeping system, some mingling endowment income with box office receipts, others forgetting that free rent

at university campuses or city auditoriums must be reported as income.

Commissioned by the NEA to study the growth of arts and cultural organizations during the 1970s, a group of social scientists bemoaned the woolliness of available data. In eighteen painful pages, the researchers cited the messiness endemic to the arts: symphony orchestras that also sponsor operas; a presenter like the Aspen Music Festival that supports chamber music, symphony and dance; the New York visual arts space The Kitchen, which receives grants in music, dance, media, museum, opera-musical theater, media, and interdisciplinary arts; the New York Shakespeare Festival, which produces its own plays and sponsors performances by other companies as well. Furthermore, the American cultural mosaic includes innumerable arts organizations with budgets under $100,000 per year, too small to count, or whose income is largely in volunteer labor or in-kind contributions. Also nettling to those attempting an orderly report were the many ephemeral groups, springing up like mushrooms after a rain, giving a few performances, and evaporating at the first dry spell. Left out entirely were such key components of the cultural landscape as the role of private philanthropy, employment of artists, and changes in geographic distribution of the arts. After spending many thousands of hours (and dollars) attempting to make sense of the fragmentary information available, the researchers concluded that their data were "of questionable quality"— but nevertheless published a one-pound report.[37]

As the NEA's managers devoutly suggested, the agency's activities seemed to be introducing the arts to new, diverse audiences. Yet despite innumerable studies deliberately designed to demonstrate this desirable result, little proof of such democratization ever emerged. Commissioned by the endowment in the mid-1970s to characterize the arts audience, Paul DiMaggio, a sociologist who has devoted a distinguished career to examining the arts, painted a bleak and static picture. He reviewed 270 previously published audience surveys only to conclude that culture consumers, as always, had more education, higher incomes, and higher-status jobs than the general public. Boiling down these hundreds of audience studies, DiMaggio's group extracted striking proof of this assertion: While professionals, teachers, artists, and writers constituted only 20 percent of the population, they formed 86 percent of the arts audience. "We could find no evidence," he wrote, "that audiences were becoming more democratic. None of the variables showed any significant change over the last fifteen years."[38]

An impressionistic account by another scholar asserted that less than 1

percent of Americans attended a single symphony concert in 1974. Calcu-
lating from precise figures for the city of Atlanta, he found that some
25,000 residents had attended any concert by the city's symphony orches-
tra, about 1.5 percent of the population. Such a pastime, he wrote, remains
"an elitist activity for the financially advantaged."[39]

This verdict applies with particular force to symphony orchestras,
America's oldest cultural institution. By far the most venerable is the New
York Philharmonic, founded in 1842. For ten dollars, a subscriber received
four seats at each of the first season's three concerts. Such a price, eighty-
three cents per concert ticket, was considered steep at the time, when the
best theater seat cost fifty cents, and one could view a play from the gallery
for twelve and a half cents. The musicians were paid a portion of box office
receipts, twenty-five dollars for three concerts. In the second season, musi-
cians earned thirty-two dollars for four concerts, and by the fourth season,
their portion rose to thirty-seven dollars. Over the years, the seasons grad-
ually lengthened, eventually bestriding most of the calendar in the last few
decades. In its first 120 years, the Philharmonic gave just over six thousand
concerts. In its first twenty years at Lincoln Center, by contrast, this
ensemble presented nearly four thousand concerts.[40]

The distension of symphony seasons in recent years has imposed intense
financial—and artistic—pressures on orchestras. No longer can any con-
ductor contemplate such a staggering premiere as took place in 1916
in Philadelphia. Then, Leopold Stokowski proposed giving the first Ameri-
can performance of Gustav Mahler's six-year-old *Symphony of 1,000* and
demanded a year of rehearsals. Drawing on an extravagant budget of
$15,000, he spent fully three months auditioning prospects for an eight-
hundred-voice chorus. The platform for the singers took six weeks to build
and cost $3,000. More money went into enlarging the Academy of Music
stage to accommodate the gigantic orchestra the work demanded. Today,
hardly a substantial audience would clamor to hear a new musical work.
Then, 25,000 attended nine performances in Philadelphia, while 10,000
others were turned away. The production then traveled to New York on
two private trains totaling seventeen cars; speculators there were demand-
ing twenty-five dollars per ticket.[41]

By contrast, the Chamber Music Society of Lincoln Center tiptoes
warily indeed toward contemporary repertoire. In the early years of its res-
idency at Lincoln Center's Alice Tully Hall, the group sometimes ad-
ventured into the twentieth century. "The audience was not very fond of
it," said Miss Tully, the principal donor of the building. "They only wanted

a little bit. . . . The [program planners] have to keep that in mind, if they expect the people to stay." The society took Miss Tully's advice to heart. In 1993–94, it offered a three-concert series, "Music of Our Time," scheduled for Monday evenings in a rehearsal studio on the tenth floor of the Juilliard School high-rise, a space seating about seventy-five people. The society's music director David Shifrin explained that he considered his ensemble's principal mission to perform the great chamber repertory of the past.[42]

Orchestra managers are understandably cautious in planning their programs in the face of the intense competition their ensembles face, not only from other musical attractions, both live and electronic, but also from other orchestras. Before the mid-1950s, all but the "Big Five" (The New York, Boston, Philadelphia, Cleveland, and Chicago symphony orchestras) played part time, the musicians supplementing their incomes with teaching and occasional chamber music or solo gigs. But the furious expansion of the 1960s swelled not only orchestra seasons but also the number of professional orchestras. In the 1961–62 season, 271 orchestras gave 2,903 concerts; in the 1969–70 season, 620 orchestras gave 6,758 concerts. Between 1966 and 1974, the number of concerts leaped by 80 percent.[43]

Where attending an orchestra concert had once been an elite obligation, a somnolent afternoon or evening's gesture in the direction of cultivation, local boosters in cities and towns across America suddenly seized on their music ensemble as emblems of go-ahead civic vitality. With the Ford Foundation showering unheard-of sums on orchestras, and with the government adding its mite, local sponsors could dream of paying for magnificent music with other people's money. In Atlanta, for example, the civic drive to become known as a first-class city included not only acquiring a major-league baseball team but also building an orchestra "as a kind of expansion team," one observer wrote, "in some new symphonic Big Ten." The new conductor was Robert Shaw, a former director of Fred Waring's Glee Club and later an assistant to George Szell in Cleveland. Shaw's predecessor had complied with the trustees' requests for light fare, including in his programming selections from *South Pacific* and *Show Boat* and medleys of songs by George Gershwin and Irving Berlin. Shaw instead dared to include a Charles Ives selection in the 1971–72 season. He also skipped attendance at some trustees' social events. For such lapses, a cabal on the board wanted to fire Shaw. He was saved when his board supporters bought a half-page newspaper advertisement asking Atlantans to write their subscription checks to "Robert Shaw, Music Director, Atlanta Symphony Orchestra." In 1965, the Ford Foundation had given the Atlanta

Symphony $750,000 spread over five years for operating expenses, plus $1 million for its endowment, to be matched by local contributions within five years and to be maintained for five more years. At the end of that decade of fiscal enhancement, the orchestra's finances were more fragile than ever; annual expenses had grown tenfold, from $300,000 to $3 million.[44]

Nor were the Big Five spared the debilitating cost squeeze. The Chicago Symphony, founded in 1891 and third oldest in the country, saw its unrestricted endowment shrink within four years after 1964 from $6.2 million to just over $1 million. Annual operating expenses ballooned by 50 percent to $3.25 million, while operating income grew barely 30 percent, to $1.55 million. The manageable deficit of $840,000 in 1964 more than doubled in three years. Faced with such a crisis, the symphony's manager said, administration "disappears like a Central American government." Meanwhile, the orchestra was giving far more concerts than ever before. In 1965, the management, urged on by the Chicago mayor Richard J. Daley, had signed a contract promising the orchestra's musicians more concerts every year until a fifty-two-week season was achieved by 1968. No one had any idea where to find the extra bookings.[45]

Similar cadenzas played out in orchestra board rooms all over the country. The major orchestras' annual budgets, which had averaged $600,000 in 1957, surged (with correction for inflation) to $2.8 million by 1971. By then, insiders sadly concluded that the Ford Foundation's largesse had been essentially counterproductive. The grants for operating expenses had been spent largely for musicians' salary increases, and the much-publicized endowment funds tempted trustees into further overspending.[46]

When the Lincoln Center concert hall opened in 1962, for example, the New York Philharmonic's musicians were earning twice as much as they had only three years earlier. By 1972, the musicians in New York, as well as in Philadelphia, Chicago, Boston, and Cleveland, included seven weeks' paid vacation in their union contracts. Players had as much free time as they'd had twenty years earlier but now they were being paid for it. The quick fix appeared to be free concerts in parks and extended tours, sponsored by the city and corporations, plus outdoor "music festivals." Boston expanded its long-established series at Tanglewood. Chicago devoted eight weeks to Ravinia. Philadelphia played at nearby Robin Hood Dell during July and traveled to Saratoga in August. Cleveland sank $7 million into the Blossom Music Center, off a turnpike between Cleveland and Akron.[47]

The American Symphony Orchestra League had opposed the NEA when it was first proposed during the early 1960s, fearing it would be the

entering wedge for government control. But as vastly increased government funds for the arts became available during the Nixon years, hard-pressed orchestras overcame their qualms. Called to a meeting at Lincoln Center in November 1969, more than two hundred orchestra delegates learned that, within two years, deficits for eighty-eight major orchestras would total $13 million. David Rockefeller told the assembly that it could expect scant increase in corporate contributions. McNeil Lowry added that foundation grants also were exhausted. Nancy Hanks then urged the group to get behind more federal money for NEA. In subsequent months, a flyer rested on each concertgoer's seat, urging him or her to write the local congressperson for increased NEA appropriations.[48]

The endowment's first formal program for orchestras distributed $2.9 million among seventy-five grantees. By 1978, music was the endowment's largest single program, swallowing some 20 percent of the agency's total budget. At the local level, meanwhile, orchestras frequently captured most of the public money available for the arts. In Baltimore during the early 1970s, for example, the symphony consistently received well over half of all arts funding, with the remainder doled out to as many as sixty-five other applicants.[49]

Underlying musicians' seemingly exorbitant salary demands was the disappointment of many at playing in an orchestra at all. Of all nonprofit art forms, orchestras provide the greatest number of individual artists with full-time employment. Yet, at conservatories, training was (and still is) oriented toward a solo career, possibly participation in a chamber music ensemble. At colleges, a music student can graduate without ever attending an orchestra rehearsal, and the lucky ones land in an academic music department where they preside over training the next generation in a similar manner. For the rest, the discovery that the world is replete with first-rate soloists, that the only outlet for decades of expensively trained talent is to join an orchestra, leads to frustration and even despair.[50]

Even as the year-round season expanded musicians' monetary rewards, the endless round of rehearsals and concerts diminished their psychic income. George Szell called the first-rate American orchestra "a luxury object, like a race horse," and worried that "when you ask a race horse to pull a truck it isn't a race horse any more." The musicians themselves expressed their disillusionment through escalating labor militancy. Yearning for more aggressive collective bargaining, they formed the International Conference of Symphony and Opera Musicians (ICSOM) in 1962. It became a special section within the American Federation of Musicians

(AFM), which had represented orchestra members since its founding in 1896. ICSOM includes forty-seven orchestras, comprising some 4,300 players. Regional orchestras formed another AFM conference in 1984, with forty-five orchestras represented. All partake of the AFM strike fund, the hardened shelter of orchestral war; it allows musicians to sustain themselves while duking it out with the management. Quite a few observers were convinced that the availability of public subsidies contributed to labor dissonance in the concert hall. "It is difficult to believe," wrote the arts economist Dick Netzer, "that musicians . . . do not take into account the existence or possibility of public financial support in staking their wage claims."[51]

In the context of salaries for other highly trained professionals, orchestra players do not appear to be grossly overpaid, especially the large majority playing for orchestras below the first tier. Typical of such musicians is Alice Goodkind, a violinist with the San Diego Symphony since 1966. Her first job had been with the Oakland Symphony, where she earned $1,700 per year. When that ensemble went bankrupt in 1986, players then were earning $13,000 for a half-year's work; their conductors received more for a single concert. In San Diego, the symphony canceled half of its 1986 season because of a $1.9-million deficit, even as the music director David Atherton took a $347,000 salary. Having played professionally for thirty-three years, Alice Goodkind reached a salary peak in 1993, $26,000 from the symphony and $5,000 playing for a six-opera season. A dedicated musician who knows the literature, she has no idea what the symphony administrators' salaries are, how many are on the payroll, or what the balance sheet looks like. Although three musicians sit on the San Diego Symphony board, she says the other trustees "treat us as stupid." Goodkind does not resent playing in an orchestra, "but it's painful to be reminded that we are the ones with the least autonomy." She finds her opera gig even more demeaning. The manager, she says, "doesn't care if the musicians are incompetent, so long as they're cheap." Hidden behind a scrim, which made the pit unbearably hot, the musicians also had to fight for adequate lighting to read brown and faded music.[52]

Such seemingly petty complaints have piled upon widespread drastic fiscal straits to prompt soul-searching throughout the field. During 1992 and 1993, the American Symphony Orchestra League published two widely publicized studies of orchestras' plight and proposed remedies. The data appeared grim. Audiences, if not dwindling, were aging. The younger listeners attracted by summer pops concerts were unconverted to more

serious sound. Loyal subscribers hated or even feared to leave the suburbs for concerts downtown. New music was generally so repellent to listeners that the average repertoire was older than it had been fifty years ago. Costs were continuing to rise while public subsidies were stretched to the limit, as was private and corporate funding. Compact discs of great performances by first-rate orchestras were setting impossible standards for lesser ensembles. Most ominous for many cities with second- and third-tier symphonies was the conclusion that there were too many orchestras and too many concerts.[53]

The American Symphony Orchestra League recommendations revolved around "Americanizing" the orchestra, somehow breaking the traditional ritual of the concert hall: the formally clad musicians tuning up; the conductor striding out to polite applause; the brief, bright overture followed by a pause to allow late arrivals to be seated; the well-known, expensive soloist playing a familiar virtuoso selection featured on his or her latest compact disc; the twenty-minute intermission for see-and-be-seen milling in the lobby; the final symphonic work by a nineteen-century European composer; the repeated curtain calls and almost obligatory standing ovation. The 1960s reexamination of all traditional institutions had challenged this unvarying routine. Culture would become more informal, one observer predicted, if musicians appeared in street clothes or even casual garb. No less an authority than Otto Klemperer called white tie and tails "archaic." Some conductors might feel free to invent the program after the audience was seated or to ask the audience to choose among several selections. The Indianapolis Symphony experimented with a "mystery night," when listeners were asked to guess what was played. The Eastman School presented a "musical picnic," offering the audience a variety of musical activities simultaneously. After a brief period of experimentation, however, most orchestras fell back into their traditional routines. The financial crises that emerged in the late 1980s triggered another round of innovative prescriptions: shorter, less formal concerts; the introduction of jazz and other strains of popular music; entertaining pre-concert lectures or social gatherings; more music drawn from other cultural traditions; better music education in schools.[54]

By the early 1990s, orchestra managers were grasping at straws in the adman's quiver to sell their product. Some desperately implied that a few hours of symphonic sound were really just as much fun, maybe more fun, than an afternoon at the ballpark. Indeed, a lucky subscriber to the Pittsburgh Symphony received a free trip to San Francisco for a Pirates-Giants

game. The brochure announcing the orchestra's 1992–93 season showed two lovers entwined above the text: "Thursday. Their hearts beat in concert . . . Friday. They heard violins . . . Saturday. A chord was struck . . . Sunday. Each movement drew them closer." Because of elaborate giveaways and glossy brochures, the amounts that orchestras spend on advertising, promotion, and marketing have risen since 1987 by 57 percent. The cost of fundraising has swelled by 52 percent.[55]

Why an expanded audience should have to be coaxed into the concert hall with such sweet coatings remains unanswered. The American Symphony Orchestra League report cited the "transcendent experience" of attending a symphony concert, but many other kinds of music seem to provide more soul-shattering episodes. Many fans report transports of ecstasy brought on by rock concerts, jazz festivals, and gospel choirs. Some of the suggestions for modernizing the orchestra advise including more of such music in the symphonic repertoire, as a distraction, perhaps, from the disagreeable medicine at the core. The jazz or salsa aficionado might well ask why he or she should pay a high price to sit passively in a formal downtown hall in order to hear what can be better enjoyed at a bar or club, while eating, drinking, talking, and dancing. Indeed, quite a bit of the concert music so solemnly presented today promised no more than entertainment when it was first composed. Haydn's witty symphonies titled *Echo*, *Clock*, and *Surprise* come instantly to mind, as do the "divertimenti" (amusements) favored by other Baroque composers; Mozart alone wrote twenty-five.

The dirge detailing orchestras' woes and the suggestions for reform imply that unless Americans support all of the nation's more than two thousand professional orchestras—about half of all the orchestras in the world— they will lose the chance to hear the great music of the past. In fact, the twenty-five most substantial orchestras in America account for more than half of the total attendance at professional symphony concerts. The closing of numerous lesser orchestras would enhance the survival of the rest, allowing them to tour more profitably and to attract more visitors to their home concerts. As it is, the managers and trustees of many secondary ensembles have abandoned the primary mission of a symphony orchestra: to be the standard and focus of the city's musical life. Aping their more substantial colleagues, they import music directors from outside, preferably abroad. These busy professionals regularly juggle several well-paid jobs, flying in to rehearse hectically and briefly, attending a social event or two and exercising themselves at the podium for two or three weeks before flying on to the next engagement. While giving much lip service to the transcendental val-

ues of music, these orchestra managers offer the community little contact
with music beyond elite fundraisers, catalogs of fiscal woes, pressures upon
local and federal grant-givers, uncoordinated forays into schoolrooms, and
exhortations to support the hometown music team.[56]

The pasteboard mystique so often substituted for genuine community
involvement by conductors waxes even grander when major orchestras are
involved. Numbering perhaps fifty, the orchestral stars describe celestial
orbits across time zones and continents, their batons imperially raised now
in Tokyo, now in London, Salzburg, or New York. Harking back to a tradi-
tion of temperamental tyrants like Arturo Toscanini, they haughtily resist
inquiries into their incomes; as one probing scholar wrote, they deem such
questions "offensive and unrelated to so refined and ethereal an art." The
spectacle of a conductor "pursuing material wealth as greedily as the stock-
broker in Row 16" would dispel the "priestly myth." However delicately
achieved, principal conductors' incomes multiplied twelvefold between
1960 and 1990, years when industrial earnings increased fourfold. In 1910,
weekly pay for a first-rate conductor was ten times that of a factory worker;
in 1990, it was fifty times a factory worker's, and the music director of a Big
Five orchestra in America averaged $700,000 per year. In this context,
orchestra musicians' bitter quests for higher wages appear reasonable,
while orchestras' perpetual pleas for additional public funding strike many
observers as insincere.[57]

Meanwhile, the repertoire steadily ages. A survey of five seasons' worth of
concerts by one hundred American orchestras with budgets of more than
$1 million per year revealed a depressing emphasis on the tried and true.
Mozart, Beethoven, Tchaikovsky, Brahms, and Haydn were the top five in
a hit parade featured in 24 percent of all concerts. Programming focused
even more narrowly around this quintet's masterpieces: Tchaikovsky's Vio-
lin Concerto was given 135 performances and Beethoven's Third Piano
Concerto was played 131 times. These repetitions alone nearly equaled all
performances of works by George Gershwin, John Harbison, John Corig-
liano, Elliott Carter, and William Schuman.[58]

Ironically, Elliott Carter, who was born in 1908, recalled his youthful
attendance at the Boston Symphony, where the conductor Serge Kousse-
vitzky insisted on inflicting copious doses of Brahms upon a restless audi-
ence. The concert hall's exit signs, Carter was told, really meant, "This way
in case of Brahms." Despite many adventuresome conductors, some of
whom would immediately repeat a new work if the audience became

restive at the first run-through, the American orchestra repertoire began to petrify as early as the 1940s. Some suggest that the villain was Arturo Toscanini, the first conductor to be hailed as the world's most renowned musician who was not also a distinguished composer. His New York Philharmonic career, as well as his radio broadcasts, which introduced a vast new audience to concert music, dwelled almost exclusively on nineteen-century Germans and Italians. At the Philharmonic, Beethoven alone bestrode nearly 20 percent of Toscanini's repertoire; the addition of Brahms and Wagner filled 40 percent of programs.[59]

By the early 1960s, Leonard Bernstein, the New York Philharmonic's *wunderkind,* sadly described "an historic curve, an arch, that began with Mozart and ended with Mahler." The configuration of the orchestra, too, had reached its final shape, he found, as "a great and glorious kind of museum, playing these repertoire works." He recommended that more composers be commissioned to create new works. Though Bernstein tripled the Philharmonic's subscriptions and attracted an estimated ten million viewers to his weekly television programs, his showmanship was derided by music critics. "Nobody loved him but the public," said the *New York Times'* Harold Schonberg. Bernstein's successor, the composer-conductor Pierre Boulez, also condemned the museumlike stasis of the orchestra repertoire. "Let's have a laboratory," he urged. "Why be afraid of flouting tradition?"[60]

Perhaps he was recalling the friendly and sometimes tumultuous receptions that audiences gave new music during the nineteenth century. Beethoven's Ninth Symphony received its American premiere in 1844, only twenty years after the composer himself conducted the first performance in Vienna. In New York, the Philharmonic's audience listened respectfully, even though the work was considered radically new and difficult. Front-page stories on December 16, 1893, greeted the world premiere of Antonín Dvořák's Ninth Symphony, "From the New World." Crowds jostled for admission to the sold-out concert, raising such a ruckus that police had to restore order outside Carnegie Hall. The mob almost blocked the Philharmonic's music director from reaching the stage door. Inside, a thunderous ovation greeted the composer as he rose from his box. The work was an instant hit; wild applause greeted the performance, the orchestra played multiple encores, and critics were also enthralled.[61]

By the 1990s, such happenings were part of a distant history. For the Philharmonic's 150th anniversary, Pierre Boulez gamely noted that he preferred controversial music to "a slow death. . . . You have valleys and you

have peaks. But that is, finally, what makes the mountain." Where, a critic asked in 1993, "is that mountain? . . . What will make an orchestra, and what will make an audience, for the next 150 years?"[62]

Sympathetic to the problem, the NEA began giving grants to composers and additional money to orchestras for performing contemporary music. The amounts were relatively small; in 1977, $470,000 went to composers and $220,000 for performances, the total about 5 percent of what orchestras were getting from the NEA. But the results were meager. New works would be performed with great fanfare once or twice, but most of them failed to pass into the repertoire. For one thing, the extra rehearsals they required were enormously expensive, some $13,000 each at the New York Philharmonic in 1993. For another, most composers had comfortable livelihoods as academics and were interested more in obscure experiments and their colleagues' approval than in engaging the musical public. Finally, audiences resisted the frequent repetitions of new music necessary for understanding it, the prelude to appreciation. The Pittsburgh Symphony discovered, for example, that its subscribers would barely tolerate one relatively brief contemporary work on every other program in a six-concert series.[63]

The subscribers take their cue from trustees in their aversion to new music. From the beginning, orchestra boards represented the social elite; in exchange for generous contributions, this group also controlled programming. When a financial crisis befell the New York Philharmonic in 1909, for example, J. P. Morgan, Joseph Pulitzer, and John D. Rockefeller spearheaded a rescue that made up deficits for three years in exchange for total control of the board. Such insider management persisted without much question into the 1960s, even though the Ford Foundation and, later, the NEA were increasingly supplementing private contributions.[64]

In Philadelphia, as at the other Big Five, leadership was dominated by names in the social register. After a fundraising consultant in 1966 urged that the Philadelphia Orchestra board's membership be broadened, more than two-thirds of the trustees were still "S.R." A late 1970s study of 504 trustees of the most prestigious cultural institutions in New York, Los Angeles, and Chicago found striking overlaps among attendance at prestigious prep schools, memberships in exclusive clubs, and directorships of leading corporations. The only change in recent times was that this exclusively Protestant turf had been invaded by a considerable number of Jews. The newcomers, however, embraced the same lifestyles and attitudes as the veterans. Striking, too, was the paucity of women. While research

shows that wives most frequently decide which cultural events the family will attend, and that women predominate among audiences and also among volunteers, they appear to be content with minimal representation on the board. A 1963 handbook for volunteers suggested, "Give me six women, a bag of cookies, and a box of tea and you'll have your orchestra." Now that orchestras collectively face the severest straits in their entire history in America, their boards' traditions of elitism, exclusivity, and snobbery may well impede their survival.[65]

Whatever happens to orchestras and their boards, Americans need not fear that the demise of serious music is imminent. The wealth of musical alternatives is staggering. Music, as well as dance, theater, performance art, storytellers, puppets, and every imaginable sort of public presentation, is now within reach of virtually every breathing American. The Bible of this eclectic universe is *Musical America,* a tome of almost eight hundred pages teeming with thousands of entertaining, enlightening, and, perhaps, even transcendent ways to spend a cultural evening. At the profitable end of the pipeline is the artists' manager or booking agent, once embodied by the legendary Sol Hurok; one of his many coups was arranging the first engagement for Isaac Stern (for a $500 fee). At the struggling, unremunerative end is the local presenter, usually a nonprofit organization eking out its income from ticket sales with donations and grants. Together they represent a comprehensive distribution system for a dazzling array of artistic diversions.[66]

The annual *Musical America* lists more than eight hundred artists' managers, ranging from individuals representing themselves to giant enterprises moving whole orchestras through time and space . . . while collecting a commission on all fees, even their members' airline tickets, meals, and hotel rooms. The most imposing agency is Columbia Artists Management, which represents more than eight hundred musicians, fifteen American and ten foreign orchestras, ten choral and vocal ensembles, seven chamber orchestras, twenty-three other musical ensembles, and seventeen dance groups. It also offers a colorful menu of popular entertainment, including touring musicals and plays; Christmas extravaganzas; folk music and dance; *Zingaro,* an equestrian opera from France; and Kurt Wenner, master street painter. Headed since 1972 by Ronald Wilford, a secretive, forbidding presence, the agency heavily promoted multiple posts for conductors and, writes one critic, "turned orchestras into flying circuses." While Wilford advertises the orchestras he represents, the list of conductors who are his clients is secret. One close observer claimed it

includes all but ten major conductors in the world, each one paying the agency 20 percent of all fees and salaries.[67]

The paradox of poverty amid plenty is completed by about two thousand local organizations that import arts presentations to their communities. Mostly nonprofit, they include universities, city governments, regional consortia, women's clubs, civic auditoriums, and performing arts centers. Some specialize in chamber music or dance, others create a varied menu that they hope will sell as a series and draw contributions from grateful subscribers. Many sprang up during the 1960s, replacing local profit-making impresarios driven out by rising ticket prices.

This was also the period of massive auditorium-building on college campuses. At Purdue, the 6,000-seat hall was deliberately designed to have one more seat than New York's Radio City Music Hall. At Iowa State, $4.9 million was raised privately for Stephens Hall, which opened in 1969 with five sold-out concerts by the New York Philharmonic. In the same year, the University of Illinois opened the $22 million Krannert Center, which includes a 2,100-seat concert hall, a 985-seat music theater, a 678-seat playhouse, and a 150-seat studio theater. Such enormous spaces challenge their managers to find a parade of attractions to fill them. The potential audience stretches far beyond the college community, attracted to the campus by the university's endorsement of what is presented. In many areas, colleges compete briskly with nearby performing arts centers.[68]

Wherever the programs are presented, finding the right formula to keep the box office busy plagues the professionals among nonprofit arts presenters, just as it did their long-gone profit-making predecessors. They peruse the ad-laden pages of *Musical America*, evaluating snippets of superlative reviews: "reached the apex of musical expression" . . . "astonishing agility" . . . "she sang with smoldering intensity" . . . "the complete interpreter" . . . "won a standing ovation" . . . "she holds the audience in the palm of her hand." But will it play in Peoria? The presenter's next step is to the mailbox, where every day's delivery includes a wealth of tapes and videos and publicity packets selling some of the thousands of stars and wannabes in this galaxy of cultural entertainment. Finally, the program-builder travels to the annual regional and national conferences of arts presenters. There, workshops, panels, and speakers advise on professional nuts and bolts, but the centerpiece is a series of cavernous, cacophonous exhibition halls, crudely dubbed "the meat market."

A throbbing bazaar, brimming with barkers, videos, and demonstrations, this panorama of primary capitalism contrasts ironically with the elevated

nature of these cultural offerings. Here Brigham Young University flogs its seven ensembles of student performers, there a William Faulkner impersonator distributes his own brochures. Peddlers in pinstripes fan out from the oversize Columbia Artists Management booth to buttonhole passersby, or at least to slip brochures into their overladen shopping bags. And the NEA's new presenting and commissioning program distributes its own literature on how to latch onto some of the $4 million or more it passes out to nonprofit presenters. So does the state arts council, which also funds performances. At the "meat market," the arts in America, in all their boisterous complexity and diversity, once more confound the holiness of the art religion with the base scrabble of cold cash.

The NEA struggled for years with finding appropriate ways of strengthening the fabric of this crazy quilt of commerce and art. During the 1970s, Nancy Hanks financed dance touring with great success, while the music and theater programs also supported local presenters. The assumption was that presenters needed public funding because ticket prices that would be high enough to cover all costs would drive away too much of the audience. The grants to local presenters offered a double-barreled benefit. Local presenters brought nationally acclaimed cultural attractions to their fans in university towns and larger cities throughout the country, pleasing congressmen concerned about too much grant money going to New York, Chicago, and San Francisco. Simultaneously, they provided major companies in these large cities with out-of-town bookings to fill their expanded seasons.

But as the growth in the arts audience began to taper off during the late 1970s, conflicts flared. Second-tier and third-tier orchestras resented the intrusion of first-tier touring ensembles. Local dance companies were struggling to survive while the city's nonprofit presenter seduced their audiences with acclaimed imports like the American Ballet Theater, the San Francisco Ballet, or the Martha Graham company.

Meanwhile, tourism grew into a major industry in cities where manufacturing had faltered, and the arts were seen as magnets for free-spending visitors. Many cities commissioned economic-impact studies to support their lobbying at state and federal levels for additional arts funding. Though the numbers are probably inflated, these reports give some idea of the arts' vital contribution to big cities' economies. They testify to the bulk of commercial interests that overshadow aesthetic considerations. The classic is a study of how New York was enriched by the 1976 exhibition of

King Tutankhamen's treasures at the Metropolitan Museum of Art. Well over one million visitors bought lodging, meals, transportation, and goods worth nearly $111 million in the city during the show's 103-day run. The same exhibition attracted almost 900,000 visitors to New Orleans, where they spent $75.2 million. In Chicago, the arts pulled in some $470 million in 1977. A 1979 study by the New England Foundation for the Arts found that culture contributed $1.5 billion to the economies of just three states within that region.[69]

Presenters joined the arts institutions themselves in arguing that they were a vital part of this money mill. Thus, the arts were harnessed to the chamber of commerce's promotional cart; instead of adding mere education, enrichment, or enjoyment to people's lives, they were luring visitors and thereby creating jobs and injecting extra money into the local economy. On this pragmatic basis, the arts sold themselves as good for everybody in town, including the vast majority of residents who shun attendance at any arts event whatsoever.

In making themselves useful instead of just standing there looking beautiful, the arts at the local level reflected the vigorous missionary outreach practiced by Livingston Biddle and Joan Mondale in behalf of the NEA. Despite its high profile with the public, the endowment was a tiny cog in the vast federal machine. Still, with a political insider at the helm and the office of the vice president behind it, even large cabinet departments agreed to bear most of the cost for the projects Biddle and Mrs. Mondale proposed, while the NEA maintained artistic control. The U.S. Department of Transportation refurbished old train stations, turned some of them into cultural centers, and bought artworks for the stations and for airports. The U.S. Department of Housing and Urban Development went along with a proposal grandly named Livable Cities in which neighborhood arts centers were developed in storefronts and abandoned buildings. The secretary of the interior smilingly posed with Biddle as they announced plans for "integrating the arts, cultural enrichment activities, and historic preservation" at national parks and recreation areas. Within NEA, Biddle started the Office of Special Constituencies to develop ways that other government agencies could pay to bring what Biddle called the "immense therapeutic blessings" of arts programs to the elderly, the handicapped, the incarcerated, and even the hospitalized.[70]

Biddle summoned a twenty-five-person task force on education, headed by David Rockefeller, to investigate ways that schoolchildren could benefit from the arts. *Coming to Our Senses* was its report, a glossy sermon illus-

trated with lots of uncaptioned photos of toddlers and teenagers playing creatively with clay and paint. More artists and writers should be hired by schools, it urged, among more than one hundred other ways to awaken children's cultural interests. To follow up, the U.S. Office of Education and NEA shared the cost of a new administrator, only to see his work sabotaged by turf wars. As Biddle picturesquely described it, while "doors opened and brightness entered his expeditions," this new administrator also suffered frustration as "thickets and briars of sheltered pathways caught at the elbow and clothing." He was soon gone, and Biddle had to admit that "only the foundations" of education/arts cooperation were laid, while "the edifice that houses the arts prominently within the halls of education is far from complete."[71]

By 1980, some 270 government agencies and departments were funding various cultural efforts. They included such unlikely nooks within Washington's labyrinth as the Peace Corps, the National Solar Heating and Cooling Information Center, the Department of Justice, and the Internal Revenue Service. Was there an ultimate purpose to this diffused endeavor? If so, it remained shadowy. The NEA itself had dispersed its benefits among 115 funding programs that dealt with applicants, among them organizations, artists, states, cities, schools, colleges, and private and philanthropic agencies. To what end? The Ford Foundation's superpatron Mac Lowry deplored "these overlapping networks" funneling money to "a steadily expanding multiplicity of services. 'Availability' of arts became as important as 'the development of cultural resources,' and 'enhancing the quality of life' was equated with supporting the creativity of artists." He saw no "clearly defined strategic aims."[72]

One of the agency's staunchest congressional friends, the Chicago congressman Sidney Yates, impatiently demanded a full-scale review of both endowments' operations. The resulting report, issued after eight months' investigation, concluded that the NEA had failed "to develop and promote a national policy for the arts." It recommended a moratorium on funding increases for the agency until the NEA's goals were clarified. Biddle was outraged by such criticism, claiming that to develop explicit policy was tantamount to anointing "a cultural czar," with power to dictate what artists would produce. He was vindicated when Yates, perhaps jogged by phone calls from his Chicago North Shore arts constituency, repudiated his own investigators' report and never again asked about NEA policy.[73]

Still, critics contended that even in the absence of explicit goals, some purpose must govern the awarding of certain grants and the rejection of

others. "The only real choice," wrote one political scientist, "is whether such a policy is made explicit . . . or whether it's implied." He preferred explicit policy, which can be discussed, criticized, and modified, over implicit policy, which remains hidden, undebated, unchanged, and quietly manipulated. When millions of dollars were going to thousands of projects, he believed, "some policy was being observed, however incoherent." How the endowment parceled out its grants was bound to exert some sort of control. When marginal fields receive substantial subsidies, wrote one sociologist, they "attract participants and develop their own networks and subcultures. In time, associations, training programs, ritual gatherings, shows, workshops, and journals emerge to institutionalize these areas." Willy-nilly, such interference enhances productivity in sectors that receive grants while discouraging it in those that do not.[74]

With no principal goal before them, the NEA's various programs and their panels of "experts" were developing guidelines that effectively filled the policy void with their own views of what should be funded. The panelist handbook for 1979 disclosed that the agency's mission was "the fostering of professional excellence in the arts, to nurture and sustain them, and equally to help create a climate in which they may flourish so they may be experienced and enjoyed by the widest possible public." This well-meaning generalization followed a preamble that was striking in its religiosity no less than in its smarmy vapidness. Humans were uniquely equipped with aesthetic sensibilities, it said, qualities "sharpened, enlivened, expressed, and developed as a celebration of life in all its forms. . . . Cultivation of this awareness is a societal good as it quickens the experience of life and enhances its quality." Such a bureaucratically mild and inclusive definition of art bore out the misgivings increasingly voiced about the flattening effect of the public dollar on the arts. "Public money is political money," wrote one critic in 1978. "It tends to promote expansion, decentralization, and redefinition in order to show that the arts are reaching the broadest possible constituency of taxpayers and voters."[75]

By then, some 20,000 grant applications were raining upon a staff of about three hundred in a single year. Twelve regional offices were drumming up even more applications, following Joan Mondale's simplistic image of a pyramid: "The broader the base, the higher the peak." But the pyramid sometimes seemed to be three thousand miles wide and a foot tall. More than seventy panels were wading through masses of multipage applications, meeting for several days, often three or four times each year. The directors and staff of the twelve program areas had their hands full simply

keeping the paper flowing, finding demographically correct panelists, and scheduling the panelists' trips to Washington. Furthermore, each program area drew its professional staff from its own field, to which most would return after their Washington stint. Together with panelists, the program staff fostered extraordinary loyalty, not to providing Americans with an interesting array of new and first-rate art but to fulfilling perceived needs within the field.[76]

The agency's own handbook for panelists noted that "field" referred to "our constituency, the artists and arts organizations we serve." A veteran music program staffer echoed this internal orientation away from the general public: "We learned to use the rules to accommodate our constituency," she said. Wherever the field was tightly organized and possessed of a vociferous constituency, as for orchestras, the panels recommended funding of about one in four applications. Without much organized pressure from a field, as with individual fellowships, the ratio was about one in forty.[77]

For panelists, judging their peers was heady indeed. Nick Webster, who then was manager of the New York Philharmonic, regularly served on panels from 1974 to 1980. During these years, the single music panel included subsections for orchestra, opera, and composers, which later became independent panels. After Biddle directed that each program also form a policy panel, the chairs of each music subpanel served on the policy group as well. Attending these meetings as often as eight times a year, Webster says he "never came away without an uplifting sense of good people." He rarely experienced conflict on major issues, but rather consensus: "The deliberations often were electric." While many, if not most, panelists were employed by institutions regularly applying for grants, suspicions that there were conflicts of interest, he said, were a case of "reality versus appearance"; a panelist from an organization whose application was being considered had to leave the room. Webster maintained that "ninety-five percent of the complaints were from people who didn't get grants because they hadn't read the guidelines."[78]

Despite such glowing accounts of panel activities, the close connections among staff, panelists, and applicants continued to nettle many observers of the process. The investigation ordered by Sidney Yates found that many panels were "a closed circle," rendering a circumscribed range of decisions. Some panelists with an interest in a particular application would make favorable comments about it before leaving the room. Pressed for decisions on huge piles of applications, panels sometimes took stunning

shortcuts. The director of the visual arts program told a congressional committee that two panelists "pre-screened" fellowship applications before the full group met, explaining that "you can certainly recognize a good artist from a klutz." Told that two-thirds of some four thousand applications had been discarded in this manner, Yates incredulously asked: "Two-thirds of the applications are klutzes?"[79]

Frivolous projects approved by the panels and then unthinkingly rubber-stamped by both the council and chair had occasionally embarrassed the endowment's friends, just as they emboldened its critics. In 1969, congressional mirth and dismay had greeted news that the poet Aram Saroyan had been paid $500 by an NEA-supported literary magazine for a one-word creation, "lighght." In 1974, Michael Straight was horrified by a stack of fellowship grants recommended by the visual arts panel that awaited his signature as acting chair when Nancy Hanks was ill. Despite misgivings, he approved mostly $3,000 grants for projects to "temporarily manipulate the Chicago skyline," to create a video about dry-fly fishing, to train porpoises for starring in an opera, to explore taxidermy as a sculpture medium, and to produce a series of paintings featuring only "extremely subtle gradations of gray." Among some twenty grants Straight refused to approve was a proposed "loop tour of the Western U.S. . . . dripping ink from Hayley, Idaho to Cody, Wyoming—an event commemorating the birthplaces of Ezra Pound and Jackson Pollock." All were subsequently approved by Hanks. To shield the endowment from derision over such awards, the guidelines for visual arts fellowships were changed: Applicants no longer needed to describe the proposed project but only to submit slides of past work and testimonials from peers.[80]

This new arrangement allowed the endowment to avoid public disgrace over funding ludicrous activities, since the proposed project was not specified, but it also emboldened some panels to approve fellowships for artists known for their provocative work. In 1977, an artist used a grant of more than $6,000 for, as she described it, "sculpting in space," tossing crepe-paper streamers from a small airplane. Newspaper publicity brought this endeavor to the attention of Senator William Proxmire, who questioned the appropriateness of tossing taxpayer money at such a purpose. Nancy Hanks defended the grant as supportive of NEA's mission to fund projects of "substantial artistic and cultural significance." The visual arts program director Brian O'Doherty also defended the grant award: The artist's work "is based upon environmental concerns that many artists now share," he wrote. "She is respected by her colleagues and is a serious and dedicated

artist." Proxmire was unconvinced. The amount was relatively small, but "it [was] the sum total of the taxes paid by three typical [low-income] taxpayers," he fulminated, and awarded the project his Golden Fleece of the Month Award.[81]

Worse than making the endowment the object of titters, if not indignation, Hanks had withheld any artistic judgment about this work. The panel had the expertise, she contended, and the chair was bound to follow its recommendations. This view totally contradicted the endowment's structure, which placed panels in a purely advisory position, while requiring concurrence by the council and final approval by the chair. In addition, the endowment was making block grants to various groups of artists and writers which then doled out the money without further NEA review.[82]

In 1979, Livingston Biddle got a taste of just how dangerous this procedure could be. The NEA gave a small grant to a New York television station, as recommended by the media arts panel, approved by the council, and signed by Biddle. The station awarded a subgrant to an experimental filmmaker; Biddle could have stopped the subgrant but saw no reason to do so. The final film was billed as a protest against cruelty to animals. It depicted the filmmaker walking before the camera with a dog, then shooting it point-blank. The videotape looped again and again through the same horrific scene for thirty minutes. "The animal was screaming and bleeding," Biddle recalled. "It went against all my principles." Considering the case an emergency, he instantly ordered the grant canceled and the endowment's name stricken from the film's credits. Though it was the only time he ever took such a step, "for three days, the to-do was almost Mapplethorpian," he said. The *Village Voice* ran an article charging that the closet censor Livingston Biddle had revealed himself at last. However, by the second day, "there were no more interviews of Biddle . . . they couldn't interview the dog or the artist . . . they couldn't pursue it." The to-do was quickly forgotten, Biddle noted. "On the Hill today, they don't even remember it."[83]

The incident demonstrated how vulnerable the endowment had become to mortification by its panelists and grant recipients. Inside the organization, panels were dividing and subdividing like amoebas, more applications were streaming in every day, staff turnover was brisk, and each field was clamoring for its due. At the top were a president and vice president of the United States determined to enlist every agency in furthering their party's social programs. Outside, detractors were gathering strength with each misstep. Congress could simply strangle the endowment by failing to

reauthorize it, or weaken it by cutting its appropriation. As much as the endowment's funding had grown during its first fifteen years, state and local funding had grown even more, giving many arts institutions a far greater share of public support than they would ever receive from Washington. Beset by such pressures, the endowment's friends trembled as an outspoken conservative loped toward the White House.

6

A NIGHT AT THE
OPERA

No sooner had Ronald Reagan charged into Washington, spewing sound and fury against Big Government, than the new president's budget people targeted the tiny NEA and NEH for massive cuts. They vowed that euthanasia would follow. From the proposed Carter budget, which called for the NEA to receive a 10 percent raise to $175 million, the Reaganites expected to slash more than half, offering $85 million. An internal budget document charged that "for too long, the Endowments have spread Federal financing into an ever-widening range of artistic and literary endeavor," driving out private and corporate support. The unkindest cut was the new administration's determination to rescind more than $30 million appropriated for the NEA during the previous year but as yet unspent. The rescission would wipe out those grantees who received most of their funding near the end of the fiscal year, including those in the media arts, the visual arts, and the dance touring. As the *coup de grâce,* the new president proposed a task force charged with justifying the butchery to come.[1]

Livingston Biddle, whose term as NEA chair still had one year to run, navigated adroitly through this fusillade. He reactivated his Republican contacts to gauge the intensity of the opposition's will, rallied his troops through congressional hearings, extended friendly feelers to the wielders of budget blades, and galvanized the stunned arts constituency into renewed activism. He reached straight to the White House, managing to entice the new occupant into attending a Kennedy Center performance by one of the endowment's regular beneficiaries, the Dance Theater of Harlem. To the man who would be known as the Teflon President, Biddle demon-

strated his own impervious overcoat: He turned back an attempt to force his early resignation. This feat enabled the chairman's most impressive maneuver, his astute courtship of the presidential task force.[2]

By the time this group convened, the president's executioners had lost considerable zeal. Rather than the assortment of philistine zealots promised by earlier rhetoric, the task force assembled twenty-nine citizens with considerable arts experience and relatively moderate views. Its three chairs offered strong backgrounds in both the arts and humanities: the actor Charlton Heston, a close personal friend of the Reagans; Hanna Gray, the president of the University of Chicago; and Daniel Terra, a millionaire collector of American art, founder of a Chicago museum, and newly appointed ambassador-at-large for cultural affairs. Surely prominent Republicans within the arts constituency had enlightened the president on how his cuts would wound orchestras, museums, operas, and other sophisticated platforms for the socially ambitious. Perhaps Hollywood friends had conveyed the film industry's stake in the endowment's support for theater, dance, and, above all, the American Film Institute.

Whatever pressures had been applied, the administration appeared to be retreating from its rash assault on the endowments. As often happens in Washington, the task force's "who" conveyed far more than the "what" of its stated objective. Rather than exposing what the conservative Heritage Foundation had only months earlier called "the creeping nationalization of culture," the group dutifully plodded through towers of paper that described in soporific detail the many corners of American culture nourished by NEA dollars. Soon, Biddle discerned "a chemistry . . . at work" within the task force. But a great neutralizer of any remaining bile was testimony from a phalanx of theater, music, and art organizations "exploring the depths of the needs involved," wrote Biddle, "and the benefits of past assistance and accompanied by reams of statistical information."[3]

Between the task force's first meeting in the Indian Treaty Room of the Old Executive Office Building on a sticky June day and its last meeting in October to issue its report, Biddle wrote, "the complexities of the arts" enmeshed the task force and slowed its direction. One member was amazed that even the conservative Charlton Heston supported government arts funding. The rescission drive meanwhile expired. In less than forty pages, the task force's final report deemed both endowments "sound" and recommended no "fundamental changes" in their operations. When Congress reviewed the NEA appropriation, Reagan's mortal cutback was trimmed to a minuscule 6 percent.[4]

As the guessing game about who would succeed Biddle engaged the endowment's insiders, previous chairs were also evaluated. Nancy Hanks was still the heroine, the agency's Joan of Arc–cum–Earth Mother. By contrast, some saw Biddle as "pliable . . . not attuned to managing" the NEA's sprawling bureaucracy—"a lot of areas were undefined." Perhaps with a thought to tidying up, the director of the NEA's opera-musical theater program confided to the former council member Beverly Sills that now a politician was needed, someone "able to deal with the power politics and horse-trading of Congress." Sent a copy of this letter, Harold Prince heartily concurred: "Why the hell do we need an artist at the head of the Endowment?" he demanded. "We need an advocate and a smart administrator. That's what we need!"[5]

Possibly this plea reached the White House, for, in September 1981, it sent the name of a quintessential "smart administrator" to the Senate for confirmation. Frank Hodsoll was deputy to the president's chief of staff James A. Baker and had been a part of the Reagan-Bush campaign team. A Yale graduate with a law degree from Stanford, Hodsoll had also been a Foreign Service officer and an official in the U.S. Commerce Department. Offered a variety of posts in the new administration, Hodsoll chose running the NEA as "great fun." The *Village Voice* pounced on his lack of arts experience, calling him the "James Watt for the arts." Biddle harbored "considerable reservations," but was impressed by Hodsoll's "quick intelligence" and varied political experience. "The best parts of the job were the evenings," Biddle told the new man when they met socially. "We could explore the arts. You'll have a wonderful time." To which Mrs. Hodsoll replied, "My interest is real estate."[6]

Amid trepidation over a conservative chair who made no bones about his ignorance of the arts, Frank Hodsoll was sworn in on November 13, 1981. His "key themes," he said reassuringly, were "excellence" and "reaching all Americans," the contradictory goals espoused by all his predecessors. With a record 27,000 applications scrambling for grants totaling $143.5 million, Hodsoll minimized a daunting reality: For the first time since its founding, the endowment had less money than the year before. The lush years of impressive budget gains had peaked in 1980. "The amount of the budget," the new chair would insist, "is less crucial than to demonstrate that the arts are important and deserving of public support." Yet the agency would never again award more than 5,500 grants, as it had in 1980, nor would its inflation-ravaged awards buy as much.[7]

A tall, handsome, quick, expressive man with a football player's bulk,

Hodsoll relished the chance to shape the agency to his design, making its machinery hum to a contemporary beat. "There were three data systems," he recalled, "but they couldn't speak to each other. . . . There was no way to track numbers." While the staff feared that he would "burn [the NEA] to the ground," he said, reform, not wrecking, was his goal: "The place was demoralized . . . it lacked management." On the artistic side, Hodsoll wanted to reverse his predecessor's expansionist tilt, which, Hodsoll believed, continued to subsidize institutions whose quality had slipped. Using the new computer system, Hodsoll compared programs and found that there was no relationship between the funds an organization received and its artistic worth. "I tried to impose consistency," he said. A staffer admired Hodsoll's dedication to educating himself about the arts: "He learned on the job," recalled Gary O. Larson, whose book *The Reluctant Patron* describes the rocky course of government arts funding. "He was quick-witted, curious, and effective," carefully studying structure and programs, and unafraid to ask questions like "What's audio art?" From the first day, Hodsoll read every single grant application: "I noticed that they tilted too far toward adding folks," he said, "away from standards."[8]

Hodsoll worked hard to weld the squabbling program directors into a team and to develop consistency through the various programs. "I gave them my philosophy and told them, 'I rely on you to advise me and run these programs. If there is controversy, I want to know about it before the grant reaches the Council.'" To deal with grumbling about the incestuous panel system, he ordered program directors to choose "a balanced, reasonable mix" of panelists "representing the entire field. I want two or three names for each slot, plus your recommendations for the best one." Hodsoll's budget allocations also aimed toward balancing contending demands. He approved a small local arts development program, an extra $1 million for interdisciplinary endeavors, seed money for arts in special communities, and modest funds for experimentation, "even if most of it failed."[9]

Despite his brisk directives, Hodsoll learned what Biddle already knew: The agency was impervious to serious reform. No chair could break the web linking major institutions in each field with the program staff, the cross-braces to service organizations, the wires between socially prominent trustees and Washington politicians. Under Hodsoll, the percentages allocated to various programs remained virtually unchanged from previous years. Music continued to gobble more than 20 percent of the endowment's money, public media and museums each received about 12 percent,

theater took close to 10 percent, and dance and Expansion Arts each about 8 percent.[10]

To enhance the arts' visibility, Hodsoll engaged the White House for an inexpensive ceremonial, the National Medal of the Arts. Begun in 1983, the festivities at a White House luncheon "set a tone," said Hodsoll. "It said that the arts are not just entertainments, but form the markers for future generations." The president noted that the American system of emphasizing private contributions to the arts had provided the nation with "a much broader cultural base" than in nations emphasizing government arts subsidies. The first twelve recipients set a pattern for the National Medal of the Arts awarded in subsequent years. They represented a carefully crafted blend of foundations, corporations, and demographically correct individuals of unquestioned achievement in their fields: the Cleveland and Dayton Hudson foundations, Philip Morris and Texaco, the architect Philip Johnson, the novelist James Michener, the poet Czeslaw Milosz, the painter Frank Stella, the playwright Luis Valdez, the mezzo-soprano Frederica von Stade, and the violinist Pinchas Zuckerman.[11]

The inclusion of two corporations underlined the striking role that business contributions were playing in supporting the arts. Encouraged by a tax law that allowed deductions for charitable contributions of up to 5 percent of net profits, corporations were already contributing far more to arts organizations than the NEA. In 1982, for example, museums were getting some $1.5 million from the NEA, but $97 million from business; theater received about $9.5 million from NEA, but more than $47 million from business; public media got just over $10 million from NEA, but $57 million from business. Corporate logos blossomed in theater programs and museum catalogs and during public television and radio station breaks; the business contribution was acknowledged in almost every arts field. While the NEA's budget had been effectively capped by the Reagan administration and sapped by inflation, corporations continued to pour additional funds into the arts. In 1982, the total topped $500 million; by 1988, it was $634 million, almost four times the endowment's portion.[12]

The drive to allow corporations to take a federal tax deduction for charitable gifts goes back to 1918, when individual donations were exempted from the income tax. When corporations were included in 1935, they contributed little; in the Depression year 1936, total corporate contributions to charities were only $30 million. By 1951, however, corporations were giving $343 million to charities. And when Congress imposed an additional

tax on excess profits during the Korean War, corporations could make charitable contributions with eighteen-cent dollars; total giving zoomed to almost $0.5 billion. But even after tax rates fell, business giving continued to increase, to more than $1 billion by 1971. As with so much research on the economics of the arts, precise statistics on the arts' share of corporate charity remain elusive. But the curve of total giving swoops consistently upward. Between 1975 and 1986, total corporate charitable contributions quadrupled from $1.2 billion to $4.5 billion, and doubled as a percentage of pretax net income to 1.94 percent. The arts' share grew from 7.5 percent to 11.9 percent. By the late 1980s, corporations were also giving the arts substantial contributions of goods, services, equipment, and executive talent.[13]

Museums were the favorite beneficiaries of corporate dollars, garnering almost 20 percent of the total in 1986; more than 90 percent of all corporate arts donors gave to museums. Music attracted about 12 percent, as did public radio and television. In deciding which projects to fund, more than 90 percent of corporations considered the impact on the local community or geographic location. Other important factors were management capability, artistic merit, and the involvement of the company's own employees in the arts group. Though the NEA frequently cited the importance of its imprimatur in attracting private funding, this criterion proved significant in barely 15 percent of corporate grants.[14]

From the beginning, all the NEA's chairs had recognized the importance of corporate funding to the health of the creative endeavor. Early in his tenure as chair, Roger Stevens had tried to sell business leaders on contributing directly to the NEA, but, despite what Biddle recalled as "an excellent lunch" in New York, "separations of viewpoint were not exactly bridged that day." While the executive types were unprepared to donate to a government agency, the Business Committee for the Arts, started in 1967 with foundation grants, was fully supported by corporate members within three years. Its first chairman, Douglas Dillon, asked members for a sort of tithe, to direct 10 percent of all their charitable giving to the arts. Through the accounting firm Touche, Ross, the committee worked hard to introduce businesslike management into arts organizations in New York, Detroit, Chicago, and San Francisco. Nancy Hanks brought business representatives into the National Council on the Arts. She hoped to funnel large corporate contributions through the Cultural Resources Project, for distribution through the NEA's "respected panel system." However, corporations were still disinterested in donating to an anonymous pool unrelated to particular organizations and unacknowledged. They wanted to choose

where the money would go and receive recognition. Biddle ran into the same barrier when he made the corporate rounds. "Conversations were candid," he wrote, but corporations would never allow the endowment to decide how to spend their money; realistically, they viewed the NEA as "a junior partner."[15]

Furthermore, most corporations were not interested in supporting experimental work. Instead, they attached themselves to well-established organizations and expected some direct benefits from their generosity. When Citibank spent $300,000 to sponsor a New York Philharmonic European tour in 1980, the bank's local staff hosted cocktail parties, social events, suppers, and receptions in every city the orchestra visited. The idea was to raise the bank's profile among the guests, primarily local politicians and business leaders. In 1981, the bank followed the same strategy, when it sponsored a Philharmonic tour to Mexico. In 1973, Springs Mills, Inc. arranged to adapt textiles in the Metropolitan Museum of Art's collections for a line of bed linens; by 1982, the museum was collecting more than $2.4 million in royalties, while Springs Mills enjoyed extra sales of nearly $70 million. The corporation SCM estimated that the $150,000 it invested in two or three art exhibitions each year yielded publicity equal to $1 million in corporate advertising.[16]

As arts institutions gratefully acknowledged the corporate philanthropists' contributions, the benefactors were indirectly shaping the culture itself. Few museum visitors understood that many of the exhibitions they enjoyed were not driven by a curator's research or an educational endeavor but by the subtle advertising message desired by a corporate sponsor. American Express, for example, was solely interested in exhibitions promoting travel: "The Vikings," "Silk Roads/China Ships," "El Greco of Toledo." AT&T's first sponsorship of a National Gallery exhibition coincided with the company's traumatic court-ordered breakup; "The New Painting" displayed the Impressionists' artistic breakthroughs from 1874 to 1886, the very years of Alexander Graham Bell's telephonic breakthroughs. Two years later, when AT&T was still battling to define itself—and with many issues of regulation pending before Congress and government agencies—the company sponsored "The Art of Paul Gauguin" at the National Gallery. Social events connected with the exhibition enabled company executives to reach out and touch the decision makers who could profoundly affect the company's future.[17]

The link between lobbying interests and the passion to support culture plays out particularly vividly on the Washington arts scene. The American

Medical Association, which regularly ranks second in congressional lobby-
ing expenditures, was the first professional society to sponsor a National
Gallery show. For almost six months in 1982–83, the doctors' trade group
used the exhibition "David Smith: Seven Major Themes" as an elegant set-
ting for receptions, lectures, and other entertainment of influential Wash-
ingtonians. In return for sponsoring the National Gallery's reinstallation of
its American paintings, the New York Stock Exchange board of directors
and its European advisory committee were guests at a reception sponsored
by the museum's trustees, along with members of Congress and other gov-
ernment officials. The speaker had no remarks about the art or the
museum; he was Secretary of the Treasury James A. Baker III and he held
forth on the challenge of economic competition and the promise of new
technology.[18]

While publicity, self-promotion, and the chance to gain the ear of the
influential frequently motivate benefactors, the American tax system guar-
antees their continuing generosity. "If the charitable impulse is the engine
that drives the train of American philanthropy," one study noted, "the char-
itable deduction is the coal that stokes the engine." The engine consists
overwhelmingly of individuals, literally millions of donors more or less vol-
untarily writing out checks or remembering their favorite charities in their
wills. Corporate and foundation contributions, not to mention direct gov-
ernment grants, are mere rivulets compared with this vast outpouring of
cash. A scholar who examined this phenomenon in the 1980s found that
individuals had contributed more than $3.6 billion to the arts and humani-
ties, well over ten times as much as foundations and corporations. In 1991,
gifts to the arts and humanities from individuals, foundations, and corpora-
tions totaled $8.8 billion.[19]

The tax deduction for private giving forms a substantial indirect govern-
ment subsidy for all charitable endeavors. In 1983, the tax the government
waived on contributions to the arts and humanities alone, whether by indi-
viduals, corporations, or foundations, was estimated at $1.75 billion. Pro-
jections by the U.S. Office of Management and Budget indicate that in
1995 this "tax expenditure" will surpass $3 billion and continue to grow
into the foreseeable future. Exemption from state and local income taxes,
plus property-tax exemptions, significantly magnifies the total tax forgive-
ness. Those who draw odious comparisons between the American govern-
ment's paltry direct appropriations for the arts and other governments'
lavish arts patronage usually overlook these generous subsidies. An Ameri-
can invention, the tax deduction for charitable contributions assures an

astonishing diversity of philanthropic endeavors; it constitutes an immense
indirect public subsidy for every nonprofit enterprise.[20]

This system of private giving formed the background for the NEA's most
ambitious program for channeling nongovernment contributions to its
clients. The idea of using grants to encourage arts organizations to seek pri-
vate matching funds had originated with the Ford Foundation in 1968,
when it offered orchestras millions of dollars to bolster their endowments
if they raised comparable sums from other donors. In 1976, Nancy Hanks
hit upon an ingenious variation on this formula: The NEA would establish
a separate pool of funds within the endowment's budget for a new category
called challenge grants. Organizations receiving these grants would have
up to three years to obtain three or even four times the NEA's grant in new
or increased private money. The plan attracted an overwhelming response
—380 organizations applied for a total of $128,767,700. With only $27 mil-
lion available, the endowment began the ticklish task of evaluating applica-
tions and facing the wrath of the rejected. The fifty-nine chosen applicants
committed themselves to raising more than $150 million, nearly double
the minimum three-to-one match. Hanks, among many others, believed
that this program was the key to solving the arts' perennially precarious
financial plight. Livingston Biddle also was certain that the increased pri-
vate donations leveraged by challenge grants would "foster long-term
stability for the nation's cultural organizations."[21]

With its emphasis on prudent, professional management, some critics
contended that the challenge grants arrangement rewarded fundraising
skill rather than artistic quality. Elizabeth Weil Perry, who managed the
program during its formative years, believed it would "give leaders of arts
organizations a fishing rod to broaden their base of support." Yet, despite
the addition of advancement grants for smaller organizations, the chal-
lenge grants tended to favor the strongest, best-known arts organizations.
The Los Angeles Music Center Fund received more than $2 million in the
first round, and $1-million grants went to such cultural pillars as the
Brooklyn Museum, Pittsburgh's Carnegie Institute, the Detroit Symphony,
the Metropolitan Museum of Art, New York's Museum of Modern Art, the
Cleveland Orchestra, Washington's National Symphony, the New York City
Ballet, the Pittsburgh Symphony, the St. Louis Symphony, and the San
Francisco Performing Arts Center. In subsequent rounds, smaller grants
went to more diverse groups and places, but the race still went mostly
to the financially swift and agile. In 1983, museums captured more than

one-quarter of the total, while music and theater each won one-eighth.[22]

The endowment claimed that challenge grants were stimulating huge increases in private arts giving; each government dollar had "leveraged" eight private ones. But finding the real gain in new or increased contributions became ever more tricky. In time, the line between "new" and "old" contributions blurred, exaggerating the ratio. The spectacular growth in private arts funding had many causes: general prosperity, corporate discovery of the publicity value of arts giving, and private donors' yen for purchasing self-esteem, public recognition, and social status. In fairly short order, the structure of these grants challenged both donors and recipients to search for creative evasions. Some arts organizations that expected a challenge grant asked major donors to hold off until the grant was approved, so that the donation would count as a match. Others suggested that donors give twice their usual amount every other year, so that the gift would look like a new donation. Some corporations concentrated their regular annual gifts among challenge grant recipients; others attributed the usual donation to a subsidiary or affiliate, making it appear like a new gift.[23]

Though grants and contributions rose steeply in almost every artistic endeavor, gross expenditures mounted even faster. In 1970, symphony orchestras collected more than $30 million in gifts toward $76.4 million in expenses; in 1980, gifts were $105 million, but expenses were $252 million; in 1990, gifts were $290.4 million, and expenses $688.8 million. Theater showed a similar pattern—in 1975 contributions of $12.7 million toward $34.5 million in expenses; in 1980, gifts of $46.3 million to offset $113.6 million in expenses; in 1990, contributions of $119.2 million went toward expenses of $336.7 million.[24]

These figures suggest that arts organizations can absorb any amount of additional funding, whether private contributions or government grants. More troubling than the figure-fudging fostered by the challenge grant system was the implication that, along with its money, the NEA was leveraging the clout of its artistic judgment. By giving its seal of approval to certain organizations—a distinct minority of all applicants—the NEA was replacing private donors' discernment as to worthy recipients with its own. While steadfastly denying that it was shaping taste, the endowment's challenge grant program inevitably channeled private giving toward the institutions and art forms it favored.[25]

To bolster private donations, the Reagan administration started yet another government agency to promote more private giving to the arts and humanities. Funded by the endowments, the President's Committee on

the Arts and the Humanities grew out of the Reagan task force's recommendations. It brought together the heads of federal cultural agencies and prestigious private arts donors and was charged with finding ways to increase private arts support and to improve the efficiency of government arts and humanities spending. In its first six years, the committee claimed to have raised $11 million for sixteen collaborative projects, including the Fund for New American Plays, while spending only $300,000 in public money.[26] The committee continues to meet in Washington three times each year, a forum where private business and government agencies discuss policy, needs, and trends. Late in 1994, President Bill Clinton sought to revitalize the committee by appointing John Brademas as its new chairman. Brademas had enjoyed a distinguished career as a friend of the arts in Congress, as well as president of New York University.

On Capitol Hill, the arts gained official recognition as a nationwide political force with the founding, in 1981, of the Congressional Arts Caucus, originally funded with contributions from the American Arts Alliance and other arts lobbying organizations. Partly in response to Reagan's threats to abolish the NEA, the caucus attracted 150 members in its first year and quickly grew to 200. It was one of a fast-growing contingent of special-interest alliances within Congress, an outgrowth of waning party discipline. By 1982, thirty-one such groups had filed for certification by the House leadership, and within two years the Arts Caucus was not only the largest but also the most powerful of all congressional special-interest gatherings.[27]

The Arts Caucus's members were preponderantly Democrats, but Republicans from states with strong arts constituencies formed a bipartisan cloakroom lobby for the arts endowment. Within a year, its founder, the Brooklyn congressman Fred Richmond, was beset by legal problems. In August 1982, he resigned his seat on the same day he pleaded guilty to income-tax evasion, marijuana possession, and making an improper payment to a federal employee, and was sentenced to a year and a day in a federal penitentiary. Richmond's successor as Arts Caucus chairman was the Long Island congressman Thomas J. Downey. Though a defense specialist, he tried gamely to rally support for subsidizing the arts. Cutting their funding, he told a conference of mayors, was "equivalent to tying da Vinci's hands behind his back and then telling him to paint the Mona Lisa."[28]

Soon after his ascension to the chairmanship in 1983, Downey expansively flexed the Art Caucus's political muscle. Within five years, he bragged to an interviewer, congressmen would be having art exhibitions in their offices and the caucus would sponsor a film festival second only to

those in Cannes and New York. His ambition was to make the caucus "a feared group." In the House, Downey, who would be defeated in 1992, played out a good cop–bad cop routine with Representative Sidney Yates, who abstained from membership in the caucus while sitting on the powerful Appropriations Committee. The combination of tiny arts appropriations and a powerful arts constituency had made the caucus "a tenacious little beast," said Downey. "If anyone wants to cut arts funding, Yates can tell them, 'Look, I've got a letter here signed by 160 members. . . . I want to keep these people happy.'" By 1993, when the Michigan representative Bob Carr replaced the defeated Downey as Arts Caucus chairman, its activities were considerably subdued. Downey's film festival had faded to a faraway fantasy as the Arts Caucus's members were embarrassed by questionable NEA grants. The only art hung by the caucus consisted of the winners of its annual high school competition, displayed in a tunnel between the Cannon House Office Building and the Capitol. The show, said the *New York Times,* was "as safe for legislators as apple pie and motherhood." In January 1995, the Arts Caucus and a covey of other special-interest groups were effectively abolished by the new economy-minded Republican congressional leadership.[29]

Possibly the most astonishing constituency of those applying steady pressure for government arts funding was that most elite and costly of arts institutions, opera. For most of its history in America, the goings-on in the Diamond Horseshoe were more fascinating to patrons and the public than the art form on the stage. Tabloid photographs caught Astors and Vanderbilts strutting into the Met, furs dripping from their shoulders, diamond tiaras glinting in the flash bulb's harsh glare. The old Metropolitan Opera House so lovingly recreated in the movie *The Age of Innocence* was the setting for intrigues among New York's patricians as convoluted as the plots unfolding behind the footlights. Boxes passed through generations of old New York like gilt-edged securities, their location a marker of social status. Subscribers picked the dates they wished to attend, filling more than 70 percent of the seats in advance, even though they did not know which operas they would see. During the 1930s, the financier Otto Kahn of the Kuhn, Loeb banking house made up deficits almost single-handedly, as lean times forced the Met's old money to accept patronage by a new business class. The corporate element entered with Texaco's sponsorship of Met radio broadcasts nationwide, the magnet for a vast new audience swarming to hear the live Met during its extensive tours. With the Met's

move to Lincoln Center, and touring curtailed by spiraling costs, the curtain rose on an astonishing surge of new American opera companies.[30]

From the Second World War to the 1990s, a cavalcade of unlikely places was seized by a lust for opera productions on the state and local levels. Companies representing Mississippi, Mobile, and Shreveport sprang up during the 1940s; Santa Fe and Orlando, in the 1950s; Grand Rapids and Fargo, during the 1960s; Nevada and Anchorage, during the 1970s; followed by Roanoke, Greensboro, Sacramento, and San Jose during the 1980s. In 1966, seven hundred companies were producing operas, but most of them were amateurs or semiprofessionals. The *Reader's Digest,* whose publisher DeWitt Wallace was an ardent contributor to the Met, proclaimed that opera, "an essential golden thread in the nation's cultural fabric, has never before been so popular." More professional opera followed and by the 1990s ninety-nine professional producing companies were part of opera's energetic lobbying and service group, Opera America. Altogether, more than 200 companies with budgets over $100,000 were regaling Americans each year with more than 15,000 performances of more than 700 different operas. Many of these companies also produced musical theater, nearly 10,000 performances annually of nearly 300 musicals. Nonprofit opera and musicals attracted well over 20 million spectators each year, about as many as symphony orchestras and considerably more than theaters.[31]

The Met meanwhile had moved from showcasing New York's elite in its box seats to presenting creditable productions of European standards on the stage. After the imperious Rudolf Franz Joseph Bing arrived as general manager in 1950, the season gradually expanded from eighteen to thirty-one weeks, and the number of subscribers grew from 5,000 to 17,000. When the Met moved into its lavish Lincoln Center house in 1966, the annual budget of $10 million was balanced. But villains lurked in the wings. By the mid-1970s, subscriptions had dropped to 58 percent of the house, and some 14 percent of all seats remained unsold. Despite a four-week cut in the season, the Met was still borrowing working capital from banks, having gone through a $5-million legacy from Martha Baird Rockefeller, $3.9 million in proceeds from the sale of the old house, and $2.6 million in insurance for costumes burned in a warehouse fire. The venerable company was reduced to leasing the house, at $10,000 per Sunday, to a rock impresario for raucous sessions by the Who; Melanie; Labelle; and Blood, Sweat and Tears.[32]

Though repeatedly rescued by government aid, the Met was simply too

big and unwieldly for conventional therapy. In 1974, it was spending more than the total box office receipts of all but four other American opera companies on just clerical, box office, and front-of-the-house staff. While the Met's box office income far exceeded the ticket revenues of all other opera companies combined, its annual deficit also was colossal, $9 million in 1976 alone. Yet such was the company's worldwide prestige that it could not be allowed to fail; it had become a key player in America's Cold War strategy on the cultural front, as well as a magnet for New York City's important tourist industry. If the Met were to go under, warned its manager Schuyler Chapin, "it would have a domino effect on all the other cultural institutions in the performing arts." By the Met's hundredth anniversary in 1983, the invalid, unlike the bohemian Mimi, had miraculously returned to blooming health. For a thirty-week New York season, plus eight weeks' touring, the Met was selling nearly one million tickets. Radio broadcasts and televised "Live from the Met" programs netted $18 million; a computer kept track of a million current, past, and potential contributors, spewing out dramatic appeals to cover shortfalls in the $74-million budget.[33]

By the 1990s, the Met continued to prosper, despite triple-digit ticket prices, amounts so steep that its weekly newspaper advertisements omitted any mention of price. Yet the costliest tickets in the high art industry did not deter more Americans every year from attending more performances of this historic, essentially European spectacle. Opera audiences appeared to lap up the improbable plots, to overlook the cartoonlike characters, and to be willing to scan supertitles for a sketchy sense of what the foreign language commotion on stage was about. The reason for opera's popularity, said Marc Scorca, who directed the Chicago Opera Theater before becoming the CEO of Opera America in 1992, is that it "resonates with contemporary multimedia art"—its sumptuous blend of text, music, drama, and dance, mimicking such popular spectacles as MTV, music videos, and rock concerts.[34]

Though many companies mingled revivals of American musicals with classic operas, not to mention a surprising number of new American works, audiences all over the country appeared insatiable for the old warhorses. Of 444 productions during the 1990–91 season, twenty-two were of *Madama Butterfly*. Ninety years after its premiere, this was the most modern of the top twelve operas that comprised 36 percent of that season's repertoire. Puccini's multi-hanky intercultural immorality tale was featured in almost 5 per cent of that year's 2,200-odd operatic performances.

Indeed, *Butterfly, Die Fledermaus,* and three Mozart operas—*The Marriage of Figaro, Così Fan Tutte,* and *The Magic Flute*—comprised almost 20 percent of all professional opera productions in America that year. Opera's platinum composer, dead for more than two hundred years, is wittily enshrined in the name of the opera company in Bartlesville, Oklahoma: OK Mozart, Inc.[35]

Continuing reliance on the top ten "poperas," as one critic styled them, is even more striking considering the vast and growing operatic literature. Lining the walls of a large storage room at Opera America's headquarters in Washington, D.C., and slowly being fed into an electronic database, is a mass of file folders holding music and librettos, production notes, reviews, and other supporting materials for some 27,000 different operas. Furthermore, generous foundation funding is briskly bringing forth a parade of new operas. Appalled that American opera companies were riding on the backs of a handful of dead European composers, the director of the Rockefeller Foundation's music program, the former *New York Times* music critic Howard Klein, initiated a five-year program to encourage new opera. The project, Opera for the Eighties and Beyond, stimulated a creative frenzy among opera composers. While in 1983 only four new works premiered, seventeen new operas were produced in 1991. When Rockefeller Foundation support ended, more than seventy new operas had been produced, stimulated by grants totaling $2.7 million.[36]

The Lila Wallace–Reader's Digest Foundation then began supporting the creation and production of new works through its Opera for a New America program. The 1992–93 season saw two dozen world premieres given by sixteen companies. Administered through Opera America, the procedure for obtaining a Wallace grant is refreshingly simple. A thirty-two-page booklet includes nine pages of guidelines in crystalline prose worthy of the *Reader's Digest* itself. To eliminate conflicts of interest, no one who stands to benefit from a grant may serve on a review panel. Compared to the large sums the NEA must distribute to its regular clients, the Wallace Foundation gives away a pittance. During the first three years, it spread just over $2 million among forty-six companies, all aimed at enlarging audiences and producing new works.[37]

Though it received no Wallace funding, even the Met was briefly infected with foundation-fed fever for new opera, producing *The Voyage* and *Ghosts of Versailles* during the early 1990s. Up to the 1993–94 season, the Met's newest production had been Benjamin Britten's *Death in Venice,* written in 1973. With a budget three times as big as that of the next largest

opera company in America, the Met prefers to emphasize a proven product, reviving less familiar operas by nineteenth-century giants: Verdi's *Stiffelio, Otello,* and *I Lombardi,* and Dvořák's *Rusalka.* Most adventuresome have been shoestring companies at the bottom of Opera America's five-level membership pyramid. Working with total annual budgets between $100,000 and $500,000, they harness volunteers and, often, students. Operating in places where opera is a rarity, they have less to lose and a great deal of publicity and prestige to gain by presenting new works. In 1993, for example, the Madison Opera in Wisconsin sold out 95 percent of its house for *Shining Brow,* an opera based on ten turbulent years in the life of the architect Frank Lloyd Wright. With an annual budget of $350,000 and a full-time staff of two to stage a pair of productions, the company raised $500,000 in grants and contributions to present *Shining Brow.* "Who would have thought it would happen here?" the *New York Times* music critic condescendingly asked, and concluded that the "provincial enterprise" had carried the commission through "in high style."[38]

One of the most unusual opera companies in America has been performing for sixty years in Central City, Colorado, a mining town about thirty miles northwest of Denver. For about six weeks each summer, visitors negotiate a winding road into the Rockies to an elevation of 8,450 feet. They sit in historic hickory chairs under an elaborately frescoed ceiling in a rough-hewn stone building restored to its 1878 splendor. Under the artistic director John Moriarty, the chairman of the opera department at the New England Conservatory of Music, some two dozen apprentices picked from among 1,200 applicants join professional stars in three rotating productions. The entire company lives in thirty historic houses owned by the opera, surrounded by gambling parlors legalized since 1992.[39]

Supporting this brief season of such popular fare as *Manon Lescaut, La Bohème,* and *The Vagabond King* is a year-round cycle of fashion shows, home tours, operatic concerts, youth performances, picnics, dinners, and parties sponsored by the Central City Opera Association, based in Denver. Income from these events, contributions, and grants supplements ticket sales to support a budget well over $2 million. While regular tickets cost as much as $47, students can attend several youth performances for $2, and adults accompanying at least four young people pay only $5. The company's outreach program for schools also brings in revenue; two back-to-back forty-five-minute performances cost $400.[40]

The recent burst of operatic creativity is matched by promoters' fanciful flights to sell performances of the old standbys. The Central City Opera

describes one of its offerings thus: "The seductive Carmen alluringly captures men's hearts and souls. But when two smitten lovers demand her allegiance, she runs from the obsession of a soldier to the arms of a toreador, only to discover that her cunning flirtation has turned into a fatal attraction." In the early 1980s, the Connecticut Opera attracted 10,000 spectators to a Hartford hockey rink, the largest indoor opera audience ever assembled, for a spectacular *Aida*. Posters pasted all over town, searchlights stabbing the sky, T-shirts in the lobby, and summaries of the next scene twinkling on the hall's electronic message boards mimicked the excitement of a rock concert. Elsewhere, opera companies' colorful brochures market their product with overwrought prose. One bills *Tosca* as "a torrid tale of love and revenge set against the telling background of a concentration camp."[41]

In San Diego, fans paid at least $80 each to pack a 14,000-seat sports arena to hear Luciano Pavarotti at a benefit for the local opera company. About 600 enthusiasts paid $250 to eat supper beforehand in an adjoining tent, where the Great One favored diners with a few bars of "Arrivederci Roma." For $1,250 each, 275 patrons received prime seats and attended a post-concert dinner where they were guaranteed a chance to shake hands with the celebrated tenor. Though the event was among the top-grossing concerts in North America for October 1992, it added only 400 people to the opera company's more than 10,000 subscribers.[42]

Critics of such glitzy promotions wonder what the razzle-dazzle has to do with enriching Americans' cultural lives and whether the public should subsidize organizations with such potent fundraising resources. Italy might support opera for its contribution to national unity and its immense popularity, but in America, grumbled one conservative opponent, it is "an exotic import of and for the rich." To spend public money on opera, he complained, "supports our national consciousness as much as a subsidy to the manufacture or the wearing of top hats and tails." The novelist E. L. Doctorow singled out opera as unworthy of public funding when he addressed the National Council on the Arts in May 1993. Unlike filmmaking, he said, "opera is not a living art in this country." The endowment's heavy support of opera, said the novelist, "betrays a belief in arts as something from the past rather than something that can spring up, startlingly, here and now."[43]

With all its showbiz potential, however, opera is blending high and low art into a distinctly American soup. In 1945, Rudolf Bing demanded that the baritone Robert Merrill tender a formal written apology before returning to the company after appearing in a Hollywood movie. In October

1989, by contrast, the Cleveland Opera premiered *Holy Blood and Crescent Moon,* written by the Hollywood composer Stewart Copeland, a founder and drummer of a disbanded rock group, the Police. The world of opera has also inspired comic book artists, who have reveled in its melodramatic plots and exaggerated characters. The comic version of Wagner's *Ring Cycle,* "suggested for mature readers," featured naked Rhine maidens and gory wounds. The *Ring* thus presented, wrote the *New York Times* critic John Rockwell, "with its flying horses and sudden transformations, is more faithful to the composer's vision than a genteel, gravity-bound stage production could ever be."[44]

Picking its way through the garish jungle of such kitschy efflorescences to find what is worthy of public support has never been easy for the endowment. From the beginning, the European heritage of concert music and opera, ballet, and theater had little trouble in gaining charitable support, whether from government, foundations, or individuals. Ironically, the art forms invented in America—musical theater, modern dance, jazz, folk art, and film—had to fight for recognition as genuine cultural treasures. After ignoring jazz altogether during its early days, the NEA gave small grants to individual artists but ignored ensembles because they were not nonprofit organizations. As the pressure to fund jazz mounted, the endowment devised a cumbersome method of distributing grants to jazz ensembles; it set up a nonprofit organization for presenters of jazz concerts. Grant amounts remained small compared with what concert music and opera were getting, and the panels charged with evaluating applications had difficulty in neatly fitting jazz composers into their rigid categories. When the bassist Charlie Mingus approached the endowment's composer-librettist panel, his grant application was sent to the jazz panel even though the proposed work was in classical form.[45]

Like jazz, the world of folk art includes an immense variety of artists, some part-time, some amateurs, some of marginal quality, some obscure and unknown. Like jazz musicians, many folk artists inhabit a quasi-commercial realm. Folk art is even more complex in that it includes music, dance, crafts, storytelling, poetry, and a vast assortment of traditional ethnic expressions. During the 1930s, when many specialists feared that folk music was dying out, the ethnomusicologist Alan Lomax traveled around the country recording traditional music for the Library of Congress. His work contributed to an extraordinary revival during the 1950s, followed by commercial success and popular blends with other traditions such as rock-

and-roll and rhythm and blues. Beginning in the 1970s, the Smithsonian sponsored the annual twelve-week summer Festival of American Folk Life, bringing as many as one hundred folk artists to perform and exhibit on the Mall in Washington each week. It climaxed with a huge gathering for the Bicentennial in 1976.[46]

Even though the Library of Congress and the Smithsonian were already supporting folk arts, Nancy Hanks considered their charming down-home glory a fine way to win over congressmen from small rural states. She started the endowment's program in 1974, with $500,000 and Allan Jabbour as director, who had been trying to expand the Library of Congress's Archive of Folk Song into a full-blown folk life center. After Jabbour returned to the Library of Congress to head the newly approved center, Bess Lomax Hawes began her long tenure as head of the NEA's folk arts program. Building on her prestige as Alan Lomax's daughter, she sponsored fieldwork to locate folk artists and ethnic communities where traditional arts were pursued. In Mississippi, the NEA's program revived the art of basket making after it was down to just one practitioner. Among Vietnamese immigrants, it supported apprentices in the art of Hmong lace making. It gave awards to makers of sweet-grass baskets in South Carolina and when the necessary grass was threatened by development, persuaded builders to set aside some land where it could continue to grow. In 1980, the NEA helped to organize the National Council for the Traditional Arts, yet another service group to lobby Congress in the endowment's behalf.[47]

Encouraged by the NEA, each state employed at least one folklorist to attempt to keep track of an astoundingly diverse galaxy of artists: Cajun accordionists and Cambodian dancers, African-American quilters and Hawaiian cowboy musicians, Alaskan Athabascan fiddlers and Tex-Mex mariachis. Since 1984, the endowment has sponsored frequent cowboy poet conclaves in Elko, Nevada, sparking 150 other such fests throughout the west. The First International Mariachi Conference, organized by NEA in 1980, spawned more such get-togethers in Houston, Tucson, Albuquerque, Los Angeles, Fresno, Salinas, and Las Vegas. Whether such popular entertainments require public funding remains open to question. The folk arts program director Dan Sheehy describes a crisis: Accelerated social change is placing smaller cultures and traditional artists under "heavy duress. . . . The next thirty years will determine the fate of countless peoples." Yet folk arts are thriving as never before in the commercial and entertainment arenas. The arts economist Dick Netzer suggested that the imminent death of folk arts has been gravely exaggerated. Alan Lomax's

strenuous efforts to save the dying tradition of folk music have magnifi-
cently succeeded, he argued: "Folk arts are flourishing." Indeed, a folk fes-
tival the NEA helped to fund in Lowell, Massachusetts, attracted a record
crowd of some 220,000 in 1992.[48]

So long as its budget was increasing, the NEA could promiscuously
expand into any nook and cranny where an art might lurk. Most of the
money could continue to go to the elitist mainstream institutions with large
budgets, high visibility, and staunch advocates. Meanwhile, relatively small
sums spent on popular mediums like jazz and folk arts demonstrated to
dubious legislators that in the endowment's elitist house there were also a
few populist rooms. To furnish them all, the agency needed an ever-
increasing budget. For, having once received a grant, having carried out a
funded project, as Hodsoll described the predicament to a congressional
committee, a cultural organization would expect another grant the follow-
ing year. With each passing year those already funded were more firmly
entrenched via precedent and connections. Loss of the grant, or even a
small reduction in it, unleashed a whirlwind of pleading letters to the NEA
and desperate phone calls to congressional offices. The grant had become
an entitlement. In a familiar pattern that sociologists call institutionaliza-
tion, more than half of the NEA's dollars were going to just over 6 percent
of all arts organizations or individuals applying for grants.[49]

Possibly the most persistent feeder at the entitlement trough was the
American Film Institute (AFI). Sprung on the fledgling NEA by direct
order of President Lyndon Johnson, the AFI at first gobbled up some 25
percent of the agency's slender resources. It was the only endowment pro-
gram specifically mentioned by the president on the day he signed the
NEA's birth certificate. Roger Stevens tried to delay this seizure by order-
ing a $91,000 study by the Stanford Research Institute to learn what the
AFI could and should accomplish. To the dismay of almost everyone inside
the NEA, the study concluded that "an institute was indeed vital to quality
in the major art form of film." The study's authors hardly glanced at the
billion-dollar film industry centered less than five hundred miles south of
the Stanford campus that already supported the American Academy of
Motion Picture Arts and Sciences. Instead, the study asserted that foreign
organizations similar to the proposed AFI had resulted in "films of interna-
tional artistic acclaim." No one at the endowment had any idea what the
new film institute was supposed to accomplish, aside from cementing
Johnson's friendships in the film community. At the end of the endow-
ment's first year of life, Stevens lamely reported that the AFI's primary

mission was "to promote the creativity of artists." However, this goal was already dissolving into a multitude of tasks—forming a film archive, conserving and restoring old films—which Stevens claimed the movie industry had ignored. In 1967, with the NEA's $1.3 million in hand, plus equal sums from the Ford Foundation and the Motion Picture Association of America, the AFI opened offices in Washington, D.C., New York, and Los Angeles. By then, its mission had drifted farther out of focus. Now, the AFI leadership announced, it would "concentrate on archives, education, advanced film studies, film production, research, and publications."[50]

The AFI's first director was George Stevens, Jr., whose father, a renowned film director, happened to sit on the National Council on the Arts. Though the endowment's counsel Charles Ruttenberg considered this appointment "incestuous" and believed that the film industry possessed ample resources to support the institute's work, the organization had powerful friends. Through the years, AFI continued to commandeer large sums without applying for them or accounting for how they were spent. Around the NEA, the film institute was "treated as a problem," said one staffer. In 1973, Congress embedded AFI in the endowment's budget by directing that the institute receive a specific amount of NEA money each year.[51]

Political differences meant little among the AFI's ardent Hollywood supporters. When the liberal Democrat Gregory Peck was joined on the council by Harper Lee, author of the novel *To Kill a Mockingbird*, the movie adaptation of which Peck had starred in, the AFI became sacrosanct. Nor could the endowment control its multifarious activities. "Who could disagree with Lincoln?" Livingston Biddle flippantly asked, referring to another of Peck's film roles. When the conservative Republican Charlton Heston replaced Peck on the council, and was chairman of the board at AFI as well, Biddle recalled one of Heston's roles and asked: "Who could argue with Moses?"[52]

With its goals and offices dispersed to the points of the compass, its leadership questionable, and its accomplishments nebulous, the AFI nevertheless marched on, gobbling up substantial federal subsidies. By 1988, it had spent more than $16 million to preserve nitrate-based films produced before 1950. It sporadically presented programs of old movies, though never achieving the continuity or coherence of the film programs at New York's Museum of Modern Art or the University of California in Los Angeles. Its magazine, *American Film*, which had never achieved stature beyond a trade publication, had been turned over to private management.

Its board of directors included some of Hollywood's wealthiest executives. Yet the political pressure for continued government support of AFI, wrote Michael Straight, was "relentless." Biddle observed that AFI caused "disputes and animosities that never quite subsided." Many within the NEA wondered why, twenty years after AFI's founding, the taxpayers should still provide one-quarter of the operating budget for an organization benefiting a huge and profitable industry. In 1986, when the movie industry grossed more than $20 billion, the endowment was still handing AFI almost $3 million, and no end was in sight.[53]

While even parsimonious Frank Hodsoll shrank from trimming a project of direct interest to the former Hollywood actor in the White House, he deftly sank some of the endowment's more embarrassing initiatives. One was a program begun in 1972 to improve the quality of art criticism. Up to 1982, about $650,000 had been spent on almost two hundred grants of $1,000 to $5,000. Recipients were such well-known art writers as Lucy Lippard, Joseph Mashek, and Carter C. Ratcliff, and such successful academics as Irving Sandler, Robert Pincus-Witten, and Donald B. Kuspit. The consultant whom Hodsoll hired to study the program brought in a scathing report. It noted that most grant applicants wrote exclusively for art insiders and few showed any sense of writing style or attempts to address a broader audience. In 1978, a panelist described all the applications as "horrible," yet $63,000 was given away. One panel rejected a careful writer whose project it did not like but funded a critic whose writing was considered "clumsy, awkward, and incoherent" because he could use the money. Panels tended to favor writers for obscure alternative publications with "specific ideological biases." In 1979, the panel "seemed bent upon correcting at one sitting two centuries of male-dominated, geographically centered criticism." In its ten-year life, the report concluded, the program's grants had wrought "no significant change in the writing ability of recipients."[54]

At an NEA conference to consider the consultant's indictment, many participants furiously greeted the idea that critics should write clearly. "All this talk about good writing," said one, "sounds very fascistic to me." Of the twenty-four conference participants, ten had received grants or sat on panels, or both. To them, wrote the conference participant Hilton Kramer, "the very concept of a conflict of interest seemed not to exist." He discerned "a mutual admiration principle" governing many grant decisions, with participants taking turns giving and receiving grants. "At the core of the program," Kramer observed, "there was a certain nucleus of friends

and professional colleagues who were assiduous in looking after each other's interests . . . the record suggests that the whole . . . program functioned as a kind of private club." A popular *Washington Post* columnist added a fatal touch of levity: "Society has no more interest in funding the flowering of a million art critics," wrote Jonathan Yardley, "than it does in subsidizing the instruction of place kickers or head waiters."[55]

It was the sort of embarrassing arrangement that Hodsoll was determined to break. He not only abolished the art critics program but also developed charts to assure that panelists were diverse demographically and within fields. Above all, he was determined to bring modern management to an agency accustomed to a seat-of-the-pants operation. Arriving on the heels of Reagan's short-lived death sentence for NEA, he calmed apprehensions within the arts world with hard work, scrupulous fairness, and firm control. "When he was appointed, he didn't know Stravinsky from Haydn," said Nick Webster, then manager of the New York Philharmonic. "But he was a political animal. He learned what [the endowment] was about and in the end became an able spokesperson for the arts. . . . He earned respect."[56]

As the nation's chief public advocate for the arts, Hodsoll, like his predecessors, endured a grueling travel schedule. During one four-month period he visited the Alabama Arts Council, attended a Los Angeles meeting of the President's Committee on the Arts, appeared at the Mid-America Arts Alliance in Kansas City, spoke at the Commonwealth Club in San Francisco, gave a luncheon speech at the New School Association in New York City, testified at oversight committee hearings in Washington, watched a Merce Cunningham dance performance in New York City, participated in a Mississippi conference for local arts in Jackson, saw the opening of the Paul Taylor Dance Company in New York, took part in the dedication of the Roger Stevens Arts Center in Winston-Salem, visited the Dallas Institute of Humanities and Culture, chaired a three-day meeting of the National Council on the Arts in Washington, addressed a volunteer urban consulting group in New York City, spent a weekend at the Spoleto Festival in Charleston, and addressed the International Society of Performing Arts Administrators in Washington.[57]

At each out-of-town venue, he followed a spartan schedule. On a morning walking tour of SoHo, he zipped in and out of eight galleries, all before noon. Typical was his San Francisco Bay Area trajectory during one hectic Saturday in August 1983. Sweeping through Sausalito, Oakland, and San Francisco, Hodsoll met with several avant-garde groups, inspected several

inner-city projects, attended a matinee of *Uncle Vanya* at the American Conservatory Theater, and spent the evening with the San Francisco Mime Troupe; lunch and dinner got a scant hour. His tour had nimbly avoided an NEA client gallery where an Australian artist was hung from the ceiling by fishhooks through his chest, legs, and abdomen while about fifty spectators listened to his heartbeat for some fifteen minutes on an amplified electro-cardiogram. Herb Caen described the event in his *San Francisco Chronicle* column, and a colleague wrote to Hodsoll: "I'm glad we missed this one!" The chair passed the clipping on to the directors of NEA's inter-arts and visual arts programs, with a note: "What do you make of these from our latest advancement grantee?"[58]

As he familiarized himself with the contemporary arts scene, Hodsoll scrutinized every panel recommendation for its potential to mortify the endowment. Perhaps privately he deplored the increasingly political and confrontational character of the self-styled avant-garde, but his public statements adroitly shunned inflammatory criticism. In a memo summoning several aides to discuss two shrill artists' forum magazines, *Cover* and *Crawl Out Your Window,* Hodsoll's assistant mildly wrote that "the chairman would like to discuss what we're doing here and generally learn more about these magazines." Rejecting a grant to the radical art critic Lucy Lippard's Political Art Documentation/Distribution organization, Hodsoll explained that there was no question about the proposal or the people involved with it but only about the "organization's ability to carry out the project." But he reminded Lippard that "decision-making authority with respect to *all* grants rests solely with the chairman; he is *advised* by the panels and National Council. Our statute stipulates this in order to assure accountability for expenditure of the taxpayers' money."[59]

In 1982, no further grants went to the Washington Women's Arts Center after it credited the NEA and the Pleasure Chest, a sexual aids emporium, with supporting its "Erotic Art Show." Hodsoll refused to fund a forum by the Heresies Collective on "the role of the creative individual within changing social structures." He also canceled a grant for a documentary film on American involvement in Latin American conflicts, saying, "It was not artistically good. . . . It had no balance; it was not professional." Another grant he rejected because of its potential to "cause such a fuss that [it] could destroy the endowment" was the Washington Project for the Arts plan to place a "high tech soapbox" bearing a cheeky Jenny Holzer slogan in front of the White House, Supreme Court, and Capitol. In his first two years, Hodsoll questioned about 5 percent of more than 5,700 grants rec-

ommended by the panels, but eventually only twenty were rejected; during his eight years as chair, said Hodsoll, he turned down fewer than 1 percent of the recommended proposals.[60]

While fending off tricksters on the "left," Hodsoll also dealt diplomatically with subtle congressional pressures for various constituents' projects. "You may be assured that [the Kingston Artists Group's] application is receiving careful attention," he wrote to the New York senator Daniel Moynihan. "We certainly appreciate receiving your very supportive comments on behalf of the [Lill Street] Gallery's proposal," he informed the Illinois senator Alan J. Dixon, adding information on precisely where the application currently lodged and when a decision would be made. When grants were awarded, Hodsoll notified the home congressman: "You will be pleased to know," he wrote to the Louisiana representative Robert L. Livingston, "that review by the Endowment and the National Council on the Arts has been positive regarding the [Louisiana World] Exposition's application."[61]

Responding to urgent local pleas for aid, states and cities were devising increasingly ingenious means of extracting public dollars for art. In Florida, a 1988 increase in the corporate annual report filing fee from $25 to $35 raised nearly $5 million to guarantee the state's fourteen major cultural institutions annual subventions of $100,000 to $500,000. Meanwhile, the Florida Arts Council continued to distribute grants capped at $40,000 to smaller groups and individuals. A finely honed formula for distributing Montana's coal severance tax gave two-thirds of the total proceeds to the state Fish, Wildlife, and Parks Department and one-third to the Montana Arts Council.[62]

Before the founding of the NEA, only New York's arts council had substantial funds to give away. After the NEA offered an initial $50,000 and promised more in subsequent years, every state and six territories organized arts councils. Urged to survey their needs, states quickly discovered what the NEA already knew: The appetite for grants appeared insatiable. In New Jersey, the arts commission in 1968–69 had only $75,000 to give away but was swamped by 168 applications asking for more than $2 million. By 1988, New Jersey was spending more than $20 million on its arts council, and a 13 percent increase the following year raised per capita spending on the arts to $296, the eighth highest in the nation. Furthermore, twenty states had embedded additional "line-item" support to one or more politically powerful arts institutions in their annual budgets, circumventing panel review for specific projects in favor of outright entitlements.[63]

In 1980, NEA's support of the arts was roughly 50 percent greater than

what the states were spending. By 1984, the federal and state shares were about equal, but, wrote one scholar, "a quiet change in the center of gravity" was inexorably shifting the burden for supporting the arts from the federal to the state level, and, even more significantly, to the local level. In 1981, orchestras were receiving 4 percent of their total income from federal sources and 8 percent from state and local agencies; by 1985, only 2 percent came from Washington and 7 percent from state and local sources. Theaters in 1981 had received 7 percent of their funding from NEA and 5 percent from state and local grants; by 1985, the federal contribution was down to 4 percent while state and local funding remained at 5 percent. The decline in the federal share of public arts funding paralleled a decline in New York's share of arts spending. As other states spent more, New York's share of total state spending fell from 30 percent in 1981 to 22 percent in 1987. As Florida, Illinois, Massachusetts, Michigan, New Jersey, and Ohio increased their arts appropriations, it appeared that the cultural torch had passed from the federal government to the states.[64]

Yet few states were prepared for wise management in this exotic terrain. Unlike the glittering array of arts luminaries sitting on the early National Council on the Arts, those appointed to state arts councils comprised an idiosyncratic assortment of political choices. In California, the first council chosen by Governor Jerry Brown possessed scant experience in the arts or their administration. "Brown owned a painting by one, admired the poetry of another, attended activities at the San Francisco Zen Center with a third, invited a fourth to sing at his inauguration, and so on," wrote two early staffers. One Brown appointee, who later became chair, was the actor Peter Coyote. "I had six rings in my ear and lived in a truck," Coyote recalled. "We created a lot of divisiveness." During its first seven years, the California Arts Council went through four directors: a novelist/painter, a theater director, a jazz promoter, and, finally, a public administrator with theater experience.[65]

A 1982 survey of state arts agencies found comparable disarray across the country. Among appointees to state councils, fewer than one in five were artists, while 22 percent were businesspeople; 16 percent, educators; 6 percent, professionals; and 20 percent, civic volunteers. According to state arts council directors, council appointees acquired their seats principally because they were politicians' friends, had political influence, or were prominent citizens. "They often come to the council unfamiliar with its programs," wrote the author of the survey, "and find themselves inundated with grant-making and policy decisions for which they are unprepared." As

a group, state arts councils were also "unfamiliar with the mission, history, and role of the agency they govern." Staff members were often equally unprepared, pressed for time, bereft of hard data, inexperienced in planning or analysis, and ignorant of how arts institutions function. Turnover was high. Meanwhile, grant applications tumbled in, doubling during the decade of the 1970s to 14,000. The states were even more lax than the endowment in allowing grants to congeal into entitlements. Patrons of leading arts institutions soon found that it was easier to make their needs known at the state capitol than in Washington. Already in the mid-1970s, two-thirds of all state grants went to continuing projects by groups that had previously received support. As state appropriations grew, grantees expanded their budgets and applied for more money.[66]

By 1992, when the state arts appropriations added up to four times federal spending, the total teetered on the brink of a precipitous plunge. Although Congress directed that states' share of the NEA budget be raised from 20 to 35 percent, many states blamed pressing budget problems for drastic reductions in arts funding. Virginia slashed the arts council appropriation by 81 percent and New York by 51 percent. New Jersey followed a 41 percent cut with a further 8 percent, and Texas cut already meager arts funding by 40 percent. In California, the governor proposed slicing the arts council's 1992–93 budget neatly in half for 1993–94 and "privatizing," a euphemism for abolishing, the agency by 1995.[67]

Faced with such draconian cuts, arts organizations pressed harder for subsidies at the local level. In the six counties of the Denver metropolitan area, a 1 percent sales tax increase in 1987 raised $13 million each year, to be allocated according to a three-tier system: 65 percent to major museums, the botanical gardens, and the zoo; 25 percent to performing arts organizations with budgets over $700,000; and the remaining 10 percent returned to the counties for small local organizations. As at the federal and state levels, the pattern of large sums for large organizations and dribbles for small ones rewarded the most vociferous pleaders from the local arts constituency. It also hobbled the efforts of modest, perhaps more innovative, enterprises to present themselves to larger audiences.[68]

In most cities, arts subsidies were financed by taxes on hotel and motel rooms, giving residents the illusion that out-of-towners were paying the bill. Buttressed by a 14.5 percent hotel tax, the New York City Department of Cultural Affairs in 1992 was spending almost $172 million on the arts, more than the NEA itself. Justifying such generous sums, a hair-thin veneer of artistic merit draped the bold—and often suspect—dollar figures

of economic impact. New York's Metropolitan Museum of Art, for example, published a study showing that two-thirds of the 642,000 visitors to its four-month-long exhibition of works by Georges Seurat came from outside the city and spent about $313 million on travel, hotels, restaurants, and shopping. These data echo the implication of hundreds of similar reports that the arts enhance not the spirit of artists and their audiences but rather the balance sheets of various tourist-oriented businesses. As Ovid noted thousands of years ago, "Nothing is of more use to man than the arts which have no utility." Yet nowhere more than at the local level are the arts more fervently invoked to fulfill the extravagant fantasies of that blustering, seductive creature perennially stalking the heart of American civic life, *Boosterus americanus*.[69]

In the publications of arts service agencies and at conferences where arts administrators trade success stories, the arts themselves star almost exclusively as contributors to local economies. In St. Louis, a 1988 study concluded that the city's sixty-six cultural organizations generated 21,000 jobs and $677 million in economic activity. In Montgomery, Alabama, a Shakespeare festival attracted more than one million patrons and 200,000 students, netting the city's economy $9.4 million. In Ashland, Oregon, Shakespeare brought in 360,000 people bearing more than $23 million. In Birmingham, Alabama, a 1992 study found that arts audiences had more than tripled during the previous decade, bringing in $53.9 million. Other studies from the late 1980s and early 1990s attributed equally rich contributions by the arts to local economies—$102 million in Cincinnati, $259 million in Orange County, California, $167 million in the state of Maryland, $1 billion in North Carolina, $1.9 billion in New England. The endowment itself claimed that in fiscal year 1992, the $123 million it gave to more than 3,500 organizations had generated some $1.376 billion in economic activity. Every NEA dollar, it was said, generated a twentyfold return in jobs, services, and contracts.[70]

The numbers so promiscuously bandied about blur considerably under the lens of careful examination. By 1993, local arts agencies were disposing of more than $600 million, far more than state arts councils and the NEA combined. However, this statistic includes subgrants from the state, which, in turn, received subgrants from federal sources. As the money trickles down through this system, the reasons for spending it are also diluted. At the federal level, the endowment's stated purpose is to support excellence in the arts while enhancing the public's access. Nearer the grass roots, however, the arts are most often treated as a commodity: The arts will "put the

city on the map," the arts will attract industry to the area, the arts will bring in tourists, the arts can heal social problems, the arts express civic pride, the arts contribute to public uplift. And finally, all these benefits cost only pennies.[71]

The confrontation between the NEA's lofty goals and localities' mundane concerns played out poignantly during the endowment's ambitious scheme for erecting art in public places. In addition to giving hundreds of communities matching grants of up to $50,000 for public art, the NEA also provided panel review for hundreds of other public works of art commissioned by the U.S. General Services Administration (GSA). By allocating 0.5 percent of construction costs of federal buildings to sculpture, murals, and other embellishments selected through endowment panels, GSA became the nation's most conspicuous single patron of public art. While the public responded with affection, or at least indifference, to most of the art commissioned under both programs, a significant number of these works raised protests, if not contempt, outrage, and mockery.

For the unveiling of Claes Oldenburg's *Batcolumn* in Chicago, a boisterous band of self-styled surrealists arrived waving signs that read, "It's a joke," and disrupted the ceremony with strident cries of "Fuck you." More politely, but no less derisively, Senator William Proxmire cited this work as a flagrant example of government waste, along with $42,500 for "a rusty piece of farm machinery in the guise of sculpture" in St. Paul; $45,000 for five steel pilings in Rochester, New York; and $60,000 for "a life-size representation of a restaurant scene" in Buffalo. Nor was the public more enchanted with other GSA commissions. In Oakland, a towering work was removed from the courthouse grounds by court order. In Minneapolis, enraged black residents wrecked an artful maze of neon tubing. In St. Louis, citizens bitterly resented the NEA's refusal to sanction a sculptural likeness of Dr. Tom Dooley. In Huron, South Dakota, virtually the entire population of 1,300 signed petitions for removal from the post office grounds of four hulking metal plates surrounding a dark wooden shape, a baffling assemblage titled *Hoe Down*. Livingston Biddle diplomatically defused an incipient riot by sending the artist to Huron. When news of the furor subsequently attracted curious gapers, Biddle lauded "another fundamental of the arts . . . the economic benefit that comes from the tourist."[72]

The NEA's missionary drive to raise artistic sensibilities in the provinces began in 1967 with a commission to erect an Alexander Calder sculpture,

La Grande Vitesse, its name a playful translation of the location, Grand Rapids, Michigan. While Calder was widely regarded as America's most famous living artist, art critics viewed him "as a sort of beloved uncle in his dotage," as one scholar wrote. His work, "while delightful, was not challenging." However, in Grand Rapids, the home district of an outspoken critic of NEA, then-Congressman Gerald Ford, controversy accompanied the project's every step. Some objected to its location, in a downtown plaza, where the city would have to remove a pond and fountain only recently installed at a cost of $18,032. Others disliked the sculpture's forty-three-foot height, its bright-red painted steel bulk, and its puzzling, sinuous shape. Still others complained that it cost some $128,000, with $45,000 from NEA and the rest to be raised locally. Letters to the *Grand Rapids Press* grumbled that the work was un-American, since it was fabricated in France, while one city supervisor regaled radio listeners with a satirical song.[73]

Through the two-year campaign to raise matching funds, the city's business elite gradually aligned in favor of *La Grande Vitesse* and were joined by Congressman Ford, who would later tell his Washington colleagues: "I did not really understand, and I do not today, what Mr. Calder was trying to tell us." This cognitive lack did not prevent Ford from acclaiming "the largest Calder in the Western hemisphere" at dedication ceremonies on Saturday, June 14, 1969. "This gigantic work comes to us as the flowering of an exalted mind," he told the assembled dignitaries. "Art gives quality to life, and so it is that this sculpture . . . raises the quality of life in our community." In a lead editorial on that festive day, the *Grand Rapids Press* rhapsodized over predictions of the sculpture's impact. It would "put Grand Rapids on the cultural map." It would "bring visitors without number" to view it. It would "make all of the art journals and probably most of the news periodicals of the country." But even without such notoriety, the city would be inspired forever by the sculpture's presence, not only in its actual bulk looming on the central square but also in graphic replicas of its silhouette on all official stationery, business cards, street banners, and even garbage trucks.[74]

The conversion of Grand Rapids' burghers to the spiritual, not to mention economic, benefits of modern art in their midst encouraged the NEA's zealots to embark on further outreach in the hinterlands. In 1969, the mayor of Wichita, Kansas, applied for a grant to celebrate the city's centenary with a major sculpture for its River Beautification Project "as a lasting reminder of the progress the city has made and will continue to make in

the years to come." To choose the artist to devise this monument, a jury composed of three local businessmen and four outside art experts assembled in Wichita. The experts were recommended by Brian O'Doherty, a flamboyant native of Ireland, a former physician turned art critic, television educator, magazine editor, art professor, and painter, who had just become director of the NEA's visual arts program.[75]

Through the wondering eyes of O'Doherty, the brouhaha that soon erupted took on a mystical aura compounded of the clichés in old Western films, the stereotypes inhabiting such novels as Sinclair Lewis's *Main Street*, and the fulminations of H. L. Mencken against the "booboisie." The locals deemed the distinguished outside jurors "snobbish and cliquish" at a party welcoming them to Wichita, O'Doherty reported to the NEA chair Nancy Hanks: "The panelists were probably terrified at the easy, healthy, stressless atmosphere, like children reared in a supermarket seeing their first trees and cattle and horses." The Wichitans had responded graciously to their guests' rudeness, he added, "in beautiful Mid-West manner." But the locals' representatives on the panel that met the following day complained bitterly that the choice of the New York sculptor James Rosati had been "stuffed down their throat." After visiting the artist two weeks later, O'Doherty reported that the head of Wichita's Second Century Committee told him that local panelists did not "heartily admire what [Rosati] does, but as he [had] been married to the same wife" for thirty-eight years and had eight grandchildren, they judged him "a fine man."[76]

Nevertheless, the letters column of the *Wichita Eagle* reverberated for months with complaints over "a takeover by outsiders," resentment that the three local panelists had been "talked down to as if they were idiots," and outrage over easterners who "did not think that anyone in the Middle West knows anything." Privately, O'Doherty lent credence to this perception when he reported to Hanks about his trip to Wichita "to make everyone happy." For a meeting with local skeptics, he said, "I had specially prepared myself and was wearing a tie."[77]

While the NEA tolerated more local input following the Wichita flap, its efforts to expose the public to uplifting art continued to suffer humiliation. The citizens of Lansing, Michigan, spurned Claes Oldenburg's proposal to erect a monumental ashtray, a project O'Doherty termed a trendsetting example of innovative public art. Nor were they amenable to Oldenburg's suggested alternative, a giant baseball mitt. The sculpture finally selected as a centerpiece for Lansing's downtown redevelopment was *Construction #150* by Jose de Rivera. For $90,000, half of it from the endowment, the

city received a work already completed, an uncommunicative double loop of stainless steel only forty-eight inches high, sixty inches wide, and thirty-eight inches deep. Perched on a tall granite base, it hovered several feet above viewers' heads. Mary Eleanor McCombie, who devoted her art history doctoral thesis to a penetrating study of NEA-sponsored public art, found that the work conveyed "an air of preciousness. . . . Lansing did not end up with something to rival the monumental Calder in Grand Rapids."[78]

The NEA's evangelists next focused on Jackson, Mississippi; citizens there appeared willing to raise local funds to match the endowment's modest $10,000 grant. The South struck Brian O'Doherty as "visually virgin," and Mississippi as a potential "National Sculptural Disaster Area." Its NEA grant approved, the city of Jackson turned to the Mississippi Art Association for three local jurors to join three named by the NEA to select an artist. O'Doherty was particularly pleased when the panel selected a thirty-three-year-old laser artist, Rockne Krebs, who was willing to design a monument within the $20,000 budget. The decision was reached during a strenuous all-day session, and O'Doherty remarked in a memo to Hanks that, "as I learned at parochial school in my home village, the Irish should always be happy when doing missionary work."[79]

However, no sooner was O'Doherty gone than the converts lapsed. When the Mississippians viewed a Krebs installation in New Orleans, they were disappointed that it was visible only in the dark and required perpetual maintenance. They rejected the artist's sketch for the *Sky Clock* in Jackson as equally impractical and paid him $2,000 to go away. In the year that followed, the Jackson group spurned two more artists of whom the NEA had approved, ignored the panelists the NEA had provided, and sorely tried Nancy Hanks with other violations of the terms of the endowment grant. Nevertheless, O'Doherty urged that the Jackson project go forward, "because it's Mississippi and because this could be a good educational experience for them." The work finally chosen, Jim Clover's series of sharklike fins bracketed by two horn-shaped pylons, stabs into the sky in front of Jackson's airport and may indeed provide people hurrying to or from their planes with a good educational experience.[80]

While the NEA strenuously insisted that it was interested only in "excellence" and had no aesthetic or cultural agenda, the internal communications described by McCombie reveal a bias for certain artists and styles and a naive, utopian belief in the redemptive powers of modern sculpture. When Northern Kentucky State University selected Red Grooms and Donald Judd to create 100,000 dollars' worth of monuments for its campus, Ira

Licht, the endowment's public art coordinator, rejoiced at the selection of "excellent artists whom we've had difficulty placing." But faint acclaim greeted the arrival on campus in 1977 of Judd's *Dropped Plane,* a severe, open-ended aluminum box, sixteen feet long and eight feet wide and deep. The trip from New York, where it was fabricated, had loosened the pins holding the massive minimalist sculpture together; it arrived in a state of imminent collapse. Furthermore, the artist growled that the sculpture's concrete base had been built twenty feet from where he had specified and insisted it be demolished and repoured in the proper spot. This tantrum, plus his refusal to be photographed for the campus newspaper and his gruff remarks to reporters, did not enhance local reception for his work.[81]

Neither did universal public jubilation greet a sculpture in Hartford, Connecticut, by another minimalist, Carl Andre, especially as it cluttered up a triangle of grassy space adjoining an eighteenth-century church and a seventeenth-century cemetery. In his first major outdoor work, Andre was seeking, as he explained, to "bring the laws of geologic time into our lives." His means were thirty-six boulders of sandstone, granite, and basalt, an aggregation weighing eleven tons, distributed in eight rows across the 300-by-60-foot plot. No brass bands or speeches dedicated this work, for which the NEA and local donors had each contributed $50,000, but an uproar followed in the media. A local television station suggested that *Stone Field Sculpture* had "carried the pet rock silliness to its ultimate conclusion." A newspaper art critic complained that it had "destroyed the tranquility of what had been a delightful and a sorely needed open space." Letters to the editor of the *Hartford Courant* derided the work as "gross waste" and its maker as "a gimmick artist." The mayor of Hartford declared that "the guy who put the rocks there is full of rocks" in a *National Enquirer* article headlined "Sculptor Gets Your Tax $$ for Putting Rocks in Rows." The artist defended his work in free public lectures, told the *Courant* that he was "just trying to create as much peace as possible," and cheerfully presented himself, in long hair and threadbare denim overalls, to mingle with business suit–clad citizens at chamber of commerce gatherings. His work, however, hardly fulfilled the city of Hartford's stated goal for it: "to create a favorable climate for the reception of all the arts."[82]

The fate of monumental sculpture in Flint, Michigan, capped the relentless slide of the endowment's public art program from utopian uplift to absurdist farce. First, the endowment gave the city $50,000 toward a monument to embellish its riverfront redevelopment project. Then the endowment somehow delayed sending its jurors to Flint while an artist was

under discussion, perhaps because the arrogance of NEA's panelists had elsewhere engendered such bitter resentment. By the time the endowment realized that its own rules had been subverted, a committee of Flint residents had picked an artist. The three panelists belatedly summoned to Flint clashed with locals, especially when the panelists unanimously "and within one minute's time" rejected the locals' chosen sculptor, Duayne Hatchett. "The swiftness and deftness of this move," complained the feisty leader of the Flint contingent, Roberta Somach, "left us outraged and intimidated." She and her colleagues concluded that "someone was telling us that we could not have our choice." After Somach fired off a volley of testy letters to the endowment, its panelists, and finally to various Michigan congressmen, the endowment agreed to the choice of Hatchett, but reduced its grant to $25,000.[83]

More than four years after the original application was approved, Hatchett's forty-foot-high creation, a series of canary-yellow aluminum parallelograms, was dedicated in the park bordering the Flint River. In celebration, a musket salute rang out, pigeons and balloons fluttered skyward, and two fire department water cannons sprayed into the air above the river, while a junior college jazz group tootled in the background. The director of the local arts institute exulted over the sculpture's power to counter Flint's image as an ugly factory town. "It's wonderful," he said, "to see it fall into place." His words took on fresh meaning four months later when the sculpture collapsed during a windstorm. After it sank into a nearby dry canal, many letters to the *Flint Journal* implied that, as McCombie states, "a sort of divine art critic" was responsible. The sculpture had been "a work of the devil," said one; its collapse was "an act of God," said another; and a third noted that the entire project "has been bedeviled by one thing and another since its inception."[84]

Nor did the gods smile upon attempts to re-erect the tumbled mass of metal atop its concrete pedestal. The artist spent two years rescuing and repairing the remnants, reportedly devoting a second mortgage on his house and an income-tax refund to the cost. Then the rewelded pieces could not be restacked by the helicopter Hatchett had hired because bolt holes for reinforcements had been drilled in the wrong places. When the monument was finally restored, its appearance was fatally altered. "Where once it had a lighter-than-air feeling," the *Flint Journal* remarked, "now it is thickened at every juncture by the bolted steel [reinforcing] plates. It looks more like an industrial product—an ironic tribute to its home town— and less like a thing of the spirit."[85]

After another storm caused the pile to wobble dangerously, the sculpture's industrial look became even more pronounced, as the city reinforced it with guy wires. By April 1985, McCombie reported, "the city was at the end of its tether." An offer to give the work away to anyone who would remove it brought no response. At dawn on April 12, 1985, a city crew unceremoniously demolished the botched mass and carted it off to be sold for scrap. City crews then attacked the base with jackhammers, but in four days diminished its bulk by only four inches; the rest was reduced to rubble by means of a specially ordered cracking agent.[86]

For Flint, this encounter with public art became a sour memory, but elsewhere, the endowment's obsession with inspiring the provinces by means of monumental sculpture continued to inspire torrents of public rage, resentment, scorn, and, most humiliating of all, laughter. After spending as much as $3 million each year for more than twenty years to embellish what it built, the General Services Administration came to grief in New York, arguably the nation's most art-wise city. There it inflicted Richard Serra's *Tilted Arc* upon a lower-Manhattan plaza where civil servants were accustomed to savoring their lunch break. Commissioned in 1979, the sculpture angered residents from the day it was installed at Federal Plaza two years later. Where previously a pleasant space offered a shaded refuge in the midst of high-rises and traffic, *Tilted Arc*'s twelve-foot-high steel curve now slashed a brutal diagonal for 120 feet. When citizens petitioned GSA to remove what they considered an eyesore, the artist cited his First Amendment rights to free speech, saying removal of his work amounted to censorship. The controversy raged for some eight years, as *Tilted Arc* turned into "Rusted Arc" and Serra's lawsuit to prevent GSA from dismantling it wound through the courts. Eventually the work was hauled away to a government motor vehicle compound in Brooklyn, but wide publicity about the controversy further injured the credibility of all government arts programs.[87]

In recent years, even artists and specialists in the field have become disenchanted with the NEA's efforts to promote public art. David Furchgott, the director of the International Sculpture Center, believes that many of the artists whose careers were made by the endowment "could not go forward without further grants." By rewarding certain kinds of work, he said, the endowment brought forth a group of artists who "looked to the NEA for guidance on what kinds of art to do" and created nothing but public art. As a critic wrote in *Art News* in 1991, the outcome was that "some shockingly bad work was defiling the landscape," and an artist noted that "there's

very little public art that hasn't failed." The artist Robert Irwin remarked that "these projects are threatening to inundate us. The whole activity has become cluttered." Mary Miss, whose thoughtful work at New York's Battery Park City was widely acclaimed, said that those who implemented percent-for-art programs were "very limited in their thinking." Even in places where public art was a matter of civic pride, the public often rebelled. In Phoenix, an overpass embellished with reliefs resembling giant teacups and teapots attracted a derisive critical gesture: Alongside the art, an anonymous passer-by had placed a discarded toilet, spray-painted with gold.[88]

Taking their cue from the endowment, many states and localities also spent millions of dollars on public art, often generating gigantic public rows. In Concord, California, fewer than fifty citizens turned up at public forums to discuss proposed commissions for public art. But when an installation of ninety-one aluminum poles sprouted in concrete traffic islands along a major street, the entire town was incensed. The *Concord Transcript* was flooded by derisive letters. An opinion survey sponsored by the newspaper showed that 92 percent of residents did not like Gary Rieveschl's *Spirit Poles* and 77 percent wanted it removed, regardless of cost. In the next city council election, a record turnout of voters defeated the one incumbent who had voted for the work, while two of the victors campaigned largely against the sculpture. Even then, California law and the artist's contract forbade removal of the work. Concord's die-hard boosters maintained that *Spirit Poles* had put the city on the map, even rejoicing when the *National Enquirer* called the work the ugliest sculpture in America. As the furor subsided, Concord's mayor said, "People did not begin to like the work, but they learned to ignore it."[89]

Though the public art program comprised a relatively small portion of the NEA's budget, the arrangement for endowment panelists to review GSA commissions magnified the visibility of its failures. McCombie's survey included 324 public art projects to which the NEA contributed up to 1980. While the public reacted mildly or indifferently to the vast majority of them, controversy, if not outright resistance, had rocked thirty-one communities with a combined population of well over 20 million. In tolerant Seattle, three projects generated substantial protests. In Hartford, citizens already angry over Carl Andre's artistic antics were so incensed over a proposed giant toothbrush by Claes Oldenburg that the project was scrapped; the public then beat back a plan for a Sol LeWitt work and only grudgingly accepted a suite of murals by the eminent black artist Romare Bearden.

Enlightened Pittsburgh retreated from a proposal for a giant $100,000 steel structure by Mark di Suvero when faced with public rage.[90]

All the public jeering, the letters to the editor declaring "phooey," the irreverent songs on the radio, the sardonic assertions that "the Emperor has no clothes," and the witty jibes about pet rocks had frayed the endowment's dignity and raised questions about its commitment to artistic excellence. The sparks generated by these public ruckuses, although localized, continued to smolder and would leap into flames when headlines described even more controversial artworks sponsored by the endowment. While the cultivated public did not look to the *National Enquirer* for guidance on artistic matters, millions of ordinary folk chuckled over its accounts of sculptural folly. Each fiasco inflicted another small wound in the NEA's public image; the blood seepage would soon attract the philistine piranhas cruising for victims in cultural waters.

By the mid-1980s, the endowment's internal structure had evolved from the exuberance and agility of youth toward the caution and even lethargy of middle age. Within its static budget, some eighteen programs jostled to support grants in as many as 120 categories. Grants that the early council had impulsively approved on sheer speculation now took much of a year on their ponderous passage toward a decision. In some programs, applicants had to notify the endowment in advance if they intended to apply, then meet stringent deadlines for submitting proposals.[91]

Still attempting to impose some coherence on this shifting kaleidoscope, the chair Frank Hodsoll initiated a rolling five-year plan for the endowment. But laborious deliberations by coveys of consultants representing each field brought forth a mouse. The NEA's mission, they stated, was "to foster the excellence, diversity, and vitality of the arts" and "to help broaden [their] availability and appreciation." The straitjacket of obligations to major clients allowed little movement toward new directions or specific targets. With all the passion and conviction of a tepid bath, the five-year planning document promised to support individual artists, "the foundation on which all else rests," but would also support artists in theater, dance, and music organizations. It would attempt to enlarge the arts audience through touring, use of radio and television, and aid for local arts organizations. It would promote arts education through television, the training of teachers, and the gathering of information about promising educational methods. Some ninety-one goals lurked in the sections devoted to specific fields; twenty-one of these started with the word

encourage, nineteen with *assist* or *help,* and eight with *improve.* What followed was impeccably bland; for example, "encourage recording and wider distribution of American music," "assist museum conservation and documentation," "improve the quality of dance training."[92]

Amid these classic platitudes, a careful reader could discern that the experts had actually grappled with a nagging problem, for which they devised a soothing new name. The problem appeared to be the age-old bugaboo stalking creative endeavor: lack of quality. But the bureaucratically correct name was now "artistic deficit." The five-year planners wondered whether the NEA should "develop a consensus in each field on the elements of artistic deficit." To what extent should the endowment "directly support institutions or individuals that are less than excellent?" The experts' tactful view on these nettling questions was that "excellence is a sliding scale. Judging it is subjective." This less than bold assertion led to another question: If lesser quality is "the only game in town," should the NEA then support it? With exceeding delicacy, the planning document tiptoed toward the ultimate question: Should an institution continue to receive money if it subsidizes only "maintenance of unrealized potential"?[93]

No euphemism could decently drape the evidence that the cultural world had turned. In almost every field of artistic endeavor, the waves of creativity pulsating through the 1950s and 1960s had crested. In theater, daring pioneers like Joseph Papp and Zelda Fichandler lost their nerve in the struggle to fill expensive new buildings and manage large staffs. In dance, the generation of Balanchine, Graham, and Tudor was aging or dead and the scythe of AIDS sliced tragically through their successors. In the visual arts, exuberant abstract expressionism and pop art were succeeded by dry, jagged, often sterile exercises in minimalism and by a rabble of mini-movements clinging to the collective nonappellation of post-modernism. In music, academic extensions of atonal and electronic experiments repelled listeners to such a degree that performances of new works had to be scheduled before the intermission, lest the audience flee.

To be sure, two decades of Americans' love affair with the arts had yielded impressive results. Between 1965 and 1984, the number of professional arts organizations had grown by 700 percent: from 58 orchestras selling 10 million tickets to 145 selling 23 million tickets; from 31 opera companies to 154; from 35 dance companies selling about one million tickets, mostly in New York City, to 250 selling 16 million tickets, 90 percent outside New York City; from 40 theater companies with attendance of about one million to 500 with attendance of 13 million. The number of

museum visitors had doubled to more than 43 million. During the decade of the 1970s alone, the arts labor force had grown by 47 percent, to more than one million, comprising about 1 percent of the total civilian labor force.[94]

These impressive statistics concealed the flattening of the creative curve endemic to every period of extraordinary achievement in the history of world culture. A fortuitous conjunction of new wealth, sophisticated patrons, and soaring individual talent underlies a golden age of Greece, a Florentine Renaissance, an Elizabethan Age. During the twentieth century, the years preceding the First World War saw such a flowering in Europe, and another in the United States during the two decades following the Second World War. At the height of such periods, the artistic universe appears boundless, imaginations soar, and genius blooms. Inevitably, a trough follows the crest, a period of consolidation, failed experiments, and an ebb of creative juices. The artistic well must recharge, and in time a fresh set of creative explorers embarks on new voyages of discovery.

By the mid-1980s, no amount of optimistic statistics, self-serving rhetoric, or awarding of grant money could reverse the cycle's descent. The masses of professional artists churned out by universities had vastly augmented the nation's cultural resources, but the price for spreading cultural amenities to every corner of America was the phenomenon so delicately labeled "artistic deficit." The Darwinian struggle for survival within a brutally competitive environment changed the character of many arts institutions; the risks of artistic innovation were often sacrificed to survival. Dance troupes revived more classics and offered fewer premieres. Planners of music seasons included more popular selections and hired more stellar soloists, while pops seasons lengthened to eke out the bottom line. Operas crossed over into musicals. Theaters resuscitated proven hits from the past at the cost of new work. Museums lured crowds with yet more and bigger exhibitions of Seurat, Van Gogh, Picasso, and the perennially attractive Impressionists. Ironically, the more ardently high culture mingled with entertainment, the more earnestly its rhetoric emphasized the sublime values of exposing the public to high art. One critic noted that the arts had lost their sense of humor and were wasting resources on efforts to "continue all artistic enterprises, even after their leaders [were] no longer with us." [95]

Charles Christopher Mark, who had crisscrossed the country to drum up a constituency for the newborn NEA, believed that the Reagan threat in 1980 had permanently maimed the organization. "The knowledge that forces are present which would move the arts backward has chilled the

creative spirit," he wrote. But election of a conservative president was only a symptom of growing public skepticism about what government could accomplish, and not just in the arts. Mark himself noted the endowment's decline. "What began as a bold design," he wrote in 1991, "has become a routine bureaucracy, an elaborate mechanism for producing the ordinary, a funnel for federal funds flowing to the bank balances of arts institutions to forestall bankruptcy in many cases."[96]

Such pessimism contrasted sharply with the idealistic goals that Mark and his colleagues brought to NEA's early helter-skelter operation. Those pioneers had pursued the dream of bringing first-rate art to every American. College enrollments were rising, leisure time was increasing, prosperity was propelling growing throngs onto a capacious escalator leading upward into the comfortable middle class. As the figures showed, the audience for the arts swelled phenomenally and spread outward from major cultural centers into the suburbs, onto college campuses, and toward more remote places. The NEA's founders sincerely believed that mere exposure to the pleasures of the arts was enough to kindle lifelong devotion, that the arts audience would grow until it included the entire population. Yet, as studies had shown all along, this audience consisted largely of well-educated, affluent folk whose affection for the arts often mingled with social ambition. More than twenty years after the NEA's founding, the choreographer Bella Lewitzky slyly remarked: "People are always talking about broadening the audience. Isn't anyone interested in deepening the audience?"[97]

As the arts slipped backward from the cutting edge, it appeared that, even by diluting artistic quality and subsidizing the best institutions, the audience could not be broadened further. To Louis Harris pollsters, respondents cited petty reasons for not attending arts performances—high ticket prices, lack of parking, cost of baby sitters, difficulty obtaining tickets—none of which seemed to be obstacles to attending sports events or rock concerts. Dick Netzer, who had studied arts subventions for the Twentieth Century Fund, wrote in 1978 that taste, not lack of money, was the obstacle to an integrated, variegated clientele for high art. Another scholar, Edward C. Banfield, in 1984 concluded that "the art public is now, as it has always been . . . relatively prosperous people who would probably enjoy art about as much in the absence of subsidies." The *Newsweek* columnist Robert J. Samuelson in 1989 called arts subsidies a "highbrow pork barrel."[98]

In truth, the arts were far from being every American's cup of tea, and no amount of government subsidy would change that hard fact. Two veterans of Minneapolis's Guthrie Theater contended that in all communities

reaching "cultural maturity," only 3 to 5 percent of the public said yes to the arts and another 12 to 15 percent said maybe. They found no reliable evidence that more people would come out to partake of any "conceivable cultural activity." Moreover, the yeses and the maybes were aging, as any visitor surveying the white hair, mature faces, and even canes and walkers at serious theater and music performances could observe. One economist argued that younger people stayed away because they were too busy consuming goods. A sociologist claimed that baby boomers, the most striking arts absentees, stayed away because they knew too much about the arts and wanted only the best. Unless lured by stars and first-rank performances, they preferred culture served up at home by the TV, CD player, or VCR. Susan Farr, the executive director of the Association of Performing Arts Presenters, does not expect this bleak prospect to change. "The arts are not a growth industry," she said. Hard as this reality is on artists and communities, "there are more arts than there are consumers."[99]

As the Reagan era ended in the late 1980s, a turning point had been passed. The federal effort to support the arts had calcified into a rigid bureaucracy dispensing mostly entitlements, its dwindling funds divided and subdivided among an ever-increasing tribe of claimants. Persistent social problems claimed priority for funding, even as steep growth in various government entitlements ate up tax resources and swelled deficits. State arts programs, on which many organizations had grown to depend, were also under threat, as tax receipts leveled off and other spending took priority. Local arts funders, who controlled by far the most money, were less interested in quality than in attracting tourists or pleasing important hometown patrons. The wider public remained disinterested in partaking of the arts. Stung by the arrogance and elitism that artists and their patrons often conveyed, many ordinary people dared to voice their displeasure. Here was a recipe for disaster.

7

FLOWERS OF EVIL

THE EXTERIOR OF THE NANCY HANKS CENTER, where the NEA has its offices, is a brooding ten-story neo-Romanesque pile on Pennsylvania Avenue, about halfway between the White House and the Capitol. Built in 1899 as the headquarters for the U.S. Postal Service, as well as Washington's main post office, the gray rusticated stone structure, with its turrets, gabled dormers, and 315-foot tower, was soon nicknamed the Old Tooth. After the Postal Service moved to more modern quarters in 1934, the building fell into decay. Almost from the day it opened, urban planners had deplored the structure's unfortunate clash with the Federal Triangle's prevailing neoclassical style. However, when the building was scheduled for demolition in 1971, it caught Nancy Hanks's fancy and she began a dogged campaign to secure it as permanent home for both endowments.

Too small for a building of its own, the NEA had camped in various Washington spaces, at times so briefly that some moving boxes were never unpacked. In one such temporary refuge, a condominium near the Watergate complex, employees were frequently driven from the building by bomb threats directed at their downstairs neighbor, the U.S. Office of Equal Employment Opportunity. Determined to find a secure permanent home for her agency, Hanks dragged her deputy Michael Straight and the Fine Arts Commission chairman J. Carter Brown to tramp through the dilapidated old post office building. The dingy, echoing interior housed the FBI's wiretapping operations, and the tower was accessible only by a rickety ladder. "It had been a favorite roosting place for the city's pigeons,"

wrote Straight. "It resembled one of those islands in the South Pacific that are made up of mountains of guano." Although Brown wanted to tear the place down, Hanks developed an imaginative plan to recycle the ramshackle hulk as a multipurpose enterprise.[1]

Ambitious plans were drawn by Benjamin Thompson, the architect responsible for the successful redevelopment of Boston's Faneuil Hall. The lower three floors, where mail had been sorted in years gone by, would house smart shops and restaurants; the balconied upper floors, from which postal inspectors had checked on the honesty of workers below, would become offices for both endowments. These offices would be arranged around a cavernous atrium 196 feet high, with a glass roof filtering daylight onto a stage and dining area that would occupy most of the main floor. By the time the structure was reopened after a $30-million renovation, Hanks was dead and her successor, Livingston Biddle, had also departed.

For the dedication on January 17, 1983, banners waved outside the building and twelve restaurants inside served barbecued spareribs and chicken, crab salad with green sauce, and pecan cheesecake. Among the distinguished guests were the *New York Times* food editor Craig Claiborne and the jazz pianist Billy Taylor. But even this festive occasion was shadowed by problems with the building. The atrium was unheated on that wintry day, and would never be heated; nor would it be air-conditioned during Washington's tropical summers. So few of the guests remained in the auditorium at the end of the dedication ceremony that the last three speakers, including the NEA chairman Frank Hodsoll, left their remarks unsaid and, according to a witness, "everybody from the platform went out in search of a drink and a few leftovers."[2]

In time, the upscale restaurants and shops were replaced by the empty calories of fast food booths and kitschy souvenir marts, which one leading guidebook found "a pity," not "in any way distinguished." From the stage blared nondescript entertainment, as performers struggled to be heard above the racket of tourists milling through by the busload. Nor did the offices upstairs convey the NEA's commitment to good design or the dignity of an agency dedicated to culture. On the balconies ringing the atrium, "the marble floors were obscured by boxes of grant applications from deadlines past," wrote John Frohnmayer, who took over as chair in the summer of 1989. "The endowment was drowning in paper and catalogues and tapes and slides, with no place to store them." He found panels, sifting applications for grants totaling many millions of dollars, working in "inhospitable conference rooms . . . heated in the summer, cooled in the winter,

noisy all the time." The staff lacked space or privacy, crammed as it was into cubicles formed by low dividers. In the spacious office reserved for the chair, Frohnmayer found "an ugly Danish modern conference table and brown upholstered chairs that went with the faded orange-brown carpet, which looked as if someone's dog had abused it."[3]

The shabby space that greeted the new chair was the first of a disillusioning—and eventually overwhelming—cascade of icy reality shocks. Growing up as the son of a successful lawyer in Medford, a lumbering and fruit-growing town in southern Oregon, he had basked in the respect accorded small-town gentry. At a country club there, where he caddied to earn pocket money, and later in Portland, he enjoyed friendly esteem among the cream of local society. Well off, attractive, athletic, and popular, the young John Frohnmayer appeared to have no cares beyond where to play his next round of golf. Yet he struggled to choose among a plethora of rewarding career options. At Stanford, he started a premed course but dropped it after a year and a half. Pursuing spiritual inclinations after his graduation, he took up a fellowship at New York's Union Theological Seminary. He briefly considered a professional singing career. After a year in New York, he transferred to the University of Chicago Divinity School, then lost interest and decided to attend law school, a step that, in those years of the Vietnam War, jeopardized his draft deferment. He volunteered for the navy, then returned from officer training school to the University of Chicago for oral exams to obtain an M.A. in Christian ethics.[4]

After four years in the navy, including a tour aboard ship in Vietnam, Frohnmayer began Oregon Law School in 1969. There he was named best oral advocate, edited the *Law Review,* and was elected to the Order of the Coif, a legal honor society. These distinctions, he wrote, "seemed to float into my life . . . simply as a matter of course." After three years with a small firm in Eugene, where he enjoyed being "a hired gun, a combatant," Frohnmayer moved to Portland with his wife, Leah, and two small sons. There he joined one of Oregon's most distinguished law firms, Tonkon, Torp, and Galen, as a litigator. The work he considered most critical to his later performance at the endowment was representing newspapers and a television station in libel and slander cases, obtaining access for reporters to public records, and reviewing news stories before publication. All these matters involved First Amendment law. This background provided Frohnmayer with an all too narrow frame through which to view the controversies that would rock the endowment.[5]

Meanwhile, the young lawyer was also getting involved with the arts. A

stint chairing a panel to select public art for the Oregon state capitol "was a raucous affair . . . with escalating decibel levels," over which, he admitted, "I was presiding in title only." In 1977, Frohnmayer was appointed to the Oregon Arts Commission, where for the next eight years he oversaw such cultural advances as bringing the Moscow (Idaho) Folk Ballet to the village of Enterprise (population 327), expanding the number of local arts councils from three to fourteen, and helping public radio stations install signal boosters so that their programming could reach sparsely populated regions in the state. "All in all," he rashly concluded, "my diverse arts and professional background qualified me for the job of chairman of the NEA."[6]

Eight years earlier, Frohnmayer had been brusquely interviewed for the job after the Oregon senator Mark Hatfield obtained an appointment for him with Ronald Reagan's aide Lyn Nofziger. "Why are you here?" Nofziger demanded, after Frohnmayer had waited forty-five minutes. "I want to be chairman of the National Endowment for the Arts," he answered. Without removing his cigar, Nofziger rumbled, "That's not a priority with us." In less than a minute the interview was over. Frohnmayer actually believed he would have gotten the job "but for the last-minute desire of a career bureaucrat, Frank Hodsoll."[7]

In the more than eight years before the call came in May 1989, Frohnmayer did little to prepare himself for the post he coveted. On the morning of his interview at the Bush White House, he wandered into the endowment's building for the first time. He was surprised to learn that one needed an appointment to pass upstairs and told the guard he wanted to "see someone in the opera and musical theater department." A chat with this program's acting director, Frohnmayer believed, would bring him up to date on "news and current issues." Within hours, Frohnmayer was in the Old Executive Office Building, sharing his philosophy with the Bush aide Chase Untermeyer. About himself, Frohnmayer said that he possessed a westerner's "sense of space and distance," and furthermore, he was an advocate, sensitive to the business community, and "a singer, an artist in [his] own right." He went on to rhapsodize about "the tapestry of American arts, their diversity and richness," until Untermeyer impatiently interrupted him with a question about "current events."[8]

When the White House phoned him in Oregon six weeks later, two sensational current events had burst upon the evening news and onto the floor of Congress. One was an oversize photograph of a Plexiglas container holding a crucifix in a yellowish liquid identified by the picture's crude title, *Piss Christ*. The work of an obscure Brooklyn artist, Andres Serrano, it had

been shown during 1987 in New York and Belgium as part of an exhibition assembled by the American Federation of the Arts. In April 1988, it had hung without incident for weeks in a group exhibition, partially funded by the NEA, at North Carolina's Southeastern Center for Contemporary Art, and later at the Virginia Museum of Art. Only after the show closed did waves of letters protesting *Piss Christ*'s blasphemy arrive in the offices of newspapers and congressmen. By May, when Frohnmayer was being seriously considered as NEA chair, Serrano was "amazed to see [his] name in the *Congressional Record*." He said, "I wasn't avant-garde until Jesse Helms made me that way."[9]

Hodsoll and the council had routinely approved the endowment's contribution to the Virginia exhibition. Swamped by grant applications and anxious to demonstrate his empathy with the avant-garde, Hodsoll had also approved, casually, on the telephone, an expansion of an exhibition of Robert Mapplethorpe photographs at the Philadelphia Institute of Contemporary Art. When the grant application first crossed his desk, he had been warned of some "rough" images, including photos of nude families. The council and Hodsoll had already agreed to help sponsor the exhibition. When Mapplethorpe died of AIDS, Hodsoll gave the curator verbal approval for turning the show into a retrospective by adding the so-called XYZ series. Many of these depictions of sadomasochistic homosexual acts had already been shown at New York's Whitney Museum without controversy; adding them to the Philadelphia show also raised no protest. But when the show arrived at Washington's Corcoran Gallery, curators were uneasy. By then, Hodsoll had left the endowment and the acting NEA chair Hugh Southern was left to issue noble words about artistic freedom in response to wrathful bluster from Senator Jesse Helms. Hodsoll noted that the issue "was great for fund-raising" in Helms's difficult reelection race. From his safe perch as assistant to Richard Darman in the U.S. Office of Management and Budget, Hodsoll speculated that if he had known about the XYZ pictures' raw content, he "would have found a way to sidetrack the project." Had they slipped through, he said, "on Day One, I would have said I was sorry, this shouldn't have happened. I would have made a purely political judgment. You don't go to war unless you win."[10]

On the phone with the Bush aide Chase Untermeyer, Frohnmayer mildly conceded that "friends have faxed me stories" about the uproar. In fact, eight days after Frohnmayer's first Washington interview, Helms had denounced Serrano on the floor of the Senate, while the New York senator

Alfonse D'Amato savagely ripped up the catalog for the exhibition in which *Piss Christ* had appeared. Thirty-seven colleagues joined them in signing an outraged letter to the endowment. The Equitable Life Insurance Company, which had cosponsored the exhibition, received 40,000 letters of protest, and the Rockefeller Foundation issued a public apology for its participation in the exhibition. On June 12, eight days before Frohnmayer's fateful phone call from the White House, the Corcoran canceled the Mapplethorpe show, and four days later the gallery was picketed by a hundred or so artists and gay rights activists as the offending photos were projected onto the white Georgia marble exterior of this dignified Beaux Arts landmark. Asked how he would handle such a riotous situation as NEA chair, Frohnmayer said he would order panelists to choose works "with the highest standards of artistic excellence." As to what he would do if the administration differed from his view about a particular grant, he said he would try hard to change the administration's position, but he considered himself "a team player, and if [he] failed to persuade, [he] would do the administration's will." To obtain "the job of which [he] had only dreamed . . . Washington, and a life of indescribable excitement . . . [a] prospect . . . thrilling beyond [his] experience," Frohnmayer choked back his much-vaunted ethics. As he would confess later, "I lied."[11]

If the Bush administration had wanted to euthanize the NEA, it could not have chosen a more suitable instrument than John Frohnmayer. While he exulted at seeing his own picture in the *New York Times,* he appeared oblivious to the reason the paper, for the first time in the endowment's history, featured the nomination of a chair on the front page. He never consulted Hodsoll as to the background for the sensational controversy swirling through the Capitol, nor did he call on Livingston Biddle, who could have provided wise counsel.

Biddle was already familiar with the Corcoran controversy, as the gallery's director had telephoned him for advice. Biddle had asked to see the show's catalog and was told it was locked in a safe. "Send it over in a brown bag," he advised. Six of the 120 photos in the show were "outrageous," he said, and he suggested that the $30,000 that NEA had given the Philadelphia Institute of Contemporary Art for organizing the exhibition be placed in escrow. He telephoned this suggestion to the acting NEA chair Hugh Southern, who wavered indecisively. If he had still been chair, Biddle said some years later, he would have summoned to Washington some of the original council's luminaries, such as Isaac Stern and Agnes De Mille, to study "what is the proper government reaction" to the controversy. He

would have reminded them of John Milton's view that "freedom without responsibility is license." After two days of media excitement, Biddle would have sent the art stars home and developed a statement based on their deliberations. This scenario, he believed, would have discouraged Jesse Helms from leaping into the limelight. "But if you vacillate . . . show any weakness or vulnerability, you're lost," said the former chair, a veteran of numerous miniflaps over controversial grants. "Once the enemy has captured the hill, he's hard to dislodge." [12]

By the time Frohnmayer took up his post on October 3, 1989, not just the hill but the entire province was under siege. The House had passed the endowment's appropriation only after cutting from it a symbolic $45,000, the total of the two controversial grants. Both the House and Senate had approved restrictions on grants to any art that "may be considered obscene, including but not limited to depictions of sadomasochism, homoeroticism, the sexual exploitation of children, or individuals engaged in sex acts and which, when taken as a whole, do not have serious literary, artistic, political, or scientific value." By then, also, the forces pushing the outer limits of publicly funded art were gathering their noisy claque. The Mapplethorpe show canceled by the Corcoran opened on July 21 at the Washington Project for the Arts to critical acclaim and record attendance, almost 50,000 visitors in twenty-five days. Crowds waited for hours to enter the room housing the controversial photos, moving eagerly past signs warning of their explicit content. One viewer commented: "I've been here four times already and this show disgusts me more each time I see it." [13]

Throughout these turbulent events, Frohnmayer lingered in Oregon, basking in "the beautiful Portland summer," as he wrote, not to mention the "heady" pursuit by newspaper and television reporters. He studied the "needs and opportunities" of various arts by chatting with executives of the Oregon Symphony, the Portland Art Museum, the musical theater in Eugene, and the Northwest Film and Video Center. From this localized research, he derived "a picture of what needed to be done." He also "read volumes" of the endowment's history and activities, of Washington politics, of ethics in public office. From "the safe harbor of [his] desk in Portland," he issued vague theoretical statements to the media about balancing censorship against the use of public dollars. Later, he would write, "I didn't know what I was talking about." On a brief visit to Washington in early August, he learned that real estate prices were "astounding. . . . Duplicating our very nice house in Portland was out of the question." [14]

While shuttling between Washington and Portland as his Senate confir-

mation approached, Frohnmayer found time to "have the cleaners remove bits of birthday cake from [his] tux," but none, apparently, for learning how the endowment worked from those who had been holding the fort during the ten tumultuous months that the chair's office had been vacant. The acting chair Hugh Southern had seen to the preparation of "a very user friendly and informative briefing book," which Frohnmayer never cracked. After a surprisingly benign Senate confirmation hearing and a swearing in by the NEH chairman Lynne Cheney, Frohnmayer met the NEA staff for the first time. Still a stranger to the place and unbriefed by anyone with experience there, he wondered how he was "to tell those who were advancing the endowment's agenda from those who were advancing their own."[15]

Problems that had plagued the agency almost from the beginning, such as its lack of specific goals, the overlap among programs, its profusion of grantees, and its high staff turnover, struck the new chairman with the force of Biblical revelation. He appeared to be shocked that "each program [had] degenerated into a private fiefdom," a situation that Livingston Biddle confronted more than a decade earlier. He noted with dismay the "class struggle" between the larger art groups, whose annual grants had become entitlements central to sustaining sharp budget growth, and smaller "emerging groups" desperate for the pittance they needed to survive. He professed incredulity that the National Council on the Arts was unable, during its quarterly three-day meetings, to scrutinize some thousand grants recommended for approval by panels, while also formulating new application guidelines and discussing overall policy. He was stunned to discover that although the staff was spending one-third of its time "preparing for, executing, or following up on council meetings," most council members "were so engaged in their careers that they would come to the meetings, give their advice pretty much off the cuff, and return to their personal work."[16]

Attempting to read all new grant applications, Frohnmayer stepped onto a nights-and-weekends treadmill, locked inside the airless offices, assaulted by sound blasts from "high school bands, rock groups, and unschooled piano bangers" in the atrium below. Three weeks after arriving on the job, he met with senior staff for the first time, in a crisis over another inflammatory exhibition funded by the NEA. "Against Our Vanishing" was scheduled to open at New York's Artists Space in two weeks. Ostensibly a protest against society's indifference to AIDS, it included nudity, but, even worse, the catalog contained desperately crude ravings by an artist who would soon die of AIDS. "At least in my ungoverned imagination," wrote David

Wojnarowicz, "I can fuck somebody without a rubber on, or I can in the privacy of my own skull douse [Jesse] Helms with a bucket of gasoline and set his putrid ass on fire or throw [archconservative] Rep. William Dannemeyer off the Empire State Building." As approved the previous year, the gallery's grant application had promised a show dealing with "sexual dependency . . . in the work of contemporary artists." The catalog, it said, would include essays by art critics.[17]

Because the exhibition did not match what was described in the application, the endowment tried to retrieve its grant money and to remove its name as a sponsor from the catalog. Artists Space refused; its only concession was to change a reference to New York's Cardinal John Joseph O'Connor in Wojnarowicz's diatribe from "a fat fucking cannibal" to "a fat cannibal." For weeks, the controversy dragged sordidly through the media, with Frohnmayer vainly chasing the headlines with clumsy attempts at damage control. While fresh provocations followed feeble counterthrusts, he was isolated, living in a rented house without a telephone. Nor did he appear to have any notion of the many other grants already awarded to projects that were equally provocative.[18]

Since the early 1980s, a self-styled avant-garde had been increasingly thrusting itself into media attention with strident political and sexual "art." Like the Artists Space show, these works claimed to be the protests of victims, but their form—abusive rhetoric and repellent images—preempted free and open discussion of serious matters. In 1979, a New York gallery specializing in artists' books, Franklin Furnace, had a run-in with the United States Information Agency over books to be included in the São Paulo Bienniale in Brazil. When the agency deemed two items too political for an art show, the gallery withdrew from the exhibition completely rather than remove them. By 1983, Franklin Furnace had developed an effective system for mining the endowment's multitudinous programs: In addition to $25,000 from the visual arts program, it had also received $20,000 in two annual advancement grants, $5,000 from the inter-arts program, and more than $128,000 from the museum program for exhibitions, performances, catalogs, and storage area upgrades.[19]

The gallery had used some of these funds in January 1984 for "Carnival Knowledge," an exhibition in which, as the Franklin Furnace director Martha Wilson put it, seven women curators asked, "Could there be feminist pornography?" For the opening, which featured saxophone dancing, mud-wrestling, and "real prostitutes talking about their real lives," crowds obstructed traffic on Franklin Street. The show exhibited explicit pho-

tographs of group sex, of priests in sadomasochistic poses, and of an infant at the breast titled *Jesus Sucks*. Various performances in "Carnival Knowl- edge" included a lesbian inserting her foot into another lesbian's vagina, an eighty-six-year-old woman boasting of sexual adventures with teenagers, and two women discussing fellatio and swallowing human semen. An *ad hoc* "Morality Action Committee" brought this circus to the NEA's atten- tion and protested to such sponsors as Exxon and Woolworth's, which instantly withdrew.[20]

In a letter to four congressmen and two senators who had complained about NEA's connection with this show, Hodsoll sympathized, but explained that "professionals" evaluated grant applications based on "artis- tic quality," and he quoted from NEA's enabling legislation forbidding any control over grantees' subject matter. He regretted that the exhibition had "offended many people" and emphasized that "NEA did not select nor support this particular exhibition, but rather supported Franklin Furnace itself in recognition of its many contributions to contemporary art."[21]

The chair also dispatched two emissaries, who told the gallery's board that henceforth the agency wanted credit only for shows it had expressly funded. Wilson was warned of the "inappropriateness of acknowledging NEA support of this specific project" and reminded that "aesthetic justifi- cation" was difficult for "bringing porn stars to Franklin Furnace." Three months later, Wilson sent the endowment a packet of supportive materials, including letters from the New York congressman Ted Weiss; Howard Moody, the pastor of Judson Memorial Church; the artist Red Grooms; and another sponsor, the Morgan Bank, as well as copies of favorable reviews.[22]

The NEA remained watchful. A year later, its auditors ordered Franklin Furnace to repay $250,000 in grants unless it could prove that the money had been matched by private donations. Martha Wilson outlasted what she calls "this interesting process [that] took five years and four business man- agers to resolve." Not a penny was repaid, although Wilson was irked to be placed on a "working capital advance" method of payment in future grants, receiving only partial payments until she produced receipts and canceled checks for matching moneys. "I believe this has been the most effective means of censorship yet," she complained, setting the tone of victimization for future funding controversies.[23]

With most of its money committed to the most conservative large institu- tions, the relatively small grants to Franklin Furnace had been part of the

NEA's efforts to demonstrate that it also supported artistic innovation. In 1972, it had elicited few protests and much admiration over a $36,500 grant to Judy Chicago for *The Dinner Party*. This work claimed to represent women's role throughout history via a triangular table with thirty-nine formal place settings that depicted vaginas stylized to convey the personalities of great feminists. In 1977, there was also little public controversy over $40,000 given to the Gay Sunshine Press for an alternative publication featuring illustrations of group sex among men and sex between men and animals. The message implicit in such grants was not lost among artists striving for attention in impossibly crowded fields: As with large public sculptures that repelled most of the public, the endowment also would fund exhibitions, performances, and literature that most people found offensive. As grant applications for such questionable projects increased, panels discerned a fresh creative trend, the flaunting of private activities in public, and felt impelled to approve such "cutting edge" enterprises as Franklin Furnace. In 1985, Thunder's Mouth Press received $25,000 to publish experimental novels, including *Saturday Night at San Marcos,* which described a pedophile molesting ten children in his garage and the victims' pleasure in sex games. In 1987, a grant to the Furnace Theater supported Cheri Gaulke's performance of *Virgin,* in which she used her naked body in a mock Christian service to "explore female sexuality in relation to religion." A 1985 NEA fellowship recipient, Frank Moore, performed *Intimate Cave* at Furnace Theater; he directed the audience members to remove their clothing and touch one another's bodies. Johanna Went was funded in 1983, 1985, and 1987 for a series of performances with props such as dildos, giant bloody tampons, and three-foot turds. The endowment's endorsement of this orgy of bad taste masquerading as avant-garde expression helped to move a passing phenomenon from obscure underground venues into mainstream institutions. In 1989, Minneapolis's respected Walker Art Center sponsored a performance by the Blueback Collective: *Dykes and Fags and Fags and Dykes* purported "to shove [the AIDS epidemic] down [heterosexuals'] throats."[24]

In the spring of 1994, a fresh controversy broke out over a performance in a Minneapolis cabaret by Ron Athey, a former heroin user who is gay and HIV positive. Before an audience of about one hundred, Athey pierced his scalp with acupuncture needles and his arm with hypodermic needles. He then carved ritual patterns in the back of an assistant and blotted the blood with paper towels, which he suspended on a clothesline over the heads of the audience. That Minneapolis's Walker Art Center had sub-

granted $150 in NEA money for this event cost the endowment nearly $3 million of its funding that summer, as Congress denounced the use of public money for such antics. When Athey brought his show to New York late in October 1994, it was sold out—and received a thirty-three-inch review in the *New York Times.* During the same week, the endowment announced that because of budget cuts, local nonprofit organizations would no longer receive $1.3 million for subgrants to individual artists.[25]

Dignifying such puerile exercises as avant-garde art, as many museums, critics, and NEA panels have, implies that the nineteenth-century tradition of an art defying bourgeois values continues to offer creative opportunities in the present day. But the spectacle of artists making a spectacle of themselves played itself out years ago, as the avant-garde discovered that its middle-class patrons possessed an almost unlimited tolerance for shock. The much-vaunted "riot" that greeted Igor Stravinsky's ballet *The Rite of Spring* in 1913 quickly segued into full houses for the Diaghilev company's subsequent productions. The incendiary dada "wedding" of a nun and a priest in 1920 soon led to a lively market for dadaists' works. Salvador Dali was lionized more than ever in smart New York salons during the 1930s, after eating the buttons off one hostess's gown.

Following the Second World War, the art public became increasingly inured to bizarre behavior or extreme provocations by artists, generally responding like an enlightened parent, with bemused smiles, sophisticated shrugs, or even politely stifled yawns. When the Lincoln Center executive committee in 1972 was anxious to lure Joseph Papp to rescue the faltering Vivian Beaumont Theater, the innovative director attempted to scandalize his stuffy interviewers. His first show, Papp announced, would include a play in which nobody wore clothes. "There was sort of an appalled silence," recalled the chairman Amyas Ames, who then quietly asked Papp whether it would be a short play, and what else he would present. "I think he was baiting," said Ames later. "He had expected to have an explosion. Perhaps he was testing us for tolerance." Instead, Ames assured Papp that Lincoln Center would not interfere with his plans: "If you want everybody to be naked, make them naked. It's none of our business."[26]

By the 1980s, it seemed as though no expression, no matter how tasteless, depraved, or insulting, could get the slightest rise out of art patrons beyond sentimental, perhaps nostalgic, references to a long-dead avant-garde. Though still ritually invoked, the cutting edge became a blunter cliché with every passing year, absorbed into the mush of academic critical discourse. With the art public all-tolerant, and the wider public

disinterested in the arcane and baffling work of contemporary artists, only one audience remained to respond in the classic manner to the strenuous provocations played out mostly in obscure galleries on gloomy side streets by desperately marginal artists—Congress.

This unruly behemoth, five hundred rampant bourgeois politicians with access to five hundred microphones, rewarded the new provocateurs with a thundering outrage not seen in the artistic world for many a decade. Surrounded by staff and sycophants, reminded daily of its wisdom and power, free from the average citizen's concerns, whether petty frustrations over traffic jams and parking or major cares over jobs, retirement income, and health care, Congress lives largely within a fictional world.

This fiction includes the fantasy city of Washington. Despite an army of homeless wraiths on the street and more than half its area occupied by a drug- and murder-racked ghetto, the fantasy paints Washington as a cultural City of Light. Indeed, Paris has often been invoked as its model: the Potomac as a Seine; a subway known as the Metro; a beltway reminiscent in its hellish rush-hour jams of the Boulevard Périphérique; its pedimented Beaux Arts buildings redolent of the *grands boulevards;* its broad radiating streets and parks laid out by the Frenchman Pierre Charles L'Enfant; its obsession with landmarks and monuments; its fascination with itself and its history; and its museums. Aside from these magnificent museums, Washington's culture remains sparse and provincial. Only massive federal subventions have floated the Kennedy Center and its cultural constituents barely above bankruptcy, nor do other venues offer the rich array of adventuresome music, theater, film, and dance expected in a world metropolis, say, Paris. These deficiencies might well have persuaded the NEA staff, its satellites of arts service organizations, and its congressional supporters that the nation as a whole is "underserved," as the bureaucratic word would have it, with cultural amenities.

In fact, L'Enfant's noble boulevards each evening are choked with cars panting to escape from the District of Columbia into suburban Maryland and Virginia. To ease these jams and to mitigate the high cost of real estate inside the Beltway, large chunks of the government itself continue to relocate outside the capital, sprawling into the countryside of adjoining states. And the arts have followed. On a typical weekend, the *Washington Post* lists film offerings on 250 screens in nearby Maryland and 179 in Virginia, while the District of Columbia offers only 71. On an average winter weekend, eleven of the nineteen live theaters are dark, as are the Kennedy Center's opera house and concert hall. Tickets to National Symphony per-

formances there cost $20 to $40, and while Washington's music lovers can find only seven orchestras selling seats for under $10, nearby Virginia and Maryland offer eighteen such ensembles.[27]

Like the establishment in a middling midwestern or southern town, official Washington is overawed not with culture but with society, with Names. It hangs on the *Washington Post's* every word about the deeds (better yet, the misdeeds) of the prominent. Reflecting the content of its leading newspaper, Washington conversation is seldom about ideas, but dwells remorselessly upon people; the tiniest tidbit sets telephones ringing and the luncheon table abuzz. Washington is enchanted with formal dress; naive as he was, John Frohnmayer knew he could not begin moving there from Portland until his tuxedo was in pristine condition. The endowment staff, by contrast, sees itself as a cultural outpost in this philistine wasteland. The sharpest barb at John Frohnmayer mustered by one NEA staffer, a dedicated bureaucrat who asked not to be identified, was: "He thought all he had to do to succeed in Washington was to bring his tuxedo."

This outraged tone conveys the disappointment of those who have devoted a good portion of their working careers to the endowment. Attracted to Washington by a sincere wish to improve the American cultural scene, to grant artists the economic freedom that may undergird creative flights, they found themselves trapped in the federal government's rigid bureaucratic hierarchy, minutely defined by civil service grade and title. Casualness in procedure and downright sloppiness in the housekeeping provided the illusion that this agency was somehow different from the drone-driven hives where faceless minions moved the paperwork through the pipeline.

The early NEA exuded a distinctly bohemian aura: Working with artists was the closest one could come to *being* an artist. Championing a bohemian avant-garde was almost as good as *being* avant-garde, and all without the discomforts and disappointments of the bohemian lifestyle. Reviewing proposals for inventive new art projects was almost as creative as inventing them yourself. To shelter artists, especially the wild and grotesque ravers at "the cutting edge," from the mundane intrusions of a bureaucratic process was almost as thrilling as *being* a cutting-edge artist. So the would-be bohemians and *artistes* who staffed so many of the endowment's messy desks danced inexorably forward toward confrontation with the archphilistines on the Hill.

In Congress, the endowment's fate has always been in the hands of a bizarre coalition. In the House, the Subcommittee on Postsecondary

Education of the Committee on Education and Labor supposedly studies the NEA's activities and recommends on authorization and budget; in the Senate, the relevant group is the Subcommittee on Education, Arts, and Humanities of the Committee on Labor and Human Resources. In both instances, the endowment is but a tiny portion of the subcommittee's responsibility; at the full-committee level, it represents but a speck in a vast universe. In budget terms, the endowment's $170-million allotment is part of funding for the U.S. Department of the Interior and other agencies that totals about $13 billion. Because rural westerners dominate the committees that oversee the Interior, the endowment emphasizes its attempts to distribute arts to rural, so-called underserved areas.

For many years, the endowment has striven to enhance culture in Montana, whose sole congressman chairs the crucial subcommittee. One result is that, as of 1989, this state's 800,000 residents enjoyed 175 museums, as the NEA, the NEH, and the Institute of Museum Services scurried to propitiate the all-important subcommittee chairman. In that year, the committee held hearings on reauthorization of all three agencies in Bozeman, Montana, where more than $1.2 million had been contributed over ten years by various federal agencies to the Museum of the Rockies. For this project, the state had given only $148,000. The hearings, benignly chaired by Montana's Pat Williams, coincided with the museum's opening festivities and were typically short on substance and long on self-congratulatory rhetoric. The actual hearing was over in three hours, most of them devoted to the empty minuet of politesse between majestic legislators and groveling sycophants, their beneficiaries. The purpose of congressional hearings is to examine the operation of federal agencies. Here, all the "testimony" had been submitted in advance and fell into two categories: glowing descriptions of how wisely the public's money had been spent and depressing accounts of "unmet needs."[28]

Only three months later, the committee continued its reauthorization hearing in Charleston, South Carolina, where the annual Spoleto Festival was in full swing. The legislators convened at 9:00 A.M. and completed their work soon after noon, the better to enjoy a weekend of cultural entertainment as guests of the festival. Here, as in Bozeman, the atmosphere reeked of quasi-royal patrons surveying their benefactions and graciously accepting kudos. A committee member asked one witness how beneficial the Spoleto Festival was to the area and the witness replied: "Very beneficial." The committeeman followed up: "How has the NEA helped?" Reply: "We couldn't have managed without it." The acting NEA director Hugh

Southern was asked whether the obviously successful Spoleto Festival would ever be able to function without his agency's funding. He hoped this would not happen, Southern replied, as the NEA's endorsement was "a stimulus . . . to remain adventurous, to seek new initiatives." Furthermore, the festival set an example for the rest of South Carolina, where the "arts infrastructure" was weak. Through the festival, he said, "goals are being set, standards are being set for artists throughout the state and region." Chairman Williams took time in this short session to remind listeners that the NEA's twenty-fifth anniversary in 1990 would be "a truly exciting and important juncture in the Endowment's existence." He lauded the agency's role as "a catalytic force in developing, expanding, and releasing the creative talents of our people."[29]

Scarcely six weeks after this effusive tribute, even the Endowment's most enthusiastic congressional boosters were running for cover. North Carolina's pugnacious senator Jesse Helms added an amendment to the NEA appropriation prohibiting grants for such "obscence or indecent materials" as "depictions of sadomasochism, homoeroticism, the exploitation of children, or individuals engaged in sex acts," as well as material offensive to "adherents of a particular religion or non-religion," or any material defaming "a person, group, or class . . . on the basis of race, creed, sex, handicap, age, or national origin." During Senate debate on the Helms amendment, the New York senator Daniel Patrick Moynihan argued that it would not inhibit the artists' right to exhibit their work; he saw no threat to artists' First Amendment rights in the proposal—perhaps it would even be a windfall, as the brouhaha could well expand their audience: "For generations the fondest hope of many a writer," he pointed out, "was that his or her work might be 'banned in Boston.'" The NEA's godfather, Senator Claiborne Pell, echoed his colleagues' disgust. He found "the works in question fully as offensive, objectionable, and obscene as they do." He deplored "serious errors in judgement" by panels who recommended NEA funding for the Mapplethorpe exhibition and other controversial activities. Nor could the endowment count on unqualified support from the House's Sidney "Mr. Arts" Yates, a Chicago liberal Democrat routinely reelected since 1948. The NEA's most durable shield in the past, as Yates told the acting director Hugh Southern, had been the press's disinterest in the agency. But Congress could not ignore the "extraordinary" volume of mail generated by the fulminations of an industrious fundamentalist preacher, the Reverend Donald Wildmon, against *Piss Christ*. When the house voted

on the Interior appropriation, which included NEA, Yates managed to beat back one amendment to cut all NEA funding and another to cut 10 percent; he was glad to escape the chamber's wrath with a cut of just $45,000, the total given to the shows including the controversial Serrano and Mapplethorpe works.[30]

The abrupt turnabout in the endowment's congressional fortunes illustrates the agency's precarious life, an existence bedeviled almost continually by Congress's tortuous procedures. Unlike cabinet departments, the NEA (like the NEH and the Institute of Museum Services) must justify its existence during the elaborate rigmarole of reauthorization. In order to pass safely through this gauntlet of hearings before a subcommittee, then before a full committee, and a final vote by all of Congress, the agency must, like a Siberian sled dashing through a pack of ravening wolves, liberally toss out chunks of goodies that key committee members can carry home to their districts. In its first twenty years, the endowment underwent six reauthorization hearings that lasted a total of 222 days. Each time, an average of seventeen witnesses testified, creating a mind-numbing record of some 7,800 acid-free pages. During these two decades, when the endowment was relatively uncontroversial, reauthorization was valid for as long as five years. Since then, two-year reauthorizations have kept the endowment on an exceedingly short leash, leaving the agency unable to plan for its future.[31]

Once reauthorized, the endowment must pass through another congressional gauntlet for its annual appropriation. Once more the fragile sled toils forward, the drivers pacifying voracious beasts with chunks of fresh meat. The vagaries of the budget process leave the agency constantly off balance. In 1977, the authorized level of $125.4 million was expected to double by 1985, but when 1985 arrived, Congress authorized only "such sums as necessary," while appropriating $163.6 million. In the following year, $167 million was authorized, but only $158.8 million appropriated. A scholar of these arcane maneuvers discovered that the endowment's appropriation averaged 30 percent more in presidential election years than in other years. However, in recent years, Congress, faced with massive budget deficits, has frequently failed to pass any budget at all before the beginning of the fiscal year, voting instead to continue the funding of the previous year until the final budget could be squeezed through. To achieve such minimal outcomes, legislators indulge in months of compromises—and compromises of compromises—until the original animal is minced, mashed, and macerated into unrecognizable hash. In 1992, for example,

the NEA's budget was besieged by a rampant Jesse Helms brandishing a brown envelope containing, he claimed, an NEA-funded magazine with a cover image of female genitalia subtitled "Read My Lips." The endowment's mite, however, clung to a mammoth $12.3-billion appropriation for the Department of the Interior and other agencies. Fevered negotiations rescued the NEA via a deal not to raise grazing fees on federal lands. A crestfallen Helms moaned that he had "been defeated by a bunch of bulls," while headlines described the transaction as "Corn for Porn."[32]

The NEA's friends have been aware for many years that the congressional goodwill upon which its life depends is fickle indeed. Nothing has come of the founders' hopes eventually to convert the agency from an infant perpetually squalling for congressional feedings into an adult with an independent life and stable income. In 1980, when the endowment's budgets appeared to be in a steady crescendo, Congressman John Brademas nevertheless deemed its future prospects "rather bleak. . . . This is not a time to be writing major programs in support of the arts." Early in 1990, the printmaker June Wayne identified both endowments' "temporariness" as their jugular vein. "The slightest shift in the political wind can blow them away," she told the College Art Association. By then, of course, the political wind had shifted drastically. From the art favored by legislators, the art that "brings people together, soothes and celebrates," as one scholar wrote, the NEA's support for raw, unprintable images had moved congressional art patronage "swiftly into the liability column."[33]

When a legislator had grumbled over the occasional controversial grant in the past, the NEA's emissaries had pacified him in the time-honored Washington manner: They kowtowed abjectly, promised never to stray from virtue again, and perhaps tossed an extra grant or two into his district. But the convergence in 1989 of a series of unfortunate projects was too much for the righteous denizens of the Capitol to ignore, especially now that the media were interested. The pornography issue was made to order for blustering rhetoric on the floor, soon followed by inflammatory fundraising appeals in behalf of those politicians running for reelection. One Republican direct-mail consultant who had sent out several million solicitations decrying NEA's lapses was jubilant over his success: "It's been a good issue," he said, "and the longer it stays around the better." Ed Rollins, then a co-chair of the National Republican Congressional Committee, eagerly endorsed use of the endowment's flaws as "a good fundraising tool."[34]

As these political professionals knew, legislative issues seldom present

themselves in such delectably black-and-white terms. But while no one publicly endorses pornography, Americans display striking ambivalence toward it. In a land lapped by periodic waves of puritanism, millions of citizens partake of it. While a strange coalition of fundamentalists and radical feminists fulminates against pornography, no one seems to know exactly how much Americans spend on smut, but estimates range as high as $9 billion, as much as is spent on all culture. The government's statistical abstract carefully documents the worth of America's production of papayas, Portland cement, and pork, but is silent as to the dollar value of lascivious videos, obscene publications, and lecherous telephone services, not to mention prostitution. During the Reagan administration, a brief flurry of indignation led to an obscenity unit within the U.S. Justice Department, with an annual budget of about $1.8 million and a staff of fifteen. But under the Clinton regime, this unit was expected to shrink and possibly disappear altogether. The Mapplethorpe photos that raised outraged cries in Congress had been viewed without reported incident in 1988 by thousands of visitors tramping through New York's Whitney Museum. A *New York Times* reviewer neatly reflected the public's ambivalence toward the photographer's graphic images: "While his compulsive, unabashed and carefully stated chronicle of this particularly strident [sadomasochistic] variety of homoeroticism may not be everyone's cup of tea," wrote Andy Grundberg, "it has proven irresistibly fascinating to much of the art world." None of the sensational photos was among the three illustrating the review.[35]

On the other hand, the NEA's visual arts panels had embraced a virulent conviction that raw pornographic images and inflammatory political statements constituted a fresh wave of "avant-garde" art. In a public statement on May 25, 1990, the NEA inter-arts program's panel on new forms claimed that it wished to "make common cause with all Americans . . . who are being systematically disempowered." Pointing to artists of the past whose works included political messages—Goya or Picasso—the panel seemed to argue that such content alone was the hallmark of cutting-edge art: A work that is "challenging and disturbing . . . precisely . . . shows us that it is worthy of consideration." The panel's fiery manifesto displayed the ravages of a particularly menacing retrovirus infecting a vocal segment of the arts world. Harking back to the outrageous manifestos issued earlier in the century by such artistic revolutionaries as the futurists and surrealists, this statement confounded shock with originality, mistaking inflammatory words and scandalous deeds for fresh ideas and sensitive execution.[36]

This statement indicated that the endowment's panels had strayed a considerable distance from their original purpose—reviewing grant applications for the chair—into political advocacy and artistic decrees. Over time, the number of panels had proliferated wildly as the NEA sought to please every conceivable constituency or art form. In 1987, 92 panels included 678 panelists exquisitely balanced as to geography, ethnicity, and gender. They reviewed almost 17,000 applications and awarded about 4,500 grants totaling about $115 million. In 1992, the visual arts program, one of the endowment's smallest, was alone bringing more than fifty panelists to Washington several times during the year, including ten panelists to review applications for alternative spaces, seven on each of three panels for fellowships, ten to twelve for public projects, five or six for challenge grants, and five for special projects.[37]

The music program, one of the NEA's largest, convened fifteen panels, with six to thirteen members each and for as long as a week, several times during fiscal year 1993. Here, too, a small program to award fellowships to composers had developed labyrinthine procedures: In March, two panels would "pre-screen" applicants; in April, another panel would award grants. By comparison, the National Institutes of Health (NIH) in 1991 used only some one hundred peer-review teams to sift through about 15,000 proposals and select 4,190 grantees; the $812 million in grants was more than eight times the NEA's grant budget. (While avoiding the expense of bringing panelists to Washington, the NIH generated a blizzard of paper; duplicating proposals and reviewers' comments, agency officials said, used about three billion sheets of paper per year.)[38]

Within the NEA's review process, conflicts of interest had always been a problem. Roger Stevens was so sensitive to this issue that he asked a partner in a commercial theater production to drop his name from the credits when the show played Washington, D.C. At its second meeting in June 1965, the National Council on the Arts approved a policy statement urging its members to sever affiliations with any organization that "could conceivably have an influential relationship" with the endowment. Less than a year later, the council backpedaled; members could participate in discussions of applications with which they were connected, while remaining "alert to avoid any action which could possibly be interpreted as a use of Council membership to further their own interests." The NEA counsel then drew up what Biddle called "a document on proprieties. . . . If any Council member was part of an organization requesting support, that member could neither speak nor write in its behalf." Later, council members also

had to leave the room while such matters were being discussed, and the same rule applied to panels.[39]

Over time, however, some panels lost interest in adhering to the rules. Laura Dean sat on a dance panel while her dance and music foundation collected $100,000. Myrna Saturn sat on the same panel when the Southern Arts Federation, of which she was deputy director, received $31,500. Gus Solomons, another member of the same panel, brought $19,000 to the dance group of which he was artistic director. In 1989, the media arts panel distributed grants totaling $232,000 to organizations with which five of the six panelists were connected. In the same year, the inter-arts program awarded grants to organizations where five of its sixteen panelists worked. Family connections also seemed to affect awards. The writer Geoffrey Wolff, who received a $20,000 literature fellowship in 1987, had served two years earlier on a panel that awarded his brother, Tobias, a $20,000 grant. In 1989, some 3,483 fellowship applications were sifted in a five-day marathon by a visual arts panel. In the first round, the six panelists spent two days scanning 34,830 slides submitted by applicants. Hastily they viewed them, five slides at a time, giving no more than two seconds to each set. In the final round, the bleary-eyed panelists voted grants of $5,000 to $15,000 to each applicant receiving four out of six votes. Among the grantees was the painter Amanda Farber, whose stepmother, Patricia Patterson, sat on the panel.[40]

The question of an artist's need for money also did not concern some panels, even though fellowships were supposed to underwrite creative sabbaticals from regular jobs. By the mid-1970s, this goal had gone by the board; Richard Estes, an immensely successful photorealist artist, received a grant even though he had not applied for one. He suggested that the endowment give the money to a young artist in need, but was told that the grant would be canceled unless he took it. Estes suspected that he was chosen in order to dispel rumors of discrimination against realist artists. In 1985, Harold Brodkey collected $20,000 to continue his novel *A Party of Animals,* which had been in progress for nearly thirty years. In 1986, Tama Janowitz received $20,000 to revise her successful novel *A Cannibal in Manhattan.* In 1987, Wallace Shawn received a $20,000 play-writing grant, even though several of his previous works had been successfully produced. Crafts artists who were earning more than $100,000 a year and had studios or homes on several continents also were receiving fellowships. In 1990, a fellowship went to Donald Baechler, who had just sold out his entire show at the Kasmin Gallery in SoHo, at prices ranging from $8,000 to $15,000.

Baechler, who had had twenty-seven solo exhibitions in galleries from Japan to Sweden to Brazil, was delighted to receive the endowment's $15,000: "I paid about a quarter of my taxes with my NEA grant."[41]

Whether they followed the rules punctiliously or tossed grants to the wealthy, to friends, relatives, colleagues, or fellow panelists, by 1990 most panels had developed an inflated notion of their role in the endowment's review process. Flattered by trips to Washington, by increased prestige among their peers, and by the reality that only a handful of their recommendations had ever been rejected by the busy council or even busier chair, many panelists had forgotten that the NEA's enabling legislation clearly stated that the panels should play only an advisory role to the council and chair. In fact, this law did not require panels at all but authorized the chair to convene them "from time to time, as appropriate." By 1990, some had begun to see themselves as flawless arbiters of taste; others, as seers able to discern the slightest creative tremor at the cutting edge. When controversy erupted, however, and the council and chair asserted their duty to review and, if necessary, disapprove questionable grants, some panels bridled, some issued public protests, and several huffily resigned.[42]

In the fall of 1989, Congress had asked the president to create an independent commission to study the NEA's grantmaking procedures and to recommend steps toward restoring the public's confidence in the process. Delayed until the spring of 1990, the commission eventually was comprised of twelve members, all appointed by President George Bush, although four were recommended by the Senate leadership and four by the House. Leading its supporting staff of eight was Margaret Jane Wyszomirski, a political scientist whose research had long focused on the arts and who would later head the NEA's policy, planning, and research division. Co-chaired by Leonard Garment and John Brademas, a former congressman who then was president of New York University, the commission summoned a task force of constitutional scholars to study standards on obscenity, and heard forty-five witnesses in Washington during six scorching days of hearings in the summer of 1990.[43]

The commission's report in September 1990 attempted to cool the boiling controversy. While disapproving of rules against obscenity, it suggested that publicly funded art must be judged more stringently than works supported privately. The endowment's "complex and delicate" task was "to offer a spacious sense of freedom to the artists and arts institutions it assists," while also remaining "accountable to all of the American people."

The process of choosing grantees, it emphasized, must be "fair, reasonable and efficient," insuring artistic freedom "while bearing in mind limits of public understanding and tolerance." However, the "wisdom, prudence, and, above all, common sense" urged by the commission were sadly lacking, not only among the runaway panels and the most rabid of grantees but also in NEA's management.[44]

Testifying before the commission, Frohnmayer stirred up a media mini-flap by carelessly answering a question about standards for publicly funded art. His reply that it might not be appropriate to display a photo of Holocaust victims in the entrance to a museum excited the wrath of no less than the *New York Times*, *Time* magazine, and the *Washington Times*, and both the Simon Wiesenthal Center for Holocaust Studies and B'nai B'rith extracted an apology. Simultaneously, while the commission was attempting to rescue the endowment from the cross-fire in which it was pinned, four strident performance artists whose grants had been canceled as obscene—self-styled as the NEA Four—filed suit to recover their funds. One was Karen Finley, who protested against male oppression by publicly smearing her naked body with chocolate. Another was John Fleck, whose stage act included urinating into a toilet. The remaining two, Tim Miller and Holly Hughes, performed work that aggressively flaunted homosexuality. Meanwhile, four newspapers had also resorted to the courts to force the council's grant-review process into open session.[45]

Two days after the independent commission's last hearing, the National Council on the Arts convened, the first session in which its grants deliberations would be open to the public. Frohnmayer aptly described his performance at this gathering: "Pull the pin on a grenade, toss it up in the air, and run under it."[46]

Despite a high ceiling and gracious proportions, room M09, where the council convened, had notoriously poor acoustics and a faltering cooling system. The roar of crowds milling among the shops and fast-food stands just outside the door drifted in distractingly. This din was augmented by the hubbub of forty reporters and full crews from four television networks in the room. It was on the second day, when the television crews were absent, that Frohnmayer learned, to his horror, that collaborators of two of the NEA Four had sat on the panel that awarded them grants. The chair then announced he would resubmit their grant applications to a new, conflict-free panel whose recommendation would be considered at the council's November meeting. At this, a referee's whistle blew and a strident contingent from ACT-UP, a vociferous AIDS activist group, chanted,

"Shame, shame, shame . . . we're here, we're queer, get used to it," while one man leaped up to recite a poem about fellatio. After five minutes of bedlam, federal officers removed the demonstrators, but some 250 confederates on the street outside continued to shout and clamor for the rest of the afternoon.[47]

What Frohnmayer described as "a zoo" ended with one council member proposing that the endowment not fund works that utilize any part of an actual human embryo or fetus; that might induce a minor to engage in sexually explicit conduct; that offensively depicted human sexual or excretory activities or organs; that denigrated religion; or that demeaned the American flag or an individual's or group's race, sex, physical handicap, religion, or national origin. Though the council rejected these rules, the very fact that they were seriously considered indicated how low the panels had sunk in their evaluations of proposed projects.[48]

The independent commission's report, in September 1990, was most scathing about the operations of panels, which "have come to dominate the process of grantmaking. This development," the commission observed, "does not satisfy expectations about public accountability" and flouts Congress's mandate that the chair be "the only person with legal authority to make grants." The endowment staff, the commission implied, had become too entwined with "those who benefit directly from the agency"; the staff "must be accountable to the chairperson rather than to the particular artistic fields or disciplines with which they work." In the past, panelists had simply left the room during consideration of an application from an organization with which they were connected. Now the commission recommended, among many other reforms, that such panelists should not serve at all, nor should grant-review panels write guidelines for applications or "be dominated by any particular interest, viewpoint or school." The commission co-chairman Brademas, who had been one of the NEA's staunchest congressional supporters, said that the set of recommendations "on one hand is respectful of freedom of expression and on the other hand, the stewardship of Congress." With Solomonic gravity, the commission noted that "many individuals on both sides" were using controversy as "a convenient and newsworthy vehicle to advance their own objectives; some do not care a great deal about whether the agency survives. America has had more than enough of this uncompromising behavior."[49]

But neither side saw any profit in allowing the controversy to simmer down. Ironically, the noisiest extremists proclaimed themselves victims, on the one hand of an oppressively puritanical society that sought to silence

dissent and, on the other, of a libertine rabble dynamiting traditional American values. Pat Buchanan, who was then contending for the Republican presidential nomination, ranted that "the left" had been "quietly seizing all the commanding heights of American art and culture. . . . The hour is late." One of the NEA Four, Holly Hughes, wailed that the endowment "blatantly and prejudicially targeted" gays and lesbians: "The homophobes in the Government don't think we're being killed off at a fast enough rate." Senator Jesse Helms, who came to symbolize the NEA's know-nothing opposition, told a North Carolina audience about his answer to a woman who wrote him that she threw up every time she heard his name: "The next time it happens, frame it and send it to the National Endowment for the Arts. They'll give you $5,000 for it." The poet Allen Ginsberg weighed in with an open letter accusing "hypocrite scoundrels" of planning to "extend their own control-addiction to arts councils, humanities programs, and universities," and he asked how long Congress, the public, and the arts would be "held hostage to this cultural Mafia." Joseph Epstein, a Northwestern University English professor who had served six years on the National Council on the Arts, described how the debate had polarized: The artistic community saw congresspeople "in the robes of the Inquisition, flames all around," while congresspeople saw in the arts community "nothing but the most decadent homosexuality, immorality, indolence, and incompetence. In the middle of this," Epstein concluded morosely, "somehow all the big questions are lost."[50]

With a clear policy and firm leadership, the endowment might have navigated relatively safely past the screams from both extremes. But policymaking had eluded all previous chairs, as they sought to pacify every conceivable "arts community" while also filling every congressperson's wish list. This vacuum at the center brought the whole structure down upon the handsome head of hapless John Frohnmayer . . . who also wallowed in his role of victim. However, he regularly tumbled into self-set traps. Reviewing videotapes of Karen Finley's stage gyrations, he found it "difficult to recommend a foul-mouthed, self-indulgent actor who was offensive by design." Yet he first told the White House that her work was "artistically supportable," and only later that he would turn down her grant. "I waffled." He rescinded a $10,000 grant for an AIDS-related exhibition at New York's Artists Space and then, besieged by protesters, he restored the funds. "I screwed up." While being considered for the chairman's job, he told a White House interviewer that he would be "a team player," carrying out the administration's will even if he disagreed with it. "I lied." When

nominated as chair, he talked about finding the balance between "absolute freedom" and "the public trust—when you're using public dollars," but later admitted, "I didn't know what I was talking about." At his confirmation hearing, he told Senator Trent Lott that he was "no less offended than the critics by some of the [Mapplethorpe] photographs," then confessed in his book: "I wasn't really offended."[51]

From the beginning, the endowment had attracted its share of virulent critics. Dismissed as ignorant naysayers, they were later joined by knowledgeable conservatives who thrust cunning daggers into the very concept of government funding for the arts. Ronald Berman, who headed the NEH during the Nixon years, decried his sister agency's lack of standards: "It is exceptionally difficult to get the NEA to state . . . the levels of quality to be attained . . . of beneficiaries to be excluded," he wrote. "It is impossible to get the NEA to state the ends of support for various arts in terms other than the satisfaction of constituents." The art historian Ernest van den Haag in 1979 compared the endowment's procedures to "mining gold by refining lots of ore." Government subsidies, he argued, were simply attracting "more people who claim to be producing real artistic gold," while "supporting the mediocre."[52]

By the mid-1980s, even Michael Straight, who had served eight years as Nancy Hanks's deputy, wondered why the NEA was handing out so many entitlements to arts institutions: "How long should the Federal government provide start-up funds for a . . . dance company which can't find them anywhere else?" he demanded. Straight also deplored the endowment's giving grants to individuals: "It creates a false sense of dependency among them and at the same time, it creates resentment toward the artists by the taxpayers, who say, 'I'm not being supported in this way.'"[53]

As happened with the endowment's decades-long labors to erect monumental sculptures among the aesthetic heathen, the most devastating critique ridiculed the NEA's earnest cultural initiatives. A *Washington Post* columnist in 1989 confessed to suggesting that Congress consider creating a National Endowment for Rodeo. The echo of the sculpture debate sounded once again in a 1990 syndicated column by the humorist Dave Barry: "You almost never hear members of the public saying, 'Hey! Let's all voluntarily chip in and pay a sculptor $100,000 to fill this park space with what appears to be the rusted remains of a helicopter crash!' . . . The government supports the arts for the same reason it purchases $400,000 fax machines and keeps dead radioactive beagles in freezers: Nobody else is willing to do it."[54]

<p style="text-align:center">❖ ❖ ❖</p>

As Frohnmayer waffled his way toward his inevitable, ignominious—but long-delayed—departure, he appointed Anne-Imelda Radice as acting chair. She had already worked many months at the endowment, either to spy on and embarrass the chair, as Frohnmayer claimed, or to extinguish political fires, as her White House sponsors demanded. Radice was a seasoned Washington warrior with some twenty years as assistant curator at the National Gallery, as architectural historian for the Capitol, as director of the creative arts division at the U.S. Information Agency, and as director of the National Museum of Women in the Arts. Discreet but unabashed, she was also a lesbian. Frohnmayer, she said, refused to benefit from her ten years' experience on the Hill, even though she told him that Congress was receiving more mail about minor raunchy NEA grants than about major sleaze in the savings and loan debacle. Having viewed performances by two of the NEA Four, she warned the chair that finding their work grantworthy was "suicide."[55]

In fact, the chair had secretly agreed to resign while breakfasting with George Bush in October 1991. About this he also lied, telling Radice only that he had "talked basketball" with the president while reassuring him that the NEA was almost out of the woods. For more than four months, Frohnmayer dithered as to the date he would leave. In February, he presided over a disastrous council meeting at which a grant was approved for a poet whose work justified the rape and maiming of a jogger in New York's Central Park. A few days later, the White House "canned my ass," as Frohnmayer so elegantly put it on the second page of his book.[56]

Even as he announced his resignation to the NEA staff on February 21, 1992, in the same inhospitable room where "the zoo" had erupted some eighteen months earlier, Frohnmayer again was deceptive. He warmly hugged a colleague whom he couldn't "stand." Then he lingered despondently on until May 1, turning up every day in his office while searching for some other Washington job. He offered his services as "an arts advocate and First Amendment lawyer" to Dickstein, Shapiro and Morin, one of whose partners, Leonard Garment, had vainly tried to persuade him that "the artists are your enemies, not your constituency. You work for Congress, the people, and the President."[57]

The endowment's "atmosphere of siege" described by the *New York Times* nine months earlier had gotten worse. "The place was a mess," said one of Frohnmayer's deputies; the chair's office was "like a war room. . . . We were constantly on the defensive." Other aides cringed at Frohnmayer's

management style: "For priorities," said one, "he had one paragraph . . . he had no substance." Where Hodsoll had four deputies, Frohnmayer had only one, said another, adding in broad understatement, "He underestimated the difficulty and complexity of running the NEA." Yet another longtime NEA staffer was equally devastating: "[He] didn't want to be bothered. . . . He had no curiosity. . . . He was distant and aloof, not quick." As usual, Frohnmayer's own words skewered himself most accurately: "Those who have worked most closely with me over extended periods say that you have to be a mind reader to figure out what I want, and I plead *nolo contendere*."[58]

Before this feckless bumbler finally cleaned out his desk, he was still lecturing anyone who would listen on how government grants for offensive art were strictly a First Amendment issue. In March 1992, he received a standing ovation when he told the National Press Club that some of the endowment's critics were the equivalent of Nazis in Germany: "You couldn't help but be chilled to the bone by the similarity." Soon after he left the NEA in May 1992, he called on members of the American Association of Museums to join the battle "to protect the artist's right to express himself as he wishes, unhindered by the tastes . . . of government." A year later, he still equated rejection of a government grant with censorship. Speeches at twenty-five colleges, he said, left him "astounded at students' ignorance of the First Amendment." Having completed his embarrassing account of his disastrous two-and-a-half-year tenure at the endowment, *Leaving Town Alive: Confessions of an Arts Warrior,* he was planning to teach college courses on the grandiose topic of "the intersection of ethics, politics, and culture."[59]

One might have expected a finely honed legal mind to comprehend that any time a panel rejects *any* grant application, it is exercising a form of censorship, and whenever the endowment refuses to fund certain categories of artistic endeavor, whether whittling, needlepoint, or country music, someone's expression is thwarted. Robert Brustein, the director of the American Repertory Theater, complained that the Carter administration undermined the NEA's panel system by introducing considerations of race, sex, ethnicity, and geography into grantmaking decisions.

For years, visual artists working in representational styles and traditional media accused the endowment of favoring abstract art. The NEA repeatedly rejected grant applications from the New York Academy of Art, founded in 1982 and accredited to award M.F.A.'s based on classical training in anatomy, drawing, painting, and sculpture. Though the school had

earned endorsements from such established artists as Andy Warhol, David Hockney, and Lucien Freud, the NEA's challenge grant panel found the school "too rigidly modelled on European academicism," and feared that its "revisionist approach would stifle the creativity of young artists." Despite appeals, the school was unable to reverse this judgment, though it took comfort from supportive comments by one of its board members: "You are . . . the new young radicals," wrote the writer Tom Wolfe. "You are the artists cut off from bourgeois society today." He pointed to the plethora of new corporate towers with a plaza in front. "You will soon find all they want is an abstract squiggle . . . or a bolus with a hole . . . the sort of sculpture that is known within architectural circles as the 'turd-in-the-plaza school of sculpture.'" When the endowment's managers learned that the academy's board included not only the acerbic Wolfe but also the former New York governor Hugh Carey and the publisher Christopher Forbes, the deputy chairman for programs sent a conciliatory letter urging the academy to apply again the following year.[60]

That censorship pervaded almost every creative showcase outside the endowment—and always had—eluded Frohnmayer completely. Washington's National Gallery primly turned down a seventeeth-century Dutch painting showing the Biblical Lot and his daughters picnicking in the nude. Its director J. Carter Brown explained, "We're a family museum." Neither did any major media show their viewers and readers the Mapplethorpe photos that caused all the fuss. When the College Art Association's *Art Journal* attempted to publish a special issue on censorship including the photos, two printers refused to handle the publication, and the co-editor was stunned by the amount of criticism he received from "quite sophisticated people who have liberal views."[61]

With Frohnmayer gone (though he had not left town, as his book's title implied, but was still holed up in a Capitol Hill townhouse), the endowment's current and past staff picked dispiritedly through the rubble he left behind. They expressed pervasive malaise over issues that had little to do with the First Amendment, rude artists, or political demagogues. Margaret Jane Wyszomirski, who headed the independent commission staff, noted that "artists had developed rising expectations that were frustrated during the 1980s." Anthony Tighe, who had also worked with the independent commission, worried about the proliferation of arts institutions: "There are just too many. . . . There'll be an inevitable shakedown." Charles Ruttenberg, the endowment's first counsel, asked, "Is more better?" and added, "I've always felt that there's a limit to what government can do." David Stewart, who had

moved from the early NEA to the Corporation for Public Broadcasting, detected the lassitude of middle age at both the NEA and CPB: "The start-up is always fun," he said, but "you can't sustain the enthusiasm. . . . It's not unlike a marriage . . . born in passion which then slips away to be replaced by something else." Ann Murphy, who for years had pleaded the NEA's cause on Capitol Hill, suggested that, at age twenty-seven, the endowment had lived long enough: "It's time to say, 'We did it!' "[62]

Sympathetic observers from the outside were equally pessimistic. Louise Wiener, who had worked hard for NEA within the Carter administration, believed that quality among members of the National Council on the Arts had declined; once it had been "the pinnacle, but then, ha!" The Actors' Equity lawyer Jack Golodner, who had worked with Nancy Hanks to gain mass support for the endowment, deplored its lack of coherent philosophy: "They're waiting for Lefty." Robert Lynch, the dynamic director of the National Assembly of Local Arts Agencies, deplored the endowment's overwhelming investment in conservative arts organizations: "The philosophy there is supply side. . . . They give lip service to encouraging the arts, but are not interested in building enthusiasm from the bottom up." Leonard Garment, the patron of the endowment's growth spurt under Richard Nixon, sounded an equally gloomy note. He had twice rejected the NEA chairmanship when it was offered by Ronald Reagan and then George Bush. In 1993, when Bill Clinton had yet left the post unfilled, he lamented that "all becomes patronage, at a sacrifice to quality. Now, even the word 'standards' is anathematized." He doubted that the NEA could reform: "It's become a bureaucracy . . . everything has a lifespan, except evil."[63]

Ironically, these bleak prognoses for the endowment contrasted sharply with the unprecedented "arts boom" that the United States had enjoyed since the end of the Second World War. Yet, in many ways, individual arts organizations were no better off than they had ever been. Fed by foundation and government grants, they also had learned to play an exceedingly sophisticated fundraising game, all the more vital because they were spending so much more on each audience member. In 1980, the average nonprofit theater spent $8 for each ticket sold; in 1991, the cost was almost $20. Average symphony spending per ticket was just over $11 in 1980 but had risen to almost $31 by 1991.[64]

Throughout these years, the endowment had taken credit for the amazing spread of the arts quilt over the American map. But by the late 1980s, many observers were alarmed by this proliferation. The cultural curmudgeon Jacques Barzun was grumbling about "a surfeit of art." In a *Harper's*

article, he mentioned Balzac's dismay in 1840 that Paris sheltered two thousand painters, and Degas' dry observation on the even greater glut fifty years later: "We must discourage the arts." Since then, Barzun noted, educational institutions, philanthropies, and well-off parents had combined to train a horde that could never be employed. Technique and professional skill, he wrote, were no longer distinguishing features, but the norm: "How can these talents find social use corresponding to their preparation?" Buffeted by intense competition, young musicians, actors, and dancers are tempted to modify their work in order to attract grants. In France, Barzun noted, subsidies for "official" artists had promoted competent, safe work, he wrote, while leaving the innovators at the margins, "often in angry opposition." Despite its diversity, the American system of arts funding also encouraged conservatism. The need to attract donors and grants, wrote the sociologist Paul DiMaggio in 1987, was "the enemy of innovation. . . . Classical music was strengthened at the expense of avant-garde composition," and theater at the expense of innovative drama. Those who subsidized the arts encouraged sound financial and administrative controls at nonprofit arts firms, with growth as the inevitable objective. Such a goal, he believed, tempted creative artists to repeat what had worked in the past rather than to take unfunded risks.[65]

Moreover, the notion of assembling various groups within an arts "campus," the dream of Lincoln Center's developers, had degenerated time after time into a squabbling nightmare. At the Los Angeles Music Center, resident groups refused to share accounting, advertising, or box office responsibilities and even kept the center from handling their television contracts. In San Francisco, the opera and symphony had once shared a manager, and the ballet had been content as a division of the opera. These arrangements crumbled during the 1960s and 1970s and by 1983 the institutions even refused to share computer services. Wherever arts centers were built, whether Milwaukee, Syracuse, Cleveland, Pittsburgh, Washington, Denver, Tulsa, or Louisville, not to mention Lincoln Center itself, tenants preferred to go their own way. Most saw themselves as vying for survival with the center management itself, since the management was booking competing groups when constituents left their space vacant.[66]

Reflecting the American passion for a private house on a private plot for each family, localities poured enormous sums into stately edifices to house their culture. Between 1962 and 1969, 173 arts centers or large theaters were completed and another 179 were on the way. In 1964, some 60 percent of donations to the arts, whether private, corporate, or government,

went into construction. Five years later, buildings alone were absorbing more than 66 percent of donations. By then, some $207 million had gone into bricks and mortar, more than the total box office receipts of all performances above the cabaret level. While a Twentieth Century Fund study in 1970 found that "audiences and a decent income for performers [were] the great needs of the arts in America," such was the lust for buildings that "edifice complex" became a cliché. Even then, arts centers appeared to be financially unviable. Lincoln Center in 1969 was virtually bankrupt and canceled its summer festival. In Atlanta, just one hundred days after civic leaders hailed the opening of the $13-million Memorial Arts Center, the resident ballet, opera, and drama companies folded, leaving the *Atlanta Constitution* grieving that "the dream is shattered."[67]

Typically, downtown businesspeople have joined the social elite in promoting construction of ambitious arts centers. In most cases, the arts themselves have least concerned the vocal and politically powerful coalitions that sell these projects to the public. Even in smaller cities, the prospect of a downtown arts center dazzled officials with fantasies of attracting new industry, luring suburban shoppers back into town, and proclaiming the city's commitment to culture. In Roanoke, Virginia, for example, the city planning commission in 1963 published an attractively illustrated brochure extolling the benefits of a downtown arts center. It "can stabilize or improve property values and taxes," the report asserted, and "can add to the cultural climate needed to attract new industry." As "a proud symbol of the city's cultural development," the center's "very existence will have profound influences upon land values and the future pattern of the city's growth and development."[68]

Such a touching faith in the power of art to reverse deep-seated economic and social trends continues to find new converts. In Newark, what is confidently described as a "$150-million center" is expected to be completed by 1996. "This is not like Lincoln Center," its architect asserted. "It will not be a marble palace in any way." Yet, with its lobbies featuring walls of glass, its genesis in urban renewal, and its blue-sky cost estimate, this project more than echoes its predecessor across the Hudson River. In Philadelphia, developers of a planned Avenue of the Arts also claim that its architecturally diverse components along ten blocks of South Broad Street bear little resemblance to Lincoln Center. But the expected benefits are no different from the pious hopes expressed by the planners of Lincoln Center: "The performing arts are good for economic development. This is seen as a real economic hope for the city."[69]

To all these non-art ingredients in the potion promoting arts centers' contribution to civic health, the drive to construct Washington's Kennedy Center added a compelling argument: The center would conquer the Soviet offensive on the Cold War's cultural front. As early as 1961, one of the project's fervent proponents predicted that "the Center will become a potent factor in the world's struggle for the minds and hearts of men." Another proponent warned that "the Soviets have 375,000 full time people working to advance their cultural offensive" and promised that, like the harnessing of atomic energy, the center would promote "peaceful uses of creative energy." Assured that no public money would be needed for construction or operation, President Dwight D. Eisenhower had endorsed the idea in 1958. Fundraising was slow and congressional support lukewarm, despite the trustees' promise to showcase the dazzling profusion of American culture: "From the ballads of the Northern lumberjacks to the chanteys of Cape Cod fishermen, the songs of Pennsylvania coal miners, and the laments of Texas cowboys." Ethnic cultures would also have their day, and "the music and dance of the American Indian should receive special attention."[70]

In November 1961, John Kennedy added his voice to those expecting the still nonexistent facility to keep "the fires of liberty burning and strong." He also mentioned the offensive Soviet horde of 375,000 cultural minions. While Congress addressed the "missile gap," few Washingtonians cared to open their purses to bridge the cultural gap. To further the faltering project, John Kennedy in October 1963 told a White House luncheon of prominent businessmen that Washington was so bereft of cultural amenities that foreign embassies considered it "a hardship post." Meanwhile, although no construction had yet taken place, Kennedy had persuaded the Department of the Interior to advance $15 million for the center's garage, to be repaid from parking revenues; the rest of the building was expected to cost $31 million. A month later, the President was dead, and within a few hours his family had agreed to name the proposed arts center for him. Congress then acted on the project swiftly and generously. By January 1964, President Lyndon Johnson signed a bill not only naming the center after the fallen president but also providing $32 million, almost three times what had been raised privately, to build it.[71]

When building began at last near the end of 1964, Roger Stevens was juggling his post as the Kennedy Center's board chairman with presiding over the NEA's birth, as well as various real estate deals and theatrical productions. Instead of completion within three years, the project dragged on

for more than six years, beset by labor disputes, government red tape, and the need for soundproofing the huge structure against the roar of jets flying into National Airport. The cost had ballooned to $70 million, due largely to what the head of the General Services Administration called "one of the most mismanaged contracts I've ever seen." *Newsweek,* among many other critical publications, denounced the project as "a great white (bipartisan) elephant." When the center opened, the architectural critics added their gibes. Ada Louise Huxtable deemed the building, designed by Edward Durell Stone, "a superbunker," its corridors "great for drag racing." Robert Hughes dismembered the building in *Time,* calling it "the most frigid tribute a modern architect has paid to the muses." The river terrace's 630-foot expanse of polished Carrara marble resembled "a new kitchen," he wrote, while the oversize faux-bronze columns and the landscaping's "regimented shrubs" conveyed "failed pomp." The entire structure suggested "an inflated Greek temple," while its grand foyer "achieves the crushing placelessness of an international air terminal."[72]

The original project had been far more ambitious. The 1957 plan was for a "great hall" seating 10,000, a second hall with 4,200 seats, a third theater for 1,800, a tourist information center, a mass-communications facility, and exhibit areas on a twenty-seven-acre site. The government would provide only the land, with all construction, maintenance, and future operations to be privately funded. As built, the place housed a 2,250-seat opera house, a 2,750-seat concert hall, a 1,150-seat theater, plus a 250-seat theater lab, all on seventeen and a half acres. The grand foyer, 600 feet long and 60 feet high, was one of the hugest rooms ever built. The heating and air-conditioning systems were the largest of their kind ever installed. Private fundraising having proved disappointing, Congress had been persuaded to add $15 million to a similar sum already committed for the garage and to declare the place a national monument, with the National Park Service charged with all future maintenance.[73]

The opening on September 8, 1971, served up all the pageantry an aspiring world cultural power could muster. The grand foyer's cavernous expanse was packed, perhaps for the last time, with animated, formally clad dignitaries. Every Kennedy except Jacqueline was on hand to hear the world premiere of Leonard Bernstein's *Mass,* conducted by the copiously weeping composer. Perhaps the *Washington Post*'s music critic was engaging in habitual boosterism when he called the work "a shattering experience"; the *New York Times'* Harold Schonberg found it "cheap and vulgar . . . a show-biz mass." On the second opening night, the Nixons heard Antal

Dorati lead the National Symphony Orchestra in an unexceptionable pro-
gram of Beethoven, Mozart, and Stravinsky, set off by a blessedly brief
"Secular Cantata No. 2" by William Schuman. Two years after being
relieved of his duties as president of Lincoln Center, the composer was a
guest in the presidential box.[74]

These decorous evenings were followed by a populist stampede of Jack-
sonian proportions. The center zoomed immediately to the top of Wash-
ington sightseeing destinations, attracting in three months more than half a
million tourists, and 400,000 ticket buyers. To this light-fingered throng,
the three restaurants in the center lost all their salt and pepper shakers and
ashtrays, several thousand menus, and "a dowry of china, glassware, silver-
ware, and table linen." The multitude made off with light bulbs, posters,
paintings, potted plants, bathroom faucets, and covers of electric outlets.
It snipped swatches of carpets and drapes, and even absconded with
Waterford crystal prisms from the chandeliers, worth $86 each. Stevens
catalogued the depredations as he threatened to close the place unless
Congress supplied $1.5 million for security, maintenance, and repairs. But
even with the money in hand, Stevens sighed, "We don't know yet what the
tourist season will bring."[75]

The popularity of the Kennedy Center among visiting kleptomaniacs
was not matched by its attraction for paying patrons. Even as the workmen
were applying the building's flimsy marble skin, a Twentieth Century Fund
study of the economics of performing arts centers indicated that a city of
700,000, then roughly Washington's population, could expect to fill a single
3,500-seat hall only six times per month. Theaters with 2,500 seats might
be filled more often, but they took in less box office revenue, needed more
subsidies, and were less attractive to major touring productions. The study
suggested that new centers incorporate rental office space or housing to
make them commercially viable. "The separation of a performing arts cen-
ter in an independent monument," it warned, "may symbolize not the
majesty of the arts but their increasing isolation."[76]

Cut off from all foot traffic, lacking a Metro stop, and soon shunned by
all but one tourist-bus excursion, the subsequent fate of the Kennedy Cen-
ter provides a textbook illustration of these caveats. The lively cultural
scene envisioned by its planners has not materialized, as the District of
Columbia lost more than 22 percent of its population between 1970 and
1992. The district moved during these same years to boasting the highest
death rate in the nation, and one of the highest birth rates, even though
abortions there numbered more than three times the national average. Its

murder rate led the nation and more than half of all families had only one parent. Such a matrix of social decay is unlikely to produce large audiences for cultural events. Meanwhile, the metropolitan area around the capital experienced smart growth, not only of population but also of performing arts centers and cultural offerings at universities.

In most cities, even the fieriest boosters might have despaired of rescuing the struggling Kennedy Center. In Washington, however, more than the nation's honor was at stake; the crumbling behemoth on the Potomac represented the front line against Soviet dancers and musicians in the cultural Cold War. Not without pride did Washingtonians acknowledge that the National Symphony's conductor Mstislav Rostropovich had fled his despotic homeland in 1974. Yet, despite acclaimed, though unadventuresome, performances, the orchestra escaped extinction in 1986 only by being absorbed into the Kennedy Center. Frisky Broadway shows toured to Washington relatively successfully, but Peter Sellars's risk-taking American National Theater folded after two years in 1986, leaving a $2-million deficit. That year, *Shear Madness*, a mindless comedy/whodunit about hairdressers, began an apparently permanent run in the 250-seat theater lab, the supposed venue for experimental, avant-garde drama. Even the well-meaning gestures toward diversity sponsored by the Washington Performing Arts Society came to grief. In 1989, this presenting organization decided to appeal to the 70 percent of Washington's population that is African-American by adding gospel concerts to its schedule. But much to the manager Doug Wheeler's chagrin, this programming raised hackles at many black churches that depended on income from dance and music programs in their own performance spaces.[77]

As the Kennedy Center was being built, a *Fortune* profile of Roger Stevens concluded that "if mistakes have been made, they will be monumental. . . . An ordinary monument just sits on its site, gazed at or glared at. . . . But this will be a monument full of playing, singing, dancing, demanding constant attention, promotion, and investment—otherwise it will stand as a bleak and echoing reproach to somebody's bad guess." Over the succeeding decades, Congress has been steadily paying for numerous bad guesses. In 1977, $4.7 million went to patch the flat concrete roof; in 1990, hundreds more roof leaks required $20 million more. In 1984, Congress forgave all the accumulated interest on $33 million in construction bonds and allowed repayment of principal at $200,000 per year for 1,275 years. In fiscal year 1989, Congress gave the National Park Service $7 million to operate the center, but in the succeeding three years, the amount

rose to more than $20 million. In addition, Congress in 1990 gave the center $15 million to clear an accumulated deficit. In fiscal year 1994, the center was asking for $28 million for maintenance and repairs, plus $5 million for education. Of course, the National Symphony, the National Opera, and various other companies that presented programs at the Kennedy Center continued to receive regular grants from the NEA and the Washington D.C. Council on the Arts.[78]

Like the Kennedy Center, the organized arts are marketing themselves with all sorts of reasons that have nothing to do with art. At the NEA, the current wisdom sees multiculturalism and education as new engines for fostering its work. After much huffing and puffing by arts lobbyists, including the Assembly of National Arts Education Associations, Congress in 1994 included the arts in its Education 2000 blueprint for school improvement. Though considerable funds will go into this endeavor, past experience indicates that educating people to love and understand the arts requires more than including art in the school curriculum. Educational research files bulge with thousands of studies, many of them funded by the NEA, of classroom endeavors in behalf of the arts. The rhetoric implies that exposing young people to the arts will effectively enhance their appreciation and future consumption of same. Little evidence supports this assumption: Schools expose children to all sorts of disciplines—mathematics, history, social studies, science—but few adults choose to pursue further knowledge in these fields. By contrast, Americans enthusiastically expend their money and leisure on interests they never learned in school: spectator sports, popular music, television, supermarket tabloids, shopping, religious activities, and socializing in bars.

Like the arts educators, the arts service organizations trot around platitudes about creativity and innovation while collecting annual NEA grants and hefty dues from a membership of widely divergent quality. They reside mostly in Washington, in makeshift-looking spaces that resemble political campaign headquarters. Desks are jammed into awkward corners, boxes cover the floors, pamphlets and papers are piled high on filing cabinets, charts and scribbled-up calendars line the walls. Usually there are mailings in progress, with the receptionist doubling as envelope stuffer. The staff moves purposefully toward the next conference, the next newsletter, the next membership drive, the next lobbying push. The arts professionals who manage these organizations appear charming, knowledgeable, persuasive, enthusiastic, much like political campaign managers. They know their own

field intimately, rattling off its statistics, its achievements, its importance in the cultural landscape, and they argue compellingly for its public support.

With the NEA in eclipse, they are searching for new solutions to financial problems. In 1993, they created a mega-organization, the National Cultural Alliance (NCA), dedicated to raising the "visibility" of the arts; as one organizer described it, "Smokey the Bear for the arts." Under the NCA's capacious umbrella, more than 23,000 cultural institutions can convey to Congress not only their support for the NEA but also their interest in low postal rates for nonprofit organizations, the use of redevelopment funds for building arts centers, and tax policies that reward private donations. Its first project was yet another survey about Americans' attitudes toward the arts and humanities. Despite questions brazenly designed to elicit favorable responses, the outcome raised substantial questions about the general public's yearning for culture. Only 59 percent agreed that the arts and humanities were a necessity and 31 percent were unable to define the humanities. While most respondents gave lip service to the benign nature of the arts and humanities, only 5 percent were "extremely interested," and even among those earning more than $50,000 annually, only 30 percent were "very interested," while 57 percent admitted that the arts and humanities play only a minor role in their lives.[79]

Such surveys strongly suggest that most Americans do not avidly seek the aesthetic and intellectual pleasures to be derived from cultural pursuits. Neither do most presidents. The Jimmy Carter inauguration featured Johnny Cash, Stevie Wonder, and Paul Simon. The first Reagan inaugural included Frank Sinatra, Ethel Merman, Glen Campbell, Woody Herman, and the Mormon Tabernacle Choir. George Bush demonstrated his regard for high art at the conclusion of a White House luncheon for ten winners of the National Medal for the Arts. The president boyishly leaped up and announced: "All right, you artists! Now I want you to meet some real artists!" A door opened revealing Joe DiMaggio and Ted Williams, who would accompany the president to the all-star game. Entertainment at the Bill Clinton inauguration was equally populist, including Barbra Streisand, Linda Ronstadt, and Fleetwood Mac.[80]

The agencies selling the arts nearer the grass roots do not refer often to the spiritual benefits of art. For them, the principal motivations for arts subsidies include downtown redevelopment, attracting tourists, and plain boosterism. Some studies designed to elicit more funding for heavy construction cite the benefits of increased daytime foot traffic and the safety value of nighttime pedestrians on deserted downtown streets. Economic-

impact reports justify arts subsidies with astonishing multiplier effects; like the miracle of the loaves and fishes, dollars "invested" in the arts acquire as much as eight times their original value as arts-patron spending trickles through the local economy. In the New York region, the "economic impact" of art and culture amounted to $9.8 billion, a 1994 study by the Port Authority of New York and New Jersey concluded. But the study also noted that this sector's nonprofit institutions contributed substantially less than one-third of the total, with the rest generated by such commercial enterprises as publishing, theater, filmmaking, television production, cable companies, advertising, art galleries, and auction houses. Together with tourism, the broadly defined arts generated some $2.5 billion in federal, state, and local taxes.[81]

Late in 1993, a two-day conference on cultural tourism heard local arts managers glowingly describe the success of various projects. New Orleans was targeting black tourists, using the city's reputation as a cradle of jazz and its enormous diversity of jazz offerings, most of them at commercial venues. In Wisconsin, Native Americans of the Chippewa tribe had been persuaded to forego their everyday garb of T-shirts and jeans in order to create an image that tourists expected: beaded and feathered regalia. The city of San Francisco helped to sponsor "Carnaval" in its culturally diverse Mission District. The traditional Shrove Tuesday festivities are supposed to precede Lent, but the weather can be chilly then, so organizers scheduled the event for Memorial Day weekend. The promotional video showed a Las Vegas–style pop show, a parade with Latin style bands and dancers clad in $800 costumes so skimpy they might have cost $100 per square inch. Since the event claimed to be multicultural, it received funding from the California Arts Council.[82]

None of these perhaps worthy activities has much to do with the scintillating sparks dancing within an artist's imagination. The creative impulse flows mostly in solitude, in subterranean silence, until it bursts into public view. Almost by definition, art is frivolous, mercurial, elusive, inconsistent, anarchic, driving. "I think of art as something . . . desperate, like breathing," E. L. Doctorow told the National Council on the Arts in May 1993. "I have always distinguished myself from the arts community." He joins a long list of artists who scorn organizations of their own kind and hoot at the very idea that government could or should help them. Herman Melville refused an invitation to join the New York Authors' Club. Sinclair Lewis spurned the Pulitzer Prize. John Sloan growled that "it would be fine to have a Ministry of the Fine Arts in this country. . . . Then we'd know where

the enemy is." Ernest Hemingway was convinced that "a good writer . . . will never like any government he lives under." Robert Frost observed that subsidized poets in Socialist states had to choose between "death and Pollyanna." William Faulkner noted that he had never known any good writing to emerge from "a free gift of money. The good writer never applies to a foundation. He's too busy writing something." John Updike preferred patronage from "a host of anonymous citizens digging into their own pockets for the price of a book or a magazine than a small body of enlightened and responsible men administering public funds."[83]

Well-meaning attempts to organize artists, to shelter them, to guide them, to speak for them must result in mediocrity, conformity, and conservatism. In the thirty years of its existence, the NEA has undoubtedly saved some worthy institutions from extinction, but it has also maintained some moribund carcasses on permanent life support. It has fostered an interest in and appreciation of various arts in all the corners of this diverse nation, but its mindless litany that "art is good, art is great" has not brought forth a better educated, more discriminating, and more critical audience. Perhaps inevitably, it has attempted to contain and channel the madly unpredictable Mississippi of artistic life in this country into the calm locks and weirs of bureaucratic processes.

If text conveys texture, the typical NEA grant application booklet speaks volumes. The 1993 version for theaters ran to eight pages of application and thirty-six pages of instructions. No felicitous phrase breaks the drab procession of definitions, admonitions, and repetitions, all in the tone of an exasperated teacher hectoring a mob of unruly children. Can they read? The sentence "Grantees may not receive funds from more than one Endowment program or category for the same expenses" appears, underlined, no less than five times. The passive voice drones anonymously: "Receipt of your application will be acknowledged." The barnacles of old disputes and hoary ambiguities encrust this text: "Those who receive grants of more than $100,000 fall under Section 319 of Public Law 101-121 regarding restriction on lobbying. . . . Those with budgets over $250,000 in their most recently completed fiscal year must submit certified audited financial statements." However, "this does not affect other state and local agency requirements for audits or the Federal Office of Management and Budget regulations governing grantees."[84]

The reader who does not yet weep for a nation whose arts are said to be nourished by the authors of such text may turn to the NEA's other publications for more reasons to grieve: "Clearly there needs to be a better

understanding of the fabric that supports culture," states the 1992 annual report. "The interrelatedness of the components of the cultural ecology needs to be recognized so that support can be most effectively invested." Such fatuous, pompous vocabulary infests the studies, surveys, recommendations, reports, and analyses churned out by the managers, conferees, scholars, and experts who comprise the arts bureaucracy. When the consultants speak, clarity and creative insights often slink out the window. The talk is of "human resources" rather than people; "conceptualizing" rather than inventing; "financial resources" rather than money; "creative resources" rather than ideas; "marketing" rather than box office appeal; "development" rather than passionate patronage; "planning cycles" rather than inspiration. These limp, polysyllabic locutions proclaim the triumph of managers over the driven dreamers on whom the unfolding culture depends.[85]

The problem of supporting the arts has become the bailiwick of a determined band of specialists, principally sociologists, political scientists, arts managers, economists, and lobbyists. They investigate the characteristics of the arts audience, various strategies for subsidizing the arts, the Byzantine byways by which Congress works its will, the interface between creativity and funding. None of these people is an artist, yet over time they have developed a kind of mandarinate abiding on a more exalted level than the artists themselves. They testify before Congress, pursue studies commissioned by the NEA or its various satraps, lecture at workshops and conferences, publish their findings (often repeatedly, with only slight alterations), and teach at universities.

With a lock on decision making in the cultural arena, they protect their turf by discouraging fresh thinking and new ideas. They reinforce the conservative undertow on the NEA by constructing newer and ever more elaborate statistical and factual structures for maintaining what is. Aping the relatively hard data of the natural sciences, the arts mandarins present complicated models and manipulate numbers to underpin predetermined conclusions. While the factual insights of social scientists who examine the arts add to knowledge and may point the way for future policy, such findings have little do with the mysteries of what makes certain individuals create marvelous things.

Micromanagement by arts bureaucrats, and NEA's efforts to satisfy its many constituencies, alienated many of the endowment's strongest earliest supporters. Agnes De Mille snappishly complained in 1976 that "most of the money is being thrown away. It's being used for political purposes.

They're spreading it around geographically, like Kiwanis, because every state has its senators and congressmen. . . . Our intent in the beginning was to help the highest, the best." Four years later, an acute observer noted that much of the art the NEA deemed cutting edge had turned "strongly antithetical, often inaccessible or destructive," and warned that if the NEA recognized "this darker side of the arts . . . as it must . . . it will inevitably clash with the agency's blue-skies, arts-boom public pronouncements." Money, he said, "changes everything. Once there are funds to be had, people begin to think more about how to get them than what to do when they arrive." The NEA aided the dissemination of culture, but "with creation, with genius, it has far less to do. The arts, it is worth remembering, will survive the National Endowment."[86]

But will the endowment survive? Since the pornography scandals, many serious critics have broached what was previously unthinkable, an end to the agency. Congress already has expressed its displeasure by paring $3 million off the fiscal 1995 budget, and by insisting that NEA distribute 35 percent of what it gets to the states; a further 5 percent has to be spent on projects in inner-city, rural, or other "underserved" areas. Laboring under such mandates, the NEA's overall contribution to cultural enterprises is dwindling. In 1991, a recent study showed, the endowment contributed just 1 percent of the total donations to the arts and humanities. With the endowment's judgment tarnished, and its funding unlikely to thrive in the future, the discussion must turn to how Americans can best underwrite the arts by other means.[87]

8

THE BEGGAR'S
OPERA

Every three months or so, the National Council on the Arts assembles for three busy days. The group that drifts into Washington these days is a faint shadow of that willful, outspoken, opinionated, and gifted band that shaped the infant NEA. Utterly self-confident, it brashly answered to the appellation: cultural czars. Not so its current heirs. Chastened by the Frohnmayer scandals, chided even by its congressional friends, ignored by a president who took well over a year to name the NEA chair, the current council seems resigned to its marginal role in Washington and in American culture as a whole. Unlike the distinguished membership of earlier years, only five current council members work principally as artists; of the rest, four are professors and fifteen are administrators, trustees, volunteers, or patrons.

Though intelligent and admirably balanced demographically, the council as a body does not command national attention or widespread respect for its members' lofty cultural achievements. Its meetings have also settled into a routine: a private one-day pre-meeting, ostensibly for reviewing grants, and two days of public sessions. The open sessions float through a ritual so bland that, much to the council's chagrin, few reporters occupy the press table; the awarding of as much as $80 million in grants receives just a few newspaper paragraphs.[1]

In 1990, the independent commission had recommended that the council form multidisciplinary committees to evaluate panel recommendations and that willingness to work on these committees be a condition for

appointment to the council. At the same time, Congress forbade the chair from funding grants disapproved by the council. However, the council's open meetings give no evidence that either of these reforms has transformed the council into much more than an honorific, cosmetic device to validate decisions reached by panels and staff. Filling vacancies ranked so low on the Clinton administration's agenda that more than a year passed before the president nominated eight worthy but hardly known replacements for members whose terms had expired as long as four years earlier. Nor did the Senate deign to confirm them for many months. No replacements were named for two others whose terms had expired in 1992, or for the six whose appointments would expire in 1994. The administration did not appear eager to draw the slightest attention to an agency that so recently had drawn impassioned public debate, rage, mortification, scorn, and ridicule. Clinton's own budget director, Leon Panetta, had recommended that the endowment be "defunded."

Like congressional hearings for reauthorization or appropriation, the council sits obediently through most of its open sessions, which are devoted largely to high-grade entertainment and heartfelt endorsement by the agency's own beneficiaries. The managers of some of the agency's programs report on their activities, grateful for a chance to weigh in on the continuing internal bickering over funds. But in the brief time available, the council fails to discuss any policies or budget allocations, the members instead seizing the microphone for generalized remarks about the obvious benefits of the arts and painful reflections on the endowment's shrunken public esteem.

If council members harbor any views as to the endowment's direction, they remain unvoiced during the public meetings. In fact, the council dispenses many millions of dollars without a single word of discussion, without even a question, in shocking haste. The presiding officer routinely drones, "Motion . . . second . . . discussion [silence] . . . all in favor . . . opposed [none] . . . abstain [none] . . . thank you." Part way through, she smiles, saying, "Now we have to start with the running-out-of-the-room-thing." Those members connected to organizations receiving grants sit poised to leave the room, as regulations on conflicts of interest require. As these matters grind through, council members stride briskly for the door, only to return almost immediately as their colleagues speedily vote. The restless toing and froing testifies to the substantial extent of subsidies to council members' own organizations. During one typical meeting, at the end of two hours spread over two days, the council members had, without

a word of discussion, disposed of more than $36 million in grants. In the vestibule, their packed bags waited for the rushed exodus to the airport. Their owners had done their duty and were obviously anxious to put the endowment's business out of mind for the coming three months.[2]

While the sums dispensed appear as impressive as the perfunctory manner of their distribution seems appalling, both phenomena testify to the NEA's diminishing role in American culture. Long before the Washington whirlwind over its questionable grants blew into the headlines, the endowment's nervous rush into a multitude of uncoordinated programs left the agency overstressed. While attempting to support arts in areas perceived as "underserved," the NEA's capacity to subsidize major arts institutions dwindled. While the early council determined to concentrate its limited funds on "excellence," the years—and political meddling—tilted funding toward a generalized sprinkling of cash over anything that appeared vaguely artistic.

In 1994, the endowment's current chair, the actress Jane Alexander, proudly noted that the agency had projects "in 90 percent or more of our congressional districts." Such proliferation may help to gain Congressional votes for reauthorization or appropriations, but it can only obscure policy and weaken the NEA's impact. As of 1993, the endowment managed eighteen programs: Ten dealt with disciplines such as dance and music; seven were aimed at specific tasks such as arts in education or helping ethnic minorities; one, media arts, handled such diverse tasks as underwriting the broadcast of arts on radio and TV, funding the American Film Institute, and administering some seventy "media centers" scattered around the country. These programs comprise the principal arteries of a ramified circulatory system carrying sustenance outward toward tiny localized capillaries.[3]

No one has much of an idea as to what body this network is supposed to nourish, and to what end. Every program includes such a multitude of subprograms that it becomes impossible to set goals or to assess results. The relatively new presenting and commissioning program, for example, offers grants for presenting organizations, for touring networks, for "initiatives" in theater and opera-musical theater, and for "services to presenting organizations." Those adept in negotiating this labyrinth may garner grants in several categories. Among them in 1992 was the Brooklyn Academy of Music. Directed by Harvey Lichtenstein, who also sat on the National Council on the Arts, this showcase for the so-called cutting edge collected $175,000, more than 10 percent of the presenting and commissioning program's entire budget.

Since 1980, the NEA's funding has increased by only 9 percent, even as its value in real dollars declined by 29 percent. Despite its high visibility, the endowment is only one among an estimated three hundred federal programs, activities, and services for the arts and humanities. Nevertheless, individual applicants have only the faintest hope of receiving a grant. The literature program, for example, rejects 97 percent of those who apply. Meanwhile, less than half of the agency's inflation-ravaged budget actually goes to the arts or artists, while 53 percent goes to administration, service groups, consultants, research, bringing panels and the council to Washington, gatherings of artists or arts organizations, assessing needs, and other elements of the "infrastructure."[4]

Such an allocation reflects a council and an agency increasingly devoted to process rather than product. The pedestrian routine of moving applications through the pipeline weighs heavily on the staff. And the brave statistics of aid given and people served convey more about the managers' procedures than the extraordinary richness and variety of American culture. Although audiences for the nonprofit institutions funded by the NEA began to level off and, in some cases, to decline during the 1980s, the number of arts institutions has continued to grow. The possibility of grant support and the tangle of grant categories have encouraged a profusion of new groups. Despite widespread hand-wringing over this glut, the number of organizations in the arts and humanities grew from 36,102 to 41,878 between 1987 and 1990. Not even the public's intense displeasure over arts grants nor the NEA's shrinking budget could stem the tide. At the end of 1993, an informed estimate put the number of cultural organizations in the United States at more than 43,000.[5]

The endowment's shotgun policy of passing out masses of small grants has conjured up an unsustainable array of needy groups and individuals. In Alaska, for example, a combined federal and state "investment" of more than $12 million between 1987 and 1991 increased the number of performing arts companies, museums, and arts centers from six to more than 250; the population of just over half a million included more than 88,500 artists, an endowment report claimed, and Alaskans had partaken of what they offered more than 26 million times. In California, 145,000 artists were said to be involved in more than 1,400 arts organizations, one for every 21,700 residents.[6]

Since 1970, the number of artists has also consistently increased much faster than the total labor force. Between 1970 and 1980, when the labor

force increased by 30 percent, actors and directors increased by 67 percent, authors by 65 percent, dancers by 78 percent, painters and sculptors by 76 percent, and musicians and composers by 41 percent. Projections to the year 2000 indicate that another explosion of creative talent is on the horizon: From a base year of 1986, total civilian employment is expected to grow by 19 percent, while the number of artists will swell by 31 percent. These figures indicate that, far from a dearth of creative talent, the nation will experience even more of a surplus.[7]

If the purpose of subsidies is to bring forth a desirable product, then public arts support has been magnificently successful. But the current support system, well meaning in its objective, has also produced unexpected consequences. Art is not a product like soybeans, but rather the outcome of imaginative endeavor by talented people, of whom there is always a limited supply. When grants prop up artists unable to attract audiences, individuals with limited abilities persist, crowding out superior talents.

As it sought to maintain failing arts institutions, the NEA and other public funders introduced into the arts ecology a system similar to a zoo. In a zoo, selected animals are sheltered from natural predators and fed regularly; decently housed and given superior medical care, the animals survive and multiply, giving pleasure and enlightenment to multitudes of visitors. For many, a trip to the zoo is the only way to experience elephants, giraffes, or alligators. But the animal they find in the zoo is only a shadow of the animal in the wild. It has lost some of its most precious characteristics: the ability to forage, to hunt, to travel, to choose its mates, and, ultimately, to adapt to new environments. The zoo animal is helplessly in the grip of its keepers: their kindness and care, their feedings, their routine, the diversions they provide, the antics of viewers outside the enclosure. This existence results in a semidomesticated beast that cannot possibly return to the wild. Caged, the leopard has the spots, but it has lost its bite. The comfort of zoo life has stolen the animal's stealth, speed, and cunning; the talent, if you will, for adapting itself to freedom.

As a concept, the zoo conveniently assembles interesting animals native to a great variety of habitats; it presents a theme park named, in all nonprofitable modesty, "Some Interesting and Amusing Animals from All Over the World." However, many animals, like insects or whales, do not lend themselves to zoo display. Nor, of course, can any zoo replicate the complex ecology of the wild, where predators, prey, and scavengers, along with plants, topography, and climate, ideally form a sustainable ecosystem. In the zoo, the living animals are sorted and separated, like inanimate speci-

mens, according to scientific logic. They cannot interact with each other; indeed, fences and moats and, if you will, the zoo culture prevent reality from intruding on this synthetic environment.

With all due respect, the arts organizations and the artists who depend on subsidies for their survival are analogous to the creatures in the zoo. Some, like many struggling symphony orchestras, may well be endangered individuals, but the species *Orchestra americanus* is itself endangered when the best must compete with a mediocre multitude maintained on artificial life support. Nor will the best move in new directions when they can depend on government entitlements to support the same old activities. They can disdain that magical elixir—the New—which for at least two centuries has fueled the evolution of modern Western culture, both high and low. Ironically, the forms and genres of popular culture have dizzily evolved in response to new technologies, new talents and tastes, while high culture clings timidly to tradition, including the frayed tradition of the avant-garde. Like the zoo population, it cannot evolve and it need not adapt to new conditions; it is protected from the challenge to change. Organized as nonprofit corporations, most high-arts institutions remain inordinately dependent on wealthy donors and trustees; their desire for an exclusive platform for social prestige reinforces tradition and prevents genuine moves in a populist direction. The high-art world of museums, operas, and symphonies, in fact, defends the last barricade of blatant social snobbery in American society.

In this endeavor, the elitist trustees and managers possess an unlikely ally: liberal, reformist intellectuals and critics who see themselves as guardians of high culture in a land that sometimes appears to be overrun by the hee-haw canned laughter of the cheapest, most vulgar, and tawdry entertainment. Sadly, their hatred, perhaps fear, of most popular entertainment has led these respected cultural opinion makers into bitter rear-guard campaigns against almost every artistic innovation of the past two centuries. In the visual arts, they denounced lithography and barred museum doors to photographers for almost a century. In music, they bedeviled Wagner and Mahler, while attempting to lock the concert hall on Gershwin and Ellington. In drama, they defended theater against film; when film survived, they deemed silents more artistic than talkies, black-and-white superior to color. While piously expounding "standards," these arbiters have consistently preferred the older, obsolete art forms while dismissing the pioneering new. As almost a given, they glorified European arts over those native to America. Belatedly, they contemplated multiculturalism,

long after the likes of African-American music and dance, Latin rhythms, and Appalachian folk songs had intrigued the multitude. These pundits habitually dismissed whatever attracted mass audiences or achieved commercial success until it had passed into history. Then they composed learned papers mourning the passing of a mythical golden age, whether of Broadway musicals, of radio drama, or of Edward R. Murrow's television.

Inexorably, the endowment's decision makers have slid down this same track. Far from supporting genuinely revolutionary art, as conservative critics charge, the NEA has spent almost all its money on good, gray, mainstream organizations that produce an unexceptionable, aging repertoire unlikely to disturb anyone. The relatively small amounts expended for "the cutting edge" have generally gone into what might be called the avant-garde mainstream, work that may be valuable or at least fashionable in an isolated academic milieu but often is too repellent, baffling, or boring to interest more than a handful of insiders. While adamantly denying that their grants favor one art form or genre over another, public funders' decisions inevitably involve aesthetic choices.

Unfortunately, history has shown that "experts" seldom have discerned the great art of their own time. Nor should they be asked to do so. In the limited, parochial culture inhabited by the NEA's founders, "excellence" appeared to be self-evident. It appeared that relatively small sums could sustain the best of America's arts. Thirty years later, with tens of thousands of applicants scrabbling for many millions of dollars, such a system cannot succeed. Like the French academy of the nineteenth century, it promotes dull, repetitious, predictable, and static art. Such a system lays a heavy finger on the cultural scales, extending the life span of exhausted forms and hampering emergence of the new.

The best that those who love the arts can do for them is to stop trying to find those deserving of aid. By this, I do not mean necessarily abolishing federal, state, or local subsidies for the arts, but rather withdrawing from the absurd exercise of trying to discern excellence amid the vast panoply of arts that this country produces. Instead, public funders should concentrate on providing all the people with access to all sorts of arts: performances, exhibitions, readings. Let the hundreds of thousands of artists this country has produced come before the audiences they all crave. Let the audiences decide what they prefer, as audiences have always decided in the past.

The way to do this is to redirect the funds now going into the costly, capricious, and ultimately futile search for worthy claimants in the cultural

arena. Instead, these funds, and perhaps more, should go to finding new venues, to filling them with any cultural presentation anyone wants to create, to publicizing what there is, and to subsidizing the cost. Such a system would bring democracy to the last corner of our culture where elitism still prevails. It would provide the wider public with the arts education now granted only to the privileged few, an education not centered artificially in a classroom but flowing from an authentic experience. And it would allow artists to test their talent in the only arena that ultimately matters, before the public.

This would alleviate the most serious problem facing all artists, except a relatively few established stars: developing an appreciative public. Instead of facing scarcity and expensive tickets, the audience would find abundance, and cheap, if not free, admission. Instead of a forced drive toward multiculturalism, diversity would naturally result, as the public samples a great variety of offerings. Instead of laboriously learning *about* the arts in a classroom, young people and their parents could savor the aesthetic thrill of experiencing art in their own leisure time. By making choices, observing many levels of skill, seeing the varieties of artistic expression, people would develop discrimination.

The way to implement such a system is to subsidize the hiring of a professional arts manager—a public impresario, if you will—for every locality or neighborhood. This person, aided by appropriate staff, would be responsible for an inventory of all spaces where performances or exhibitions could take place: school auditoriums and cafeterias, outdoor plazas and parks, shopping malls, churches, community centers, office complexes, business parks, factories, and even courtrooms and prisons. The arts manager would then book these spaces for anyone wanting to use them. The object would be to use all these spaces to the utmost, presenting programs during lunch time and late afternoons as well as evenings and weekends. The arts manager would maintain a schedule, see to necessary insurance, cleanup, security, and bookkeeping. The public impresario would also publicize and advertise the offerings, perhaps maintain a telephone hotline and computer bulletin board, and present excerpts on local public radio and television. Admission prices would range from free to whatever the traffic will bear, with the performers collecting all proceeds after expenses were covered. The public impresario would also distribute vouchers as widely as possible, at schools and community centers, through clubs, clinics, and welfare offices. Each voucher would entitle the bearer to free admission

and the program would reimburse each performing group for the vouchers it redeems. The vouchers could also be used to subscribe to literary magazines, to purchase works of art, or to pay for music lessons or transportation to arts events in nearby communities.

This reform would cost no more than what public agencies are now spending on the minority of arts they support. It would extricate them from the contentious task of judging quality. It would enhance cultural diversity. It would free legislators from persistent accusations that they are subsidizing elitist forms and institutions and from the lobbying pressure of those contending for limited funds. It would open wide the windows on the cultural scene to fresh winds of imagination and talent. In many ways, it would replicate the incredibly rich and varied culture of the nineteenth century, a time when the bourgeoisie supplanted kings and aristocrats as the Western world's principal patrons of the arts. George Eliot and Charles Dickens wrote fiction for this audience, Verdi and Puccini composed operas for it, Henrik Ibsen created dramas for it, Gilbert and Sullivan made it laugh, Sarah Bernhardt brought it to tears, Manet and Renoir painted pictures not only for it but *of* it; in short, the creative energies of literally thousands of talented artists were poured into entertaining, enlightening, and captivating men and women who previously had been cultural bystanders.

This was the great age of the beginnings of modern culture, when museums, opera companies, and symphonies (and zoos!) came to life, when cheap books, newspapers, magazines, and prints found a mass readership, when the middle ranks of society became interested in food and fashion and the lower ranks partook of street shows, beer gardens, and music halls. Despite widespread poverty, all aspects of cultural life, whether high or low, developed an opulence and abundance never before seen on the planet. For the first time, quite ordinary people had many choices of how to spend their leisure time, especially as more of them lived in urbanized places, and they participated with zest and considerable discrimination. In New Orleans, for example, two opera companies competed between 1835 and 1841, often touring to New York and Philadelphia during the steamy summer months. At home, for a population of less than 100,000, they presented more than five hundred performances of nearly one hundred operas, including that enduring American favorite Gaetano Donizetti's *Lucia di Lammermoor,* barely two years after its Italian premiere.[8]

This audience patronized a musical culture enchanted with virtuoso performers and new works, music that forms the mainstay of that museum

of music dominating the concert hall and opera repertoire today. Often uneducated and shockingly uncouth, this audience buzzed with conversation during the performance, applauded whenever it pleased, and shouted until favorite passages were repeated . . . and repeated. This culture flowered entirely without public subsidy, relying solely on its appeal to audiences. Because of this market orientation, nineteenth-century culture is a vast graveyard of operas, plays, and music, works presented briefly and never heard or seen again. In that ephemeral quality, it resembles the twentieth-century world of film, television, popular literature, and music. But the nineteenth-century works that survived the acid test of audience appeal established themselves as classics, revived again and again to delight new audiences. There is a reason that each Christmas *The Nutcracker* balances the books for hundreds of dance companies and that the much-maligned "war horses" continue to pull opera companies and symphonies out of red-ink potholes.

Bestriding the diffusion of nineteenth-century performing arts was the impresario, a flamboyant figure who confidently negotiated a financial tightrope, poised between temperamental, demanding artists and finicky, fickle audiences. Impresarios booked performing spaces, arranged tours, and chose programming they believed would appeal to audiences. They flourished into the twentieth century until after the Second World War, when university arts series and nonprofit presenting organizations drove impresarios off the cultural stage. By subsidizing nonprofit presenters, the NEA and other public arts funders are now attempting to reconstruct a sort of bionic impresario who is supposed to arrange for cultural presentations that also fulfill non-art agendas, such as educating the young, including the poor, enforcing multiculturalism, and attracting tourists. The only component of the cultural scene unserved by these earnest efforts is also its largest component: the audience.

Devoting public funds to this neglected sector by establishing public impresarios would provide a handsome return on the investment for all the figures in the arts equation. New artists and organizations would have a chance to test their talents before a live audience, largely free from the tyranny of a few critics. Established artists and organizations could try out new directions without huge investments of time and money. Bringing low-priced art to schools, community centers, and shopping malls would allow the public to sample a great rainbow of the arts in an informal setting, to sharpen its critical skills, as the nineteenth-century audience did so brilliantly, and to take part in shaping artists' careers. Public funders would be

relieved of the pressures and outright abuse that flow from their attempts
to measure artistic worth. Politicians could turn from petty wrangles over
controversial art to serious issues no one else can decide.

There are many ways to pay for this utopia. None of them could support
the NEA as it currently operates. The cheapest, most efficient approach
would be to distribute the current NEA appropriation to the states, with a
mandate to use the money for building audiences and to stop all efforts to
assess quality. Congress could also create a true endowment independent
of further appropriations. This new organization would fit the classic defini-
tion: a substantial pool of capital whose income supports a defined pur-
pose. Such an endowment could initially be created through a government
guarantee to contribute the $170 million or so that the NEA now gets
annually. A board of directors that includes private and public figures of
great prestige, a body resembling the Smithsonian's board, could attract
private contributions and also underwrite income-producing enterprises,
such as a national magazine of the arts, sales of videos and CDs, and per-
haps arts programs packaged for television. Private contributors would be
attracted to such a structure, as they are to the Smithsonian.

An endowment on a far grander scale could result from a tiny tax, on the
order of half of 1 percent on all entertainment and limited to five years.
Such a tax, if applied only to movie tickets, video rentals, commercial enter-
tainment, and professional sports, would raise close to $2 billion each year.
At the end of five years, this nest egg, invested like any other endowment,
for a conservative 6 percent return, would produce about $600 million to be
used in annual subventions for the arts. Such an endowment could also
accept contributions from individuals, corporations, and foundations.

Above all, Congress should get itself out of the culture business. It pos-
sesses neither the money nor the discriminating taste to bring forth any
quality at all. Its drive to spread federal largesse evenly across this huge,
diverse nation promotes the sort of deal making that balances benefits, say,
to farmers against those of urban dwellers; but such delicately negotiated
handouts cannot possibly enhance the cultural scene. Ultimately, Con-
gress's quiver contains just two arrows for attacking national problems: sub-
sidy and mandate. Neither of these blunt instruments can have much
effect on the immensely varied, immensely complex industry called Amer-
ican culture.

A thoughtful way to conclude the present system would be to declare
that the endowment and its subsidiary programs have achieved their goals
of both excellence and access and that the arts require no further federal

intervention. If the arts go into serious decline in the future, there's no reason in the world that we sovereign people cannot start another agency to support individual grants once more. The advantage of trying a different system of arts support is that the fields would regroup and reorganize. Some organizations would fail; others would merge. A level playing field would allow new organizations to start and to compete with established ones on an equal basis. A pause would also winnow the fields down to a manageable size. It would force artists to assess their commitment to their art.

The current system is most counterproductive because, like a zoo, it isolates each animal from other species with which it would normally interact and separates its inmates from the natural ecosystem of a wild environment. It cuts off a relatively small nonprofit segment of the culture from the much larger entertainment industry. This system ignores the promiscuous, delicious, vital crossovers between popular and elite, low and high, common and refined, commercial and nonprofit, which form the most striking—and unique—feature of American culture. Those who dispense philanthropic funding, whether public or private, may avert their eyes and close their checkbooks to the vulgar arts produced for money. Certainly, the tax code favors the virtuously "poor" nonprofit organization . . . even if it pays its stars princely wages . . . even if it benefits mostly well-off patrons . . . even if it mounts lavish productions destined for the commercial market. Such anomalies indicate that the supposed wall between nonprofit and commercial culture has the substance of sugar icing.

This mythical barrier has never impeded creative talent from vigorously applying itself in both arenas: Actors cross readily from movies and television commercials to nonprofit institutional theater to Broadway; jazz artists migrate from nightclubs to Lincoln Center; orchestras and their conductors derive handsome incomes from commercial recordings. Not even the U.S. Census Bureau can draw the line between painters of canvases and designers of advertising, between writers of serious literature and those who concoct advertising copy, between composers of concert music and writers of popular songs. The consumers of culture also select their entertainment from a wildly eclectic menu: the zoo in the morning, the museum in the afternoon, the movies in the evening; opera in the park, a play downtown, a weekend jazz festival, a rock concert. In the context of such striking diversity, the effort to sort out refined entertainment from vulgar distractions becomes futile indeed. Local jurisdictions, which spend the most public arts money, may hold forth on the spiritual benefits of the arts, but

they sell the public on the need for such subsidies with practical commercial considerations—revitalizing downtown areas, attracting new industry, luring conventions, and increasing tourism.

In sharp contrast to this pragmatic reality, the NEA acts like a naive, thoroughly addled Lady Bountiful. It purveys a multitude of fictions: that Americans do not contribute generously to the arts; that a bureaucratic process can discover and foster creative talent; that nonprofit arts deserve support while commercial arts do not; that there exists a distinct cultural realm worthy of subsidy, a realm easily distinguished from simple entertainment; and, worst of all, that the arts in America would perish without federal intervention.

Over time, Lady Bountiful has adopted many guises, always linked to various politically chic propaganda points. As an infant beauty, she believed in tiding over temporarily needy arts organizations, just until they could get on their feet. Approaching adolescence, she brightly proclaimed that just about anything artsy offered salvation to just about everyone just about everywhere. As a teenager, she went slumming, lending her charms to calming troubled neighborhoods and brightening life for the ill, the elderly, the marginal. In her early adult incarnation, she took up the bohemian life, helping us to savor the *frisson* of the forbidden. Throughout all these phases, she enlisted us at the front line of America's cultural Cold War defense. As a mature matron of thirty, she insists that multiculturalism and more arts in the classroom will take us closer to the promised land of civilized life.

Like Lady Bountiful, the nineteenth-century dispenser of charity, the National Endowment for the Arts is neither evil nor wanton. But in all its thirty years, the agency's focus has never been clarified beyond a multitude of half-measures, initiatives, and pilot projects with the tepid goal, as President Clinton described it, of "making the arts a part of everyone's life." Along the way, it has cobbled together a bizarre assortment of constituencies, ranging from the staid trustees of elite institutions to shrill players of a single confrontational note. The promise of money has lured them all into the safe, orderly, predictable environment of the cultural zoo. True, life outside is riskier; for some it presents a remorseless universe of tooth and claw. But the arts have survived far longer without government intervention than with subsidies. Artists work their magic because they must, and they work best in the wild. It is time to turn the animals loose.

NOTES

CHAPTER 1: SEVENTY-SIX TROMBONES

1. Meredith Willson, *The Music Man* (New York: Putnam, 1958), pp. 33–37; Brooks Atkinson, "Theatre: Music Man," *New York Times,* Dec. 20, 1957.
2. John Kenneth Galbraith, *The Affluent Society* (New York: New American Library, 1958), p. 117.
3. "In a Second Revolution the New Role for Culture," editorial, *Life,* Dec. 26, 1960, pp. 44–45.
4. Stevenson quote and remarks by Rossiter from Clinton Rossiter in John K. Jessup et al., *The National Purpose* (New York: Holt, Rinehart and Winston, 1960), pp. 86–87.
5. Carleton Sprague Smith, "The Growing Awareness of America's Cultural Needs," n.d., pp. ii–iii, Hal Prince Papers, and "What Goes Into," pt. 2, n.d., unpaginated, National Cultural Center Papers, both in the Library of the Performing Arts, New York Public Library (hereafter cited as NYPL Performing Arts Library).
6. Nelson H. H. Graburn, quoted in *Museums for a New Century: A Report of the Commission on Museums for a New Century* (Washington, D.C.: American Association of Museums, 1984), p. 59.
7. Philip Kotler in Michael P. Mokwa, William M. Dawson, and E. Arthur Prieve, eds., *Marketing the Arts* (New York: Praeger, 1980), p. xiii.
8. Marcel Proust, *Remembrance of Things Past,* vol. 1, trans. C. K. Scott Moncrieff (New York: Random House, 1934), p. 745.

9. Patricia Carr Bowie, "Cultural History of Los Angeles, 1850–1967: From Rural Backwash to World Center," Ph.D. diss., University of Southern California, 1980, pp. 313–14; David King Dunaway, *Huxley in Hollywood* (London: Bloomsbury, 1989), p. 88.

10. Quoted in Daniel J. Boorstin, *The Americans: The Democratic Experience* (New York: Random House, 1973), p. 504.

11. Lawrence W. Levine, *Highbrow/Lowbrow: The Emergence of Cultural Hierarchy in America* (Cambridge, Mass.: Harvard University Press, 1988).

12. Paul DiMaggio in DiMaggio, ed., *Nonprofit Enterprise in the Arts: Studies in Mission and Constraint* (New York: Oxford University Press, 1986), pp. 46–47.

13. Dwight Macdonald in Bernard Rosenberg and David Manning White, eds., *Mass Culture: The Popular Arts in America* (New York: Free Press, 1957), pp. 61–64; Robert M. Hutchins, The *University of Utopia* (Chicago: University of Chicago Press, 1953), p. 8.

14. Caroline Violette and Rachelle Taqqu, eds., *Issues in Supporting the Arts* (Ithaca, N.Y.: Cornell University Press, 1982), p. 18.

15. Andy Warhol, *The Philosophy of Andy Warhol: From A to B and Back Again* (San Diego: Harvest/Harcourt Brace Jovanovich, 1975), p. 13; Carol Vogel, "15 Minutes and Then Some at the New Warhol Museum," *New York Times,* May 16, 1994.

16. Arthur C. Danto, "Censorship and Subsidy in the Arts," in the *Bulletin of the American Academy of Arts and Sciences* (Oct. 1993): 34–35.

CHAPTER 2: WEST SIDE STORY

1. Elliot Willensky and Norval White, *AIA Guide to New York City* (San Diego: Harcourt Brace Jovanovich, 1988), p. 279.

2. Jean Dalrymple, *From the Last Row* (Clifton, N.J.: James T. White, 1975), pp. i–ii; Thomas Kessner, *Fiorello La Guardia and the Making of Modern New York* (New York: Penguin, 1991), p. 553.

3. Dalrymple, *From the Last Row,* pp. 16–17.

4. Ibid., pp. 18–19.

5. Ibid., pp. 22–23, 25–26, 29–36, 37.

6. Ibid, pp. i–ii, 1; interview with Jean Dalrymple, Jan. 11, 1993, New York City.

7. Dalrymple, *From the Last Row,* pp. 47–48.

8. Ibid, pp. 54, 60.

9. Interview with Jean Dalrymple, Jan. 11, 1993, New York City.

10. Dalrymple, *From the Last Row,* pp. 93–94, 127–28.

11. Interview with Jean Dalrymple, Jan. 11, 1993, New York City.

12. Dalrymple, *From the Last Row,* pp. 153, 156; Sharon Zane interview with Ernest S. Heller, Oct. 16, 1990, Oral History Project, Lincoln Center Archives.

13. Ralph G. Martin, *Lincoln Center: For the Performing Arts* (Englewood Cliffs, N.J.: Prentice-Hall, 1971), p. 67; Dalrymple, *From the Last Row,* pp. 187–88, 212.

14. *Historical Statistics of the United States: Colonial Times to 1970,* pt. 1 (Washington, D.C.: U.S. Government Printing Office, 1975), pp. 126–27; Leo Bogart, *The Age of Television: A Study of Viewing Habits and the Impact of Television on American Life* (New York: Ungar, 1958), p. 3.

15. Data from Robert H. Bremner and Gary W. Reichard, eds., *Reshaping America: Society and Institutions, 1945–1960* (Columbus: Ohio State University Press, 1982), pp. ix–x; and Reynold M. Wik in David D. Van Tassel and Michael G. Hall, eds., *Science and Society in the United States* (Homewood, Ill.: Dorsey, 1966), p. 82.

16. U.S. Department of Commerce statistics in Eric Larrabee and Rolf Meyersohn, eds., *Mass Leisure* (Glencoe, Ill.: Free Press, 1958), p. 276; Mark I. Gelfand in Bremner and Reichard, *Reshaping America,* pp. 266–67.

17. Willensky and White, *AIA Guide to New York City,* pp. 896–97; John B. Rae, *The Road and the Car in American Life* (Cambridge, Mass.: MIT Press, 1971), pp. 236, 240.

18. Edgar B. Young, *Lincoln Center: The Building of an Institution* (New York: New York University Press, 1980), pp. 12, 19.

19. Ibid., pp. 11–12

20. Ibid., p. 12; for further details and sources on Rockefeller Center, see Alice Goldfarb Marquis, *Hopes and Ashes: The Birth of Modern Times, 1929–39* (New York: Free Press, 1986), pp. 159–62.

21. Sharon Zane interview with Robert E. Blum, Nov. 24, 1990, Oral History Project, Lincoln Center Archives; Young, *Lincoln Center,* p. 20.

22. Ibid., pp. 21–22.

23. Theodore E. Seelye, President, Day & Zimmerman, to Exploratory Committee for a Musical Arts Center, Dec. 31, 1956, Lincoln Center Archives.

24. Day & Zimmerman, "Report on Survey to Determine Feasibility of Creating and Operating a Performing Arts Center in New York City," Dec. 31, 1956, Lincoln Center Archives.

25. Willensky and White, *AIA Guide to New York City,* pp. 896–97.

26. Sharon Zane interview with W. McNeil Lowry, Jan. 11, 1990, Oral History Project, Lincoln Center Archives.

27. Peter Collier and David Horowitz, *The Rockefellers: An American Dynasty* (New York: Holt, Rinehart and Winston, 1976), pp. 195–96.

28. John Ensor Harr and Peter J. Johnson, *The Rockefeller Conscience: An American Family in Public and in Private* (New York: Scribner's, 1991), pp. 125–28.

29. Young, *Lincoln Center,* p. 18.

30. Collier and Horowitz, *The Rockefellers,* p. 194; Young, *Lincoln Center,* pp. 32–33; Martin Mayer, *Bricks, Mortar, and the Performing Arts* (New York: Twentieth Century Fund, 1970).

31. Sharon Zane interview with William Schuman, Sept. 27 and Oct. 4, 1990, Oral History Project, Lincoln Center Archives.

32. Martin, *Lincoln Center,* p. 18.

33. Robert Moses' speech at the Salute to Lincoln Square luncheon of the West Side Association of Commerce, Essex House Hotel, Oct. 14, 1957, NYPL Performing Arts Library.

34. Robert A. Caro, *The Power Broker: Robert Moses and the Fall of New York* (New York: Vintage, 1975), pp. 1014–16.

35. Young, *Lincoln Center,* pp. 44–45.

36. Ibid., pp. 98–99, 105.

37. Harry Rogers, "The Dawn of a New Era," *West Side News,* May 14, 1959, Lincoln Center Archives.

38. Young, *Lincoln Center,* p. 106.

39. John D. Rockefeller III, foreword to the Lincoln Center progress report, June 1959, NYPL Performing Arts Library.

40. Carleton Sprague Smith, "The Case," pt. 1, sec. 1, Oct. 1960, National Cultural Center Papers, unpaginated, NYPL Performing Arts Library.

41. Ibid.; Edward C. Banfield, *The Democratic Muse* (New York: Basic Books, 1984), p. 109; Charles H. Anderson and John D. Murray, eds., *Work and Life Styles Among Academicians* (Cambridge, Mass.: Schenkman, 1971), p. 143.

42. Ronald Lora in Bremner and Reichard, *Reshaping America,* pp. 234–35.

43. *Historical Statistics of the United States,* p. 388; American Council for the Arts in Education, *Coming to Our Senses: The Significance of the Arts for American Education* (New York: McGraw-Hill, 1977), pp. 128–29.

44. American Council for the Arts in Education, *Coming to Our Senses,* pp. 133–34.

45. Robert Brustein, "The Spirit of Excellence: Theater and the University," *New Republic,* Nov. 16, 1974, p. 14.

46. Jack Morrison, *Rise of the Arts on the American Campus* (New York: McGraw-Hill, 1973), pp. 29–30, 10–11, 14.

47. Russell Lynes, "The Artist as Uneconomic Man," *Saturday Review,* Feb. 28, 1970, p. 28.

48. Mayer, *Bricks, Mortar, and the Performing Arts,* p. 73; Morrison, *Rise of the Arts on the American Campus,* p. 31.

49. David Riesman, *Constraint and Variety in American Education* (Lincoln: University of Nebraska Press, 1956), p. 106.

50. Richard J. Barber, *The Politics of Research* (Washington, D.C.: Public Affairs Press, 1966), pp. 60–61, 63; Anderson and Murray, *Work and Life Styles Among Academicians,* p. 8.

51. Bill Kauffman, "Subsidies to the Arts: Cultivating Mediocrity," Cato Institute Policy Analysis, no. 137, Aug. 8, 1990, p. 3.

52. Jacques Barzun, *The House of Intellect* (New York: Harper, 1950), pp. 11–12; Robert M. Hutchins, *The University of Utopia* (Chicago: University of Chicago Press, 1953), p. 41.

53. "Opera at Lincoln Center," undated booklet (ca. 1957?), p. 9. Lincoln Center Papers, NYPL Performing Arts Library.

54. Young, *Lincoln Center,* p. 81.

55. Martin, *Lincoln Center,* pp. 20–21; Harr and Johnson, *The Rockefeller Conscience,* pp. 153–54.

56. Interview with W. McNeil Lowry, Jan. 11, 1993, New York City; Young, *Lincoln Center,* pp. 30–31, 36–37.

57. Ibid., pp. 74–75.

58. Ibid., pp. 68–69.

59. Ibid., pp. 87–88; Harr and Johnson, *The Rockefeller Conscience,* p. 130; Joan Peyser, "Lincoln Center: Planning for Music," *Commentary,* May 1961, pp. 416–17.

60. Harr and Johnson, *The Rockefeller Conscience,* p. 131; Peyser, "Lincoln Center," pp. 417, 419.

61. Harr and Johnson, *The Rockefeller Conscience,* p. 155; Sharon Zane interview with William Schuman, Oct. 4, 1990, Oral History Project, Lincoln Center Archives.

62. Sharon Zane interview with William Schuman, July 10, 1990, Oral History Project, Lincoln Center Archives.

63. Sharon Zane interview with William Schuman, Aug. 23, 1990, Oral History Project, Lincoln Center Archives.

64. Sharon Zane interview with William Schuman, Aug. 23 and Sept. 27, 1990, Oral History Project, Lincoln Center Archives.

65. "An Enclave," *New Yorker,* Feb. 17, 1962, p. 27.

66. Sharon Zane interview with William Schuman, Sept. 27, 1990, Oral History Project, Lincoln Center Archives; quoted in Young, *Lincoln Center,* pp. 283–84.

67. Gary O. Larson, *The Reluctant Patron* (Philadelphia: University of Pennsylvania Press, 1983), pp. 162–63.

68. Dwight Macdonald, *The Ford Foundation: The Men and the Millions* (New York: Reynal, 1956), pp. 86–87, 89, 57–58.

69. Barzun, *The House of Intellect,* pp. 180, 183; Macdonald, *The Ford Foundation,* pp. 95–96, 100–102.

70. Ibid. pp. 51–52, 139, 63–65.

71. Sharon Zane interview with W. McNeil Lowry, Jan. 11, 1990, Oral History Project, Lincoln Center Archives; interview with W. McNeil Lowry, June 29, 1992, New York City.

72. Macdonald, *The Ford Foundation,* p. 70; Sharon Zane interview with W. McNeil Lowry, Jan. 11, 1990, Oral History Project, Lincoln Center Archives.

73. Kathleen D. McCarthy, "American Cultural Philanthropy: Past, Present, and Future," *Annals of the American Academy of Political and Social Science* (Jan. 1984): pp. 19–20; Bradley G. Morison and Julie Gordon Dalgleish, *Waiting in the Wings* (New York: American Council for the Arts, 1987), pp. 20–21; W. McNeil Lowry, ed., *Performing Arts and American Society* (Englewood Cliffs, N.J.: Prentice-Hall, 1978), pp. 8–16.

74. Dalrymple, *From the Last Row,* pp. 196–99, 205.

75. Sharon Zane interview with W. McNeil Lowry, Jan. 14, 1990, Oral History Project, Lincoln Center Archives.

76. Sharon Zane interview with W. McNeil Lowry, Jan. 11, 1990, Oral History Project, Lincoln Center Archives.

77. Interview with W. McNeil Lowry, Jan. 11, 1993, New York City.

78. Sharon Zane interview with Ernest S. Heller, Oct. 16, 1990, Oral History Project, Lincoln Center Archives.

79. Young, *Lincoln Center,* pp. 70, 155–56; Harr and Johnson, *The Rockefeller Conscience,* p. 142; Russell Lynes, "A Parlor for New York," *Harper's,* May 1964, p. 30.

80. Harr and Johnson, *The Rockefeller Conscience,* pp. 139–40; Sharon Zane interview with W. McNeil Lowry, Jan. 14, 1991, Oral History Project, Lincoln Center Archives.

81. Sharon Zane interview with Robert E. Blum, June 30 and Nov. 24, 1990, Oral History Project, Lincoln Center Archives.

82. Sharon Zane interview with Ernest S. Heller, Oct. 16, 1990, Oral History Project, Lincoln Center Archives.

83. Leonard Silk and Mark Silk, *The American Establishment* (New York: Basic Books, 1980), pp. 40–41; E. Digby Baltzell, *The Protestant Establishment: Aristocracy and Caste in America* (New York: Random House, 1964), pp. 336–37; Charles Silberman, *A Certain People: American Jews and Their Lives Today* (New York: Summit, 1985), p. 109.

84. Young, *Lincoln Center*, p. 137; Martin, *Lincoln Center*, pp. 18–19.

85. Baltzell, *The Protestant Establishment*, p. 316; Silberman, *A Certain People*, p. 188.

86. Dalrymple, *From the Last Row*, pp. 218–19.

87. Collier and Horowitz, *The Rockefellers*, pp. 196–97; Marquis, *Hopes and Ashes*, p. 161; Sharon Zane interview with William Schuman, Sept. 27, 1990, Oral History Project, Lincoln Center Archives.

88. Gideon Chagy, ed., *The State of the Arts and Corporate Support* (New York: Eriksson, 1971), pp. 102–3.

89. Sharon Zane interviews with Ernest S. Heller, Oct. 16, 1990, and W. McNeil Lowry, Jan. 14, 1991, Oral History Project, Lincoln Center Archives; Mayer, *Bricks, Mortar, and the Performing Arts*, p. 38; Dalrymple, *From the Last Row*, pp. 8–9; interview with Jean Dalrymple, Jan. 11, 1993, New York City; Harold C. Schonberg, "City and Lincoln Centers in Battle Over State Theater," *New York Times*, Nov. 8, 1964; Milton Esterow, "City Center Joins Lincoln Center," *New York Times*, Jan. 11, 1965.

90. Young, *Lincoln Center*, pp. 167, 170–71; Harold C. Schonberg, "Music: The Occasion," *New York Times*, Sept. 24, 1962.

91. Sharon Zane interviews with Robert E. Blum, Nov. 24, 1990, and William Schuman, Sept. 27, 1990, Oral History Project, Lincoln Center Archives; Young, *Lincoln Center*, pp. 177–78.

92. Ibid., pp. 179–80, 306; "Mr. Bernstein of Lincoln Center," *Newsweek*, Sept. 24, 1962, p. 43.

93. Young, *Lincoln Center*, pp. 252–54; Martin, *Lincoln Center*, pp. 127, 132.

94. Young, *Lincoln Center*, p. 251; Robert Kotlowitz, "On the Midway at LC," *Harper's*, Dec. 1966, pp. 136–37.

95. Mayer, *Bricks, Mortar, and the Performing Arts*, p. 18; Martin, *Lincoln Center*, pp. 130–32.

96. Ibid., p. 134; Mayer, *Bricks, Mortar, and the Performing Arts*, pp. 29–30.

97. Sharon Zane interview with Amyas Ames, Oct. 17, 1990, Oral History Project, Lincoln Center Archives; Martin, *Lincoln Center*, pp. 140–41.

98. Peyser, "Lincoln Center," p. 414; Mayer, *Bricks, Mortar, and the Performing Arts*, pp. 26–27.

99. Martin, *Lincoln Center*, p. 17; "Cultural Centers Across the Land," *Newsweek*, Sept. 24, 1962, p. 54.

100. Harr and Johnson, *The Rockefeller Conscience*, pp. 146–47; Ira Wolfert, "New York Builds a Great New Music Center," *Reader's Digest*, Oct. 1962, p. 208.

101. Young, *Lincoln Center*, pp. 279–80; Thomas M. Self in James W. Toland, ed., *The Music Center Story: A Decade of Achievement, 1964–1974* (Los Angeles: Music Center, 1974), pp. 120, 122, 125.

102. Ibid., pp. 122–23; "'Cleopatra' Will Premiere Tonight," *Los Angeles Times,* June 19, 1963; "Premiere of 'Cleopatra' Raises $1,094,000 for Music Center," *Los Angeles Times,* June 20, 1963.

103. David Halberstam, *The Powers That Be* (New York: Dell, 1980), pp. 376–90.

CHAPTER 3: A MAN FOR ALL SEASONS

1. Terry Lynn Cornwell in Judith H. Balfe and Margaret Jane Wyszomirski, eds., *Art, Ideology, and Politics* (New York: Praeger, 1985), p. 248.

2. "The Growing Awareness of America's Cultural Needs," n.d., p. v, Hal Prince Papers, NYPL Performing Arts Library.

3. Livingston Biddle, *Our Government and the Arts: A Perspective from the Inside* (New York: American Council for the Arts, 1988), p. 17; Charles Richard Swaim, "The Fine Politics of Art: Organizational Behavior, Budgetary Strategies, and Some Implications for Art Policy," Ph.D. diss., University of Colorado, Boulder, 1977, p. 21.

4. Ibid., p. 17; Gary O. Larson, *The Reluctant Patron* (Philadelphia: University of Pennsylvania Press, 1983), pp. 151–52; George Garrett, "Art Is Always Political When the Government Starts Giving Grants," *Chronicles* (June 1990): 19; Arthur Gelb and Barbara Gelb, "Culture Makes a Hit at the White House," *New York Times Magazine,* Jan. 28, 1962, p. 9.

5. Larson, *The Reluctant Patron,* pp. 153–54.

6. Mel Scott, *The States and the Arts: The California Arts Commission and the Emerging Federal-State Partnership* (Berkeley: University of California Institute of Governmental Studies, 1971), pp. 7–8; Biddle, *Our Government and the Arts,* p. 95.

7. Interview with Jack Golodner, Nov. 12, 1992, Washington, D.C.; John Wetenhall in Harriet Senie and Sally Webster, eds., *Critical Issues in Public Art: Content, Context, and Controversy* (New York: HarperCollins, 1992), pp. 145–46; Larson, *The Reluctant Patron,* pp. 157, 161–62.

8. Ibid., pp. 154–55, 160; John F. Kennedy remarks to the advisory commission of the National Cultural Center, Nov. 14, 1961, NYPL Performing Arts Library.

9. National Cultural Center memo to members of the Advisory Committee on the Arts, Mar. 30, 1962, NYPL Performing Arts Library; Gore Vidal, *Homage to Daniel Shays: Collected Essays, 1952–1972* (New York: Random House, 1972), p. 215.

10. Interview with Jack Golodner, Nov. 12, 1992, Washington, D.C.; Biddle, *Our Government and the Arts,* p. 18; interview with Thomas Hoving,

Sept. 15, 1992, New York City; Wetenhall in *Critical Issues in Public Art,* pp. 151–53.

11. Biddle, *Our Government and the Arts,* p. 19; Swaim, "The Fine Politics of Art," pp. 22–23.

12. Larson, *The Reluctant Patron,* p. 162; Frederick Dorian, *Commitment to Culture* (Pittsburgh: University of Pittsburgh Press, 1964), pp. 1–2.

13. Fannie Taylor and Anthony L. Barresi, *The Arts at a New Frontier: The National Endowment for the Arts* (New York: Plenum, 1984), pp. 59–60.

14. Summary of Actions, National Cultural Center Board of Trustees, Nov. 14, 1961, and "National Cultural Center," undated flyer, Jean Dalrymple Papers, NYPL Performing Arts Library.

15. Rolf B. Meyersohn in Bernard Rosenberg and David Manning White, eds., *Mass Culture: The Popular Arts in America* (Glencoe, Ill: Free Press, 1957), pp. 345–46, 356; Leo Bogart, *The Age of Television: A Study of Viewing Habits and the Impact of Television on American Life* (New York: Ungar, 1958), pp. 5–6, 11; Paul F. Lazarsfeld and Robert K. Merton in Rosenberg and White, *Mass Culture,* p. 458.

16. Meyersohn in *Mass Culture,* p. 342.

17. Larson, *The Reluctant Patron,* pp. 187–88; Biddle, *Our Government and the Arts,* pp. 59–61.

18. Ibid., pp. 63–64.

19. Swaim, "The Fine Politics of Art," pp. 24–25.

20. Charles Christopher Mark, *Reluctant Bureaucrats: The Struggle to Establish the National Endowment for the Arts* (Dubuque, Iowa: Kendall/Hunt, 1991), pp. 31–32.

21. "Pot Shots at Culture," *New Republic,* Apr. 22, 1967, p. 17; Biddle, *Our Government and the Arts,* pp. 69, 167; Alvin Toffler, *The Culture Consumers* (New York: St. Martin's, 1964), pp. 188–89; Paul DiMaggio, ed., *Nonprofit Enterprise in the Arts: Studies in Mission and Constraint* (New York: Oxford University Press, 1986), p. 130; Stanley Kauffmann, "Can Culture Explode? Notes on Subsidizing the Arts," *Commentary,* Aug. 1965, p. 21.

22. Joan Blumenthal, "Art for Power's Sake," *The Objectivist,* Dec. 1968, pp. 567–68; Biddle, *Our Government and the Arts,* pp. 105–6; Mark, *Reluctant Bureaucrats,* p. 187.

23. Quoted in Philip M. Crane, "Eliminate the National Endowment for the Arts," *USA Today* (magazine), July 1991; quoted in Biddle, *Our Government and the Arts,* pp. 76–77; Mary Eleanor McCombie, "Art and Policy: The National Endowment for the Arts' Art in Public Places Program, 1967–1980," Ph.D. diss., University of Texas, Austin, 1992, p. 42.

24. Biddle, *Our Government and the Arts,* p. 15; Dorian, *Commitment to*

Culture, pp. 2–3; "Government and the Arts: How Much to Whom?" *Newsweek,* July 18, 1966, p. 60.

25. Ibid., p. 56; Wetenhall in *Critical Issues in Public Art,* p. 148; Gideon Chagy, ed., *The State of the Arts and Corporate Support* (New York: Eriksson, 1971), pp. 87–88.

26. George Gelles in W. McNeil Lowry, ed., *Performing Arts and American Society* (Englewood Cliffs, N.J.: Prentice-Hall, 1978), pp. 61–62.

27. Malcolm Richardson, "Partners in Cultural Philanthropy: Public and Private Sectors," *Culturefront* (winter 1992): 57–58; Bradley G. Morison and Julie Gordon Dalgleish, *Waiting in the Wings* (New York: American Council for the Arts, 1987), pp. 21–22; interview with W. McNeil Lowry, Jan. 11, 1993, New York City.

28. Michael Straight, "Government's Contribution to Creative Expression," *New Republic,* Nov. 16, 1974, p. 17; Biddle, *Our Government and the Arts,* p. 198.

29. Ibid., pp. 67–68; interview with David Stewart, May 18, 1993, Washington D.C.; McCombie, "Art and Policy," p. 51.

30. Patricia Linden, "Fashion's Grande Dame," *Harper's Bazaar,* Feb. 1993; interview with Eleanor Lambert, Sept. 21, 1992, New York City.

31. Taylor and Barresi, *The Arts at a New Frontier,* pp. 70, 72.

32. Michael Straight, *Twigs for an Eagle's Nest: Government and the Arts, 1965–1978* (New York: Devon, 1979), pp. 14–15.

33. Ibid., p. 15.

34. Rockefeller Brothers Fund, *The Performing Arts: Problems and Prospects* (New York: McGraw-Hill, 1965); William J. Baumol and William G. Bowen, *Performing Arts: The Economic Dilemma* (New York: Twentieth Century Fund, 1966); John Ensor Harr and Peter J. Johnson, *The Rockefeller Conscience: An American Family in Public and in Private* (New York: Scribner's, 1991), pp. 263–64; interview with Jack Golodner, Nov. 12, 1992, Washington, D.C.

35. Taylor and Barresi, *The Arts at a New Frontier,* pp. 95–96; Michael Straight, *Nancy Hanks, an Intimate Portrait; The Creation of a National Commitment to the Arts* (Durham, N.C.: Duke University Press, 1988), pp. 98, 129.

36. Mark, *Reluctant Bureaucrats,* pp. 121–23; Taylor and Barresi, *The Arts at a New Frontier,* pp. 89–91.

37. Straight, *Nancy Hanks,* p. 128; Taylor and Barresi, *The Arts at a New Frontier,* pp. 85, 88–89, 96, 100; National Council on the Arts, *First Five Years: Fiscal 1966 through Fiscal 1970* (Washington, D.C.: National Endowment for the Arts, 1970), pp. 1–4.

38. Taylor and Barresi, *The Arts at a New Frontier,* pp. 84–85, 89, 100.

39. Biddle, *Our Government and the Arts,* p. 181.

40. Larson, *The Reluctant Patron,* pp. 209–11; McCombie, "Art and Policy," pp. 48–49.

41. Alvin H. Reiss, *Culture and Company* (New York: Twayne, 1972), pp. 118–19; Biddle, *Our Government and the Arts,* pp. 224–25; Straight, *Nancy Hanks,* pp. 229–30.

42. Biddle, *Our Government and the Arts,* p. 149.

43. Interview with Ruth Mayleas, Sept. 17, 1992, New York City; Mark, *Reluctant Bureaucrats,* pp. xi–xii; interview with David Stewart, May 18, 1993, Washington, D.C.; interview with Charles Ruttenberg, Nov. 11, 1992, Washington, D.C.

44. Interview with Ana Steele, Nov. 18, 1992, Washington, D.C.

45. Interview with Richard H. Hedrich, Nov. 11, 1992. Washington, D.C.

46. National Endowment for the Arts, First Annual Report, 1964–65, NEA Archives.

47. Duncan Norton-Taylor, "Roger Stevens: A Performing Art," *Fortune,* Mar. 1966, pp. 152, 200, 202.

48. Interview with Charles Ruttenberg, Nov. 11, 1992, Washington, D.C.; interview with Charles McWhorter, June 26, 1992, New York City; interview with Richard H. Hedrich, Nov. 11, 1992, Washington, D.C.

49. Mark, *Reluctant Bureaucrats,* pp. 29–30; interview with David Stewart, May 18, 1993, Washington, D.C.

50. Interview with Charles Ruttenberg, Nov. 11, 1992, Washington, D.C.

51. Taylor and Barresi, *The Arts at a New Frontier,* p. 57.

52. Tom Prideaux, "The Man Behind Washington's Kennedy Center," *Smithsonian,* Jan. 1979, p. 58; Brendan Gill, *John F. Kennedy Center for the Performing Arts* (New York: Abrams, 1981), p. 41; interview with David Stewart, May 18, 1993, Washington, D.C.

53. Mark, *Reluctant Bureaucrats,* p. 142; interview with David Stewart, May 18, 1993, Washington, D.C.

54. Interview with Paul Spreiregen, Nov. 9, 1992, Washington, D.C.

55. Milton Baron to Roger L. Stevens, Dec. 23, 1957, and *Romulus* Investor List, Jan. 1962, both in the Roger L. Stevens Papers, NYPL Performing Arts Library.

56. Stanley Kauffmann, "The Theater in New York," *New York Affairs,* summer 1978, p. 32; Glenn Collins, "Circle in the Square, Legendary Theater, Struggles to Survive," *New York Times,* Jan. 21, 1993.

57. Bradley G. Morison and Kay Fliehr, *In Search of an Audience* (New York: Pitman, 1968), pp. 4–6.

58. Ibid., pp. 13, 48, 63, 222–25.

59. Dwight Macdonald, *The Ford Foundation: The Men and the Millions* (New York: Reynal, 1956), p. 90.

60. Sharon Zane interview with W. McNeil Lowry, Jan. 11, 1990, Oral

History Project, Lincoln Center Archives; William Harris, "Phoenix or Ashes for La Mama?" *New York Times,* Sept. 6, 1992.

61. Julius Novick in Lowry, *Performing Arts and American Society,* p. 108; Ford Foundation, *Finances of the Performing Arts,* vol. 1 (New York: Ford Foundation, 1974), p. 17; interview with Peter Zeisler, Sept. 22, 1992, New York City.

62. National Council on the Arts, *First Five Years;* Straight, *Twigs for an Eagle's Nest,* p. 221.

63. Interview with Ruth Mayleas, Sept. 17, 1992, New York City; telephone interview with Ray Tatar, Oct. 7, 1993; Samuel Schwarz et al., *Growth of Arts and Cultural Organizations in the Decade of the 70s* (Washington, D.C.: National Endowment for the Arts, 1983), p. 420.

64. U.S. Bureau of the Census, *Statistical Abstract of the United States,* (Washington, D.C.: U.S. Dept. of Commerce, 1992), p. 243.

65. U.S. Department of Health, Education and Welfare, *Higher Education Earned Degrees Conferred* (Washington, D.C.: U.S. Government Printing Office, 1957–58, 1964–65, 1969–70).

66. Interview with Marilyn Kim, Nov. 9, 1993, New York City.

67. Telephone interview with Ray Tatar, Oct. 7, 1993.

68. Interview with Jessica Andrews, Apr. 21, 1993, Washington, D.C.

69. George C. White and Konrad H. Matthaei, both in "Newsletter," President's Committee on the Arts and the Humanities, Dec. 1992, pp. 4, 3; Exploring the Metropolis, Inc., "1982–1992–2002: A Generation of Theater," in *Complementary Assets: The Entertainment Arts Industry,* pt. 2, (New York: Exploring the Metropolis, Inc., 1993) p. 22.

70. Mervyn Rothstein, "Joseph Papp Reorganizes the Shakespeare Festival to Add 'Creative Blood,'" *New York Times,* May 29, 1990; Bruce Weber, "Papp Theater's Changes Are Debated," *New York Times,* Mar. 16, 1993; Frank Rich, "Opening a Window at a Theater Gone Stale," *New York Times,* Mar. 21, 1993.

71. Todd London, *The Artistic Home: Discussions with Artistic Directors of America's Institutional Theaters* (New York: Theater Communications Group, 1988), pp. 8–10, 13–14, 26–28, 63.

72. Michael Murray to Jules Irving, Apr. 19, 1968, Lincoln Center Papers, NYPL Performing Arts Library; Kauffmann, "Can Culture Explode?" p. 22.

73. Frank Hodsoll in John P. Robinson, ed., *Social Science and the Arts* (Lanham, Md.: University Press of America, 1985), p. 89.

74. Straight, *Nancy Hanks,* p. 226; Welton Jones, "'Tommy' Will Hit Broadway," *San Diego Union-Tribune,* Oct. 30, 1992; Mervyn Rothstein, "Passionate Beliefs Renew a Fight Over Art and Profit," *New York Times,* May 15, 1990; Glenn Collins, "Who's Paying for Broadway's New Boom?" *New York Times,* Apr. 16, 1992.

75. National Endowment for the Arts, Second Annual Report, 1965–66, NEA Archives; U.S. Department of Health, Education and Welfare, *Higher Education Earned Degrees Conferred* (Washington, D.C.: U.S. Government Printing Office, 1957–58, 1969–70.)

76. Roger Stevens, "State of the Arts: A 1966 Balance Sheet," *Saturday Review*, Mar. 12, 1966, p. 24; Paul DiMaggio and Michael Useem, "Cultural Democracy in a Period of Cultural Expansion: The Social Composition of Arts Audiences in the U.S.," *Social Problems* (Dec. 1978): 180.

77. Mark, *Reluctant Bureaucrats*, pp. 91, 97, 99.

78. National Council on the Arts, *The First Five Years;* Mark, *Reluctant Bureaucrats*, pp. 111–12.

79. Reiss, *Culture and Company*, p. 125; Sharon Zane interview with Amyas Ames, Oct. 17, 1990, Oral History Project, Lincoln Center Archives.

80. Roger L. Stevens, "America's Stake in the Arts," *Saturday Review*, Feb. 28, 1970, pp. 19–21.

81. Mark, *Reluctant Bureaucrats*, pp. 169–70; Charles C. Mark in Elizabeth Sweeting, ed., *Patron or Paymaster: The Arts Council Dilemma* (London: Calouste Gulbenkian Foundation, 1982), p. 91.

CHAPTER 4: THE NUTCRACKER

1. Roger Stevens, "State of the Arts: A 1966 Balance Sheet," *Saturday Review*, Mar. 12, 1966, p. 25.

2. Livingston Biddle, *Our Government and the Arts: A Perspective from the Inside* (New York: American Council for the Arts, 1988), pp. 265–70.

3. Fawn M. Brodie, *Richard Nixon: The Shaping of His Character* (New York: Norton, 1981), pp. 105, 115; Michael Straight, *Nancy Hanks, an Intimate Portrait: The Creation of a National Commitment to the Arts* (Durham, N.C.: Duke University Press, 1988), p. 103.

4. Sharon Zane interview with Amyas Ames, Oct. 17, 1990, Oral History Project, Lincoln Center Archives; Straight, *Nancy Hanks*, pp. 105–7; interview with Thomas Hoving, Sept. 15, 1992, New York City.

5. Straight, *Nancy Hanks*, pp. 106, 110–11; Leonard Garment, "Education and the Future of the Arts," Second Annual Nancy Hanks Lecture on Arts and Public Policy, Apr. 12, 1989, Washington, D.C., p. 3.

6. Alvin H. Reiss, *Culture and Company* (New York: Twayne, 1972), pp. 119–22.

7. Garment, "Education and the Future of the Arts," pp. 4–5; Michael Straight, *Twigs for an Eagle's Nest: Government and the Arts; 1965–1978* (New York: Devon, 1979), p. 25; interview with Leonard Garment, Apr.

21, 1993, Washington, D.C.; Tom Wicker, *One of Us: Richard Nixon and the American Dream* (New York: Random House, 1991), pp. 7, 8, 11.

8. Interview with Leonard Garment, Apr. 21, 1993, Washington, D.C.

9. Ibid.

10. Charles Richard Swaim, "The Fine Politics of Art: Organizational Behavior, Budgetary Strategies, and Some Implications for Art Policy," Ph.D. diss., University of Colorado, Boulder, 1977; interview with Leonard Garment, Apr. 21, 1993, Washington, D.C.

11. Quoted in Mary Eleanor McCombie, "Art and Policy: The National Endowment for the Arts' Art in Public Places Program, 1967–1980," Ph.D. diss., University of Texas, Austin, 1992, pp. 56–57, 61–62.

12. *National Endowment for the Arts, 1965–1985: A Brief Chronology of Federal Involvement in the Arts* (Washington, D.C.: National Endowment for the Arts, 1985), p. 25.

13. Michael Useem in Richard A. Peterson, ed., *The Production of Culture* (Beverly Hills, Calif.: Sage, 1976), p. 133; Junius Eddy, "Government, the Arts, and Ghetto Youth," *Public Administration Review* (July/Aug. 1970): 339–400, 404–5.

14. Judith Broder Sellner in Caroline Violette and Rachelle Taqqu, eds., *Issues in Supporting the Arts* (Ithaca, N.Y.: Cornell University Press, 1982), p. 19; Bernard Taper, *The Arts in Boston* (Cambridge, Mass.: Harvard University Press, 1970), p. 94; Robert O. Anderson in Gideon Chagy, ed., *The State of the Arts and Corporate Support* (New York: Eriksson, 1971), p. 4; Ronald Berman, *Culture and Politics* (Lanham, Md.: University Press of America, 1984), p. 129.

15. Gideon Chagy in Chagy, ed., *The State of the Arts and Corporate Support*, pp. 102–3; 106–8, 132–33; Biddle, *Our Government and the Arts*, pp. 442, 73–74.

16. Straight, *Nancy Hanks*, p. 15.

17. Ibid., pp. 21, 32.

18. Ibid., p. 39.

19. Ibid., pp. 48–51.

20. Ibid., p. 64.

21. Ibid., p. 80.

22. Interviews with Robert Wade, Nov. 13, 1992, and Melody Wayland, Nov. 18, 1992, both in Washington, D.C.; interview with Renato Danese, Jan. 13, 1993, New York City.

23. Interview with Carl Stover, Nov. 20, 1992, Washington, D.C.; quoted in Swaim, "The Fine Politics of Art," p. 108.

24. Interview with Jack Golodner, Nov. 12, 1992, Washington, D.C.

25. Ibid.

26. Granville Meader in Chagy, *The State of the Arts and Corporate Support*, p. 23.

27. Bradley G. Morison and Kay Fliehr, *In Search of an Audience* (New York: Pitman, 1968), p. 51; Ford Foundation, *Finances of the Performing Arts*, vol. 2 (New York: Ford Foundation, 1974), pp. 5–8.

28. National Research Center of the Arts, *Americans and the Arts: A Survey of Public Opinion* (New York: Associated Councils of the Arts, 1975), p. 1.

29. Ibid., pp. 58–60, 62–65.

30. Ibid., pp. 26, 19, 108.

31. Edward Arian, *Unfulfilled Promise: Public Subsidy of the Arts in America* (Philadelphia: Temple University Press, 1989), pp. 46–47; *National Endowment for the Arts, 1965–1985*, p. 34; Biddle, *Our Government and the Arts*, p. 290.

32. Interview with Ana Steele, Nov. 18, 1992, Washington, D.C.; Straight, *Nancy Hanks*, pp. 199, 213; Faye Levine, *The Culture Barons: An Analysis of Power and Money in the Arts* (New York: Crowell, 1976), p. 160; Joseph Wesley Zeigler, *Arts in Crisis: The National Endowment for the Arts versus America* (Chicago: A Cappella, 1994), p. 34.

33. Reiss, *Culture and Company*, pp. 115–17.

34. *Ford Foundation Support for the Arts in the United States*, Ford Foundation working paper, 1985; Harold L. Vogel, *Entertainment Industry Economics: A Guide for Financial Analysis* (New York: Cambridge University Press, 1986), p. 325.

35. Interview with Richard H. Hedrich, Nov. 11, 1992, Washington, D.C.

36. Berman, *Culture and Politics*, pp. 5–7.

37. Interview with Richard H. Hedrich, Nov. 11, 1992, Washington, D.C.

38. Interview with Ronald Berman, Mar. 23, 1993, La Jolla, Calif.; Berman, *Culture and Politics*, p. 11.

39. Interview with Thomas Hoving, Sept. 15, 1992, New York City; Thomas Hoving, *Making the Mummies Dance: Inside the Metropolitan Museum of Art* (New York: Simon & Schuster, 1993), pp. 350–52; interview with Ronald Berman, Mar. 23, 1993, La Jolla, Calif.

40. Interview with Richard H. Hedrich, Nov. 11, 1992, Washington, D.C.; interview with Wilder Greene, Sept. 21, 1992, New York City.

41. Straight, *Nancy Hanks*, pp. 86, 199; American Association of Museums, *America's Museums: The Belmont Report* (Washington, D.C.: American Association of Museums, 1968).

42. "Around the Endowment," *Cultural Post* (July/Aug. 1978): 2.

43. Straight, *Nancy Hanks*, pp. 196–99, 205.

44. Ibid., pp. 205–6.

45. Meader in *The State of the Arts and Corporate Support*, p. 30; Leigh Carney, "Support for Museums," *Cultural Post* (May/June 1978): 3.

46. *Museums for a New Century: A Report of the Commission on Museums for a New Century* (Washington, D.C.: American Association of Museums, 1984), p. 18.

47. Institute for Museum Services, *The Nature and Level of Federal Support for Museums in FY 1985 and 1986* (Washington, D.C.: National Foundation on the Arts and the Humanities, 1988).

48. Interviews with C. Douglas Dillon, Sept. 17, 1992, and Stephen Benedict, Sept. 16, 1992, both in New York City; Berman, *Culture and Politics,* pp. 14–15.

49. Straight, *Twigs for an Eagle's Nest,* pp. 97–9; Straight, *Nancy Hanks,* pp. 392–93.

50. Michael Straight, *After Long Silence* (New York: Norton, 1983), pp. 314–26.

51. Fannie Taylor and Anthony L. Barresi, *The Arts at a New Frontier: The National Endowment for the Arts* (New York: Plenum, 1984), p. 131; interview with Jean Dalrymple, Jan. 11, 1993, New York City; interview with Ana Steele, Nov. 18, 1992, Washington D.C.

52. "Tax Money for Arts: What It Is Buying," *U.S. News and World Report,* Feb. 5, 1973, pp. 84–85; "For an 'Uncultured' America, World Leadership in the Arts," *U.S. News and World Report,* Oct. 7, 1974, p. 59.

53. "Note for the Files, Nancy Hanks' Appointment," Sept. 22, 1969, and other papers at the NEA library, Washington, D.C.

54. Taylor and Barresi, *The Arts at a New Frontier,* pp. 131–32; Straight, *Nancy Hanks,* pp. 191–93.

55. Levine, *The Culture Barons,* p. 161; McCombie, "Art and Policy," p. 58; Hal Prince to Nancy Hanks, Sept. 8, 1977, Hal Prince Papers, NYPL Performing Arts Library; interview with Nick Webster, Sept. 17, 1992, New York City; interview with Allan Jabbour, Apr. 19, 1993, Washington, D.C.

56. Charles Christopher Mark, *Reluctant Bureaucrats: The Struggle to Establish the National Endowment for the Arts* (Dubuque, Iowa: Kendall/Hunt, 1991), pp. 136–37; Charles C. Mark in Elizabeth Sweeting, ed., *Patron or Paymaster: The Arts Council Dilemma* (London: Calouste Gulbenkian Foundation, 1982), p. 92; June Batten Arey, *State Arts Agencies in Transition* (Wayzata, Minn.: Spring Hill Conference Center, 1975), pp. ix–x; *National Endowment for the Arts, 1965–1985,* p. 30; Straight, *Nancy Hanks,* pp. 353–55.

57. Mark, *Reluctant Bureaucrats,* pp. 90–91; Berman, *Culture and Politics,* p. 24.

58. For details, see Laura Fermi, *Illustrious Immigrants: The Intellectual Migration from Europe, 1930–41* (Chicago: University of Chicago Press, 1968); H. Stuart Hughes, *The Sea Change: The Migration of Social Thought, 1930–1965* (New York: Harper & Row, 1975); Jarrell C. Jackman and Carla M. Borden, *The Muses Flee Hitler: Cultural Transfer and Adaptation, 1930–1945* (Washington, D.C.: Smithsonian, 1983); Anthony Heilbut, *Exiled in Paradise: German Refugee Artists and Intellectuals in America from the 1930s to the Present* (New York: Viking, 1983).

59. George M. Irwin in Bruce Cutler, ed., *Arts at the Grass Roots* (Lawrence: University Press of Kansas, 1968), pp. 8–9.

60. Michael K. Newton and Lawrence Kelly, both in Cutler, *Arts at the Grass Roots*, pp. 32–33; 26–27.

61. Mrs. Jack Glenn and Bruce Cutler, both in Cutler, *Arts at the Grass Roots*, pp. 52, 1, 5–6.

62. Interview with Jonathan Katz, Apr. 20, 1993, Washington, D.C.

63. Richard A. Peterson in Paul DiMaggio, ed., *Nonprofit Enterprise in the Arts: Studies in Mission and Constraint* (New York: Oxford University Press, 1986), p. 165.

64. Leonard Burkat, "Program Notes for Circus Polka, Igor Stravinsky," *Performing Arts* (Mar. 1993): 6.

65. Interview with Rhoda Grauer, Sept. 23, 1992, New York City; Joseph Wesley Zeigler, "Centrality Without Philosophy: The Crisis in the Arts," *New York Affairs*, summer 1978, p. 14.

66. Interview with Rhoda Grauer, Sept. 23, 1992, New York City.

67. Ibid.

68. Ibid.

69. Levine, *The Culture Barons*, pp. 70, 74–75.

70. Mark, *Reluctant Bureaucrats*, p. 83; Taylor and Barresi, *The Arts at a New Frontier*, p. 203.

71. Swaim, "The Fine Politics of Art," p. 59; Joseph H. Mazo in W. McNeil Lowry, ed., *Performing Arts and American Society* (Englewood Cliffs, N.J.: Prentice-Hall, 1978), p. 90; Straight, *Nancy Hanks*, p. 219.

72. Mazo in Lowry, *Performing Arts and American Society*, pp. 80–82.

73. Ben Yagoda, "Uncle Sam as Impresario: Are We Funding Junk?" *Saturday Review*, July 1980, p. 16; interview with Rhoda Grauer, Sept. 23, 1992, New York City.

74. Interview with Dick Netzer, Sept. 23, 1992, New York City; Preston Turegano, "Holiday Shows Are Big Gifts for Troupes," *San Diego Union-Tribune*, Dec. 21, 1992; "Chelsea Clinton to Dance in Capital 'Nutcracker,'" *New York Times*, Nov. 24, 1993; Jennifer Dunning, "Ballet Theater Revives, With Help from Friends," *New York Times*, June 3, 1993.

75. Dunning, "Ballet Theater Revives"; Jennifer Dunning, "Ballet Theater Completes Its Board Reorganization," *New York Times*, Nov. 22, 1993.

76. Anne Marie Welsh, "Dance, Crumbling Support," *San Diego Union-Tribune*, Jan. 24, 1993.

77. Interview with Bonnie Brooks, May 19, 1993, Washington, D.C.

78. Interview with Jean Isaacs, Mar. 23, 1993, San Diego.

79. Ibid.

80. National Endowment for the Arts, *New Dimensions for the Arts,*

1971–1972 (Washington, D.C.: U.S. Government Printing Office, 1993), p. 63; *National Endowment for the Arts, 1965–1985*, pp. 27–28.

81. Interview with Nick Webster, Sept. 17, 1992, New York City.

82. Interview with Larry Ridley, June 25, 1992, New York City.

83. Mark, *Reluctant Bureaucrats*, p. 87; Biddle, *Our Government and the Arts*, p. 206.

84. Straight, *Nancy Hanks*, pp. 286–87.

85. Interview with Nick Webster, Sept. 17, 1992, New York City; Taylor and Barresi, *The Arts at a New Frontier*, p. 130.

86. Ibid., pp. 171, 175; Straight, *Nancy Hanks*, pp. 187–88; Swaim, "The Fine Politics of Art," pp. 43–44, 48.

87. Interview with W. McNeil Lowry, Jan. 11, 1993, New York City; McCombie, "Art and Policy," pp. 59–60.

88. Taylor and Barresi, *The Arts at a New Frontier*, pp. 154–55, 157, 159; Harold Prince to Nancy Hanks, June 16, 1977, Hal Prince Papers, NYPL Performing Arts Library; Straight, *Nancy Hanks*, pp. 273–74.

89. Ibid., pp. 274–78.

90. Mark, *Reluctant Bureaucrats*, pp. 203–4.

91. Zeigler, "Centrality Without Philosophy," pp. 12–13, 16; Dick Netzer, "The Arts: New York's Best Export Industry," *New York Affairs*, summer 1978, p. 57.

92. Swaim, "The Fine Politics of Art," pp. 153–55.

CHAPTER 5: THE SORCERER'S APPRENTICE

1. Memorandum to members, former members, panel chairmen, and guests of the National Council on the Arts, July 25, 1974, Hal Prince Papers, NYPL Performing Arts Library; *National Endowment for the Arts, 1965–1985: A Brief Chronology of Federal Involvement in the Arts* (Washington, D.C.: National Endowment for the Arts, 1985).

2. National Endowment for the Arts, First Annual Report, 1964–65, NEA Archives; Minutes of the 39th Meeting of the National Council on the Arts, May 1–4, 1975, July 14, 1975, Seattle, Hal Prince Papers, NYPL Performing Arts Library.

3. Interview with Eleanor Lambert, Sept. 21, 1992, New York City.

4. Interview with Charles McWhorter, June 26, 1992, New York City.

5. Interview with W. McNeil Lowry, June 29, 1992, New York City; interview with Charles McWhorter, June 26, 1992, New York City.

6. Michael Straight, *Twigs for an Eagle's Nest: Government and the Arts, 1965–1978* (New York: Devon, 1979), pp. 81–82; Hal Prince to Frank

Weissberg, May 14, 1982, Hal Prince Papers, NYPL Performing Arts Library.

7. J. C. Dickinson, Jr., to Harold Prince, June 10, 1977, Hal Prince Papers, NYPL Performing Arts Library.

8. Certificate appointing Harold Prince to the National Council on the Arts, Sept. 14, 1976, Hal Prince Papers, NYPL Performing Arts Library.

9. Dickinson to Prince, June 10, 1977.

10. Harold Prince to Roger Kennedy, June 7, 1978, Hal Prince Papers, NYPL Performing Arts Library.

11. Minutes of the 39th Meeting of the National Council on the Arts; Harold Prince to Michael Straight, Nov. 30, 1976, and Straight to Prince, Dec. 14, 1976, Hal Prince Papers, NYPL Performing Arts Library.

12. Tom Bethell, "Welfare Arts," *Public Interest* (fall 1978): 134–38.

13. Livingston Biddle, *Our Government and the Arts: A Perspective from the Inside* (New York: American Council for the Arts, 1988), p. 6.

14. Ibid., pp. 3–7.

15. Interview with Livingston Biddle, Apr. 22, 1993, Washington, D.C.

16. Ibid.

17. Ibid.; interview with John Wessel, June 30, 1992, New York City; Biddle, *Our Government and the Arts,* p. 383.

18. Lawrence D. Mankin, "The National Endowment for the Arts: The Biddle Years and After," *Journal of Arts Management and the Law* (summer 1984): pp. 64–65.

19. Interview with Phil Kadis, Apr. 20, 1993, Washington, D.C.

20. Interview with Louise Wiener, Nov. 12, 1992, Washington, D.C.; Biddle, *Our Government and the Arts,* pp. 411–12.

21. Ibid., pp. 388–90, 374–75.

22. Michael Straight, *Nancy Hanks, an Intimate Portrait: The Creation of a National Commitment to the Arts* (Durham, N.C.: Duke University Press, 1988), p. 378; Biddle, *Our Government and the Arts,* p. 370.

23. Finlay Lewis, *Mondale: Portrait of an American Politician* (New York: Harper & Row, 1980), pp. 269–71.

24. Ibid., pp. 211, 268.

25. Ibid., p. 102.

26. Steven M. Gillon, *Democrats' Dilemma: Walter F. Mondale and the Liberal Legacy* (New York: Columbia University Press, 1992), pp. 49–51.

27. Lewis, *Mondale,* pp. 148–49.

28. Gillon, *Democrats' Dilemma,* pp. 83, 144–45.

29. Lewis, *Mondale,* pp. 270–71; Bethell, "Welfare Arts," p. 134.

30. Dick Netzer, "Large-Scale Public Support for the Arts," *New York Affairs,* fall 1974, p. 87; Chilton Williamson, Jr., "The Great American Arts Debate," *National Review,* Mar. 17, 1978, p. 352.

31. Ronald Berman, "Art vs. the Arts," *Commentary*, Nov. 1979, pp. 48–49, 52.

32. Karl E. Meyer, *The Art Museum: Power, Money, Ethics* (New York: William Morrow, 1979), pp. 74–75; Joseph Wesley Zeigler, *Arts in Crisis: The National Endowment for the Arts versus America* (Chicago: A Cappella, 1994), p. 38.

33. Edward Arian, *Unfulfilled Promise: Public Subsidy of the Arts in America* (Philadelphia: Temple University Press, 1989), pp. 70–71; interview with Charles McWhorter, June 26, 1992, New York City.

34. Biddle, *Our Government and the Arts*, pp. 412–13; Charles Christopher Mark, *Reluctant Bureaucrats: The Struggle to Establish the National Endowment for the Arts* (Dubuque, Iowa: Kendall/Hunt, 1991), pp. 114–15, 130.

35. Interview with Elizabeth Weil Perry, Nov. 16, 1992, Washington, D.C.; Mary L. Weaver in Margaret Jane Wyszomirski, ed., *Congress and the Arts: A Precarious Alliance* (New York: American Council for the Arts, 1988), pp. 41–43; Barbara Gamarekian, "Arts Groups Gird for Battle in Capital," *New York Times,* Aug. 29, 1989; Williamson, "The Great American Arts Debate," p. 355.

36. John P. Robinson, ed., *Social Science and the Arts* (Lanham, Md.: University Press of America, 1985), pp. 8–11.

37. Samuel Schwarz et al., *Growth of Arts and Cultural Organizations in the Decade of the 70s* (Washington, D.C.: National Endowment for the Arts, 1983), pp. 16–17, 25, 39, 41.

38. Paul DiMaggio, Michael Useem, and Paula Brown, *Survey of Arts Audience Research* (Washington, D.C.: National Endowment for the Arts, 1978), pp. 3, 22.

39. Joseph Roddy in W. McNeil Lowry, ed., *Performing Arts and American Society* (Englewood Cliffs, N.J.: Prentice-Hall, 1978), p. 34.

40. "Stagebill," New York Philharmonic 150th Anniversary Edition, 1992, p. 22; Alan Rich, *The Lincoln Center Story* (New York: American Heritage, 1984), pp. 86–87.

41. Edward Arian, *Bach, Beethoven, and Bureaucracy: The Case of the Philadelphia Orchestra* (University: University of Alabama Press, 1971), pp. 6–7.

42. Sharon Zane interview with Alice Tully, Jan. 8, 1991, Oral History Project, Lincoln Center Archives; Allan Kozinn, "New Features Next Season for Chamber Music Society," *New York Times,* Mar. 11, 1993.

43. Samuel Lipman, "Funding the Piper," *Commentary,* Jan. 1979, p. 57.

44. Roddy in *Performing Arts and American Society*, pp. 28–29, 33–34.

45. Martin Mayer, "Managing Orchestras Is a Fine Art Too," *Fortune,* Sept. 1, 1968, p. 106.

46. Lipman, "Funding the Piper," p. 55; Martin Mayer, "Where the Dollars Go," *Saturday Review,* Feb. 28, 1970, p. 24.

47. "Mr. Bernstein of Lincoln Center," *Newsweek,* Sept. 24, 1962, pp. 55–56; Donald L. Engle in Gideon Chagy, ed., *The State of the Arts and Corporate Support* (New York: Eriksson, 1971), p. 82; Mayer, "Managing Orchestras Is a Fine Art Too," pp. 106, 110.

48. Straight, *Nancy Hanks,* pp. 139–41.

49. Arian, *Unfulfilled Promise,* pp. 36–37; Catherine French, "Then and Now: The Causes and Consequences of Change in the Past Five Decades of American Orchestras," *Symphony,* July/Aug. 1992, p. 27; David Cwi and Albert Diehl, *In Search of a Regional Policy for the Arts* (Baltimore: Joint Committee on Cultural Resources, 1975), pp. 166–81.

50. American Symphony Orchestra League, *Americanizing the American Orchestra: Report of the National Task Force for the American Orchestra: An Initiative for Change* (Washington, D.C.: American Symphony Orchestra League, 1993), pp. 70–71; Arian, *Bach, Beethoven, and Bureaucracy,* pp. 82–83, 89–90.

51. Martin Mayer, *Bricks, Mortar, and the Performing Arts* (New York: Twentieth Century Fund, 1970), p. 80; American Symphony Orchestra League, *Americanizing the American Orchestra,* pp. 68–70; Netzer, "Large-Scale Public Support for the Arts," pp. 84–85.

52. Norman Lebrecht, *The Maestro Myth: Great Conductors in Pursuit of Power* (New York: Simon & Schuster, 1991), pp. 324–25; interview with Alice Goodkind, Mar. 24, 1993, San Diego.

53. American Symphony Orchestra League, *Americanizing the American Orchestra,* pp. 84–85.

54. Alvin H. Reiss, *Culture and Company* (New York: Twayne, 1972), pp. 245–46.

55. Jamie James, "Sex and the 'Singles' Symphony," *New York Times,* May 2, 1993; Wolf Organization, *The Financial Condition of Orchestras,* pt. 1, (Washington, D.C.: American Symphony Orchestra League, 1992), p. iv.

56. Lebrecht, *The Maestro Myth,* pp. 262–63; Harold L. Vogel, *Entertainment Industry Economics: A Guide for Financial Analysis* (New York: Cambridge University Press, 1986), p. 321.

57. Lebrecht, *The Maestro Myth,* pp. 318–20.

58. American Symphony Orchestra League, *Americanizing the American Orchestra,* pp. 18–19.

59. Lebrecht, *The Maestro Myth,* pp. 133–34; Joseph Horowitz, *Understanding Toscanini: How He Became an American Culture God and Helped Create a New Audience for Old Music* (Minneapolis: University of Minnesota Press, 1987), pp. 132–33.

60. Ralph G. Martin, *Lincoln Center: For the Performing Arts* (Englewood Cliffs, N.J.: Prentice-Hall, 1971), pp. 42–43.

61. "Stagebill," New York Philharmonic 150th Anniversary Edition, pp. 22, 64.

62. Paul Griffiths, "The Philharmonic's Hundred-and-Fiftieth," *New York Times,* Jan. 11, 1993.

63. Lipman, "Funding the Piper," p. 57; Lebrecht, *The Maestro Myth,* pp. 180–81; James R. Oestreich, "Speak Loudly, Carry No Stick," *New York Times,* May 23, 1993; American Symphony Orchestra League, *Americanizing the American Orchestra,* pp. 20–21.

64. "Stagebill," New York Philharmonic 150th Anniversary Edition, p. 26.

65. Arian, *Bach, Beethoven, and Bureaucracy,* pp. 58–59; Richard L. Zweigenhaft and William Domhoff, *Jews in the Protestant Establishment* (New York: Praeger, 1982), p. 68; French, "Then and Now," p. 91.

66. Bruce Cutler, ed., *Arts at the Grass Roots* (Lawrence: University Press of Kansas, 1968), p. 99.

67. Sedgwick Clark, ed., *Musical America* (New York: Musical America Publishing, 1993), pp. 274–82; Lebrecht, *The Maestro Myth,* pp. 314–15, 318, 305.

68. Mayer, *Bricks, Mortar, and the Performing Arts,* pp. 71–73.

69. Judith Broder Sellner in Caroline Violette and Rachelle Taqqu, eds., *Issues in Supporting the Arts* (Ithaca, N.Y.: Cornell University Press, 1982), p. 19; Philip Kotler in Michael P. Mokwa, William M. Dawson, and E. Arthur Prieve, eds., *Marketing the Arts* (New York: Praeger, 1980), p. xiii; *Museums for a New Century: A Report of the Commission on Museums for a New Century* (Washington, D.C.: American Association of Museums, 1984), p. 20.

70. Biddle, *Our Government and the Arts,* pp. 428–30, 435.

71. Ibid., pp. 435–38.

72. Federal Council on the Arts and the Humanities, *Cultural Directory II* (Washington, D.C.: Smithsonian, 1980); Lowry, *Performing Arts and American Society,* pp. 20–21.

73. Biddle, *Our Government and the Arts,* pp. 400–407.

74. Michael S. Joyce, "Government Funding of Culture: What Price the Arts?" *Annals of the American Academy of Political and Social Science* (Jan. 1984): 29–30; Michael Useem in Richard A. Peterson, ed., *The Production of Culture* (Beverly Hills, Calif.: Sage, 1976), p. 138.

75. National Endowment for the Arts, *Panelist Handbook* (Washington, D.C.: National Endowment for the Arts, 1979), p. 10; Joseph Wesley Zeigler, "Centrality Without Philosophy: The Crisis in the Arts," *New York Affairs,* summer 1978, p. 19.

76. Interview with John Wessel, June 30, 1992, New York City.

77. National Endowment for the Arts, *Panelist Handbook,* p. 34; interview with Melody Wayland, Nov. 18, 1992, Washington, D.C.; Charles Richard

Swaim, "The Fine Politics of Art: Organizational Behavior, Budgetary Strategies, and Some Implications for Art Policy," Ph.D. diss., University of Colorado, Boulder, 1977, pp. 48–49.

78. Interview with Nick Webster, Sept. 17, 1992, New York City.

79. Arian, *Unfulfilled Promise*, pp. 51–52; Mankin, "The National Endowment for the Arts," p. 66.

80. Independent Commission, *Report to Congress on the National Endowment for the Arts* (Washington, D.C.: Independent Commission, 1990), pp. 37–38; Straight, *Twigs for an Eagle's Nest,* pp. 130–32.

81. Straight, *Nancy Hanks,* pp. 334–35.

82. Ibid., pp. 335–36.

83. Interview with Livingston Biddle, Apr. 22, 1993, Washington, D.C.

CHAPTER 6: A NIGHT AT THE OPERA

1. Livingston Biddle, *Our Government and the Arts: A Perspective from the Inside* (New York: American Council for the Arts, 1988), p. 492.

2. Ibid., pp. 493–96.

3. Gary O. Larson, *The Reluctant Patron* (Philadelphia: University of Pennsylvania Press, 1983), p. xv; Biddle, *Our Government and the Arts,* pp. 502–3.

4. Ibid., pp. 503–6; Barnabas McHenry, "Notes on the Presidential Task Force on the Arts and Humanities and President's Committee on the Arts and Humanities," *Annals of the American Academy of Political and Social Science* (Jan. 1984): 109.

5. Interview with Benny Andrews, Sept. 15, 1992, New York City; Edward Corn to Beverly Sills, Dec. 19, 1980, and Harold Prince to Corn, Jan. 21, 1981, Hal Prince Papers, NYPL Performing Arts Library.

6. Fannie Taylor and Anthony L. Barresi, *The Arts at a New Frontier: The National Endowment for the Arts* (New York: Plenum, 1984), p. 239; interview with Frank Hodsoll, Nov. 13, 1992, Washington, D.C.; interview with Gary O. Larson, Nov. 19, 1992, Washington, D.C.; Biddle, *Our Government and the Arts,* p. 506; interview with Livingston Biddle, Apr. 22, 1993, Washington, D.C.

7. *National Endowment for the Arts, 1965–1985: A Brief Chronology of Federal Involvement in the Arts* (Washington, D.C.: National Endowment for the Art, 1985), p. 41; interview with Frank Hodsoll, Nov. 13, 1992, Washington, D.C.

8. Interview with Gary O. Larson, Nov. 19, 1992, Washington, D.C.; interview with Frank Hodsoll, Nov. 13, 1992, Washington, D.C.

9. Ibid.; Kevin V. Mulcahy in Judith H. Balfe and Margaret Jane Wys-
 zomirski, eds., *Art, Ideology, and Politics* (New York: Praeger, 1985), p.
 326.

10. Harold L. Vogel, *Entertainment Industry Economics: A Guide for Finan-
 cial Analysis* (New York: Cambridge University Press, 1986), p. 326.

11. Interview with Frank Hodsoll, Nov. 13, 1992, Washington, D.C.; Irvin
 Molotsky, "Reagan Calls for Medal for Leaders in the Arts," *New York
 Times*, May 18, 1983; *National Endowment for the Arts, 1965-1985*, p.
 52.

12. Vogel, *Entertainment Industry Economics*, pp. 326-27; U.S. Bureau of
 the Census, *Statistical Abstract of the United States* (Washington, D.C.:
 U.S. Dept. of Commerce, 1992), p. 243.

13. Alvin H. Reiss, *Culture and Company* (New York: Twayne, 1972), p. 17;
 Michael Useem in Margaret Jane Wyszomirski and Pat Clubb, eds., *Costs
 of Culture: Patterns and Prospects of Private Arts Patronage* (New York:
 American Council for the Arts, 1989), p. 47.

14. Ibid., pp. 54-55.

15. Biddle, *Our Government and the Arts,* pp. 440-42; G. A. McLellan in
 Gideon Chagy, ed., *The State of the Arts and Corporate Support* (New
 York: Eriksson, 1971), pp. 12-13.

16. Biddle, *Our Government and the Arts,* p. 443; Suzanne Koblentz Good-
 man, *Partners: A Practical Guide to Corporate Support for the Arts* (New
 York: Cultural Assistance Center, 1982), pp. 14-15.

17. Alice Goldfarb Marquis, *The Art Biz* (Chicago: Contemporary, 1991), p.
 331; Diane J. Gingold and Elizabeth A. C. Weil, *The Corporate Patron*
 (New York: Fortune, 1991), pp. 21, 29-30.

18. Larry Makinson, *Open Secrets: The Encyclopedia of Congressional
 Money and Politics* (Washington, D.C.: Center for Responsive Politics,
 1992), p. 24; Gingold and Weil, *The Corporate Patron*, pp. 25, 137.

19. President's Committee on the Arts and the Humanities, *Report to the
 President and to NEA and NEH* (Washington, D.C.: President's Commit-
 tee on the Arts and the Humanities, 1988), p. 9; Vogel, *Entertainment
 Industry Economics*, p. 324.

20. Mark Davidson Schuster, "The Interrelationship Between Public and
 Private Funding of the Arts in the U.S.," *Journal of Arts Management
 and Law* (winter 1985): p. 86; *Budget of the United States Government:
 Analytical Perspectives* (Washington, D.C.: U.S. Government Printing
 Office, 1994), p. 55.

21. Diane J. Gingold, *The Challenge Grant Experience* (Washington, D.C.:
 National Endowment for the Arts, 1980), pp. iv, 1-2.

22. Interview with Elizabeth Weil Perry, Nov. 16, 1992, Washington, D.C.;

Martin Mayer in W. McNeil Lowry, ed., *Performing Arts and American Society* (Englewood Cliffs, N.J.: Prentice-Hall, 1978), p. 52; Gingold, *The Challenge Grant Experience,* pp. 101–3; Edward Arian, *Unfulfilled Promise: Public Subsidy of the Arts in America* (Philadelphia: Temple University Press, 1989), p. 63.

23. Schuster, "The Interrelationship Between Public and Private Funding of the Arts in the U.S.," p. 78.

24. Mark Davidson Schuster in Wyszomirski and Clubb, *Costs of Culture,* pp. 76–77; U.S. Bureau of the Census, *Statistical Abstract of the United States* (Washington, D.C.: U.S. Dept. of Commerce, 1993), p. 256.

25. Schuster in *Costs of Culture,* p. 79.

26. President's Committee on the Arts and the Humanities, *Report to the President and to NEA and NEH,* pp. 1–5; President's Committee on the Arts and the Humanities, *Report to the President* (Washington D.C.: President Committee on the Arts and the Humanities, 1992), pp. 1–4.

27. William J. Keens, "The Arts Caucus: Coming of Age in Washington," *American Arts* (Mar. 1983): 17; *Guide to Congress* (Washington, D.C.: Congressional Quarterly, 1982), p. 756.

28. "The City: Richmond Leaves Federal Prison," *New York Times,* Sept. 7, 1983; Michael S. Joyce, "Government Funding of Culture: What Price the Arts?" *Annals of the American Academy of Political and Social Science* (Jan. 1984): 28.

29. Margaret Jane Wyszomirski in Wyszomirski, ed., *Congress and the Arts: A Precarious Alliance* (New York: American Council for the Arts, 1988), pp. 22–23; Keens, "The Arts Caucus," pp. 17–18, 20; Barbara Gamarekian, "Juggling Money, Taste and Art on Capitol Hill," *New York Times,* June 30, 1989.

30. John Dizikes, *Opera in America: A Cultural History* (New Haven: Yale University Press, 1994), pp. 284–92; Martin Mayer, "The Big Business of Opera," *Fortune,* Oct. 17, 1983, p. 150; Faye Levine, *The Culture Barons: An Analysis of Power and Money in the Arts* (New York: Crowell, 1976), pp. 44-45.

31. Ardis Krainik, "President's Message," in *Profile: A Guide to Opera America and the Opera America Membership* (Washington, D.C.: Opera America, 1991), pp. 6, 8–10; "Mr. Bing Calls the Tune," *Reader's Digest,* Dec. 1966, p. 134; Samuel Schwarz et al., *Growth of Arts and Cultural Organizations in the Decade of the 70s* (Washington, D.C.: National Endowment for the Arts, 1983), p. 384; U.S. Bureau of the Census, *Statistical Abstract of the United States* (1993), p. 256.

32. "Mr. Bing Calls the Tune," p. 132; Mayer, "The Big Business of Opera," p. 148; Levine, *The Culture Barons,* p. 57.

33. Ford Foundation, *Finances of the Performing Arts,* vol. 1 (New York:

Ford Foundation, 1974), p. 20; Levine, *The Culture Barons*, pp. 55–56; Mayer, "The Big Business of Opera," pp. 146, 148, 154.

34. Interview with Marc Scorca, Apr. 19, 1993, Washington, D.C.

35. Krainik, "President's Message," pp. 16–17; *Opera America Newsline,* Sept. 1993, p. 6.

36. Interview with Marc Scorca, Apr. 19, 1993, Washington, D.C.; Howard Klein, "The Shoulder Season," David Dichiera, "Essay," Ben Krywosz, "Essay," and "Grants," all in *Opera America's Opera for the 80s and Beyond: Final Report* (Washington, D.C.: Opera America, 1993), pp. 6–7, 10–11, 17–18, 64.

37. *Lila Wallace–Reader's Digest Opera for a New America: Program Guidelines and Application Forms* (Washington, D.C.: Opera America, 1991); Marianne Harding, "Report on the Third Year of the Lila Wallace–Reader's Digest Opera for a New America Project," *Opera America Newsline,* Jan. 1994, p. 20.

38. Interview with Marc Scorca, Apr. 19, 1993, Washington, D.C.; Bernard Holland, "The Metropolitan Opera Is Exploring the Byways," *New York Times,* Nov. 28, 1992; James Oestreich, "Frank Lloyd Wright Joins Opera's Pantheon," *New York Times,* Apr. 28, 1993.

39. "Central City Opera," brochure, Central City Opera Association, Denver, Colorado, 1994.

40. "High Notes," fall 1993, and "Outreach and Education Programs," flyer, both by the Central City Opera Association, Denver, Colorado.

41. Sonja S. Gold in William S. Hendon and James L. Shanahan, eds., *Economics of Cultural Decisions* (Cambridge, Mass.: Abt, 1983), pp. 212–13; Colin Graham, address given at the 23rd Opera America Annual Conference, Feb. 18, 1993, reprinted in "Outlook," *Opera America Newsline,* July/Aug. 1993.

42. Burl Stiff, "For a Pretty Penny, Patrons Meet Pavarotti," *San Diego Union-Tribune,* Oct. 27, 1992; Valerie Scher, "Classical Clash," *San Diego Union-Tribune,* Jan. 17, 1993.

43. Ernest van den Haag, "Should the Government Subsidize the Arts?" *Policy Review* (fall 1979): 66; E. L. Doctorow, "Remarks," presented to the National Council on the Arts, May 14, 1993.

44. Levine, *The Culture Barons,* p. 47; John Rockwell, "And Now, Comics of the Niebelungen," *New York Times,* Apr. 5, 1990.

45. Interview with Gary O. Larson, Nov. 19, 1992, Washington, D.C.; interview with Larry Ridley, June 25, 1992, New York City.

46. Interview with Dan Sheehy, Nov. 18, 1992, Washington, D.C.

47. Interview with Hugh Southern, Nov. 10, 1992, Washington, D.C.; interview with Dan Sheehy, Nov. 18, 1992, Washington, D.C.

48. Ibid.; interview with Dick Netzer, Sept. 23, 1992, New York City;

National Endowment for the Arts, *Folk Arts Program History,* May 1992, pp. 6–8.

49. Hearing on the Grant Making Process of the National Endowment for the Arts, Subcommittee on Postsecondary Education, Committee on Education and Labor, House of Representatives, 98th Cong., June 28, 1984; Mulcahy in *Art, Ideology, and Politics,* p. 333.

50. Roger Stevens, "State of the Arts: A 1966 Balance Sheet," *Saturday Review,* Mar. 12, 1966, p. 133; Biddle, *Our Government and the Arts,* p. 221; Taylor and Barresi, *The Arts at a New Frontier,* p. 92.

51. Interview with Carl Stover, Nov. 20, 1992, Washington, D.C.; Ronald Berman, *Culture and Politics* (Lanham, Md.: University Press of America, 1984), p. 59.

52. Interview with Charles Ruttenberg, Nov. 11, 1992, Washington, D.C.; Biddle, *Our Government and the Arts,* pp. 222–23.

53. Michael Straight, *Nancy Hanks, an Intimate Portrait: The Creation of a National Commitment to the Arts* (Durham, N.C.: Duke University Press, 1988), pp. 227–28; Biddle, *Our Government and the Arts,* pp. 181, 222–23; National Endowment for the Arts, *Five-Year Planning Document, 1990–1994* (Washington, D.C.: National Endowment for the Arts, 1988), p. 277.

54. John Beardsley, "The Art Critics Fellowship Program: Analysis and Recommendations," Consultant's Report for NEA, Aug. 1983, pp. 1, 5, 7–10, 13.

55. Hilton Kramer, "Criticism Endowed: Reflections on a Debacle," *New Criterion,* Nov. 1983, pp. 1–3; Jonathan Yardley, "Taking It for Grants," *Washington Post,* Apr. 9, 1984.

56. Interview with Ruth Berenson-Muhlen, Nov. 16, 1992, Washington, D.C.; interview with Nick Webster, Sept. 17, 1992, New York City.

57. Cary McMullen memo to All Program Directors, Division Heads, and Regional Representatives, Feb. 1, 1983, Benny Andrews Papers, New York City (private collection).

58. John C. Wessel memo to Franklin Furnace, the Kitchen, Artists Space, Museum of Holography, Alternative Museum, Drawing Center, Cayman Gallery, and Just Above Midtown, Nov. 8, 1982; Len Hunter, Renee Levine, and Ed Martenson memo to Francis Hodsoll, Feb. 18, 1983, all from Benny Andrews Papers.

59. Cary McMullen memo to Hugh Southern, Benny Andrews, Ruth Berenson-Muhlen, and Frank Conroy, Dec. 22, 1982; Francis Hodsoll draft letter to Lucy Lippard, 1983; Hodsoll letter to Lippard, Mar. 21, 1983, all from Benny Andrews Papers.

60. Steven C. Dubin, *Arresting Images: Impolitic Art and Uncivil Actions* (New York: Routledge, 1992), pp. 281, 283; interview with Frank Hodsoll, Nov. 13, 1992, Washington, D.C.

61. Francis Hodsoll to Sen. Daniel P. Moynihan and to Sen. Alan J. Dixon, both Jan. 7, 1984; Hodsoll to Rep. Robert L. Livingston, Dec. 9, 1983, all from Benny Andrews Papers.

62. Marete Wester, *Art Start: Funding Innovations for Local Arts Agencies* (Washington, D.C.: National Assembly of Local Arts Agencies, 1992), p. 8.

63. Mulcahy in *Art, Ideology, and Politics,* pp. 322–23; Mel Scott, *The States and the Arts: The California Arts Commission and the Emerging Federal-State Partnership* (Berkeley: University of California Institute of Governmental Studies, 1971), p. 69; Terri Lynn Cornwell, *Democracy and the Arts: The Role of Participation,* (New York: Praeger, 1990), p. 191.

64. Paul DiMaggio, ed., *Nonprofit Enterprise in the Arts: Studies in Mission and Constraint* (New York: Oxford University Press, 1986), pp. 81–82; Margaret Jane Wyszomirski in Wyszomirski and Clubb, *Costs of Culture,* p. 2; Wyszomirski, *Congress and the Arts,* pp. 27–28.

65. Don Adams and Arlene Goldbard, "Cultural Democracy vs. Democratization of High Culture," *Social Policy* (May/June 1981): 55; William H. Honan, "Brown and Clinton and Their Pursuit of the Arts World," *New York Times,* Apr. 6, 1992; Scott, *The States and the Arts,* pp. 78–79.

66. David Cwi in Hendon and Shanahan, *Economics of Cultural Decisions,* pp. 42–44.

67. Interview with Jonathan Katz, Apr. 20, 1993, Washington, D.C.; Michael Howie, "Two Sides Debate If State Should Fund the Arts," *Champaign-Urbana News-Gazette,* May 25, 1992; Preston Turegano, "Arts Groups to Fight to Save State Agency," *San Diego Union-Tribune,* Jan. 18, 1993.

68. Wester, *Art Start,* pp. 20–22.

69. "Met Museum Reports on Spending," *New York Times,* Sept. 24, 1992; quoted in Joseph Zeigler in John P. Robinson, ed., *Social Science and the Arts* (Lanham, Md.: University Press of America, 1985), pp. 83–84.

70. "The Arts and the Economy," flyer distributed at National Council on the Arts meeting, May 13–15, 1993, Washington, D.C.

71. Robert L. Lynch and Robert L. Marsicano, "Will the NEA be Jane Alexander's Most Challenging Role?" in "Partnership: An Advocate for Public and Private Support of the Arts," National Assembly of Local Arts Agencies flyer, fall 1993.

72. William Proxmire, *The Fleecing of America* (Boston: Houghton Mifflin, 1980), pp. 99–100; Michael Straight, *Twigs for an Eagle's Nest: Government and the Arts, 1965–1978* (New York: Devon, 1979), pp. 47–49; Biddle, *Our Government and the Arts,* pp. 431–34.

73. Mary Eleanor McCombie, "Art and Policy: The National Endowment for the Arts' Art in Public Places Program, 1967–1980," Ph.D. diss., University of Texas, Austin, 1992, pp. 100–105, 108.

74. Ibid., pp. 65–66, 107–10.

75. Ibid., pp. 115–16, 120.
76. Ibid., pp. 122–23.
77. Ibid., pp. 126–29.
78. Ibid., pp. 133–37, 142–44.
79. Ibid., pp. 145–46, 149–50.
80. Ibid., pp. 148–54.
81. Ibid., pp. 162–65.
82. Ibid., pp. 172, 174–75, 177–79; John Beardsley, *Art in Public Places* (Washington, D.C.: Partners for Livable Places, 1981), pp. 77–78.
83. McCombie, "Art and Policy," pp. 198, 202–3, 217.
84. Ibid., pp. 217–19.
85. Ibid., pp. 220–22.
86. Ibid., pp. 222–23.
87. David W. Dunlap, "Moving Day Arrives for Disputed Sculpture," *New York Times*, Mar. 11, 1989; Todd S. Purdum, "Sculpture's Move Delayed by Judge," *New York Times*, Mar. 12, 1989.
88. Interview with David Furchgott, Apr. 21, 1993, Washington, D.C.; Avis Berman, "Public Sculpture's New Look," *Art News*, Sept. 1991, pp. 105–6; interview with Karen Pomeroy, Sept. 11, 1992, San Diego.
89. David Forst, "No Longer Poles Apart," *Art News*, Apr. 1992, pp. 29–30.
90. McCombie, "Art and Policy," pp. 252–464.
91. Interview with Margaret Jane Wyszomirski, Nov. 16, 1992, Washington, D.C.
92. National Endowment for the Arts, *Five-Year Planning Document, 1986–1990* (Washington, D.C.: Superintendent of Documents, 1984), pp. 2–12, 379–90.
93. Ibid., pp. 18–20.
94. Mulcahy in *Art, Ideology, and Politics*, p. 333; Frank Hodsoll in Robinson, *Social Science and the Arts,* p. 90.
95. Joseph Wesley Zeigler, "Centrality Without Philosophy: The Crisis in the Arts," *New York Affairs*, summer 1978, p. 16; Zeigler in *Social Science and the Arts*, pp. 83–84.
96. Charles Christopher Mark, *Reluctant Bureaucrats: The Struggle to Establish the National Endowment for the Arts* (Dubuque, Iowa: Kendall/Hunt, 1991), p. 188.
97. Bruce L. Payne in Richard C. Swaim, ed., *The Modern Muse: The Support and Condition of Artists* (New York: American Council for the Arts, 1989), p. 79.
98. Blayne Cutler, "Our Cities, Our Selves: Orchestras in a Changing American Landscape," *Symphony,* July/Aug. 1992, pp. 94–95; Dick Netzer, *The Subsidized Muse* (New York: Cambridge University Press, 1978), p. 20; Edward C. Banfield, *The Democratic Muse* (New York: Basic Books,

1984), pp. 72–73; Robert J. Samuelson, "Highbrow Pork Barrel," *Washington Post,* Aug. 16, 1989.

99. Bradley G. Morison and Julie Gordon Dalgleish, *Waiting in the Wings* (New York: American Council for the Arts, 1987), pp. 48–49; Vogel, *Entertainment Industry Economics,* p. 317; Judith Huggins Balfe in Wyszomirski and Clubb, *Costs of Culture,* pp. 10–11; interview with Susan Farr, Nov. 19, 1992, Washington, D.C.

CHAPTER 7: FLOWERS OF EVIL

1. Michael Straight, *Nancy Hanks, an Intimate Portrait; The Creation of a National Commitment to the Arts* (Durham, N.C.: Duke University Press, 1988), pp. 126, 271–72.

2. Sarah Booth Conroy, "Memories of Hanks," *Washington Post,* Jan. 18, 1983.

3. Robert S. Kane, *Washington, D.C. at Its Best* (Lincolnwood, Ill.: Passport, 1991), p. 197; John Frohnmayer, *Leaving Town Alive: Confessions of an Arts Warrior* (Boston: Houghton Mifflin, 1993), pp. 60–61, 63.

4. Ibid., pp. 14–15.

5. Ibid., pp. 15–16.

6. Ibid., pp. 17–19.

7. Ibid., pp. 7, 21.

8. Ibid., pp. 21, 23.

9. Interview with Andres Serrano, Sept. 23, 1992, New York City.

10. Interview with Frank Hodsoll, Nov. 13, 1992, Washington, D.C.

11. Barbara Gamarekian, "Mapplethorpe Backers Picket the Corcoran," *New York Times,* June 17, 1989; William H. Honan, "Congressional Anger Threatens Arts," *New York Times,* June 20, 1989; Frohnmayer, *Leaving Town Alive,* pp. 25, 27, 30.

12. Interview with Livingston Biddle, Apr. 22, 1993, Washington, D.C.

13. Philip Brookman in Richard Bolton, ed., *Culture Wars: Documents from the Recent Controversies in the Arts* (New York: New Press, 1992), pp. xvi–xvii.

14. Frohnmayer, *Leaving Town Alive,* pp. 47–51.

15. Joseph Wesley Zeigler, *Arts in Crisis: The National Endowment for the Arts versus America* (Chicago: A Cappella, 1994), p. 68; Frohnmayer, *Leaving Town Alive,* pp. 51, 61.

16. Ibid., pp. 61, 63–64.

17. Ibid., pp. 75–77.

18. Ibid., pp. 75–80.

19. Martha Wilson, "Statement," Franklin Furnace flyer, June 1992;

unsigned, undated (ca. Mar. 1984) draft letter to Paul Morrissey, Benny Andrews Papers, New York City.

20. Wilson, "Statement," Franklin Furnace flyer, June 1992; Robert H. Knight, "The National Endowment for the Arts: Misusing the Taxpayer's Money," *Heritage Foundation Backgrounder,* Jan. 18, 1991, pp. 21–22.

21. Frank Hodsoll to Reps. Bill Goodling, Eldon Rudd, Bob Stump, Dan Daniel and Sens. John W. Warner and Barry Goldwater, May 30, 1984, Benny Andrews Papers.

22. Michael Faubion memo to Benny Andrews, Feb. 28, 1984; Martha Wilson to Hugh Southern, Apr. 18, 1984, Benny Andrews Papers.

23. Wilson, "Statement," Franklin Furnace flyer, June 1992.

24. Knight, "The National Endowment for the Arts," pp. 22–25.

25. William Grimes, "Performer's Pain Spreads to Arts Endowment," *New York Times,* July 7, 1994; Ben Brantley, "A Touch of Infamy is Enough," *New York Times,* Oct. 29, 1994; Diana Jean Schemo, "N.E.A. Eliminates Indirect Grants to Artists," *New York Times,* Nov. 3, 1994.

26. Sharon Zane interview with Amyas Ames, Oct. 17, 1990, Oral History Project, Lincoln Center Archives.

27. Theater listings, *Washington Post,* Feb. 23, 1994; Kevin McManus, "Community Classics," *Washington Post Weekend,* Feb. 25, 1994, pp. 8–10.

28. Hearing on the Reauthorization of the National Endowments for the Arts and Humanities and the Institute for Museum Services, Subcommittee on Postsecondary Education, Committee on Education and Labor, House of Representatives, Apr. 1, 1989, Bozeman, Mont., pp. 2, 5–7.

29. Field Hearing on the Reauthorization of the National Endowments for the Arts and Humanities, Subcommittee on Postsecondary Education, Committee on Education and Labor, House of Representatives, June 9, 1989, Charleston, S.C.

30. Senate debate over the Helms amendment, quoted in Bolton, *Culture Wars,* pp. 83–84; interview with Hugh Southern, Nov. 10, 1992, Washington, D.C.; Frohnmayer, *Leaving Town Alive,* p. 36.

31. Kevin V. Mulcahy in Margaret Jane Wyszomirski, ed., *Congress and the Arts: A Precarious Alliance* (New York: American Council for the Arts, 1988), p. 64.

32. Margaret Jane Wyszomirski in Wyszomirski, *Congress and the Arts,* pp. 10–11, 14–16; Robin Cembalest, "Corn for Porn," *Art News,* Feb. 1992, p. 27.

33. Mary Lynn Kotz, "John Brademas," *Art News,* Sept. 1980, p. 96; June Wayne, "College Art Association Convocation Address," Feb. 1990, New York City, reprinted in *Women Artists News,* spring/summer 1990; Steven C. Dubin, *Arresting Images: Impolitic Art and Uncivil Actions* (New York: Routledge, 1992), pp. 283–84.

34. Frohnmayer, *Leaving Town Alive*, p. 227.

35. Laura Lederer, ed., *Take Back the Night: Women on Pornography* (New York: William Morrow, 1980), p. 17; "Despite U.S. Campaign, a Boom in Pornography," *New York Times*, July 3, 1993; Andy Grundberg, "The Allure of Mapplethorpe's Photographs," *New York Times*, July 31, 1988.

36. NEA Artists' Projects: New Forms Panel, "Statement," May 25, 1990, in Bolton, *Culture Wars*, pp. 213–14.

37. National Endowment for the Arts, "Panel Study Report to Congress," Oct. 1987, NEA Archives; interview with Bert Kubli, Nov. 19, 1992, Washington, D.C.

38. National Endowment for the Arts, "Fiscal 1993 Music Advisory Panel Meeting Schedule," Nov. 19, 1992, NEA Archives; Anne E. West, letter to the editor, *New York Times*, Nov. 24, 1992; Daniel S. Greenberg, "NIH is a Sacred Cow that Needs to be Corralled," *San Diego Union-Tribune*, Nov. 23, 1992.

39. Roger L. Stevens to Sol Jacobson, Jan. 11, 1965, NYPL Performing Arts Library; National Endowment for the Arts, First Annual Report, 1964–65, NEA Archives; Fannie Taylor and Anthony L. Barresi, *The Arts at a New Frontier: The National Endowment for the Arts* (New York: Plume, 1984), p. 106; Livingston Biddle, *Our Government and the Arts: A Perspective from the Inside* (New York: American Council for the Arts, 1988), pp. 255–56; Charles Christopher Mark, *Reluctant Bureaucrats: The Struggle to Establish the National Endowment for the Arts* (Dubuque, Iowa: Kendall/Hunt, 1991), p. 113.

40. Knight, "The National Endowment for the Arts," pp. 16–17; Mark Lasswell, "Logrolling in the Wonderful World of the Arts," *Wall Street Journal*, Oct. 31, 1990.

41. James F. Cooper, "Realist Artists Need Not Apply at the NEA," *Human Events*, May 12, 1990, p. 9; Lasswell, "Logrolling in the Wonderful World of the Arts."

42. Independent Commission, *Report to Congress on the National Endowment for the Arts* (Washington, D.C.; Independent Commission, 1990), p. 26.

43. Frohnmayer, *Leaving Town Alive*, pp. 159–60; Independent Commission, *Report*, inside front cover, pp. 46–53.

44. Ibid., pp. 2–3.

45. Frohnmayer, *Leaving Town Alive*, pp. 184–87.

46. Ibid., p. 187.

47. Ibid., pp. 188, 190–91, 193–94.

48. Ibid., p. 194.

49. Independent Commission, *Report*, pp. 25–26, 58–59, 63–64, 66–67,

93–94; Barbara Gamarekian, "Congressional Panel Opposes Legislation to Limit Arts Grants," *New York Times,* Sept. 12, 1990.

50. Patrick Buchanan, "Losing the War for America's Culture," *Washington Times,* May 22, 1989; Holly Hughes and Richard Elovich, "Homophobia at the N.E.A.," *New York Times,* July 28, 1990; "Nation: 'Hurdles and Hoops' for the NEA Bill," *Art News,* Nov. 1990; Allen Ginsberg, "Letter Concerning NEA," Aug. 14, 1989, quoted in Bolton, *Culture Wars,* p. 92; Richard Bernstein, "The Endowment: A Reflective Defense of It and a Show that Tweaks It: Arts Advisor Says the Problem Isn't Obscenity, It's Mediocrity," *New York Times,* Aug. 14, 1990.

51. Frohnmayer, *Leaving Town Alive,* pp. 176–77; "Artnotes," *New Art Examiner,* Mar. 1991; Frohnmayer, *Leaving Town Alive,* pp. 25, 50, 53.

52. Ronald Berman, *Culture and Politics* (Lanham, Md.: University Press of America, 1984), pp. 147–48; Ernest van den Haag, "Should the Government Subsidize the Arts?" *Policy Review* (fall 1979): 69–70.

53. Michael Straight in Robin Blaser and Robert Dunham, eds., *Art and Reality: A Casebook of Concern* (Vancouver, British Columbia: Talon, 1986), p. 163.

54. Robert J. Samuelson, "Highbrow Pork Barrel," *Washington Post,* Aug. 16, 1989; Dave Barry, "The Naked Truth," *Miami Herald,* Dec. 16, 1990.

55. Interviews with Anne-Imelda Radice, May 19, 1993, Washington, D.C.; John Wessel, June 30, 1992, New York City; W. McNeil Lowry, June 29, 1992, New York City.

56. Blair Kamin, "Interim Chairwoman to Assume Command at Arts Endowment," *Chicago Tribune,* Apr. 30, 1992; interview with Anne-Imelda Radice, May 19, 1993, Washington, D.C.

57. Frohnmayer, *Leaving Town Alive,* p. 331; William H. Honan, "Why Frohnmayer Lost U.S. Arts Post," *New York Times,* Feb. 27, 1992; interviews with Leonard Garment, Apr. 21, 1993, and Anne-Imelda Radice, May 19, 1993, both in Washington, D.C.

58. David Johnston, "Lightning Bolts from Left and Right Can't Resist Arts Endowment Chief," *New York Times,* May 3, 1991; interviews with Randolph N. McCausland, Nov. 19, 1992; Anthony Tighe, Nov. 17, 1992; Hugh Southern, Nov. 10, 1992; and Gary O. Larson, Nov. 19, 1992, all in Washington, D.C.; Frohnmayer, *Leaving Town Alive,* pp. 148–49.

59. William H. Honan, "Arts Chief Bids Bush Frank Farewell," *New York Times,* Mar. 23, 1992; Eric Gibson, "Money, Money . . . Educate . . . Educate . . . Money, Money," *Art Newspaper,* June 1992; interview with John Frohnmayer, Apr. 20, 1993, Washington, D.C.

60. Robert Brustein, "Don't Punish the Arts," *New York Times,* June 23, 1989; NEA memo to New York Academy of Art, Dec. 20, 1989 and New York Academy of Art memo to NEA, Jan. 5, 1990, Sherry French Papers,

New York City (private collection); Tom Wolfe, "The New Radicals in the Arts," *American Arts Quarterly* (fall 1990): 4–5. Ana Steele to Gregory Hedberg, May 9, 1990, Sherry French Papers.

61. Paul Jeromack, "Prudish, Vain, but a Great Director," *Art Newspaper,* Mar. 1992; Robin Cembalest, "Who Does It Shock? Why Does It Shock?" *Art News,* Mar. 1992, pp. 32, 34.

62. Interviews with Margaret Jane Wyszomirski, Nov. 16, 1992, Anthony Tighe, Nov. 17, 1992, Charles Ruttenberg, Nov. 11, 1992, David Stewart, May 18, 1993, and Ann Murphy, Nov. 17, 1992, all in Washington, D.C.

63. Interviews with Louise Wiener, Nov. 12, 1992, Jack Golodner, Nov. 12, 1992, and Robert Lynch, Nov. 9, 1992, all in Washington, D.C.

64. U.S. Bureau of the Census, *Statistical Abstract of the United States* (Washington, D.C.: U.S. Dept. of Commerce, 1993), p. 256.

65. Jacques Barzun, "A Surfeit of Art and Why Government Need Not Encourage It," *Harper's,* July 1986, pp. 46–48; Paul DiMaggio in DiMaggio, ed., *The Nonprofit Sector: A Research Handbook* (New Haven: Yale University Press, 1987), pp. 208–9.

66. Marc R. Freedman in Paul DiMaggio, ed., *Nonprofit Enterprise in the Arts: Studies in Mission and Constraint* (New York: Oxford University Press, 1986), pp. 200, 206–9.

67. Martin Mayer, *Bricks, Mortar, and the Performing Arts* (New York: Twentieth Century Fund, 1970), pp. 1, 99; Mayer, "Where the Dollars Go," *Saturday Review,* Feb. 28, 1970, pp. 24, 80; "Cultural Centers— Wanted: A Fiscal Wizard," *Time,* Dec. 13, 1968, p. 67; "Complete," *New Yorker,* Nov. 8, 1969, pp. 48–49; "Arts Centers: High Cost of Culture," *Time,* Jan. 24, 1969, p. 59; "Culture Shock," *Newsweek,* Jan. 27, 1969, p. 94.

68. Roanoke City Planning Commission, "Toward a Fine Arts Center in Roanoke," 1963, pp. 6, 25.

69. Rebecca Morris, "Here Comes the Neighborhood: All Over America, Theatres Are Leading the Way for Urban Renewal," *American Theatre,* Oct. 1993, pp. 50–51.

70. Jarrold A. Kieffer, radio remarks on WGMS, Feb. 16, 1961, and Col. L. Corrin Strong, "Peaceful Uses of Creative Energy," speech given at the Tri-States Conference on the Arts, Apr. 29, 1961, Richmond, Virginia, both in the NYPL Performing Arts Library; Brendan Gill, *John F. Kennedy Center for the Performing Arts* (New York: Abrams, 1981), pp. 23–24; Board of Trustees, National Cultural Center Annual Report, Dec. 31, 1960, NYPL Performing Arts Library.

71. "Remarks of the President to the Advisory Committee of the National Cultural Center," Nov. 14, 1961, Hal Prince Papers, NYPL Performing Arts Library; Gill, *John F. Kennedy Center,* pp. 17–18, 35–36.

72. Ibid., p. 39; "Battle of the Potomac," *Newsweek,* Jan. 31, 1972, p. 85; "Grand Night in a Superbunker," *Time,* Sept. 20, 1971, p. 40; Robert Hughes, "The New Monuments," *Time,* Sept. 13, 1971, p. 66.

73. Charlotte Allen, "The Dead Kennedy Center," *Washington City Paper,* Dec. 11, 1992, pp. 38, 40–41; Gill, *John F. Kennedy Center,* pp. 29, 31.

74. "Arts Center Debut—More Controversy," *U.S. News and World Report,* Sept. 20, 1971, p. 73; Gill, *John F. Kennedy Center,* pp. 42–43.

75. "Memorials: The JFK Ripoff," *Newsweek,* Dec. 13, 1971, p. 37.

76. Mayer, *Bricks, Mortar, and the Performing Arts,* pp. 3–7.

77. Allen, "The Dead Kennedy Center," pp. 32–33; interview with Doug Wheeler, May 21, 1993, Washington, D.C.

78. Duncan Norton-Taylor, "Roger Stevens: A Performing Art," *Fortune,* Mar. 1966, p. 204; Allen, "The Dead Kennedy Center," pp. 33–34, 41–42.

79. Interview with Robert Lynch, Nov. 9, 1992, Washington, D.C.; National Cultural Alliance, "Fact Sheet," Washington, D.C., 1993; Research and Forecasts, "The Importance of the Arts and Humanities to American Society" (Washington, D.C.; National Cultural Alliance, Feb. 1993).

80. Joe David Bellamy, "On Pens and $words," *Nation,* Nov. 30, 1992, p. 668; David Barton, "Musical Patchwork Set for Inaugural," *San Diego Union-Tribune,* Jan. 12, 1993.

81. Arts Research Center, *The Arts as an Industry: Their Economic Importance to the New York–New Jersey Metropolitan Region* (New York: Alliance for the Arts, 1993), pp. 3–5; Martin E. Segal, "For New York City and State, the Arts Are Bread and Butter," letter to the editor, *New York Times,* Mar. 12, 1993.

82. Panel presentations on "Cultural Diversity and Heritage—Maximizing Our Assets," Conference on Cultural Tourism, Dec. 2–3, 1993, San Diego.

83. E. L. Doctorow, "Remarks," presented to the National Council on the Arts, May 14, 1993; Suzanne Fields, "Public Subsidies Abuse the Arts," *Chicago Sun-Times,* Aug. 14, 1990; quoted in Bill Kauffman, "Subsidies to the Arts: Cultivating Mediocrity," Cato Institute Policy Analysis, no. 137, Aug. 8, 1990, pp. 14–15.

84. National Endowment for the Arts, "Theater, Support to Organizations, Application Guidelines," 1993–94 Performance Season.

85. National Endowment for the Arts, *The Arts in America: A Report to the President and to the Congress* (Washington, D.C.: National Endowment for the Arts, 1992).

86. Quoted in Zeigler, *Arts in Crisis,* p. 33; Ben Yagoda, "Uncle Sam as Impresario: Are We Funding Junk?" *Saturday Review,* July 1980, p. 17.

87. Zeigler, *Arts in Crisis,* pp. 130–31, 62.

CHAPTER 8: THE BEGGAR'S OPERA

1. "Arts Agency Can Keep Meetings Closed," *New York Times,* Apr. 30, 1992.

2. Independent Commission, *Report to Congress on the National Endowment for the Arts,* (Washington, D.C.: Independent Commission, 1990) p. 70.

3. Sam Walker, "Jane Alexander Works to Recast NEA Image," *Christian Science Monitor,* Jan. 21, 1994.

4. "Summary of NEA Appropriations," *Congressional Digest,* Jan. 1991, p. 10; "Scope of Federal Arts Funding," *Congressional Digest,* Jan. 1991, pp. 4, 6; Calvin Reid, "NEA Lit Program in Major Study of Literary Funding," *Publishers Weekly,* Feb. 14, 1994, p. 9; Jacob Neusner, letter to the editor, *Wall Street Journal,* Aug. 31, 1990.

5. Joseph Wesley Zeigler, *Arts in Crisis: The National Endowment for the Arts versus America* (Chicago: A Cappella, 1994), p. 148.

6. Liza Mundy, "National Endowment for Administrators," *Washington Monthly,* June 1991, pp. 52–53; National Endowment for the Arts, *The Arts in America: A Report to the President and to the Congress* (Washington, D.C.: National Endowment for the Arts, 1992).

7. Richard C. Swaim in Swaim, ed., *The Modern Muse: The Support and Condition of Artists* (New York: American Council for the Arts, 1989), pp. 48, 51–52.

8. John Dizikes, *Opera in America: A Cultural History* (New Haven: Yale University Press, 1993), pp. 30–32.

INDEX